D0906993

JOHN POPE-HENNESSY

RAPHAEL

THE WRIGHTSMAN LECTURES

NEW YORK UNIVERSITY PRESS

Frontispiece. Raphael: *Madonna della Sedia*. Florence, Palazzo Pitti

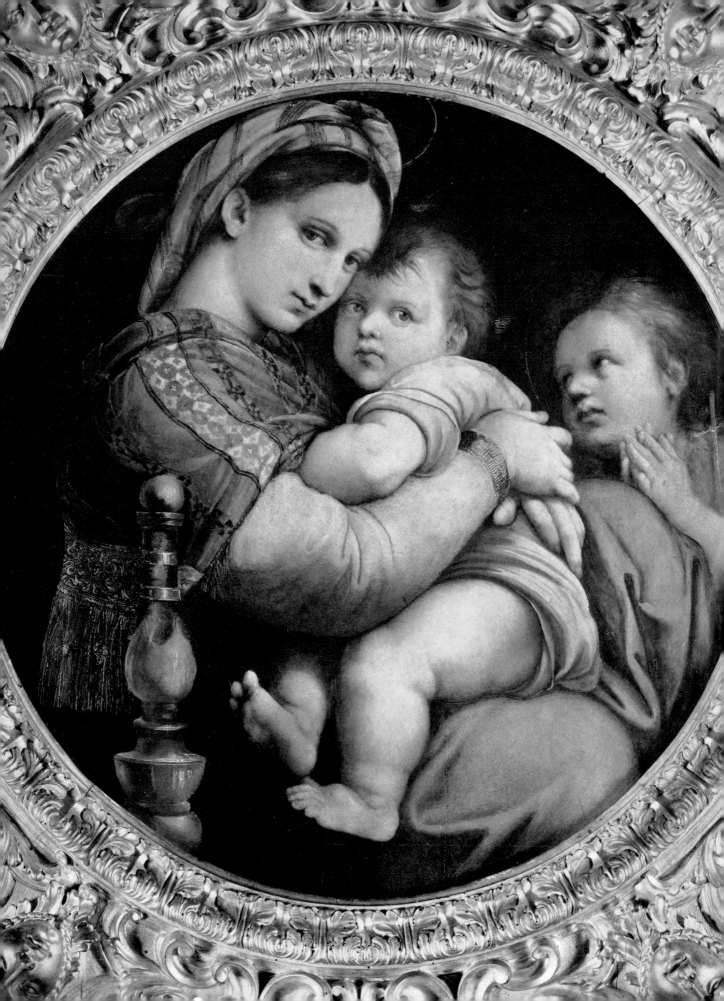

JOHN POPE-HENNESSY

RAPHAEL

THE WRIGHTSMAN LECTURES

DELIVERED UNDER THE AUSPICES

OF THE NEW YORK UNIVERSITY

INSTITUTE OF FINE ARTS

NEW YORK UNIVERSITY PRESS

This is the fourth volume
of the Wrightsman Lectures,
which are delivered annually
under the auspices of the
New York University Institute of Fine Arts

LIBRARY OF CONGRESS CARD NUMBER: 70–88138
ISBN: 0-8147-0476-X

PRINTED BY R. & R. CLARK LTD · EDINBURGH
BOUND BY QUINN & BODEN COMPANY, INC., RAHWAY, NEW JERSEY

CONTENTS

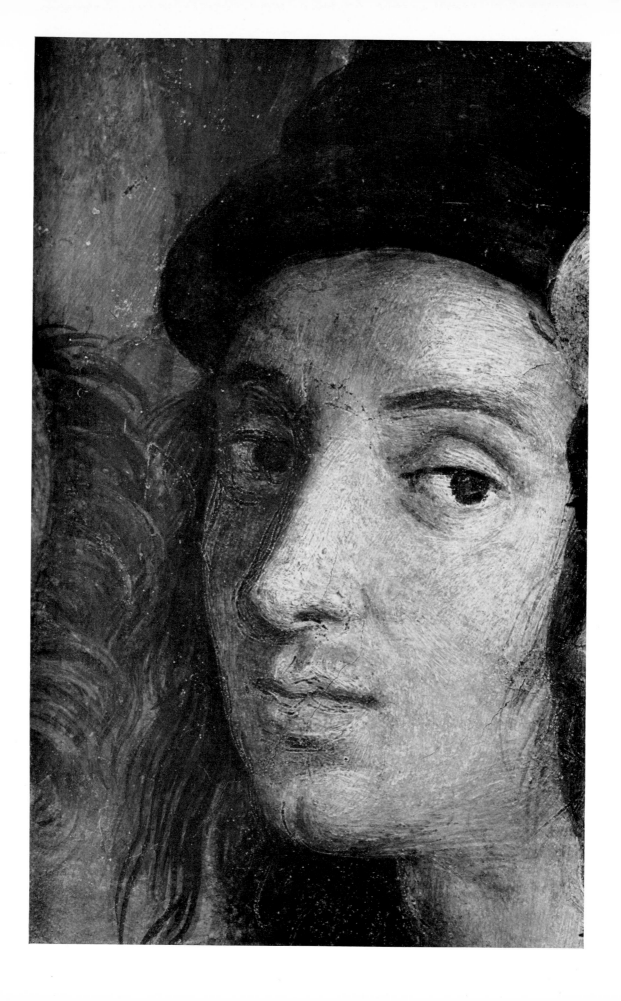

PREFACE

'PERCHANCE, THEN,' says a German painter to the heroine of Hawthorne's *Marble Faun*, 'Raphael has a rival in your heart? He was your first love; but young maidens are not always constant, and one flame is sometimes extinguished by another!' Raphael was also the first love of the writer of this book. In conducting classes about his work (as I have been compelled from time to time to do), I have found myself hampered by the lack of any volume which would explain, in simple terms, how he worked and why his paintings deserve more sympathetic notice than they receive today. Could such a volume be produced? The occasion for making the attempt was provided by an invitation from New York University to deliver The Wrightsman Lectures. The form adopted for the lectures is deliberately unorthodox, and they do not constitute a monograph on Raphael. Not only do they contain no reference to Raphael's practice as an architect, but even in the field of painting many works are not discussed. I shall be satisfied if, after he has read them, the reader returns with renewed visual interest and heightened visual pleasure to Raphael's work.

The last twenty years have witnessed a revival of Raphael studies, and in preparing this book I have felt something of a trespasser. Without the catalogues of the drawings in the British Museum by Philip Pouncey and John Gere and of the drawings at Oxford by K. T. Parker, the *catalogue raisonné* of Raphael's paintings by Dussler, the noble pages of Freedberg, and the articles of younger Raphael students, headed by Dr. Konrad Oberhuber, the task would have been even harder than it proved. I must record a special debt to Professor D. Redig de Campos for facilities for studying the frescoes in the Stanze, to Professor Ulrich Middeldorf and the staff of the Kunsthistorisches Institut in Florence, where much of the preliminary work was done, and to Professor Craig Hugh Smyth and the staff of the Institute of Fine Arts of New York University, under whose auspices the lectures were given. Last and most cordially I must thank Mr. and Mrs. Charles Wrightsman, without whose generous support the arguments set out in this book would never have been formulated and who ensured that the delivery of the lectures should be a uniquely enjoyable experience.

John Pope-Hennessy

1. Raphael: *Self-Portrait in the School of Athens*. Vatican

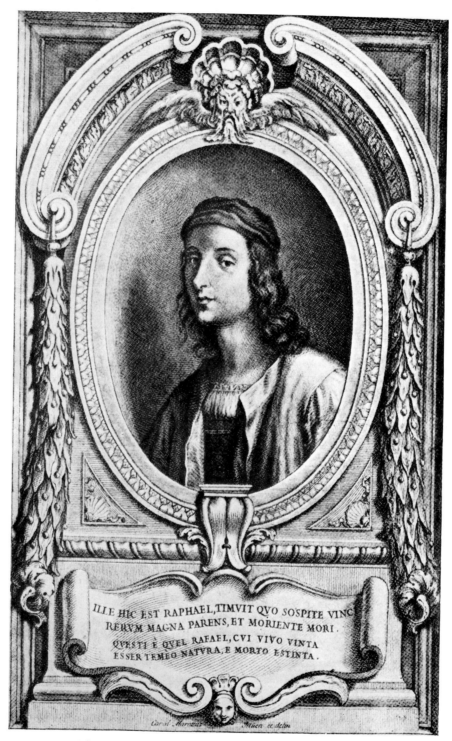

ILLE HIC EST RAPHAEL, TIMVIT QVO SOSPITE VINC
RERVM MAGNA PARENS, ET MORIENTE MORI.

QVESTI E QVEL RAFAEL, CVI VIVO VINTA
ESSER TEMEO NATVRA, E MORTO ESTINTA.

Carol. Marattus *frecit et delin*

2. Maratta: *Engraving after Raphael's Self-Portrait in the School of Athens*

I · THE CHANGING IMAGE

EIGHTY-SIX YEARS AGO two men, an Englishman and an Italian, published what is, to this day, the best book on Raphael.[1] Its opening words are these: 'Raphael! At the mere whisper of this magic name our whole being seems spellbound. Wonder, delight, awe take possession of our souls, and throw us into a whirl of contending emotions.' The present book proceeds from the contrary assumption, that Raphael's reputation lies in the past, and that to us his works speak less directly than those of painters who were once looked on as his inferiors. For this the critics by whom his paintings have been eulogised, the scholars who have raked them over, the restorers who have tampered with them, and the commercial firms by which they are exploited, must all accept some measure of responsibility. But the root cause lies in a tendency, evident from a very early time, to substitute for the real Raphael an abstraction behind which the author of the paintings is concealed.

The tradition of Raphael's physical appearance testifies to this. About 1506 he painted a self-portrait which is now in the Uffizi,[2] and three years later he introduced another into the *School of Athens* (Fig. 1).[3] The first of the self-portraits is gravely damaged,[4] and the second is so bland and unrevealing that it has often been dismissed as a restorer's work.[5] Recent cleaning has, however, shown that it is well preserved, and there is no alternative but to conclude that Raphael, at twenty-six, looked as he does in the fresco. Bland this self-portrait may appear, but it was still more lively than the image that his pupils transmitted to posterity. In an altarpiece of *St. Luke painting the Virgin* in the Accademia di San Luca, designed soon after Raphael's death, an ideal likeness, based on the portrait in the fresco, is introduced.[6] By the seventeenth century it was generally believed that this picture was painted for the Academy by Raphael, and the supposed self-portrait was treated with credulous respect. In 1674 when a marble bust was carved for Raphael's tomb in the Pantheon, its author was enjoined to follow the portrait in this painting.[7] The view commonly taken of Raphael's appearance at this time is explained by the most sensitive of his interpreters, Bellori. Raphael, declares Bellori,[8] was endowed by heaven with proportions of the utmost beauty and with demeanour of the utmost grace, though his delicate complexion and long neck betrayed the weakness in his constitution that brought his life prematurely to a close. Against the background of this myth the self-portrait in the *School of Athens* was adapted by Carlo Maratta in an engraving (Fig. 2),[9] in which the few traces of character that can be detected in the fresco are effaced. In the eighteenth century Maratta's etiolated Raphael was reproduced by

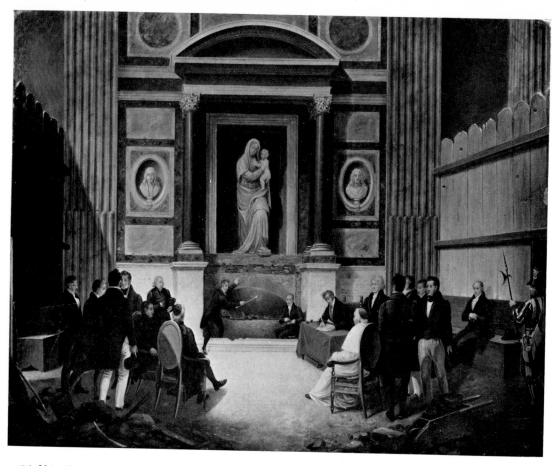

3. Diofebi: *The Opening of Raphael's Tomb*. Copenhagen, Thorvaldsens Museum

Mengs,[10] and in the nineteenth century he appears once more, 'dressed in a white robe, as symbolical of the universality of his genius, uniting all the qualities which we gaze on with wonder, in their separate state, in others', in Overbeck's *Religion glorified by the Fine Arts*.[11]

With the advent of the Romantic movement, Raphael's life and physiognomy became the object of new curiosity, which reached its climax in 1833 with the cere-monial opening of his tomb (Fig. 3).[12] A pretext for this operation was afforded by the fact that the Accademia di San Luca owned a skull, whose authenticity had frequently been challenged, but which had been exhibited throughout the eighteenth century as that of Raphael. The tomb was unwalled in the presence of the Vicar of the Pope, the Governor of Rome, a number of academicians and 'l'élite de la haute société du pays', and revealed a pinewood coffin in which were Raphael's skull and skeleton. Measured by the Professor of Clinical Surgery in the University of Rome, they proved to be consistent in all respects with the self-portrait in the *School of Athens*, though they presented one unexpected feature, a large larynx from which it

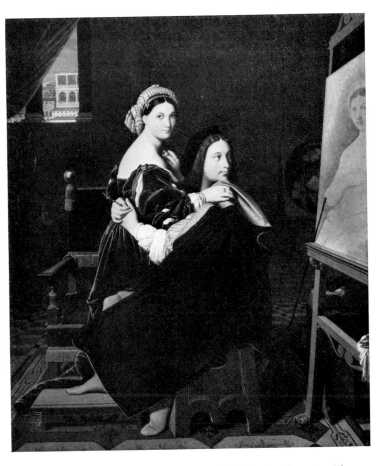

4. Ingres: *Raphael and the Fornarina*. Harvard University, Fogg Art Museum

was inferred that Raphael's voice was louder than might otherwise have been sup-posed.

The only authoritative source for Raphael's biography was the standard life written by Vasari, but to it there was added, in 1790, a forged life of Raphael by Comolli,[13] in which the facts corresponded with those given by Vasari but were presented more sentimentally. A reading of this book led Ingres to plan five paintings devoted to the life of Raphael. The first and last were to illustrate Raphael's birth and death, and the intervening paintings were to show Raphael being presented by Bramante to the Pope, Raphael's betrothal to the niece of Cardinal Bibbiena, and Raphael and his mistress, the Fornarina.[14] Only two of the five pictures were carried out – the betrothal scene and *Raphael and the Fornarina* (Fig. 4), of which four versions were produced over a period of almost fifty years.[15]

The task that Ingres did not complete was accomplished in 1833 by the engraver Johann Riepenhausen.[16] According to Vasari, Raphael, in the months following his birth in 1483, was suckled by his mother, not a foster-mother, and Riepenhausen

reconstructs the scene; a cradle, based on the cradles in Raphael's late Madonnas, stands in the corner of the room. Vasari tells us that as a boy Raphael helped his father, Giovanni Santi, to paint pictures, and Riepenhausen shows him doing so. Before long, however, it was decreed that the young genius should leave home – this is the subject of one of the most vivid of the engravings – and he was consigned by his father to the studio of Perugino. In Riepenhausen's print the apprentices of Perugino look on the gifted newcomer with unconcealed dismay. Roughly ten years elapse, and then in 1504 Raphael arrives in Florence, where Michelangelo seizes the first opportunity to show him the cartoon for his Battle fresco in the Palazzo della Signoria (Fig. 5), and where he takes a tip or two from Fra Bartolommeo. This Florentine sojourn is cut short, and we next see Raphael in 1508 presented by his fellow townsman Bramante to the Pope. In Rome, as he is sitting in a trance-like condition in his studio, he receives a mystic vision of the *Sistine Madonna*. Success follows success. He becomes chief architect of St. Peter's, designs the statue of Jonah for the Chigi Chapel in Santa Maria del Popolo, and paints the portrait of Pope Leo X. All this is represented by Riepenhausen on a single plate, in which the Pope visits Raphael's studio and admires the portrait and the model for the statue. On the adjacent plate Raphael assumes responsibility for

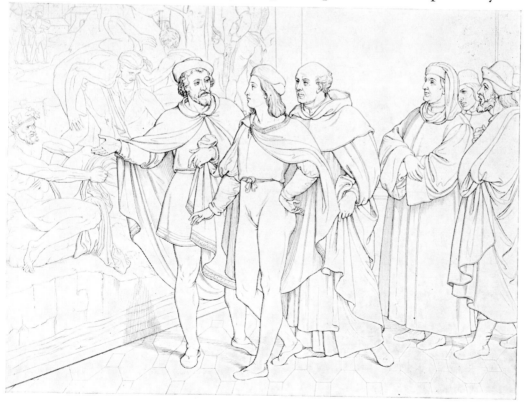

5. J. Riepenhausen: *Raphael is shown the Cartoon for the Battle of Cascina by Michelangelo*. Engraving

6. E. Eichens after Giovanni Santi:
The Child Raphael.
Engraving

conserving the antiquities of Rome. But his frail body is worn down by this multiplicity of tasks, and in 1520, surrounded by lamenting friends and pupils, he expires, with the unfinished altarpiece of the *Transfiguration* standing beside his bed.

The same decade that saw the publication of Riepenhausen's prints witnessed the issue of an epoch-making monograph on Raphael. Johann David Passavant's *Raffael von Urbino und sein Vater Giovanni Santi*[17] consisted of a volume of biography, a catalogue and a portfolio of engravings, and a number of the plates in the portfolio, as well as two plates in a third appendix volume which came out after a lapse of twenty years, are devoted to portraits of the artist Passavant discussed, 'der schönste Genius der modernen Kunst'. In the early nineteenth century it was believed that Raphael had twice been painted as a child, in an altarpiece and fresco by Giovanni Santi.[18] Prints of the three-year-old figure from the altarpiece were very popular (Fig. 6), and he and the small boy from the fresco are reproduced by Passavant. It was also supposed that Raphael recorded his own features as a sulky-looking child of twelve in a portrait in the Borghese Gallery,[19] and was depicted as a languid youth of twenty, in a fresco by Pinturicchio at Siena.[20] Passavant includes both portraits.

But his text belies its illustrations; it offers the first serious analysis of Raphael's style and contains what was, till recently, the only catalogue of his paintings.

One of the minds on which Passavant's book made a strong impact was that of the Prince Consort. When Prince Albert assumed control at Windsor, he at once directed his attention to the drawings by Old Masters in the Royal Library. As he reviewed the Raphael drawings, 'His Royal Highness' interest was attracted by observing in very many cases the various discrepancies between the first sketch and the finished painting. . . . To endeavour to trace the motives for these changes and variations was a deeply interesting task, the accomplishment of which alone would tend to give a real insight into the artist's mind, and also enable us to appreciate his creations, almost as if we had watched their origin and progress in his own studio.' From this observation the so-called Raphael Collection at Windsor sprang. On Prince Albert's instructions, the drawings by Raphael in the Royal Library were photographed and the owners of other drawings were cajoled into following this example, to such effect that 'with one single exception no owner ever refused to allow the faithful reproductions of his treasures to be deposited in the Prince's portfolios'. The resulting collection has been properly described as 'a beautiful memorial of how an artist can be and ought to be studied, and what results may be obtained when a mind capable of following the purest genius in its noblest aspirations undertakes the task'.

Before it could be used in the imaginative way that he envisaged, the Prince Consort died. With Queen Victoria's approval the collection was augmented, and a catalogue was printed in 1876,[21] but the intellectual impulse behind it was at an end. Study of Raphael was, however, carried forward in two complementary monographs. One, by a Frenchman, Müntz, was the product of a single brain,[22] while in the other the material was sifted by two minds, Cavalcaselle the connoisseur and Crowe, to whom the historical synthesis was due. In Italy it is the habit to treat Crowe as a parasite on Cavalcaselle, but this is utterly unwarranted. Art history is not synonymous with connoisseurship, and the work of other connoisseurs might have been longer lasting had it been buttressed by a Crowe.

Such was the position at the end of the century, when there appeared a little book in which study of Raphael was transformed. Written by Oskar Fischel, it contained a short critical account of Raphael's drawings.[23] From it there grew a corpus of Raphael drawings, also by Fischel, the work of which the Prince Consort had dreamed and on which present-day study of Raphael rests.[24] Knowledge that it was in gestation had a paralysing influence on other scholars, and through the nineteen-twenties and thirties attention consequently switched to the artists who emerged from Raphael's studio and away from Raphael himself. At his death Fischel left a monograph more or less ready for the press; it appeared, in a poor

7. Raphael: *Self-Portrait* (detail). Paris, Louvre

English translation, in 1948, and in German in 1962.[25] Fischel's Raphael looked rather different from the Raphael of the nineteenth century. He had the wide-spaced, calculating eyes, the firm jaw and the tightly compressed lips that are shown in an engraving by Bonasone, a fresco in the Villa Lante, and the painting known as *Raphael and his Fencing Master* in the Louvre (Fig. 7).[26] The text none the less returned to the idolatrous tradition of the writer Fischel called 'the pious Passavant'. In his approach to Raphael's drawings Fischel had been unfailingly pragmatical, but like his predecessors he regarded Raphael's paintings as concepts not as artefacts.

The idealist attitude to Raphael propagated by Bellori and maintained by Fischel would matter less had it not left its mark on Raphael's work. It did so in two ways. For centuries Raphael's were the most coveted pictures in the world, and because they were coveted they were moved recklessly from place to place. The main culprits were the French, who after 1797 sequestrated most of Raphael's altarpieces.[27] The *Coronation of the Virgin* (now in the Vatican) was removed to Paris from the chapel for which it had been painted at Perugia,[28] the *Madonna del Baldacchino* was lifted from the Palazzo Pitti,[29] the *Madonna di Foligno* was filched from Foligno,[30] the *St. Cecilia* was confiscated from San Giovanni in Monte at Bologna,[31] the *Madonna del Pesce* and the *Spasimo di Sicilia* and the *Visitation* were taken to Paris from Madrid,[32] and the *Transfiguration* was wrested from San Pietro in Montorio.[33] The pictures were carefully transported, by the low standards prevailing at the time, but every one of them returned, after 1815, in a worse state than it had left. True, they were treated with what was thought of as scientific care. A committee reported on them individually, and the *Coronation of the Virgin* was exhibited in the damaged state in which it had arrived in order to convince an already sceptical public that restoration was really necessary. The reason for this propaganda was that restoration in France round 1800 carried a different significance from restoration in Germany or Italy; it meant that the paint film of panel paintings was transferred to canvas. To do them justice, the French damaged their own Raphaels first. Two pictures painted by Raphael for Francis I of France, the *St. Michael* and the *Holy Family of Francis I*, were transferred from panel to canvas in the middle of the eighteenth century, with the lamentable consequences we see in the Louvre today.[34] In the event the *Coronation of the Virgin* and the *Madonna di Foligno* were transferred to canvas without serious loss, while other paintings – the *St. Cecilia* from Bologna was one of them – were treated less efficaciously. Before the supernatural reputation of one painting, the *Transfiguration*, the committee quailed. It was not transferred, it was not even cradled, and the restorers were authorised only to replace the flaking paint. There is a good deal of contemporary evidence for the *Doctor's Dilemma* atmosphere in which these restorations were carried out. It has been claimed that the motive behind this period of pillage was the wish to create a European art capital in Paris. What matters now

is the result, that not one single altarpiece by Raphael can be seen in the setting for which it was designed, and that paintings which appear up to that time to have been fairly well preserved were impaired as works of art. Very few major paintings escaped. The *Sistine Madonna* did so, because it was sold to the Elector of Saxony in 1754, and so did the *Ansidei Madonna* which arrived in England ten years later. The closest shave was with the Brera *Sposalizio*. It was offered in 1798 by the Municipality of Città di Castello as a forced gift to a general from Brescia, who succumbed to the appeal of profit-taking. Sold to a scrupulous Milanese collector, it was left to the Ospedale Maggiore in Milan, and was moved thence to the Brera in 1806.[35]

The second way in which the idealist attitude to Raphael affected Raphael's paintings arose out of stupidity. The intention was respectful enough; it was to diminish the inexplicable gap between the idea of Raphael and the reality of Raphael's work. Unfortunately it was the idea of Raphael not his paintings that was at fault. In the eighteenth or early nineteenth century the damaged *Canigiani Madonna* (Fig. 9), then at Düsseldorf, was judged to look inadequately Raphaelesque; the angels with which Raphael completed the composition at the top were consequently painted out, and can now be seen only in copies and in X-ray photographs (Fig. 8).[36] The *Bridgewater Madonna*, which belonged to Seignelay, the son of Colbert, and was later in the Orleans Gallery, was transferred, like the paintings in the Louvre, from panel to canvas; the original background was painted out and a false window was inserted on the right.[37] In Florence the *Madonna del Granduca*, which was bought for the Palatine Gallery in 1799, escaped this drastic surgery, but may originally have had a landscape background which was covered by the dark background that we see today.[38] So popular is it in this form that it cannot be cleaned and is unlikely ever to be properly investigated. With the *Alba Madonna* in Washington the opposite occurred; in the accustomed fashion it was transferred to canvas in the Hermitage and diligently cleaned, and before joining the Mellon Collection it was cleaned still more thoroughly.[39] Some of Raphael's panel paintings are, none the less, extremely well preserved. The *Esterházy Madonna* in Budapest is one,[40] and others are the *St. Catherine of Alexandria* in London and the *Large Cowper Madonna* in the National Gallery of Art. The difference can best be seen in Washington, where visitors can turn from the scrubbed *Alba Madonna* to the *Large Cowper Madonna*, in which the richness of Raphael's facture is unimpaired and only the gold haloes have been renewed.[41] Pictures stand up to neglect better than to solicitude, and Raphael's bear the scars of too much love.

The havoc wrought on Raphael's frescoes by affectionate restorers dates from a much earlier time. In 1580, under Pope Gregory XIII, panic broke out over the deteriorating state of the frescoes in the Villa Farnesina, and some of them were engraved by Cherubino Alberti.[42] No remedial action was taken, however, for

8. Raphael: *Radiograph of the Canigiani Holy Family*. Munich, Alte Pinakothek

9. Raphael: *The Canigiani Holy Family*. Munich, Alte Pinakothek

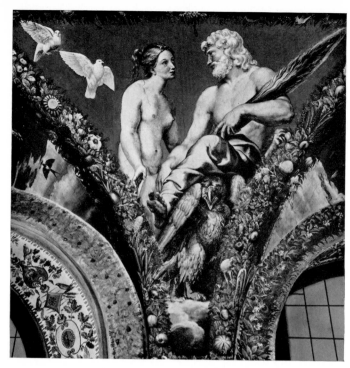

10. Raphael (restored by Maratta):
Venus as a Suppliant before Jupiter.
Rome, Villa Farnesina

almost a hundred years, and when it came it was inspired by the principal painter in Rome, Carlo Maratta.[43] Though the frescoes were one of the prime sources of seventeenth-century decorative painting, the colours, we are told, had lost their freshness, the half-tones had all but vanished, and only traces of the blue backgrounds remained. Widespread protests, none the less, were made when the intention to restore them became known, and in retrospect the protests appear justified. Maratta repainted the backgrounds – to such good purpose that a visitor as little sensitive to visual values as was Gibbon complained that the 'staring blue' he had put into them 'hurt the loggia very much' – and since the bases of the pendentives were incomplete – the garlands by Giovanni da Udine that framed them did not reach down to the cornice – he extended them.[44] Where the indications of Raphael's forms were judged to be inadequate – the scene of *Venus as a Suppliant before Jupiter* was a case in point (Fig. 10) – Maratta, with the punctiliousness of an academician, returned to the classical sculptures Raphael had studied, among them the Antinous and the Belvedere torso in the Vatican.[45] In the large frescoes on the ceiling the Bacchus and Hercules in the *Wedding Feast of Cupid and Psyche* and the Mercury, the Amor, and the head of Psyche in the *Council of the Gods* are due not to Raphael but to Maratta.[46] At the same time the plaster was reattached with eight hundred and fifty large lead nails. The implications of Maratta's policy can best be judged by comparing the right-hand part of the *Council of the Gods* (Fig. 11) with Raphael's preliminary drawing (Fig. 12), which is vastly superior in expression and vitality.[47] Maratta was a disinterested zealot, and it would

20

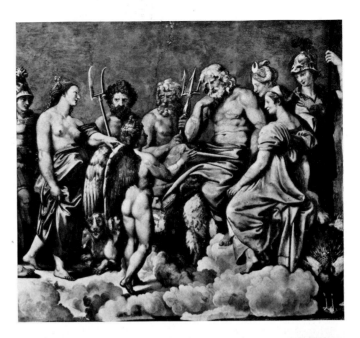

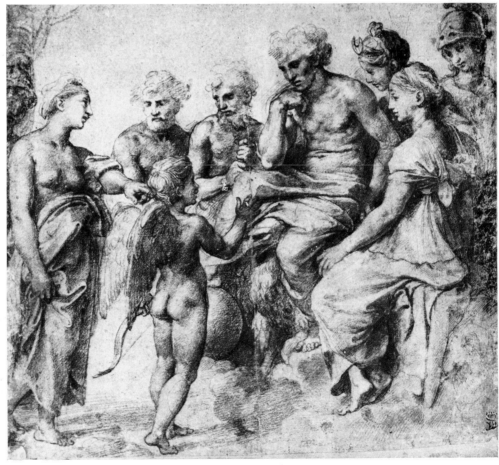

11 (above). Raphael (assisted and restored):
The Council of the Gods (detail). Rome, Villa Farnesina

12 (below). Raphael: *Study for the right half
of the Council of the Gods.* Paris, Institut Néerlandais

be wrong to condemn him out of hand. But Raphael restored is Raphael inter-
preted; it is different from the real thing.

In an adjacent room the *Triumph of Galatea* (Fig. 13) was better protected and
correspondingly better preserved. Visiting the Villa Farnesina in 1644, Evelyn
watched the constantly replenished group of artists drawing from the *Psyche* frescoes,
and noted that the *Galatea* was 'carefully preserved in the Cuppord at one of the
ends of this walke to protect it from the air, because it is a most stupendous lively
painting'. Thanks to this, when it came to be restored, only fifty of Maratta's nails
were required.[48] The effect of liveliness cannot have been enhanced, for when
Richardson saw it in 1720, he complained that the drapery looked heavy and dark.[49]
In the eighteen-sixties it was restored once more. According to Crowe and Caval-
caselle, the eyes of Galatea were holes in the plaster and her hair had been in part
repainted over a new ground, while the sea and the sky were extensively retouched.[50]

Through most of the sixteenth century Raphael's greatest works, the frescoes in
the Vatican, were not accessible to visitors. They were in the apartments of the Pope,
and even when a Pope moved to other rooms in the vicinity, they preserved an aura
of privacy. Vasari was so ill acquainted with them as to be unaware of the differ-
ences between the fresco of *Parnassus* and the engraving that Marcantonio Raimondi
based on Raphael's first design. During a visit to Rome in 1575 the French
archaeologist Blaise de Vigenères as a matter of course paid his respects to the
Villa Farnesina, but did not secure access to the Stanze of the Vatican. Only the
Loggia, with its grotesques and the little frescoes that came later to be known as
Raphael's Bible, could from time to time be visited. This situation persisted till the
late sixteenth century, when under Sixtus V the Vatican buildings were extended
and the Popes moved to more commodious premises. From then on the frescoes
could be studied, and were studied to excess.

Visiting the Vatican today, it is hard to imagine what the Stanze looked like at
this time. The lower part of the walls were damaged in 1527 during the Sack of
Rome – some of them still bear traces of the Lutheran graffiti which were scratched
on them by German troops – and the upper frescoes also suffered local damage – the
heads of Pope Julius II and Cardinal Giovanni de' Medici in the Stanza della
Segnatura (Fig. 14), for example, were defaced.[51] In the first room, the Stanza del-
l'Incendio, the *Battle of Ostia* was a good deal deteriorated, and some of the fore-
ground figures in the *Coronation of Charlemagne* were copied on new plaster by
Sabbatini.[52] By the mid-seventeenth century, when Bellori came to Rome, dust had
formed a hard film over the surface and certain heads were practically illegible.[53]
At long last Carlo Maratta was appointed superintendent of the Stanze with the
charge of cleaning the frescoes, but so vocal was the opposition that work could
not be started till 1702. That it could be begun at all was due to the election as

13. Raphael: *The Triumph of Galatea*. Rome, Villa Farnesina

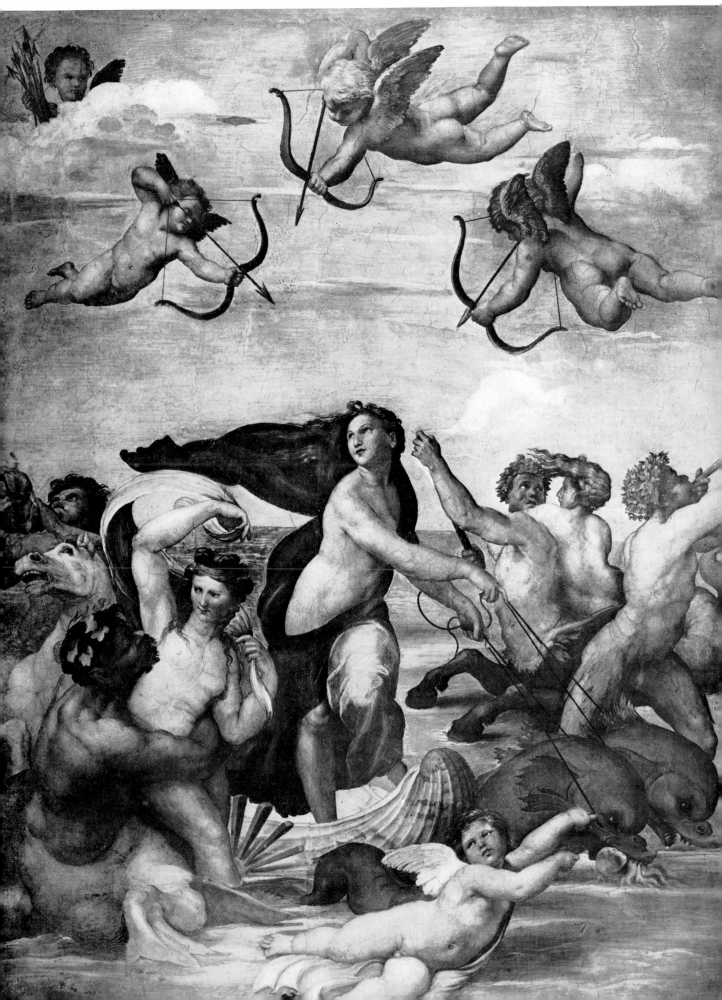

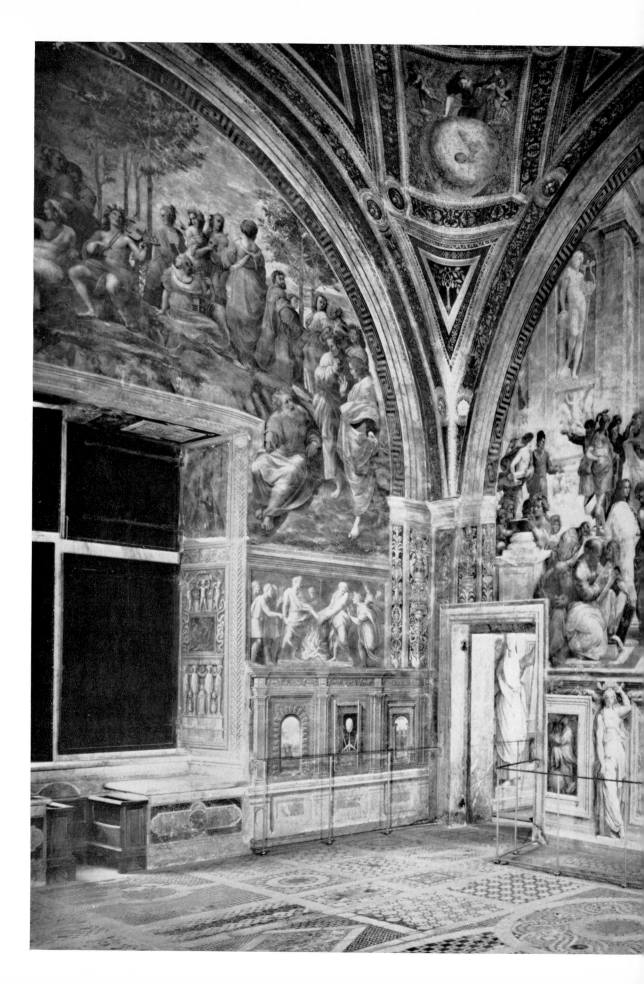

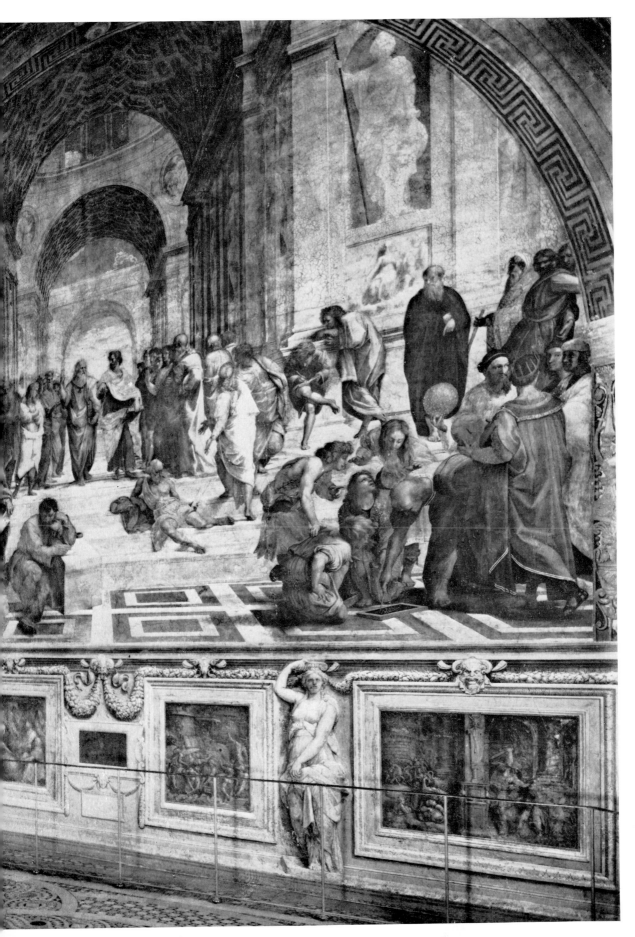

14. *Stanza della Segnatura*. Vatican

Pope of Clement XI, who came from Urbino and had a special devotion to Raphael and his work. To protect Maratta against the clamour that was raised all over Rome, the Pope visited the Stanze to signify his personal approval of what was being done. Otherwise, in the words put into Maratta's mouth by the eighteenth-century critic Giovanni Bottari, these miracles of our profession would have perished miserably because of past neglect and the superstition of ignorant connoisseurs.

Even after investigation during a recent, responsible cleaning, the limits of Maratta's work are not absolutely clear. He fixed back the intonaco with his favourite nails, and where Raphael's *secco* surface modelling had vanished, as it had on the white draperies of the *School of Athens*, he substituted *secco* modelling of his own. Some parts were totally destroyed. One of them was the left arm of the youth leaning towards Euclid in the *School of Athens* (Fig. 15). The present arm and part of the face are due to Maratta, and tests have proved that there is nothing beneath.[54] It seems that Maratta's treatment did not appreciably lighten the frescoes. Artists could read them, of course – in the eighteenth and early nineteenth centuries the

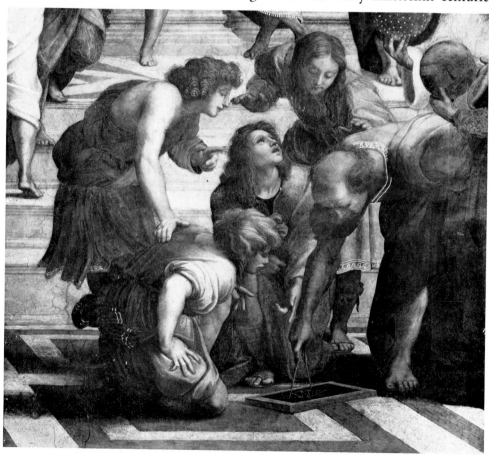

15. Raphael (restored in part by Maratta): *Detail from the School of Athens.* Vatican

usual method of study was to stick a piece of paper on to the surface of the fresco and trace the detail through it – but amateurs felt a sense of disillusionment. Goethe declared that visiting the Stanze was like reading Homer from a torn and faded manuscript,[55] and the writer of a French travel book of 1806 was haunted, as he went through rooms, by fear that before long only the ghosts of the frescoes would be visible. It was high time, he declared, to have them copied in mosaic.[56] In 1844 Hazlitt was disappointed by a visit to the Vatican. 'What,' he was asked on his return, 'do you think of these same frescoes?' 'Much the same as before I saw them,' he replied. 'As far as I could judge they are very like the prints. I do not think the spectator's idea of them is enhanced beyond this. The Rafaelles, of which you have a distinct and admirable view, are somewhat faded – I do not mean in colour, but the outline is injured.'[57] Théophile Gautier described the same experience. 'Au Vatican l'on cherche Raphaël en ruines', he wrote. Yet the eyes of Ingres filled with tears when he bade farewell to the Stanze in 1841, and throughout the whole period to which these rather depressing accounts of the frescoes relate, a host of artists – Domenichino and Poussin and Rubens, Albani and Sacchi and Pietro da Cortona, Reynolds and Mengs – drank from the magic spring.

Though for a great part of the sixteenth century the Stanze suffered from the handicap of inaccessibility, there was a compensating factor, that Raphael was the first artist whose work was widely reproduced.[58] Occasionally complete compositions were engraved. One of them was the *Triumph of Galatea*[59], which was turned by Bartel Bruyn into a *Lucretia* and was used in one way or another by Dürer, Holbein, Goltzius, and Poussin[60]. The scene also appeared on majolica dishes; after a sixteenth-century repast you might find the *Galatea* gazing up at you from the middle of the plate. Religious paintings were propagated in rather the same way. The great altarpiece of *Christ carrying the Cross*, now in Madrid (Fig. 16), was engraved almost as soon as it was finished (Fig. 18), and within ten or fifteen years of its completion was copied in the cheap medium of majolica (Fig. 17) and the costly medium of tapestry (Fig. 19).[61] But in the engravings made after 1510 by Marcantonio Raimondi what was transmitted was as a rule not the completed work but a preliminary sketch.

Not unexpectedly the most successful of Marcantonio's engravings after Raphael were designs that embodied the same style principles as did the frescoes, but were intended from the first for the medium in which they were executed. First among them was the *Massacre of the Innocents*, which was designed immediately before the frescoes in the Stanza of Heliodorus. Within a year or two it found its way into the Duomo at Parma, and later it was copied in Germany, Holland, and France, and enjoyed a rather surprising vogue among the monks of Athos.[62] Another was the *Judgement of Paris* (Fig. 20), which was adapted from two

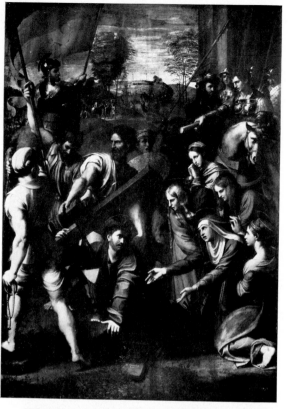

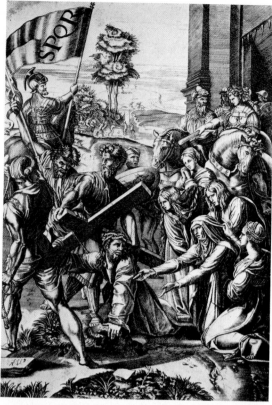

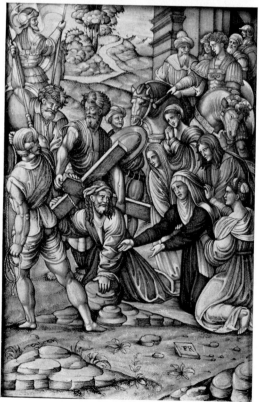

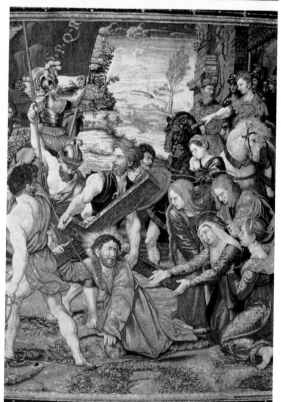

16 (above). Raphael:
Christ carrying the Cross. Madrid, Prado

17 (below). After Raphael:
Majolica Plaque. London, Victoria and Albert Museum

18 (above). Agostino Veneziano after Raphael:
Christ carrying the Cross. Engraving

19 (below). After Raphael:
Tapestry. Private Collection

sarcophagus reliefs, and helped to determine the attitude to the antique of Scorel and Uytewael and Rubens.[63] At a pace which even nowadays we should consider fast, these and other images were merged in a European cultural consciousness. To the barbaric North they carried a message of reason and light.

The most prominent and most revealing of the works by which Raphael's style was diffused were the Sistine tapestries. In 1515, at the height of his career, when the frescoes in the Stanza della Segnatura and the Stanza of Heliodorus were complete and the fresco of the *Burning of the Borgo* was well advanced, the focus of Raphael's interest shifted abruptly from the Stanze to the Sistine Chapel, and he began work on the tapestry cartoons. The cartoons were despatched to Brussels, and seven completed tapestries were delivered in 1519. Other versions were made too, so that before long sets of these magniloquent designs could be seen in Mantua, Paris, London, and Madrid. From an expressive standpoint the tapestries were inferior to the cartoons, but they and the engravings based on Raphael's preparatory drawings spread the same concepts of nobility, decorum, and restraint.[64]

Nobility, decorum, and restraint are redolent of orthodoxy, and it must therefore be stressed that Raphael in his own lifetime and for long afterwards was a highly controversial artist. In Rome his relations with Michelangelo were tantamount to a cold war. He seems to have owed his summons to the papal court to a fellow artist

20. Marcantonio Raimondi after Raphael: *The Judgement of Paris*

from Urbino, the architect Bramante – if he did not, he was closely allied with Bramante from the time that he arrived – and Bramante and Michelangelo were already at daggers drawn. When Michelangelo in 1506 broke off work on the first version of the Julius tomb and fled from Rome, one of his excuses was that Bramante wished to poison him. Bramante, whether from prejudice or from conviction, strained every nerve to prevent the allocation of the Sistine Ceiling to Michelangelo. Moreover, he had access to the Sistine Chapel, and during the three years when Raphael and Michelangelo were competing in close proximity, one on the scaffolding in the Chapel and the other in the Stanza della Segnatura, he was accused by Michelangelo of admitting Raphael to the Chapel and of allowing him to climb the scaffolding and study the unfinished frescoes.

After the election of Pope Leo X in 1513 papal taste veered decisively towards Raphael and away from Michelangelo. Baccio d'Agnolo, the architect, wishing to ingratiate himself with Michelangelo, had to avow himself the 'nemico capitale' of the hated Raphael,[65] and from Florence Michelangelo thoughtfully supplied the painter Sebastiano del Piombo with ammunition in the form of drawings and *concetti* for an altarpiece with the sole purpose that Raphael should be discountenanced. In Rome Leonardo Sellaio joyfully reported that Raphael's newly disclosed frescoes in the Villa Farnesina were 'chosa vituperosa a un gran maestro', even worse than his last frescoes in the Vatican. Years later when Condivi, in his life of Michelangelo, wished to offer decisive proof of his hero's generosity, his way of doing so was to declare that Michelangelo habitually spoke well of all his rivals, 'even of Raphael of Urbino'.[66]

Raphael and his supporters were well able to defend themselves. Told about the drawings sent to Sebastiano del Piombo, Raphael, in conversation with Pietro Aretino, declared himself delighted, since his victory would then be over Michelangelo.[67] His pupils too were ready to fight back, as the painter Rosso discovered in Rome when he was threatened with assassination for criticising Raphael's work.[68] Years later, Michelangelo's apologists admitted only that there had been 'qualche contesa nella pittura' between him and Raphael.

Part of the trouble was personal. Of the two artists it was Raphael who enjoyed the greater worldly success. After the disclosure of the Sistine Ceiling in 1512, Michelangelo, in a state of mounting tension, was occupied with the Julius tomb, pressed for money and from time to time accused of misappropriating funds, while Raphael (as we learn from Pietro Aretino, to whom he habitually showed his paintings before he revealed them to the outside world) was living 'like a prince rather than a private person, bestowing his virtues and his money liberally on all those students of the arts who might have need of them'.[69] He was chief architect of St. Peter's, was in charge of the recuperation of antiquities, and at his death was

thought, rightly or wrongly, to have a cardinalate in the bag. 'Beside the excellence of his painting,' says Aretino, 'Raphael had every virtue and every grace that is appropriate to a gentleman.' In 1557, when it was published, this success story must have made ungrateful reading to the farouche old recluse who was carving the *Rondanini Pietà*.

Principle was involved as well as personality. Michelangelo claimed that his own works were the product of a sublime intuitive faculty in which reason played little part, whereas Raphael had his art not from nature but from long study, and was, by implication, the top of an inferior class. When the first edition of Vasari's *Lives* appeared in 1550, Michelangelo objected to Vasari's account of his career. Though it was laudatory, it did not praise him in quite the way he wished, and he accordingly dictated to Condivi an essay in auto-hagiography. Probably he objected to the life of Raphael too, for when the second edition of the *Lives* appeared in 1568 one significant addition was made to the earlier text.[70] This passage caused Bellori, a hundred years later, to protest that Vasari had devalued Raphael by presenting him as a disciple of Michelangelo.[71] The sense of the inserted passage is as follows. In his youth Raphael copied the manner of his master Perugino, and improved on it, but when he went to Florence and saw the work of Leonardo, he was astonished. Determined to practise a more truthful style, he imitated Leonardo, surpassing him in sweetness and in a certain natural facility, though the 'certo fondamento terribile di concetti e grandezza d'arte' for which Leonardo was pre-eminent lay beyond his reach. At the same time he encountered the nude figures in Michelangelo's Battle cartoon. Master as Raphael was, he once more became a pupil, and though he had till then made no action studies from the nude, he contrived in a few months to learn the discipline that ought properly to have been absorbed in years of study at an earlier, more impressionable age. Most other artists, says Vasari condescendingly, would have relinquished the attempt. As it was, he was constrained to recognise that never could he rival Michelangelo's consummate mastery of the naked form. His native shrewdness told him, however, that the art of painting did not consist solely in the depiction of nude men, and that artists who excelled in narrative could also gain the reputation of perfect painters. His sights were consequently set on achieving an 'ottimo universale' in all those aspects of art which pertained to narrative, in the conviction that there he could equal Michelangelo and perhaps surpass him. The passage ends with two admonitory sentences. 'I shall add this,' says Vasari (and one can imagine Michelangelo leaning approvingly over his shoulder as he wrote), 'that everyone ought to content himself with doing gladly those things towards which he feels instinctively inclined and should not be tempted by the spirit of competition to set his hand to tasks which nature did not intend him to perform. When a style is adequate, it should not be strained by efforts to surpass the

work of men who, by virtue of great natural talent and grace given to them by God, have performed, or are performing, artistic miracles.'

Vasari's argument is more than a little disingenuous. The convictions that Michelangelo expressed to Condivi and that Vasari embodied in the 1568 edition of the *Lives* were the fruit of his old age, and it is doubtful how far they were applicable to his youth. Had drawings for the Sistine Ceiling survived in the same numbers as drawings for the frescoes in the Stanze, it might transpire that the creative procedure of the two artists at the time they were in competition was more uniform than Michelangelo would have us think. Yet for contemporaries the difference between them was real enough, as can be seen from the classical apology for Raphael.

Written by Lodovico Dolce, it appeared in Venice in 1557, seven years after the publication of the first edition of Vasari's *Lives* and eleven years before the publication of the second, and its protagonist was that formidable figure Pietro Aretino.[72] Aretino is supplied with a sparring partner in the person of a certain Giovanni Francesco Fabrini, into whose mouth is put the Vasarian view of the supremacy of Michelangelo. Fabrini attacks at once. 'No one', he says, 'who has seen the divine Michelangelo's paintings need look at paintings by any other artist.' 'This', he adds provocatively, 'is a common view.' A common view, Aretino replies, among people who repeat each other's opinions as one sheep follows the next, and with a few painters who are the apes of Michelangelo. Those who regarded Raphael as Michelangelo's inferior were for the most part sculptors, 'who considered only Michelangelo's excellence in design and the forceful air of his figures, not knowing that ease is the highest accomplishment of any art, and that other requisites are necessary to constitute a painter beside design. Were we to call in the best judges of painting, whether painters or others, we should find their votes cast one and all in favour of Raphael.' The reason for their preference would have been this, that art was the imitation of nature, and that the painter who came closest to nature was the most accomplished artist. Perfect naturalness was to be found in Raphael, but not in Michelangelo. Fifty years later Zuccaro, in the *Lament for Painting*, praised Raphael on precisely the same grounds, that he was 'ne l'imitation maraviglioso'.[73]

The Aristotelian theory of imitation encouraged a belief that verbal and visual descriptions were interchangeable. 'The painter', says Aretino in Dolce's treatise, 'endeavours to represent Nature by means of lines and colours, in whatsoever is perceptible to the eye; and the poet, by the medium of words, represents not only what the eye can see, but what the mind can understand as well.' Fabrini for once agrees. 'The analogy between poets and painters', he replies, 'is just. Others have esteemed the painter a mute poet and the poet a speaking painter.' Later in the century this point was sharpened by another critic, Armenini, who declared that

21. Raphael: *Baldassare Castiglione*. Paris, Louvre

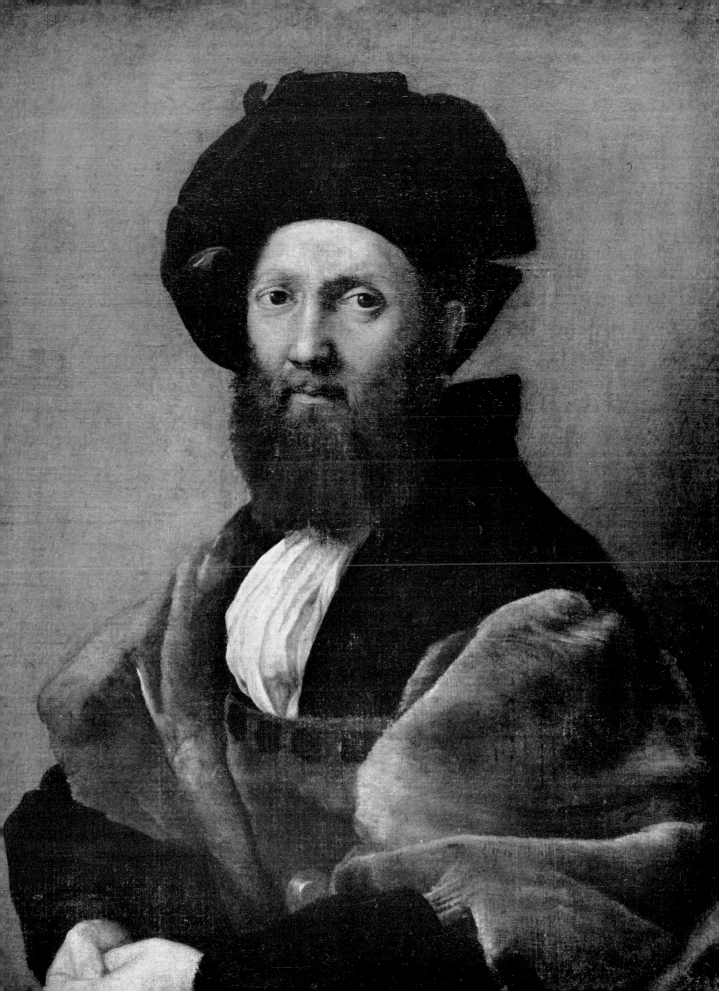

though one art employed colour and the other words, both depended from the same invention, were subject to the same rules of harmony and aimed at similar effects.[74] In this spirit Dolce praises Raphael for describing scenes in paint better than they could be described in words, while Castiglione, in the preface to his *Cortegiano*, asks that the book should be regarded as a picture, 'a painted portrait of the court of Urbino, prepared not by Raphael or Michelangelo, but by an ignoble artist'. In the Seicento the notion of the painter as mute poet becomes a commonplace, but it is in Raphael's circle that it first assumes a practical significance.[75] There is a consistent literary propulsion behind Raphael's world of forms, and his paintings are intended to be read. If their content be ignored, he remains one of the most sensitive and resourceful artists who has ever lived, but unless we are prepared to read them, not pedagogically but on the plane of ordinary humanity, we shall miss some of the qualities that seemed to his contemporaries and successors to make him the superior of every other artist. In the last thirty years we have learned to look again at paintings by classicising artists of the seventeenth century, Annibale Carracci, Poussin, and Domenichino, in the way that they were looked at when they were new, and with Raphael we must do that too.

Dolce tells us that Raphael 'constantly drew from four to six distinct sketches or designs of the history of a picture'.[76] Something of the same kind is implied in a famous letter which he wrote to Castiglione in 1514, possibly with reference to the fresco of the *Burning of the Borgo*: 'I have made drawings of several kinds round the invention of Your Excellency, and they satisfy everyone to whom they have been shown, but I fear they will not satisfy your judgement, and for that reason they do not satisfy my own. Your Excellency must make your choice if any of them seems to you to be worthy.'[77] Once the idea, the fruit of inspiration, had been chosen, it was subjected to the logic of a formidably rational mind. One of the prerequisites of story-telling is, however, that some freedom of invention be preserved, and it is no accident that Raphael's work, from first to last, is filled with *pentimenti* where he tries out new turns of phrase. Beginning in the *Three Graces* at Chantilly and in the *Madonna of the Meadow* in Vienna, and continuing in the *Disputa* and in the *Burning of the Borgo*, they have the effect of corrections on a manuscript.

Whatever glosses are put on them today, Raphael can hardly have conceived his paintings as acrostics designed for iconographers.[78] Though he was an unwaveringly intellectual artist – Pater applies to him that deterrent term 'scholar' – he could clothe even abstruse ideas in an intelligible visual form, and was an adept at making himself understood. Academically the ideas that underlie his paintings – the harmonic intervals drawn on a slate on the left side of the *School of Athens*, for example[79] – are of the utmost interest, but we are undoing Raphael's work if we give them more emphasis than he accorded them.

One of the central problems in the study of Roman High Renaissance art is to establish the relation between the ideas that were embodied in the work of art and the work of art that was produced. Michelangelo claimed that on the Sistine Ceiling he was allowed to paint whatever he wished, but there is no way of telling whether he intended to imply that he devised the programme of the frescoes or was responsible only for the visual form the programme took. For all the oceans of ink and misplaced dogmatism that have been devoted to the question, we are no nearer a solution of it now than we were fifty years ago. With Raphael the same question presents itself, but with a difference. Whereas with Michelangelo we have a body of material in the shape of letters, poems, dialogues, and contemporary descriptions, from which we can form some impression of his thought processes and intellectual capacity, with Raphael we know practically nothing of the man behind the artist. It is fruitless to inquire how far the ideas embodied in his work were personal to him and how far they were thrown up by the milieu in which he moved, since there is no evidence whatever on which an answer can be based. The wisest words on this matter were spoken in the seventeenth century by Bellori. 'Whoever was the author of the programme,' he declares,[80] 'it is not to be denied that Raphael, by the force of his own genius, developed and ornamented it, and conferred upon it an appropriate form, filling it with actions and expressions that he himself conceived, so that the invention seems to spring from a single intellect and to be informed by a single mind. To compose a fully comprehended and perfect painting, an argument proposed by some learned man, be he poet or philosopher, will not suffice if the painter himself is not able and experienced in so representing it that it becomes marvellous to the sight. Many things are agreeable in writing when adorned with the ornament of words which languish once they are translated into paint. For this reason it is essential that the painter possess a universal knowledge of things and practice the assiduous contemplation of nature.' The great changes of direction in Raphael's style – from the static narrative of the *Entombment* to the philosophical theorem of the Stanza della Segnatura, from the lyrical idyll of the *Parnassus* to the forceful drama of the *Heliodorus*, from the restrained tapestry cartoons to the rhetorical *Transfiguration* – become more intelligible if they can be looked on as the consequence of advice that he received than if they are regarded as the outcome of spontaneous changes in his attitude to painting. The time was past when the unlettered painter was supplied with a particularised programme written by some Dominican god-from-a-machine, and with the emergence of the painter intellectual (for that pre-eminently Raphael was) the channels of communication become subtler and less reconstructible. As we look at the portraits Raphael made of the members of his circle, Castiglione (Fig. 21), Inghirami, Navagero (Fig. 22), and the rest, we cannot but speculate which of them contributed, and how, to the scaffolding of thought that sustains his work.

22. Raphael:
Andrea Navagero and Agostino Beazzano.
Rome, Galleria Doria

On one aspect of Raphael's style we can speak with greater confidence. The concept of imitation connotes what we would now think of as two rather different processes, the imitation of nature – that is the portrayal of scenes or events or states of mind – and the imitation of art – that is study of the sources where scenes and events and states of mind have been portrayed. For Raphael, therefore, painting was not confined to the rendering of what his mind conceived or what lay before his eyes, but involved as well the imbibing of a whole series of precedents, in the work of his contemporaries as well as in antiquity, through which, like artists in antiquity, he arrived at an original result. Many earlier artists had endeavoured to establish contact with the world of the antique, but it was Raphael who first worked out a means whereby the antique could be assimilated, integrally and without distortion, into the fabric of the art of his own day. On a less ambitious level and in a less elevated form the Neo-Aristotelian method he pursued was propagated in academies of art from the sixteenth century down to the nineteenth.

It is not the purpose of this book to bring to bear upon these problems a battery of new facts and theories about Raphael. In the past thirty years there has come into existence a vast scholastic literature on Raphael's iconography. It would, indeed, be easy to devote six lectures solely to this aspect of his work. Instead iconography has here been whittled down to the simpler theme of Raphael's subject matter, and no attempt has been made to pursue it beyond the point at which it can be shown to have determined the work of art that he produced. Concurrently the line of demarcation between Raphael and the members of his studio has been the subject of much debate. Writers on Giulio Romano in particular have made raids on Raphael, taking away whatever appeared portable. It can at least be claimed that tradition is on

their side. When Bernini was in Paris in 1665, he was shown a Madonna that had belonged to Mazarin. Looking at it, he declared 'Raphael never painted this; it must be by Giulio Romano.' The general tendency throughout this book will be to say the opposite, 'Giulio Romano never painted this; it must be by Raphael', but matters of attribution will be mentioned only when there is no viable alternative. The reason for this is that these lectures deal with Raphael's creative processes and with the influence they exerted on the creative processes of other artists. The second lecture discusses the part that figure drawing plays in Raphael's work, the third describes the structure of Raphael's paintings, the fourth is devoted to Raphael as a literary artist, the mute poet of the *Aretino*, and the fifth examines the depreciated currency of the Madonnas. The theme of the sixth and last is Raphael's legacy not to his immediate heirs, but to the generations of artists who followed him.

Mention has been made of some of the reasons which make it difficult for us to approach Raphael's work with the intuitive sympathy that was felt for it a hundred years ago. The greatest impediment of all is that in a superficial sense we know it so extremely well. The symbol of this predicament is a painting by Zoffany (Fig. 23) which shows a group of connoisseurs in Florence examining the *Madonna della Sedia* and comparing it with the picture from the Palazzo Niccolini that is now called the *Large Cowper Madonna*.[81] When pictures have been studied so meticulously for so long, how can we look at them afresh? The dice are loaded against success. Yet Raphael's paintings are, and can be shown to be, evolving organisms, the products of an artistic conscience whose workings are in large part reconstructible, and a sovereign remedy for the staleness we may feel before the finished works is to restudy the processes by which they were produced.

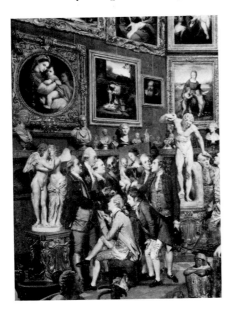

23. Zoffany: *The Tribuna of the Uffizi* (detail).
Reproduced by gracious permission of H.M. the Queen

37

24. Raphael: *Study for the Coronation of St. Nicholas of Tolentino*. Lille, Musée Wicar

II · THE CREATIVE ACT

NOT LONG AGO as I was walking up the street in which I live in London I noticed that a child had been scribbling on a wall. The drawing showed the age-old emblem of an arrow piercing a heart, and beneath it were the three words, 'I love drawing'. Raphael loved drawing too, and the moment when his paintings were conceived is that at which his hand moved across the paper and the first figure notation was set down. The study of Raphael must therefore begin by investigating what his drawings have to teach us of the way in which he worked.

Not unnaturally his earliest working methods were those in which he had been trained. Their nature is established by a painting made in 1504 by an artist with whom Raphael was associated at Urbino, Timoteo Viti (Fig. 25).[1] It shows two Bishop Saints seated in front of an arched window; beneath them is a double flight of steps, and in the foreground are two kneeling figures in profile with hands clasped in prayer, on the left the Archbishop of Urbino, Arrivabene, and on the right the Duke, Guidobaldo da Montefeltro. In the full sense of the term the picture is conventional; the purpose of the architectural structure is to provide a setting for the figures, and the disposition of the figures within it is anything but natural. Yet one and all were studied from the life. A finished drawing for the Saint in the act of benediction on the right shows a studio assistant sitting stolidly with right hand raised on the edge of a small wooden stool.[2] Similar drawings must have been made for the second Saint and the two donors, for in a sketch for the whole altar-piece (Fig. 26) all four appear in the same form.[3] The apprentice posing for the left-hand Saint is represented in the apron he was wearing when the artist instructed him to sit, and a third assistant kneeling in front in profile also wears his working clothes. In the painting these links with life are severed; the types of the rear figures are idealised, the foreground figures are equipped with portrait heads, and the jerkins and hose are replaced by vestments or by formal robes.

This procedure was not peculiar to Timoteo Viti; it was also used by Perugino. We know, once more from a drawing (Fig. 27), that before Perugino painted the panel of *Tobias and the Angel* in London,[4] a workshop assistant and a little boy stood patiently before the easel as the artist set down the pose.[5] When Raphael began work on his first recorded altarpiece, he operated in exactly the same way. The painting, which was commissioned in 1500 for Città di Castello and no longer exists in its entirety, showed St. Nicholas of Tolentino accompanied by three angels with the devil beneath his feet.[6] At the sides above his head were half-length figures of the

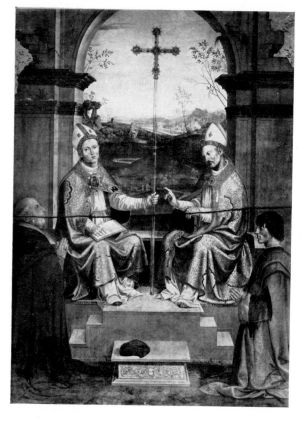

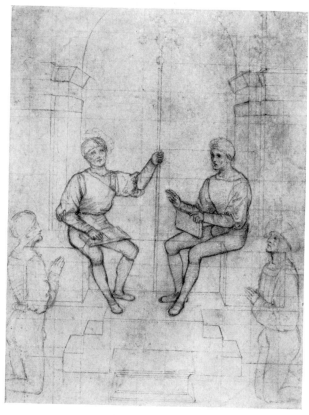

25. Timoteo Viti: *Altarpiece.*
Urbino, Galleria Nazionale delle Marche

26. Timoteo Viti: *Study for the Urbino Altarpiece.*
London, British Museum

Virgin and of the founder of his order St. Augustine holding out circlets or diadems. At the top was God the Father with the Saint's heavenly crown.[7] In a drawing for the composition at Lille (Fig. 24), a studio assistant doubles the roles of God the Father and the standing Saint. But though the method in this sheet is the same as Timoteo Viti's and Perugino's, there is a difference in the way in which it is applied. The light is so disposed that the model impersonating God the Father is fully three-dimensional, and even the iconographical motif of the foreshortened crowns is deliberately used to establish the three-dimensional existence of the figures holding them. Raphael's superior gift is apparent in the clarity with which the forms before him are registered. If the life study at Oxford for the hand of Raphael's St. Augustine[8] is compared with a life study at Oxford for the hand of Perugino's Archangel,[9] it will transpire that Raphael has the firmer apprehension of the hand both as an organism and as a form in space.

The habit of drawing from the living model was one that Raphael never lost. On a never-to-be-forgotten occasion, when he was working in Rome on the *School of Athens*, he induced Bramante to pose for the figure of Pythagoras.[10] A little later his studio assistants are found impersonating Christ and the Apostles in a preliminary

study for one of the tapestry cartoons,[11] and not long after we can observe him draw-
ing the foreshortened figure of God the Father for the cupola of the Chigi Chapel
from a model prone on the workshop floor (Fig. 28).[12]

One of the mysteries of drawing is that the greatest artists can achieve a sense of
volume through line alone. That talent was denied to Perugino, who customarily
has recourse to a system of careful hatching, in which the lighted forward areas are
segregated from darker areas at the back. Raphael disdains any such expedient. In a
study for the head of St. Nicholas of Tolentino at Lille (Fig. 29),[13] lines round the
shoulder and through the doublet attest the presence of a body beneath, while the
exquisitely precise edges of the collar and the cap invest the face with an appearance
of tactility.

Skilled as he was in chalk, Raphael was no less adept with the pen. At the time

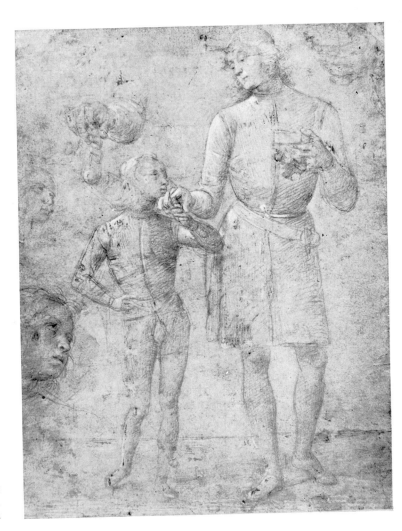

27. Perugino:
Study of Tobias and Angel.
Oxford, Ashmolean Museum

he was working on the *Coronation of St. Nicholas of Tolentino*, the main novelty in Città di Castello was an altarpiece of the *Martyrdom of St. Sebastian* in San Domenico painted by Signorelli a year or two before.[14] The proof that Raphael studied it takes the form of a pen drawing made from a soldier in the foreground of the painting (Fig. 30).[15] Raphael's drawing is a critique, not a copy, of Signorelli's figure; the forms of the weight-bearing leg and of the belt are rectified, and the protruding surfaces of the calf and thigh are registered by bounding lines in each of which the pen has held the paper for just a little longer than we should expect.

28. Raphael: *Study for the Cupola of the Chigi Chapel, S. Maria del Popolo.* Oxford, Ashmolean Museum

29. Raphael:
*Study for the Coronation
of St. Nicholas of Tolentino.*
Lille, Musée Wicar

The *Coronation of St. Nicholas of Tolentino* has been dismembered, and there are no drawings for Raphael's second altarpiece, the *Crucifixion* in the National Gallery in London.[16] Not till 1502, therefore, with the *Coronation of the Virgin* in the Vatican (Fig. 31), can we establish the relation between Raphael's preliminary studies and a completed work. Commissioned by Alessandra degli Oddi, whose family was forced to leave Perugia in 1503, the composition is divided horizontally across the centre.[17] Beneath are the Apostles, grouped round the empty tomb, and above, in a niche formed by four music-making angels, is the Virgin crowned by Christ. One of the freshest, most elegant figures in this luminous painting is an angel on the left sounding a tambourine. Such ease and delicacy could have been achieved only if the

43

30. Raphael: *Study after Signorelli.*
Oxford, Ashmolean Museum

posture were fully understood, and it is no surprise to learn from a drawing at Oxford (Fig. 33) that this figure and the other angels, like the two seated Saints in the *St. Nicholas of Tolentino*, were indeed studied from the life.[18] In the drawing a male model is shown with arms raised walking forwards across the studio floor, and in the painting, where the figure is embellished with windswept drapery (Fig. 32), the movement is intensified. In no painting by Perugino is motion represented as subtly and convincingly as it is here.

Whereas the heads of the attendant Saints in the *Crucifixion* altarpiece in London are smooth and featureless – in this they recall the Saints of Perugino – the heads of the Apostles at the bottom of the *Coronation of the Virgin* are differentiated. Once again we can reconstruct the method by which Raphael arrived at this result, since in this part of the painting he had recourse to what are called auxiliary cartoons.[19] This term is self-explanatory. An auxiliary cartoon is a drawing made after the cartoon for an altarpiece has been pricked and transferred to panel, but before the painting is begun. Typical of the auxiliary cartoons is a sheet in the British Museum (Fig. 34) for the head of St. James the Great on the right side of the *Coronation* (Fig. 35).[20] It was traced from the cartoon (hence the little spots that record the punctures), and was then redrawn, so that the neck and jaw were strengthened and the features were more sharply defined; this accounts for the precision and firm modelling of the painted head. As can be seen in an auxiliary cartoon at Windsor for the heads of St. Paul and an apostle at his side,[21] this technique permitted a research into expression which was a new factor in Umbrian painting. By the standard of Raphael's later works, the *Coronation of the Virgin* may appear

44

31. Raphael: *The Coronation of the Virgin*. Pinacoteca Vaticana

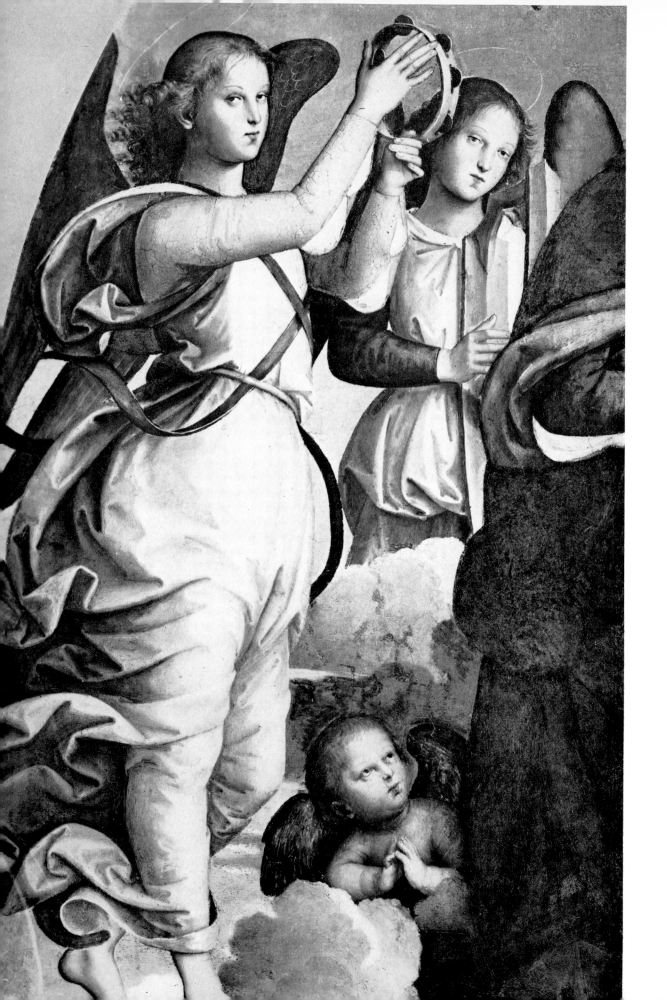

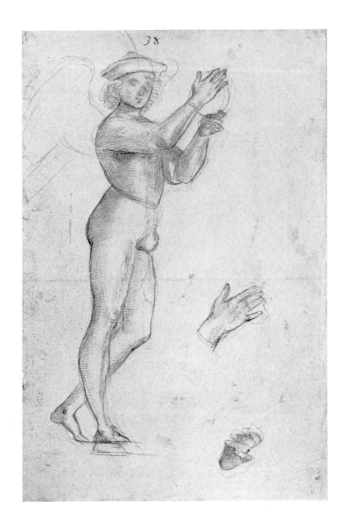

33. Raphael:
Study for the Coronation of the Virgin.
Oxford, Ashmolean Museum

immature, but already the participants are individuals whose faces can be read. The altarpiece indeed is the first painting to give an impression of the quivering sensibility of Raphael as an interpreter.

No composition drawing survives for the *Coronation of the Virgin*, but a sketch at Stockholm (Fig. 36) is related to the panel of the *Adoration of the Magi* in the predella beneath (Fig. 37).[22] In the drawing the upright of the stable and the kneeling King fall in the centre of the composition, and the figures are arranged in frieze-like fashion across the scene. In the painted version the design is extended on the left by the addition of a group of horsemen and a landscape background is introduced, while the relationship between the figures is more ambiguous. If quality were the sole test, the painting might be regarded as the earlier and the drawing as the later version of the scheme. The likely explanation of the discrepancy is that at this time drawing was Raphael's natural medium of expression, and that when multi-figure compositions were realised in paint there was a loss of freshness and clarity. This was still

32. Raphael: *Detail from the Coronation of the Virgin.* Pinacoteca Vaticana

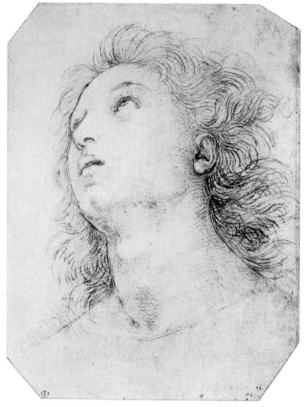

34. Raphael: *Study for the Coronation of the Virgin.* London, British Museum

35. Raphael: *Detail of St. James the Great from the Coronation of the Virgin.* Pinacoteca Vaticana

the case as late as 1507 when Raphael executed the *Entombment* altarpiece. Only in fresco, in the *Trinity* in San Severo at Perugia, was the vitality that is invariably present in preliminary drawings carried through into a fully elaborated work.

The most forward-looking aspect of the drawing for the *Adoration of the Magi* is the attention Raphael gives to the division of the figures into coherent, self-consistent groups. This is apparent also in a drawing (Fig. 38) for the companion predella panel, the *Presentation in the Temple.*[23] In it, with miraculous simplicity, the upright figures of the Virgin and St. Joseph beside the altar are bound together by the horizontal Child. When two years later Raphael arrived in Florence, one of his first discoveries would have been paintings where the figures were not planned in isolation, but were conceived in larger units, each with its own formal character. The supreme example of this rhythmic interplay was the unfinished *Adoration of the Magi* which had been begun by Leonardo da Vinci for San Donato a Scopeto. Raphael's impressions of this work, like all the really formative, really profound experiences to which he was subjected, took some years to bear fruit. Not till 1510 were the lessons of Leonardo's altarpiece applied to his own paintings in the centripetal groups in the foreground of the *School of Athens,* and not till 1512, in the *Galatea* and the *Sibyls*

48

36 (above). Raphael: *Adoration of the Magi*. Stockholm, National Museum
37 (below). Raphael: *Adoration of the Magi*. Pinacoteca Vaticana

38. Raphael: *Study for the Presentation in the Temple*. Oxford, Ashmolean Museum

in Santa Maria della Pace, were they reaffirmed with a lucidity far surpassing Leonardo's. Already in Raphael's Florentine drawings there are indications of the future movement of his thoughts. Beside this the study of human figures in action in the work of Michelangelo was of secondary consequence, though at first it seems to have bulked larger in Raphael's consciousness.

The Florentine painting in which Raphael's creative procedure can be most fully reconstructed by means of drawings is the one in which the influence of Michelangelo is most strongly felt, the *Entombment* of 1507 in the Borghese Gallery (Fig. 39).[24] Though it was commissioned for the Baglioni Chapel in San Francesco at Perugia, it was planned, and the cartoon for it may even have been made, in Florence. The context in which it must be reinstated is established by a painting on which Peru-

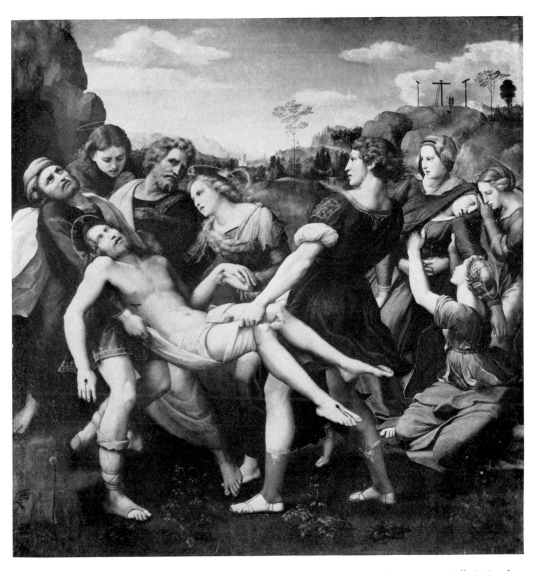

39. Raphael: *The Entombment*. Rome, Galleria Borghese

gino and a Florentine artist, Filippino Lippi, are known to have collaborated.[25] Designed by Lippi in 1503 for the Florentine church of the Annunziata, it repre⁄ sents the *Deposition* (Fig. 40). When Lippi died, in the spring of 1504, the contract was transferred to Perugino. At that time only the upper part of the altarpiece was far advanced, but a reliable record of Lippi's intentions for the lower part is provided by a workshop copy in New York.[26] There are traces of Perugino's hand in the upper section of the painting – the figure of Christ has, indeed, been ascribed, not very convincingly, to Raphael – and Perugino and a member of his studio executed the whole lower register. When Perugino started work, the placing of the figures must have been indicated on the panel, and only one of them, the Magdalen, was radically changed; she became a placid figure gazing up at the dead Christ. The

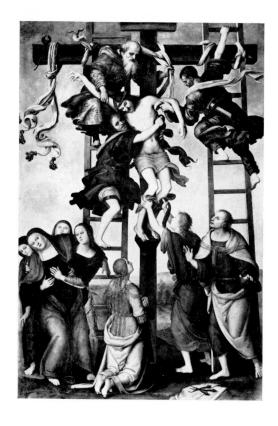

40. Perugino and Filippino Lippi:
The Deposition.
Florence, Accademia

six other figures were modified. The startled gestures of St. John and Joseph of
Arimathaea on the right were reduced in potency, and on the left the Virgin was
depicted with open eyes, not as an unconscious figure about to slump on to the
ground. Perugino's command of movement was more limited than Filippino Lippi's
and he conceived the scene in elegiac, non-dramatic terms, bringing Filippino's
altarpiece into line with a painting of the *Lamentation over the dead Christ* which he
himself had painted for Santa Chiara in Florence nine years earlier (Fig. 41).[27]

Perugino's *Lamentation* is a masterly design; the central group is constructed as a
pyramid flanked by standing figures at the sides. Our first evidence of Raphael's
intentions for the Baglioni altarpiece is contained in a drawing at Oxford (Fig. 42),
where the subject, the *Lamentation over the dead Christ*, is the same as Perugino's, and
the scheme also follows Perugino's, though the female figure at the apex of the
triangle has been deleted and the poses of the other figures are more relaxed.[28]
Raphael aspired to a more highly integrated central group. To achieve this the legs
of Christ are supported on the knees of the seated Magdalen, the heads of the two
figures on the left are placed on a diagonal running through the Virgin's head, and
St. John, on the right, is shown with head bowed, as Joseph of Arimathaea at his
side points towards the corpse. The horizon cuts the heads of the rear figures at the
same level as in Perugino's painting.

There can be little doubt that the purpose of this drawing was practical. Not only

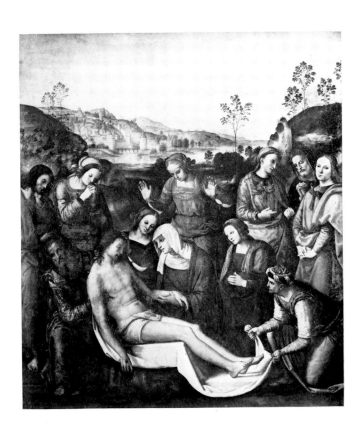

41. Perugino:
Lamentation over the dead Christ.
Florence, Palazzo Pitti

is a module inscribed on it, but we know two other sheets in which the composition is revised. In the first (Fig. 46) the Magdalen is in a more erect position, and Joseph of Arimathaea and Nicodemus gaze down at the dead Christ.[29] This change would have affected the axis of the design, and is a striking instance of a phenomenon which is habitual in Raphael, that he depended for his formal inspiration on a narrative rethinking of his theme. In the second drawing the changes are more radical.[30] Behind the female figure in the centre is a second standing woman, the mourning figure on the left is shown in profile, and St. John is isolated, Joseph of Arimathaea having been transferred from the right side to the left. The effect of this revision was to reconstitute the figures as a more active group.

One of the most momentous of Raphael's Florentine experiences was his encounter with the cartoon for the *Battle of Cascina* by Michelangelo, where eighteen active figures were fused into a unitary scheme. Though none of the motifs in Raphael's latest drawing of the *Lamentation* depends from the cartoon, it marks an effort to impose a similar conception on the altarpiece. But action in a painting of the *Lamentation over the dead Christ* was supererogatory; it did not arise naturally from the exigencies of the scene. If Raphael's altarpiece were to become an active unit, its subject had also to be revised. The point of transition is marked by a drawing in London which has as its subject the *Entombment*, not the *Lamentation over the dead Christ* (Fig. 43).[31] This drawing is not a definitive solution; the bearers of the corpse

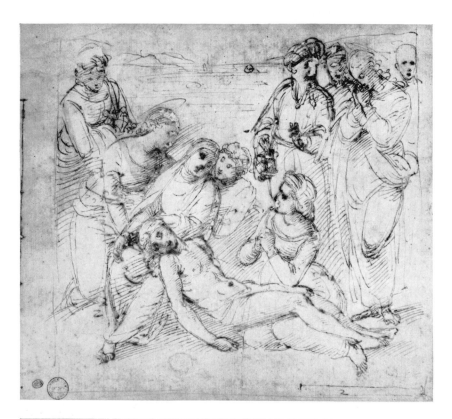

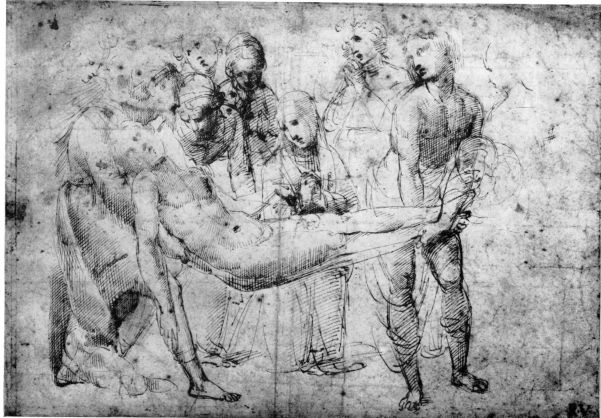

42 (above). Raphael: *Lamentation over the dead Christ*. Oxford, Ashmolean Museum

43 (below). Raphael: *Study for the Entombment*. London, British Museum

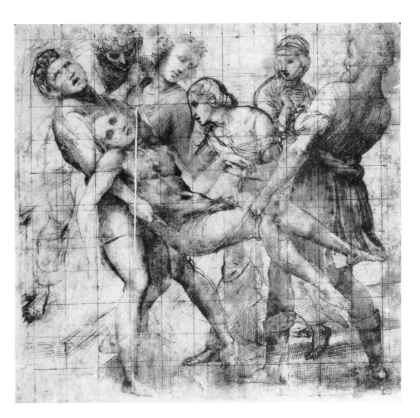

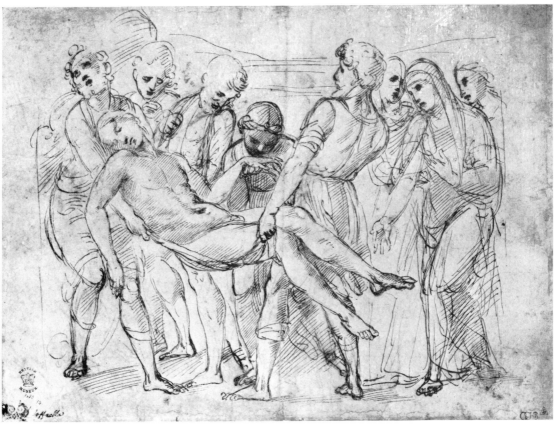

44 (above). Raphael: *Study for the Entombment*. Florence, Uffizi
45 (below). Raphael: *Study for the Entombment*. London, British Museum

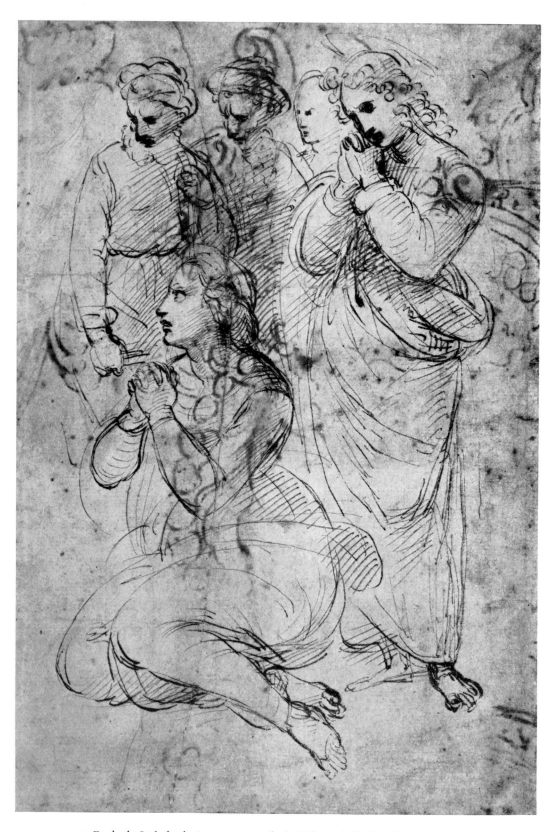

46. Raphael: *Study for the Lamentation over the dead Christ*. Oxford, Ashmolean Museum

are more prominent than the other mourners, and St. John, depicted in the same pose as in the Oxford drawing, is set inconspicuously at the back. But in one stage more it became the *Entombment* that we know (Fig. 45).[32]

With the change of subject, Raphael turned to a new source of inspiration, a classical sarcophagus with the death of Meleager. The compositional pattern of the earlier drawings was none the less preserved. A long diagonal line still led from the head of the bearer on the extreme left to a void in the middle of the scene, and the right side was still occupied by boldly placed vertical figures. The right-hand section of the composition in particular needed further thought, and the figure of the Virgin following the corpse was accordingly replaced by a fainting Virgin, which had the advantage first of lending variety to the design, and second of balancing the diagonal on the left with a diagonal opposite. The compositional implications of this change are apparent in a drawing in the British Museum, where the Virgin is represented by a skeleton.[33]

Once the body of Christ was raised, there was no longer any place for a kneeling figure behind the corpse, and the artist was therefore free to reinsert a kneeling woman on the right. In the British Museum drawing the head of this figure appears twice, once in the pose that had been used in the Oxford *Lamentation* sheet, and a second time turned away towards the Virgin at the back. The possibilities of a kneeling figure with head turned away had been explored by Michelangelo in the Virgin of the *Doni Tondo* of about 1505. A final solution was not reached immediately, and at one unhappy moment, recorded in a copy of a lost drawing by Raphael, a space separated the kneeling woman from the Virgin behind her.[34]

Once the right side of the altarpiece was refashioned in this way, further changes were demanded in the centre and on the left. In the centre the bowed frontal face of the woman kissing the hand of Christ interrupted the sweep of the diagonal. In a beautiful squared drawing in Florence (Fig. 44) her head is turned almost in profile to the left, and Christ's head is also slightly turned, so that she looks at it full in the face.[35] Moreover, there was a danger that the diagonal on the right might be more emphatic than that on the other side. The only method of correcting this was to change the elevation of the figures on the left, and a step, the entry to the tomb-chamber, was therefore introduced. As a result St. John stood on a higher level than the other figures, while the figure on the extreme left, involved in the new task of lifting the body up the step, could be intensified. Between the completion of this drawing and the preparation of the cartoon a few more changes were made; the supporting figure in profile on the right was now clean-shaven and the third head from the left was represented with a beard. More significant, the composition in the Uffizi drawing was cut on the left-hand side and its centre shifted slightly to the right. This done, it was transferred to panel, and was set in frieze-like fashion on a

47. Raphael:
Study for the Entombment.
Paris, Institut Néerlandais

naturalistic foreground before a landscape with the mount of Calvary on the right.

It is a common criticism of this splendid painting that the element of calculation behind it could be guessed at even if no drawings for it were preserved. The fact that it was executed in Raphael's Perugian studio, in part by an assistant, no doubt deprived it of some vivacity.[36] Certainly, the Magdalen in the painting has lost just a little of the sentient character of the beautiful preliminary drawing in the Lugt collection (Fig. 47),[37] and the chain of figures moves less easily than in the sublime composition sketch in London. This is, however, the first work by Raphael that leaves us with the sense of a growth potential that breaks all natural bounds. In drawing after drawing we see him disciplining his own genius, wrestling with his own convictions, and dictating the statement of belief on which his earliest Roman frescoes rest.

Raphael seems to have moved to Rome between April 1508, when he addressed a letter from Florence to his uncle at Urbino, and September of the same year, when he despatched a letter from Rome to the painter Francia.[38] In what we now think of as his Florentine years, from 1504 till 1508, he travelled backwards and forwards between Florence, Perugia, and Urbino, and he may indeed have visited Rome before the summer of 1508. The nineteenth-century Raphael scholar Grimm published a document which purported to show that he was in Rome in the early spring, but the document was later withdrawn as a forgery and has not been traced.[39] Whether it was a forgery or no, it provides a salutary warning of the dangers of a

rigid interpretation of Raphael's movements at this time on the basis of the scanty evidence available. More important than the date is the reason why he moved, and here too we can only speculate. If, as is possible, Raphael left Perugia for Florence in 1504 because Perugino had signed a contract to complete Filippino Lippi's altarpiece for the Annunziata,[40] he may have left Florence for Rome in 1508 because Perugino had begun the decoration of the ceiling in the Stanza dell'Incendio of the Vatican.[41] But it is also possible that his contact was through Urbino, whose rulers had long standing connections with the papal court.[42] Be that as it may, by January 1509 Raphael was at work in the Stanza della Segnatura, the room which houses the frescoes of *Parnassus*, the *Disputa*, and the *School of Athens*.

The *Disputa* (Fig. 51) was the first fresco to be carried out,[43] and is the scene for which most figure drawings are preserved. So numerous are they that it is almost as though Raphael had recorded in a journal the changes in his creative intentions as work on the design progressed. Most of the drawings must date from the end of 1508 and the first months of 1509, and they were probably translated into fresco in the winter of that year. The chain of ideas behind the composition is established by the figure of Theology on the ceiling above it, with its legend 'Divinarum rerum notitia'. On its simplest level the subject is the glorification of the Eucharist, but if the evidence of the drawings is to be believed the Eucharist was introduced only belatedly into the scheme. The programme of the fresco comes from St. Bonaventure, and depicts in panoramic form the efforts of human theologians to penetrate the divine mystery.[44] At the top is the Redeemer, with God the Father above him, the Holy Ghost beneath his feet and the Virgin and St. John the Baptist at his side. On a concave platform of cloud on a slightly lower level are two groups of six figures, three at each side from the Old and three from the New Testament, and round the altar beneath are seated, from left to right, St. Gregory the Great (with the features of the reigning Pope), Jerome, Ambrose, and Augustine. Behind them stand SS. Ignatius of Antioch and Athanasius, with Clement and Origen, and beyond are the Doctors of the Church. On the left a bald headed man, perhaps a converted heretic or sceptic, raises his head from an open book as his attention is directed by a youth to the Eucharist in the centre of the scene.

The earliest evidence for the form of the *Disputa* is contained in a drawing at Windsor for the left half of the fresco field (Fig. 48).[45] At the top, set on a higher level than in the fresco, is Christ in a circular glory with the Virgin and two Saints or Prophets to the left. Below, seated on a cloud, are two Evangelists. Two other male figures appear under the central Christ in the same register. Beneath on the left is a colonnade which recedes diagonally through the picture space. Its forward end rests on the projection plane, and it extends across the back in the form of a low balustrade. On the foremost column are the papal tiara and a coat of arms to which

48 (above). Raphael: *Study for the Disputa*. Windsor Castle, Royal Library
49 (below). Raphael: *Study for the Disputa*. Chantilly, Musée Condé

attention is directed by a pointing figure on the extreme left standing on a cloud. This figure has been interpreted as a woman, but is almost certainly a man. To the right of the column are a seated monk with back turned and eleven other figures. If this drawing were projected on to the area Raphael had to fill, the resulting fresco would consist of a narrow foreground filled with figures, boxed in by architecture at the sides. The unrelated upper section would contain the four Evangelists, four Saints or Prophets, and two male figures in addition to the central group. At this stage it was not intended that the Sacrament should be depicted, and the centre of the lower part was void.

These inferences can be confirmed from two sheets in which the upper and lower parts of the scheme are elaborated. The first, at Chantilly (Fig. 49), shows all the figures from the bottom of the fresco save those at the two ends.[46] The group is now ranged round four seated men, two in a forward and two in a rear-plane, of whom only St. Jerome can be identified with confidence. At the back the animating impulse is supplied by secondary figures, who peer into the books held by the seated Saints. The source of Raphael's inspiration in these figures was the San Donato a Scopeto *Adoration of the Magi* of Leonardo, where the crouching attendants of the Magi press inwards in precisely the same way. A male figure on the left with hand

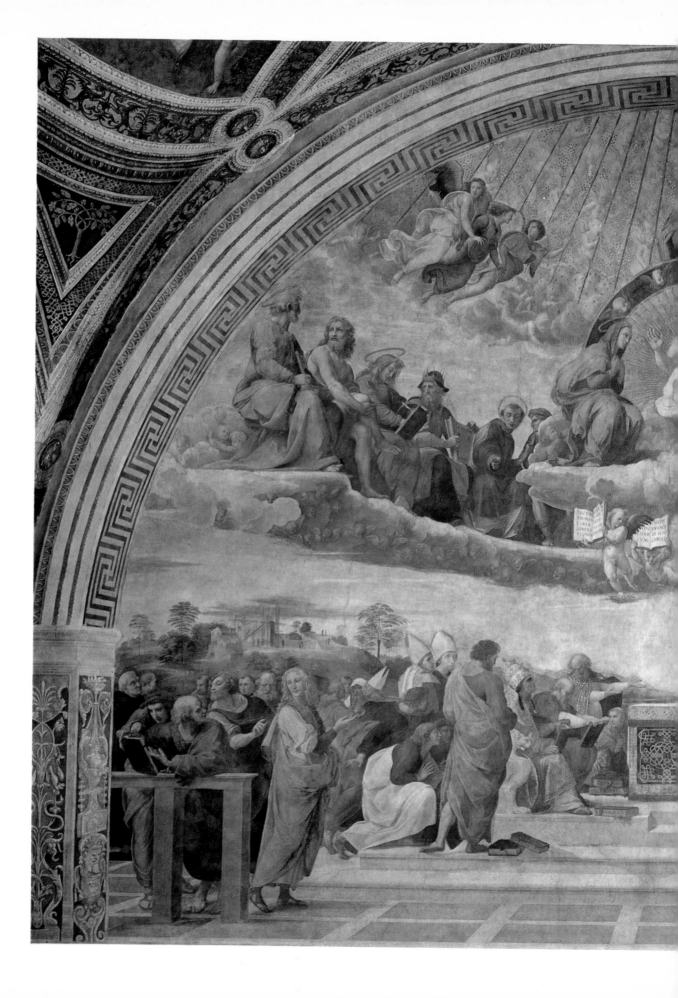

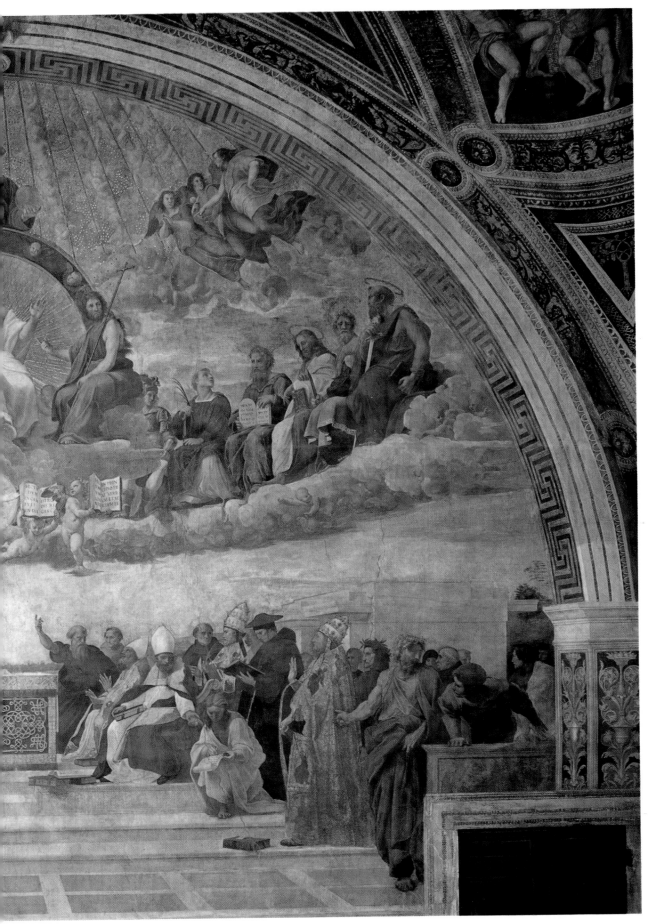

51. Raphael: *The Disputa*. Vatican

pressed to his chin springs directly from Leonardo's *Adoration*, as does a figure with back turned. Raphael's study of the unfinished altarpiece is also evident in the technique, which fulfils the same function as Leonardo's underpainting, and establishes the main areas of light and darkness in the composition. In the second of the elaborated drawings, at Oxford (Fig. 50),[47] the figures are distributed between two planes, as they are in Raphael's only earlier fresco, the *Trinity* of 1505 in San Severo at Perugia. The front plane is occupied by the Evangelists and the rear plane by Christ and the paired figures beneath his feet, who prove to be St. Peter and St. Paul. The diminutive and distant Christ is shown blessing the figures below.

The surviving drawings suggest that Raphael must have spent weeks working on this scheme. In a beautiful chalk drawing at Windsor the group at the bottom is opened out,[48] and copies from lost drawings by Raphael show the figures in the nude.[49] But – and this is the main gap in our knowledge of the fresco – we have no information at all as to the stages by which this design was transformed into the design that we have now, for in the next composition drawing, in the British Museum (Fig. 52),[50] the vital change has already taken place. In the centre is an altar, not the altar of the fresco, but a classical altar with inscriptions, and on it is a chalice with the Sacrament. By this means a central narrative focus was for the first time introduced into the scene. An altar involved steps, and steps made it possible to group the figures in ascending emphasis. The colonnade on the left was done away

52. Raphael: *Study for the Disputa.* London, British Museum

with, and was replaced by a balustrade on the same pattern as the balustrade at the back of the first scheme. Pope Julius II as St. Gregory the Great is now seated on a classical throne, as he is in the fresco. The fact that his head and the heads of a number of the other figures are turned away is the only proof we have that the figures at the top were still set on a more distant plane than those below.

Once again the scheme seemed to Raphael definitive enough to justify the making of nude studies. A composition drawing exists at Frankfurt (Fig. 53),[51] and in it the naked figures of St. Gregory the Great and of the three kneeling youths before the throne take on a compelling urgency. In two places the composition is revised; on the left the group of four standing men has been modified, and on the right the figures beside St. Jerome are shown ranged behind the altar on steps which evidently correspond with those in front.

None the less the Frankfurt drawing seems to have revealed to Raphael as it reveals to us that all was not yet well. A danger of monotony was latent in the uniform heights of the three kneeling figures before the throne and of the three standing figures behind them, while on the left the standing figures tended to blunt the inward accent of the figure at the end. For this reason in a composition drawing in Vienna (Fig. 54)[52] the three kneeling figures are moved to the left and redisposed as a pyramid; their place is taken by a standing figure with back turned, and the standing men behind St. Gregory the Great are reduced from three to two. At the

53. Raphael: *Study for the Disputa*. Frankfurt, Staedel Institute

back of St. Jerome a standing figure pointing towards the Sacrament makes his ap⁄
pearance for the first time, and on the extreme left is a youth adapted from the figure
pointing to the Della Rovere arms in the earliest of the studies for the fresco. This
drawing represents the fresco as it was carried out, save that the altar is not yet masked
by an embroidered altar frontal, the steps leading to it have not yet been reduced
from six to three, and the two figures on the extreme left are retained and have not been
deleted in favour of the much more complicated group that is depicted in the fresco.

The evidence for changes of intention on the right⁄hand side is less complete, but
drawings for single figures or groups of figures survive. From one of them we know
that the bearded man standing with right arm raised to the right of the altar was at
one time to have worn a mitre, and in the fresco a mitre is actually incised in the
intonaco.[53] The most ambitious and most carefully studied figure on this side of
the composition is the youth at the extreme right leaning forwards across a wall.
If a drawing at Montpellier is any guide,[54] he was originally to have leaned further
forward and to have been placed a little to the left of the position he now occupies,
with his right hand on the corner of the balustrade. This study was evidently made
from a life model, and was immediately succeeded by a second, in which the right
hand was placed flat on the wall exactly as in the completed work.

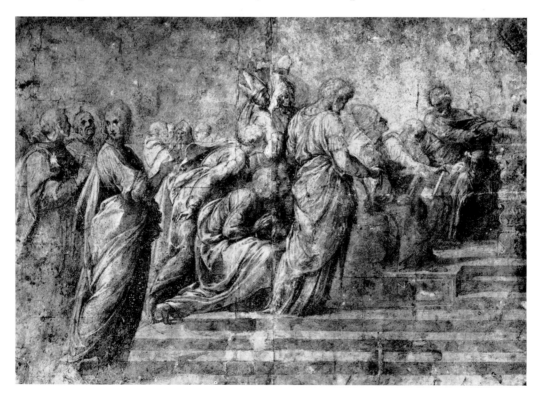

54. Raphael: *Study for the Disputa*. Vienna, Albertina

54a. Raphael: *Study for the Disputa*.
London, British Museum

Five of the sheets for these elevated figures afford a rather unedifying glimpse of Raphael's private life (Fig. 54a).[55] They contain drafts for Petrarchan love lyrics, one of which was translated by Richardson in the seventeen-twenties in the form:

Sweet Remembrance, hour of bliss
When we met, but now the more
I mourn as when the sailor is
Starless distant far from shore.

The poems are neither so trivial nor so inexpert as this version suggests, but one has some sympathy with the nineteenth-century commentators who contested their authorship. 'At a period when writing exhibited such polish,' wrote one of them, 'we cannot show Raphael in a ragged coat.' But it was also possible to argue the opposite, that because the poems were by Raphael, they must on that account be meritorious, and this view was adopted by Grimm. 'There is no poem by Michelangelo', he declares, 'from which, as from these passionate lines of Raphael, the sweet sap of intoxicating happiness gushes forth as from ripe fruit.' What is remarkable about the poems is not their content, but their incongruity on the sheets where they occur.

The stages by which the upper section of the *Disputa* was developed from the state in which we see it in the Oxford drawing to the state in which we see it in the fresco are unrecorded. Enough composition drawings survive, however, to illustrate some of the problems with which Raphael's mind engaged. In a beautiful chalk study in the British Museum[56] an attempt is made to relate the flying angels on the right to the concavity of the surrounding space, and in a curious drawing in Milan[57] the main figures are shown in the nude in a simplified notation which suggests that Raphael at the time thought of them as forms in space and nothing more. Before long identities were given to these diagrams. In a superb study for the central Christ at Lille (Fig. 56)[58] the drapery undulates rhythmically across the legs. In the whole of Italian art there are very few drawings of drapery as masterly as this. A chalk drawing for the pose and drapery of the Virgin to the left of Christ

is in the Ambrosiana in Milan.[59] When this sketch was embodied in the fresco, its unifying impulse was perceptibly impaired. The whole nature of the commission evoked in Raphael a drawing style of unprecedented breadth. If the life studies for the early altarpiece of the *Coronation of the Virgin* of 1502 are juxtaposed with the great life study in Florence for the figure of Adam on the left of the *Disputa* (Fig. 55), it might seem that a century, and not just seven years, elapsed between the two.

Through the whole time that Raphael was employed in the Stanza della Segnatura, Michelangelo was engaged upon the ceiling of the Sistine Chapel only a few minutes' walk away. Secrecy shrouded his activities, but in a letter to his father of September 1509 he reported the concluding payment for the first section of the ceiling. Presumably the finished part included the *Drunkenness of Noah*, the *Flood* and *Noah's Sacrifice*, with the eight nude figures in their vicinity, five Prophets or Sibyls, and two narrative pendentive scenes. Once the scaffolding was moved, these frescoes must have been continuously visible, and there is every reason to suppose that they became available to Raphael exactly at the moment when the *Disputa* was

55. Raphael: *Study for the Figure of Adam in the Disputa.* Florence, Uffizi

56. Raphael: *Study for the Figure of Christ in the Disputa.* Lille, Musée Wicar

57. Raphael: *Christ from the Disputa.* Vatican

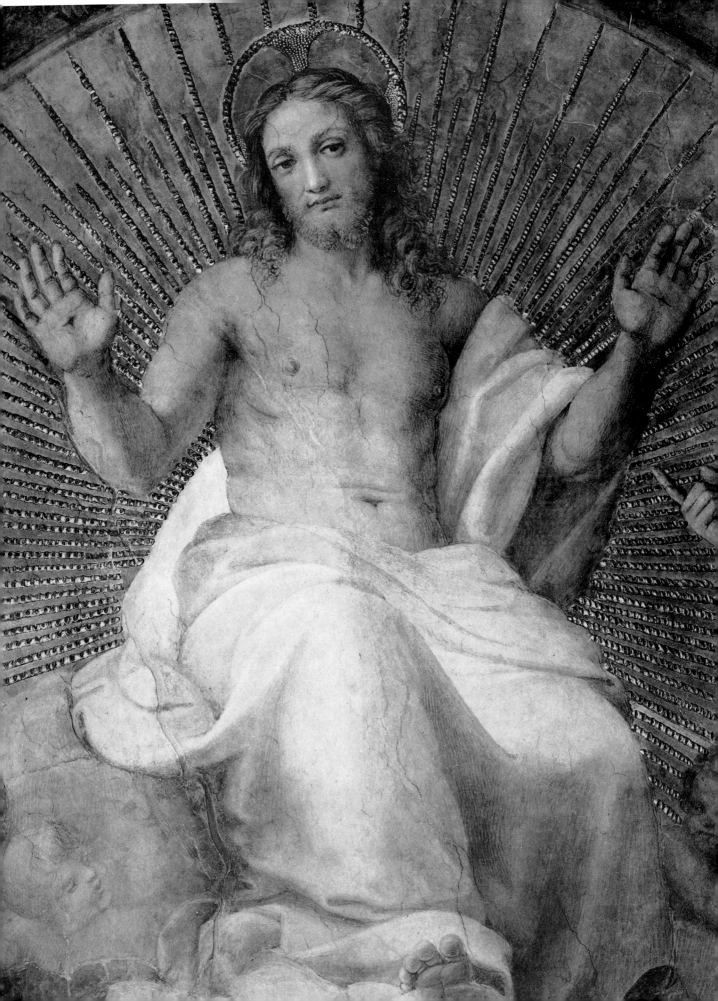

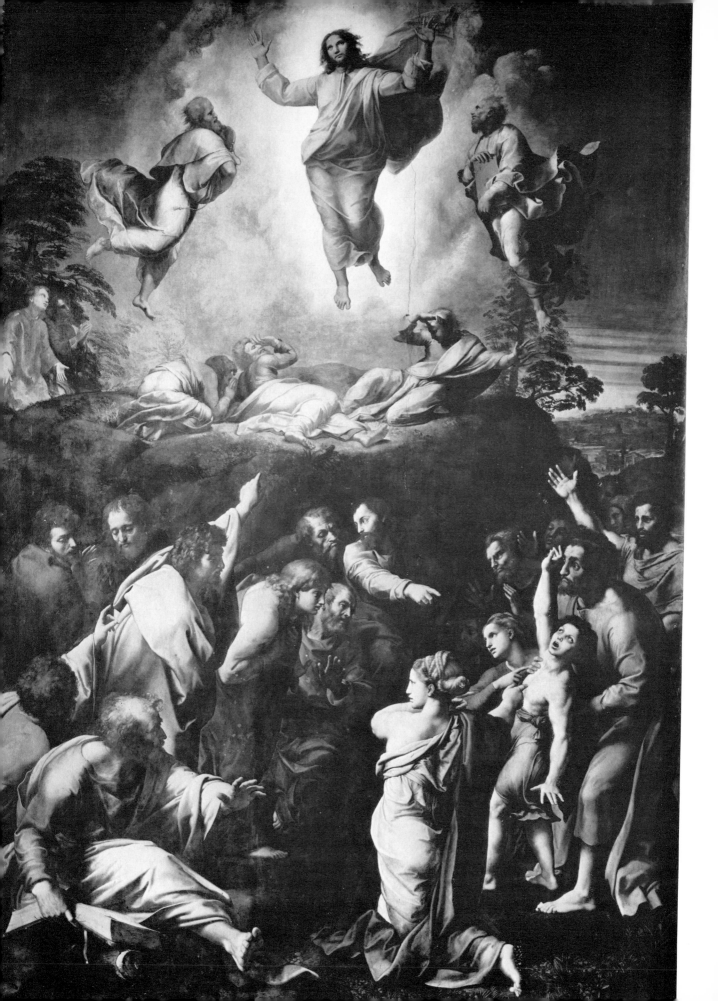

59. After Raphael: *Modello for the Transfiguration*. Vienna, Albertina

60. After Raphael: *Modello for the Transfiguration*. Paris, Louvre

under way. Their action on him must have been as pervasive and intense as that of the *Battle of Cascina* in Florence five years before, and it expressed itself in a broadening of his pictorial style, a new amplitude of gesture, a new strength of plasticity, and a new sense of heroic scale. The drawing style that he evolved in connection with the fresco is the first point at which the change becomes perceptible. The source of influence was Michelangelo the painter not Michelangelo the draughtsman. Never does Raphael, like Michelangelo in the few drawings for the Sistine Ceiling that survive, use chalk as a chisel with which to excavate his forms, and even in his boldest drawings there is an intimation of light and colour values that is essentially unsculptural.

With none of the later frescoes in the Stanze do preliminary drawings enable us to follow Raphael's thought processes as closely as we can here. In the case of only one late work, indeed, the altarpiece of the *Transfiguration* (Fig. 58),[60] is detailed reconstruction of his creative procedure possible. The circumstances out of which it grew were created artificially by Cardinal Giulio de' Medici. Sympathetic though he was towards artists, Giulio de' Medici believed that in allotting his commissions an element of competition produced the best results. In 1525, when he was Pope, he awarded the commission for the marble group of *Hercules and Cacus* to Bandinelli,

58. Raphael: *Transfiguration*. Pinacoteca Vaticana

not to Michelangelo, because he was convinced that rivalry would spur each of the two sculptors on, Bandinelli to carve a greater statue than he might otherwise have done and Michelangelo to achieve new prodigies in the Medici Chapel. In 1516, as Cardinal, he followed the same course. Requiring an altarpiece for the Cathedral of his see, Narbonne, he placed contracts with two painters, one of them Raphael and the other Sebastiano del Piombo. Raphael was an autonomous party to this competition, but Sebastiano del Piombo was not; he carried, says Aretino, the lance of Michelangelo. From Florence Michelangelo proffered not only moral backing, but drawings for Sebastiano's altarpiece, and the atmosphere of venom in which the paintings were designed can be gauged from the letters addressed to him by Sebastiano and his associates. Fortified by Michelangelo's assistance, Sebastiano started work in January 1517, and by September 1519 his painting was complete.[61] Raphael kept his own counsel, and his altarpiece was still unfinished when he died. Two years later the balance of the purchase price, about one-third of the total figure, was claimed by Raphael's heir, Giulio Romano, and in 1523 the painting was installed over the high altar of San Pietro in Montorio.

The only mitigating feature of this arrangement was that the two altarpieces represented different subjects. One, that allotted to Sebastiano, was the *Raising of Lazarus,* and the other was the *Transfiguration.* Sebastiano therefore was committed to a dramatic multi-figure scene, while Raphael was required to paint the kind of altarpiece in which he had already proved that he excelled, a painting with few figures and no dramatic interest. The original project for the *Transfiguration* can be deduced from a workshop copy in Vienna after a lost sketch-model by Raphael for the painting (Fig. 59).[62] It shows Christ standing on Mount Tabor between the flying figures of Moses and Elias. With hands raised and head bent, he looks down at the three Apostles kneeling in front. Above is a vision of God the Father, and on the right, in profile, kneel Saints Felicianus and Agapitus, whose deaths are cele-brated on the liturgical feast of the Transfiguration. Between the making of this sketch-model and the preparation of a second, which we know only from a version by a Raphael pupil in the Louvre (Fig. 60),[63] the conception was drastically revised. The effect of the changes was to lessen the discrepancy between Raphael's painting and Sebastiano's. The Transfiguration is moved to the top of the scene, God the Father is omitted, and though Christ is still shown standing, with Moses and Elias standing beside him, the three Apostles now shrink back as though overpowered by the radiance of his divinity. The two Saints are inserted at the left, as they are in the completed altarpiece. The reason why the central group is raised is that the foreground is occupied by a new scene. It illustrates a passage that occurs in the same chapter of the gospels as the account of the Transfiguration. According to St. Mark, Christ, when he came down from the mountain, found the Apostles surrounded by

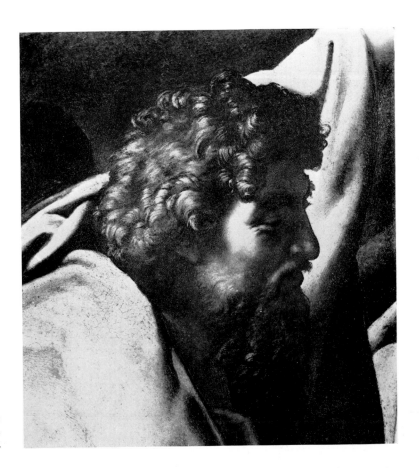

61. Raphael:
Detail from the Transfiguration.
Pinacoteca Vaticana

a multitude, one of whom had with him his afflicted son. In Christ's absence the attempt of the disciples to effect the miracle of healing failed, and the boy was subsequently healed by Christ. In the gospel narrative the two episodes of the Transfiguration and the healing of the boy are unrelated, but in the Louvre sketch-model they are linked, and linked so closely that a number of the figures gesticulate towards the upper scene, while in the finished painting even the 'lunatic and sore-vexed child' gazes up, with his arm raised in testimony, towards the transfigured Christ.

Like the *Raising of Lazarus*, Raphael's altarpiece therefore portrays a miracle, but a miracle of a rather special kind. St. Matthew, after describing the curing of the boy by Christ, goes on to tell how the Apostles questioned Christ asking, 'Why could we not cast devils out?', and how Christ answered, 'Because of your unbelief'. The revised programme adopted for the painting seems to be based on an antithesis between the Apostles in the foreground beset by human doubt and the supernatural confidence of the transfigured Christ above. In the eighteenth century it was objected by Shaftesbury and other rationalist critics that in the painting two unrelated scenes were shown.[64] The classic reply to these criticisms is that of Goethe:[65] 'In the absence of the Lord the disconsolate parents have brought their possessed son to

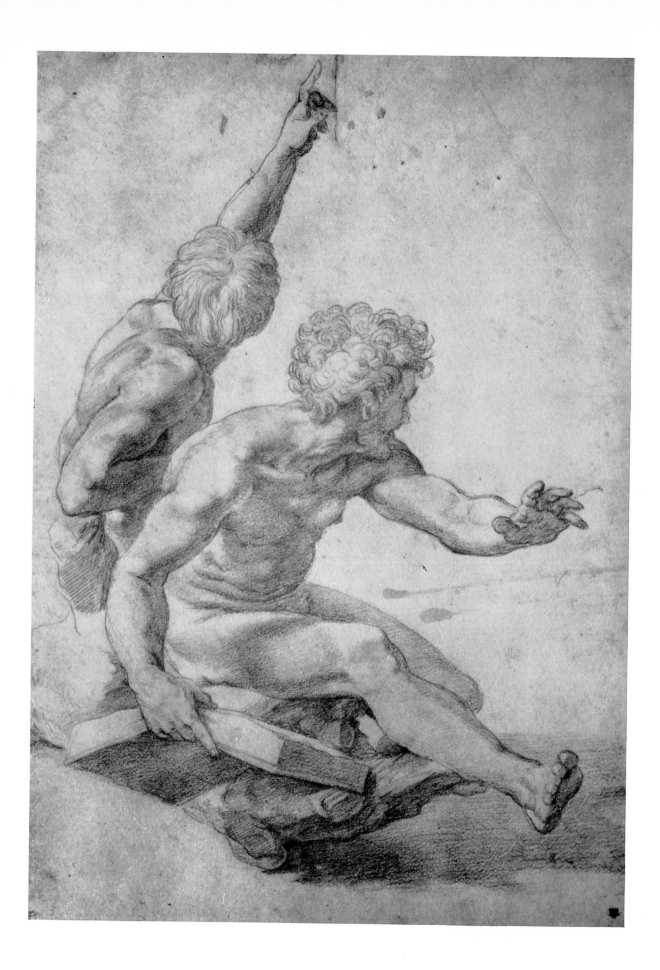

the disciples after they had probably tried to exorcise the evil spirit themselves. One of them has even opened a book to see whether a traditional spell could not be found which would be effective against this malady – but in vain. At this moment He who alone has power appears, transfigured in glory, and acknowledged by His two great forerunners, and all are looking up at Him and pointing to the vision as the only source of salvation. What is the point then of separating the upper action from the lower? Both are one.'

Though the *Transfiguration* can, like the *Disputa*, be analysed in terms of its preliminary drawings, the function they fulfil is rather different. The groping forward movement of Raphael's drawings for the fresco is a symptom of inexperience. By the time of the *Transfiguration* his style was fully formed, and full notation was no longer given to each change of thought. Two of the customary composition studies of naked figures have survived, one for the upper part by Raphael[66] and the other for the whole painting by a member of his shop,[67] but most of the autograph preliminary studies are concerned with research into expression and not with definition of a pose. The Apostle in the left foreground, when we first meet him in a life drawing in the nude at Chatsworth (Fig. 62),[68] is curly-haired. In the cartoon his head was bald, and it appears in this fashion in an auxiliary cartoon in London (Fig. 63).[69] In the painting (Fig. 64) the type is again modified. Still more penetrating is an auxiliary cartoon at Chatsworth (Fig. 65) for the head and hand of the standing Apostle pointing towards Christ (Fig. 61).[70] With its masterly command of the lighting of the softly modelled features, this is one of the finest drawings Raphael made. In an action study in the Louvre (Fig. 66)[71] the young Apostle in the centre of the scene moves forward like the Eve in an *Expulsion* group, and at Oxford there is a superb auxiliary cartoon (Fig. 67) for the questioning head and for the head and hands of the Apostle to his right (Fig. 68).[72] The fact that so many of these drawings are auxiliary cartoons implies that the design was complete in all its details before Raphael's death, and even figures that he did not paint – the kneeling woman in the foreground, for example, and the possessed boy and his father to the right – must therefore have been planned by Raphael. In the case of the kneeling woman this can be proved from an autograph drawing of the profile head,[73] and in the case of the boy and his father it can be inferred, though the surviving drawing, like the corresponding figures in the painting, is by Giulio Romano.[74]

The true nature of these buoyant, confident studies is thrown into relief by three visionary sheets in which Michelangelo worked out the pose of Lazarus in the rival painting. The Lazarus is a dream image, mannered and mysterious, whereas the drawings for the *Transfiguration* exalt reality. In the heads the expressive possibilities of directed light are investigated with new potency, and the hands are studied with the same remorseless concentration as the hands in the *Coronation of St. Nicholas of*

75

62. Raphael: *Study for St. Andrew and a second Apostle*. Chatsworth

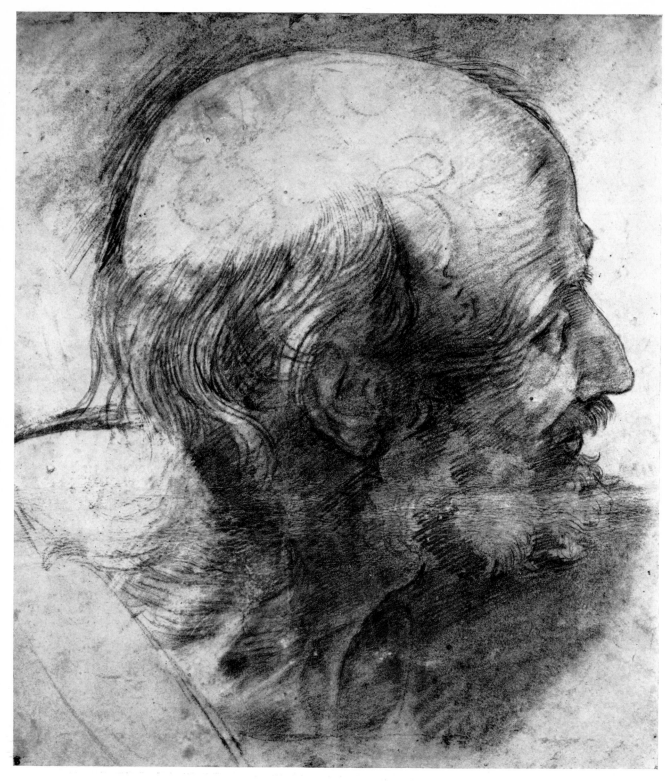

63. Raphael: *Study for an Apostle*. London, British Museum

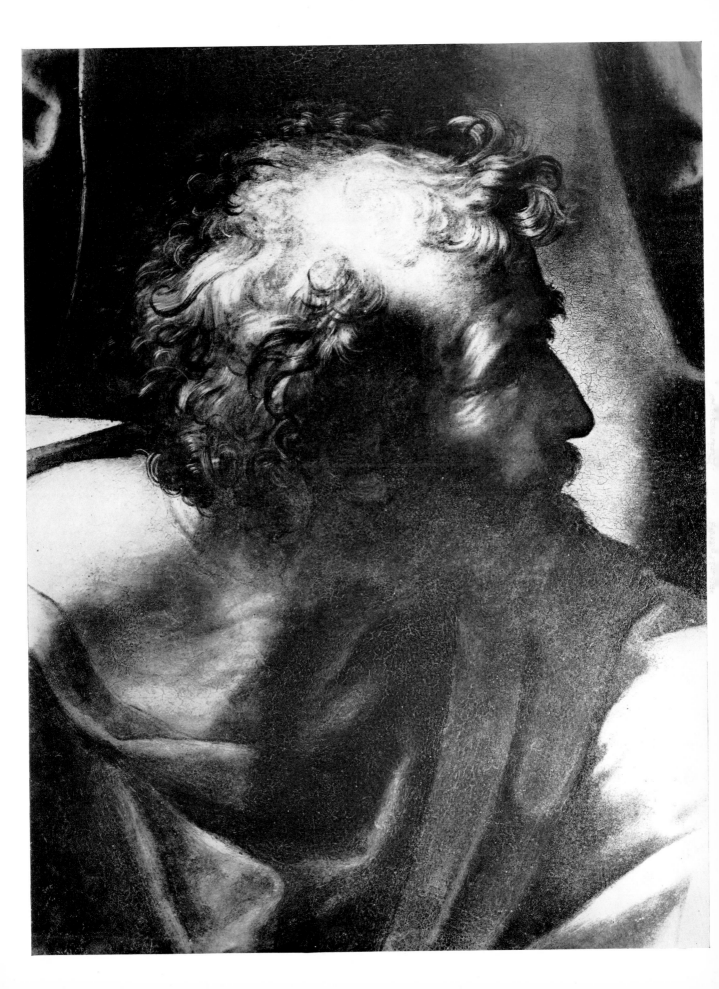

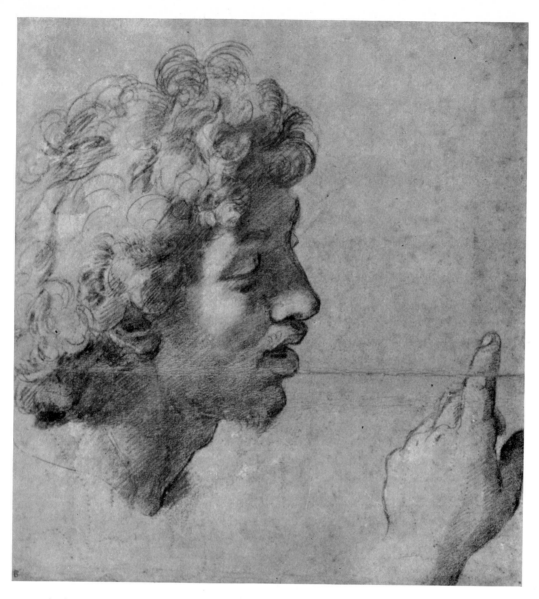

65. Raphael: *Study for the Transfiguration*. Chatsworth

Tolentino of twenty years before. Ingres declared that Raphael and the living model were synonymous, and Fuseli said rather the same thing. 'No Dutch master', he affirmed, 'was ever more subservient to Nature's laws than Raffaello.' In the drawings for the *Transfiguration* as in those for the *St. Nicholas of Tolentino* what the mind conceives is validated by the observations of the eye. But the mental conceptions of 1520 were different from those of 1500, and the observations of the eye were different too. They were more faithful, more penetrating, more profound, and the artist they reveal is a High Renaissance Caravaggio, who employs the language of perception to transmit a spiritual truth.

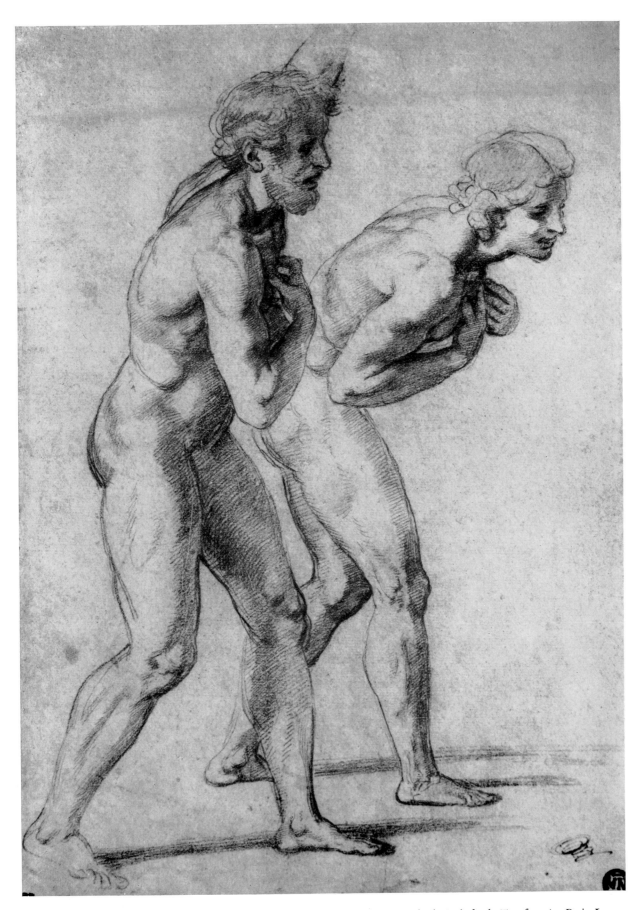

66. Raphael: *Study for the Transfiguration*. Paris, Louvre

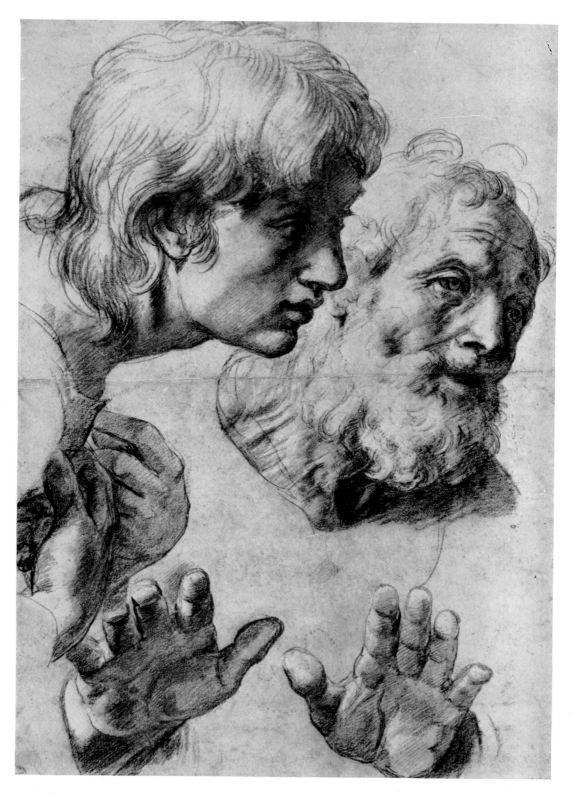

67. Raphael: *Study for the Transfiguration*. Oxford, Ashmolean Museum

68. Raphael: *Detail from the Transfiguration*. Pinacoteca Vaticana

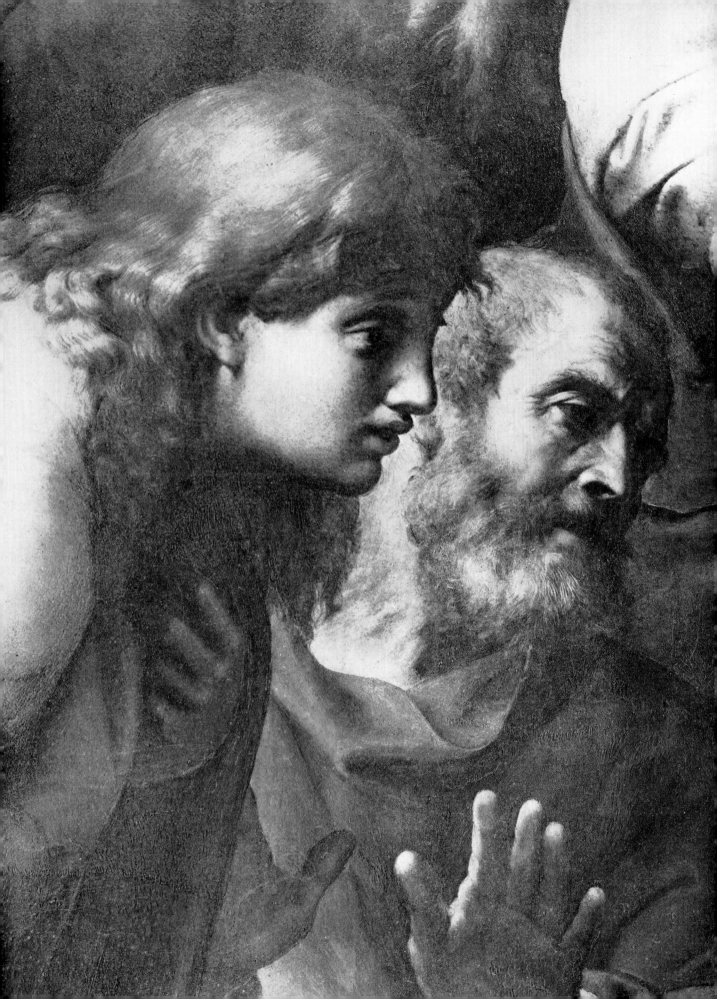

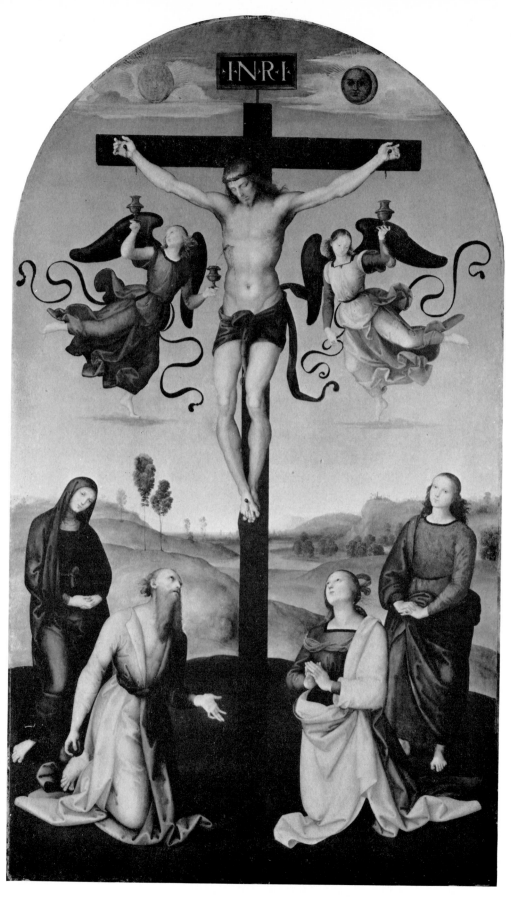

69. Raphael: *Christ on the Cross with Four Saints*.
London, National Gallery

III · SPACE AND STRUCTURE

WHEN WE GO into the Stanza della Segnatura of the Vatican, our first impression is of sublime spaciousness. In no earlier frescoed room is pictorial space put to such lucid and such elevated use. The expedients that are employed here are the outcome of a series of experiments that can be traced back to Raphael's earliest works. Vasari says of the painter's first surviving altarpiece that if it were not signed by Raphael it would be taken for a work by Perugino. Its subject is the *Crucifixion* (Fig. 69), and it was painted when Raphael was nineteen for S. Domenico at Città di Castello.[1] The altar on which it stood bears the date 1503, and in composition it is related to a *Crucifixion* altarpiece painted by Perugino a year earlier for S. Francesco in Monte at Perugia. As soon as we compare the altarpieces, it transpires that structurally and spatially Raphael's is far superior. The pairs of figures at the sides are placed, like architectural forms, on two converging diagonals, and the Cross rises from a median point between them. Behind is a landscape which conveys, through truth of tone, a sense of optical validity. When the painting was in its original position, this factor must have been still more strongly felt, for beneath it was a predella whose two surviving panels have a continuous strip of landscape at the back.[2]

Landscape backgrounds are often found in predella panels by Perugino. To take one instance only, the *Assumption of the Virgin* beneath Perugino's altarpiece at Fano[3] has as its background a stereotyped vista which was intended to create, in minds conditioned to the rolling Umbrian countryside, a sense of out-of-doors. Raphael's panels make use of this convention, but in them it is revised in the light of what the painter saw. Throughout his life Raphael must have made landscape drawings. Very few of them survive, but his finished paintings testify that he did so in much more unambiguous fashion than do the pictures of Fra Bartolommeo, a large number of whose landscape drawings are preserved. In painting after painting the proof is there to hand – in the marshy background of the *Madonna of the Meadow*, where the distant trees are recorded with the delicacy of a High Renaissance Claude; in the misty hills of the *Belle Jardinière*; in the broken paling and the cypresses reflected in the water in the *St. Catherine of Alexandria* in London; and in the winding path and thickets of the *Disputa*.

The predella panel of the *Assumption of the Virgin* in Perugino's Fano altarpiece is accompanied by the scene of the *Annunciation*, which takes place in constructed space (Fig. 70). The pillared hall, as always in Perugino's paintings, is painstakingly projected, but the receding guide-lines of the architecture lead to the Virgin's head,

and the perspective structure is therefore put to literary not spatial use. In the *Annunciation* (Fig. 71) in the predella of Raphael's *Coronation of the Virgin* in the Vatican, on the other hand, the setting is mensurable and consistent, and the figures of the Virgin and of the Annunciatory Angel seem to have been inserted, like puppets in a toy theatre, on a pre-existing stage. A preliminary drawing for this panel in the Louvre[4] illustrates the technique of space projection whereby Raphael arrived at this result.

There is no record of the year in which Raphael became a member of Perugino's studio. It has been argued that he joined it as a boy, and worked there till he is first mentioned, in 1500, as an independent master.[5] It has also been contended that after his father Giovanni Santi died in 1494 he stayed on in his workshop at Urbino, moving to Perugia only in 1499.[6] Whichever view we entertain, it must be recognised that Raphael was an Urbinate not a Perugian artist, and that his methods of pictorial construction are the outcome of a tradition of geometry which may have been transmitted by Piero della Francesca to Giovanni Santi and which was handed on, by Giovanni Santi or some member of his studio, to his son. Attempts have frequently been made to isolate Raphael's contribution to the paintings produced in the late fourteen-nineties by Perugino. The heightened sensibility of certain of the figures in Perugino's frescoes in the Cambio at Perugia has been credited to the young Raphael, but he may equally have been responsible for the unwontedly audacious structure of the tomb in Perugino's *Resurrection* in the Vatican (Fig. 72).[7]

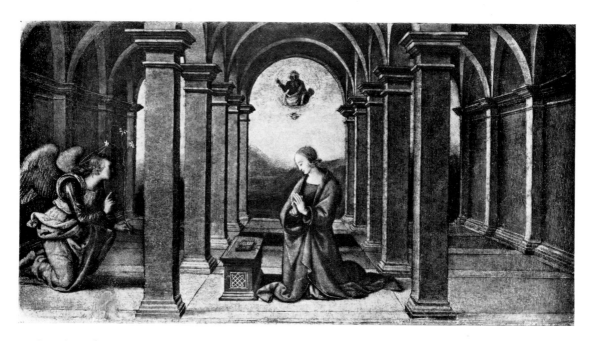

70. Perugino: *The Annunciation*. Fano, S. Maria Nuova

The dichotomy between the methods of space projection employed by the two artists can be traced more clearly in two altarpieces of the *Marriage of the Virgin*, both of which were painted after Raphael had left Perugino's shop. Perugino's *Sposalizio* (Fig. 73) was commissioned for the Cathedral at Perugia in 1499, was begun only after some delay, and was probably completed about 1505.[8] The *Sposalizio* of Raphael (Fig. 74), though commissioned later, was finished a year earlier; it is dated 1504, and was painted for S. Francesco at Città di Castello.[9] In both pictures the foreground is filled with figures, and a temple approached by steps stands at the back. In Perugino's painting the temple arch is depicted on the level of the eye, whereas in Raphael's the steps are the culminating point in a logical perspective scheme and the colonnade is seen from underneath.[10] The relation of the figures strung out across the foreground of Perugino's painting to the figures in the middle distance is insecure, while Raphael's beautifully graduated pavement leads the eye firmly towards the figures at the back. There were still limits at this time to Raphael's competence. Only the three strips of dark paving in the centre are projected mathematically, and the two strips at the edge were added, in freehand, to the central scheme. But when we wonder, as we must sometimes do, exactly how it was that Raphael, when he arrived in Rome in 1508, could project the architecture of the *Disputa* and of the *School of Athens*, we must remember that the answer lies in the Brera altarpiece.

The most convincing proof of Raphael's virtuosity occurs in the foreground of the scene, where the figures are not posed in line, as they are in Perugino's painting, but

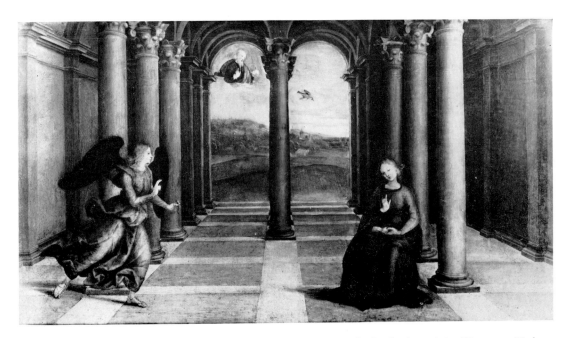

71. Raphael: *The Annunciation*. Pinacoteca Vaticana

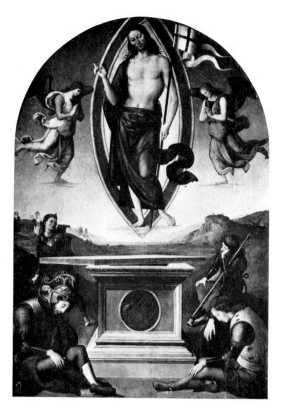

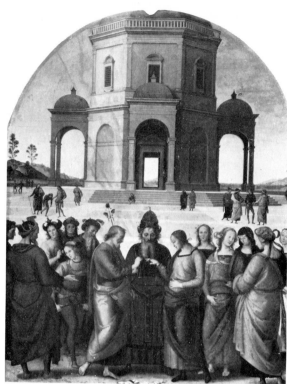

72. Perugino: *The Resurrection*. Pinacoteca Vaticana 73. Perugino: *The Marriage of the Virgin*. Caen

are grouped in a protruding arc. In the Brera the painting is hung at eye level, but in its original position the bottom of the panel was about six feet from the ground, and Raphael made allowance for that fact. The female figure on the left tilts slightly forward, the youth breaking a wand is so contrived as to indicate the distance of the other figures from the projection plane, and the eye comes to rest where Raphael intended that it should, on the hands of the Virgin and St. Joseph linked by the stooping figure of the High Priest.

The skilful planning of the *Sposalizio* must be borne in mind when we read the passages in which Vasari tells us that Raphael, because of his excellence as a designer, prepared sketches and cartoons for Pinturicchio's frescoes in the Piccolo/mini Library of Siena Cathedral.[11] As a fresco painter, Pinturicchio was more concerned than Perugino with perspectival space, and in seven of the ten frescoes in the Library the structure is consistent with his known practice at Spello and in the Aracoeli. Typical of them is the fresco of *Pius II at Ancona*, where the main block of figures is set parallel to the picture plane with a distant landscape seemingly painted on a drop curtain behind. The design of this scene is different in kind from that of *Aeneas Sylvius crowned by the Emperor Frederick III*, where the beautifully articu/lated setting is marred only by the intrusive upper storey of a loggia at the back,

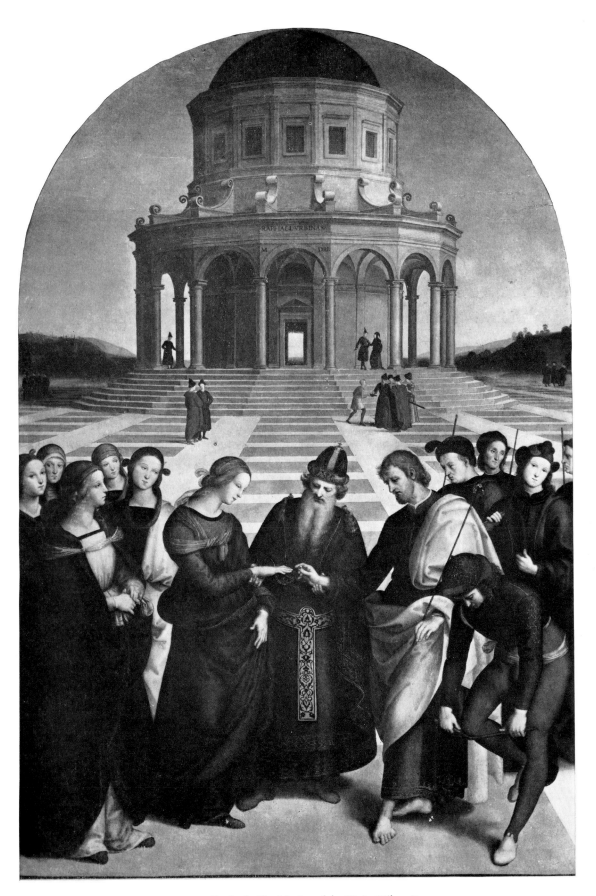

74. Raphael: *The Marriage of the Virgin*. Milan, Brera

or of *Aeneas Sylvius leaving for the Council of Basle*, which is planned with the same fluency. In one fresco, moreover, the front figures swing forwards in precisely the same fashion as the figures in the *Sposalizio* (Fig. 76).[12] Drawings by Raphael for these three frescoes are preserved (Fig. 75).[13] In the frescoes as Pinturicchio and the members of his workshop painted them the space illusion is limited. The drawings, on the other hand, present a continuum of space; the foreground, middle ground, and distance are perfectly adjusted, and the scene, from the front to the barely visible horizon, is portrayed with absolute consistency. Not only do these sheets record Raphael's first thoughts about the art of fresco, but they reveal in embryo the instinctive sense for the potential of the fresco field that is one of the glories of the Stanza della Segnatura.

Soon after, theory is translated into fact in the fresco in San Severo at Perugia (Fig. 77).[14] Planned as a kind of alcove in the wall, it is built up from a low viewing point, so that what we see is not the surface of the cloudy platform, but its leading edge. This was a Florentine technique – it was employed in 1501 in the *Last Judgement* painted by Fra Bartolommeo and Albertinelli in San Marco – and Raphael probably intended that the bottom of his fresco should recede in the same fashion as

75. Raphael:
Study for the Betrothal of the Emperor Frederick III.
Florence, Contini-Bonacossi Collection

76. Pinturicchio:
The Betrothal of the Emperor Frederick III.
Siena Cathedral, Piccolomini Library

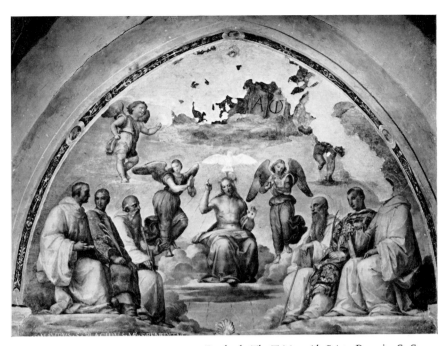

77. Raphael: *The Trinity with Saints*. Perugia, S. Severo

the part above. The present lower section was added sixteen years later by Perugino.

The San Severo fresco is a great deal more forward-looking than the three conventional Madonna altarpieces for which Raphael was responsible. Two of them were painted for Perugia and one for Florence, and the first (Fig. 78), now in New York, must have been commissioned, and was probably begun, before Raphael left for Florence in 1504.[15] As in the altarpiece painted in 1495 by Perugino for the Palazzo Pubblico in Perugia, light floods on to the upper surface of the steps beneath the Virgin's throne, though Raphael evinces a far stronger sense than Perugino for the geometrical progression of the three cubic forms. Probably the altarpiece was not completed till 1505 or 1506, for the figures of SS. Peter and Paul, like the San Severo fresco, reveal the influence of Fra Bartolommeo. The female Saints behind are set on a higher level than the two forward Saints and on a lower level than the throne. The scheme of the *Ansidei Madonna* of 1505 in London (Fig. 79)[16] is more rational and more compact; there are two figures at the sides, and their relationship to the main group is established with great confidence. The steps are projected from a lower viewing point than in the earlier painting, and the baldacchino is therefore seen from underneath. Just as in the *Sposalizio* there is a contrast between the strongly coloured foreground and the luminous architecture at the back, so in the *Ansidei Madonna* the throne and figures are offset by the limpid expanse of a pale grey arch.

Though elements from these two altarpieces are redisposed once more in a pen drawing of about 1505 at Frankfurt (Fig. 80), Raphael undertook no further painting of this kind till 1507, when he planned but did not complete the *Madonna del*

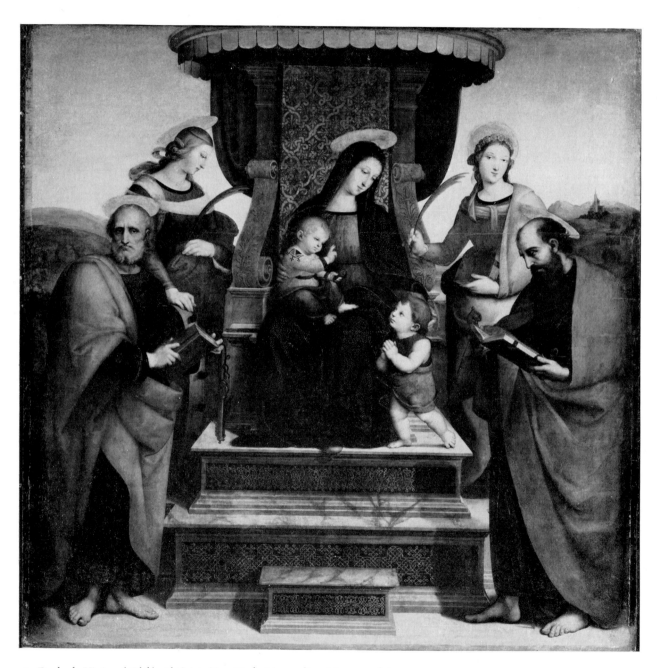

78. Raphael: *Virgin and Child with Saints*. New York, Metropolitan Museum of Art

79. Raphael: *Ansidei Madonna*. London, National Gallery

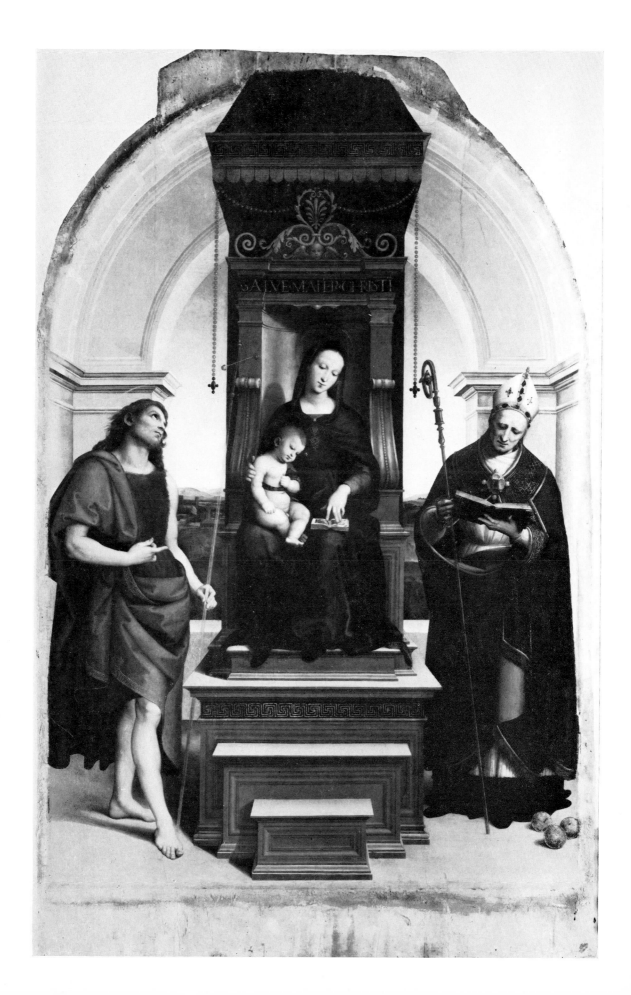

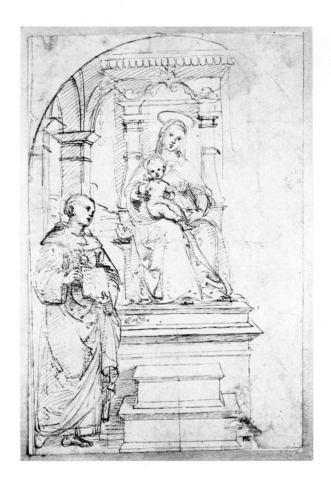

80. Raphael:
Study for an Altarpiece.
Frankfurt, Staedel Institute

Baldacchino for the Dei altar in Santo Spirito in Florence (Fig. 81).[17] The baldacchino is again visualised from beneath, and the steps are now projected from so low a point that the upper surface is invisible. In this respect the altarpieces represent three successive stages in a continuing experiment. Only with the last of them, however, can we reconstruct the reasoning by which they were produced. In a composition drawing for the *Madonna del Baldacchino* at Chatsworth,[18] the two Saints on the left are shown in conversation (as they are in the completed work), the bearded Saint opposite looks up ecstatically at the Child, and St. Augustine at the front is shown with eyes down-turned. When the altarpiece was painted, the rear Saints were opened out, as though shrinking backwards from the throne, and the pose of St. Augustine was modified; he gazes at the spectator and gestures with his right hand towards the central group. This is the first intimation of a device that is put to brilliant use in the foreground of the *Parnassus*.

Work on the Dei altarpiece was broken off in 1508, when Raphael was summoned to the papal court.[19] At first he seems to have worked on an equal footing with other artists employed on the decoration of the Pope's apartments, and only in October 1509, when he was appointed by Julius II to the office of Writer of the

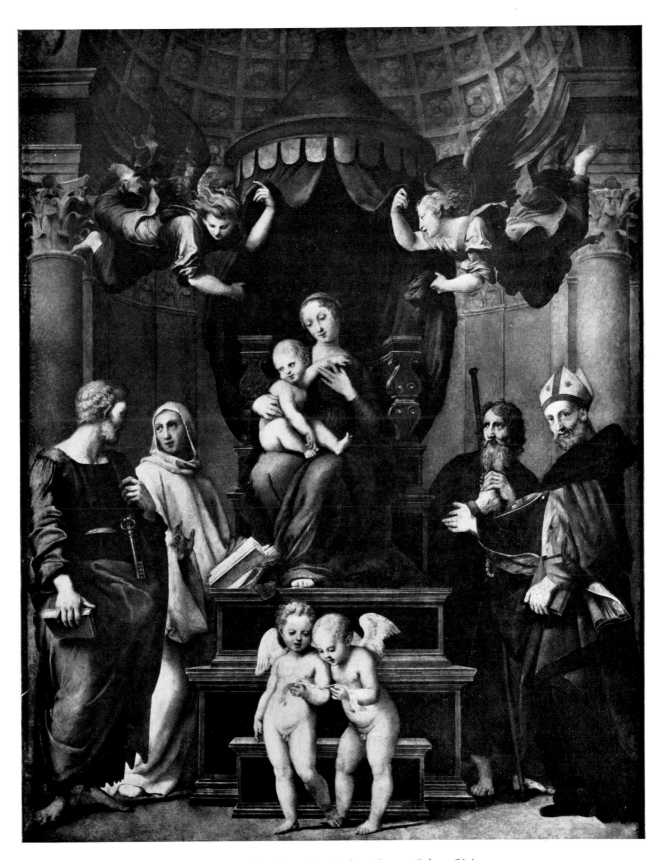

81. Raphael: *Madonna del Baldacchino*. Florence, Palazzo Pitti

Papal Briefs,[20] can it be claimed that he enjoyed exclusive favour as the artist in charge of the rooms that are now called the Stanze. They are three in number. The first (the last to be decorated personally by Raphael) houses the fresco of the *Burning of the Borgo*, and is therefore known as the Stanza dell'Incendio. The second (the first to be painted by Raphael) is the Stanza della Segnatura, and the third (the second in which Raphael worked) contains the *Mass at Bolsena* and the *Freeing of St. Peter*, and is known, from the dominant fresco in the room, as the Stanza of Heliodorus. Beyond the Stanza of Heliodorus is the so-called Sala di Costantino, part of whose decoration was planned after 1517 by Raphael. The rooms had been used in the fifteenth century by Popes Nicholas V and Sixtus IV, and according to the diary of Paris de Grassis the Pope moved to them in 1507 from the Borgia apartments on the floor below.

The first artist to be involved in the redecoration of the rooms was Perugino, who was entrusted with the ceiling of the Stanza dell'Incendio.[21] This ceiling remains intact, and is decorated with the papal stemma and four roundels with the Creation and scenes from the life of Christ. The next artist of whom account has to be taken is the Lombard painter Sodoma, who had been working since 1503 in Siena and its neighbourhood. His fresco cycles at Sant'Anna in Camprena near Pienza and at Monte Oliveto Maggiore brought him to the attention of Sigismondo Chigi, by whom he was employed locally on frescoes from Ovid and from the life of Julius Caesar, before he was passed on by Sigismondo to his brother Agostino, and by Agostino to the Pope. In October 1508 Sodoma was also working on a ceiling in the new apartments, that of the Stanza della Segnatura.[22] A native Sienese artist, Baldassare Peruzzi, may have been engaged at the same time on the ceiling of the Stanza of Heliodorus, though there is no documentary evidence of his employment there.[23] On the other hand we know that in the last three months of 1508 a Lombard painter, Bramantino, a painter from the Romagna, Michele del Bocca da Imola, and a Northern painter, Johannes Ruysch, were occupied in decorating the new rooms, and that in 1509 they were joined by an artist from Bergamo, Lorenzo Lotto.[24]

When Raphael started work in the Stanza della Segnatura (Fig. 14) late in 1508, the frescoes he envisaged differed in a great many respects from the frescoes he eventually produced.[25] There is no documentary evidence for the order in which the wall frescoes were painted, but in two of them, the *Disputa* and the *Parnassus*, much of the work was carried out *a secco*, after the plaster dried, while in the two remaining scenes the *secco* component was considerably less. *Secco* painting is found sporadically in every fresco Raphael painted, but its preponderance in the *Disputa* and the *Parnassus* seems to imply that when he painted them he was still a relatively inexperienced decorative artist.[26] Before these frescoes were begun, the structure of the room was modified; a retaining wall was built to receive the *Disputa* and the height of the

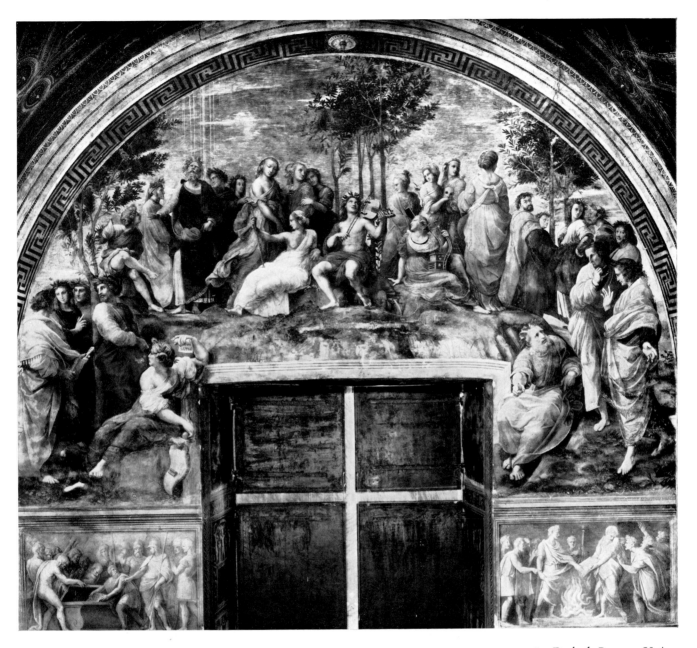

82. Raphael: *Parnassus*. Vatican

windows was reduced, evidently with a view to increasing the space available for frescoes on the two end walls.[27] From the figure drawings for the *Disputa* it can be established that in its first form the fresco was planned as a tiered structure with a narrower base than the composition we see now, and that through revision it was deepened and opened out till it acquired its present breadth and scale. The *Parnassus* (Fig. 82) seems to have developed in rather the same way. The earliest record of the composition occurs in an engraving by Marcantonio Raimondi based on a drawing by Raphael (Fig. 83).[28] In the centre, above the window, is Apollo

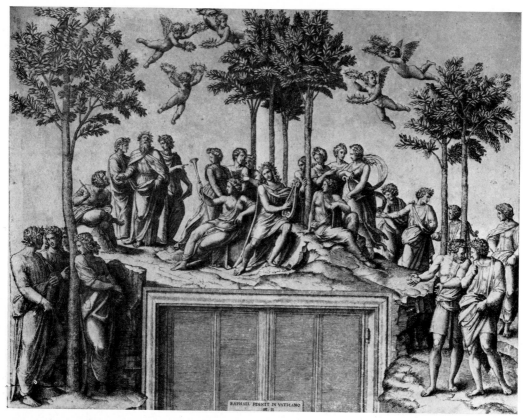

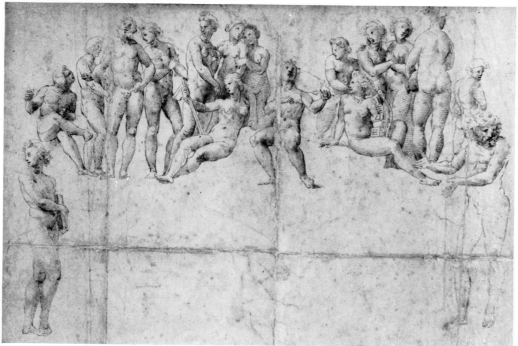

83 (above). Marcantonio Raimondi after Raphael: *Parnassus*.
84 (below). After Raphael: *Study for the Parnassus*. Oxford, Ashmolean Museum

seated with his lyre on his left thigh and the nine Muses round him. The Muse on the extreme left, who is represented almost in full face in the fresco, is shown in profile to the left, and the Muse on the extreme right, who is shown in the fresco with back turned, appears in left profile as well. Separated from the central group are Homer, Dante, and Virgil on the left and three more poets on the right. Given the shape of the fresco field, which included the wall surfaces beside the window as well as the wall surface above it, it was inevitable that the figures on each side of the window should be represented on a forward plane, and should therefore be larger in size than the figures above, and in the engraving they are depicted in this way, divorced from the main group. The scheme forcibly reminds us of the window frescoes devised by Pinturicchio a decade earlier for the Sala dei Misteri of the Appartamento Borgia immediately beneath the Stanze, where the scale of the rear figures is very similar and the main scene is also flanked by standing figures in full-length. Before the faults implicit in it could be rectified, it was necessary to redefine the spatial area in such a way that the figure of Apollo was no longer seated immediately above the architrave and the figures at the sides were no longer divided from those above.

As with the *Disputa*, the next phase was the making of nude studies of the poses. Here we have only a copy of a drawing by Raphael at Oxford (Fig. 84)[29] to guide us in establishing just what occurred. First the cartoon for the central figure was changed; the image of Apollo holding a lyre was abandoned, and replaced by a new

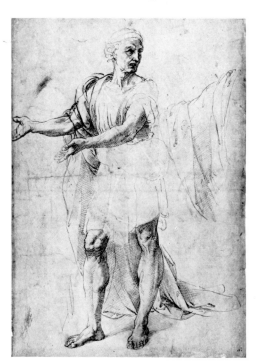

85. Raphael: *Study for the Parnassus.*
London, British Museum

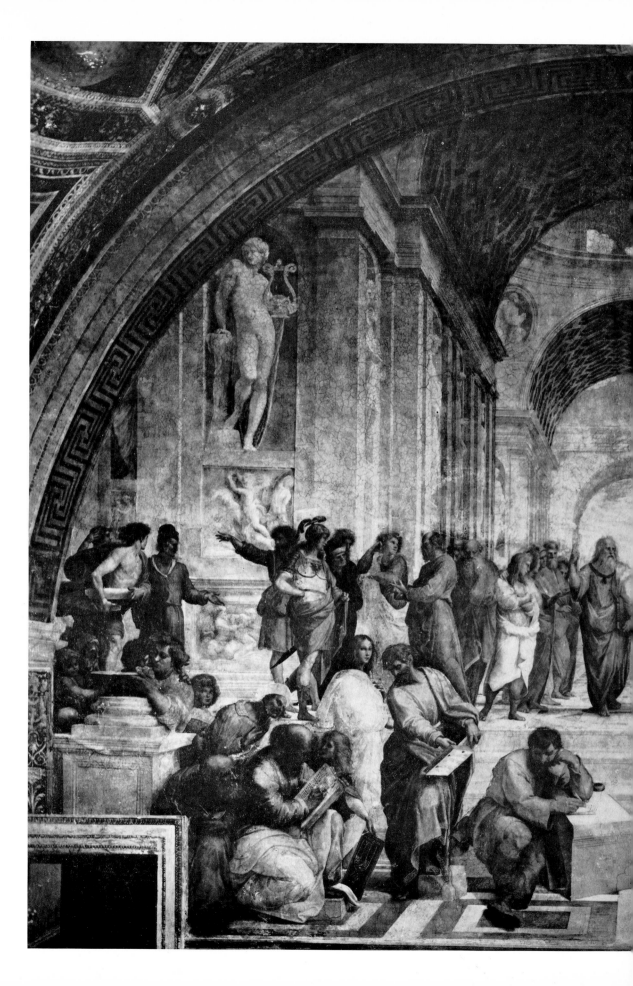

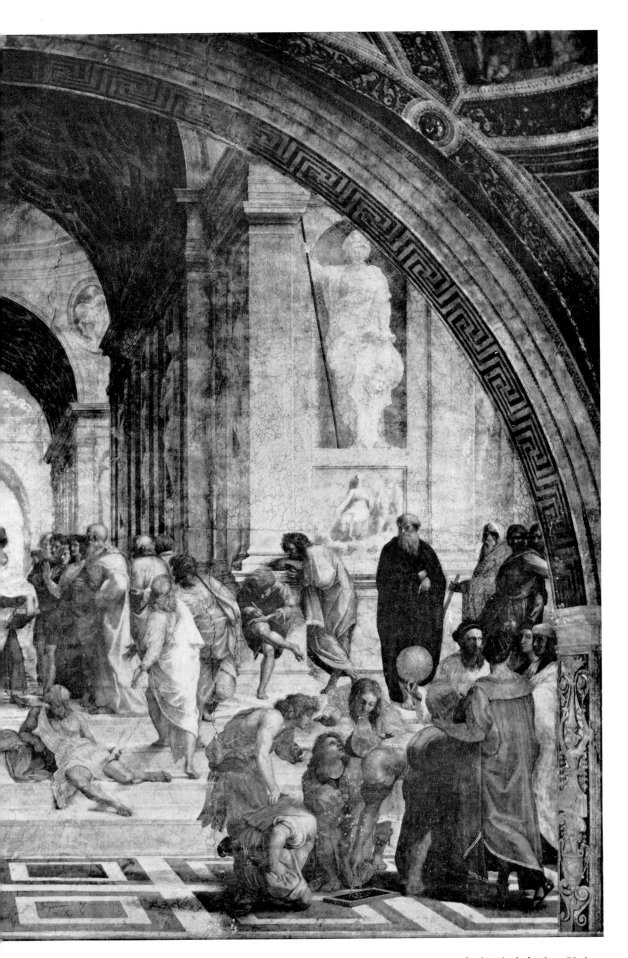

86. Raphael: *School of Athens*. Vatican

image of Apollo playing a *lira da braccio*. Three of the Muses on the left were retained, but the head of the fourth, that on the outside, was turned, lending the group greater coherence than it had had before. The adjacent figures of poets were retained, but were moved further to the right, so that the groups of poets and muses began to coalesce. On the right Raphael's thinking followed somewhat the same lines. A tree-trunk hiding part of the head of one Muse was removed, and the Muse to the right was turned so that this group likewise became more homogeneous. Again he confronted the problem of linking this group to the group of poets near by, and this was solved (as it is solved in the fresco) by introducing a male figure walking down-hill with head turned frontally. As yet no comparable thought was given to the forward areas, which remain essentially in the same state as in the print. Prob-ably these were the last parts of the scheme to be resolved, for a detailed study for the poet on the right (Fig. 85)[30] shows him in precisely the same pose as in the Oxford drawing, and only after this was made could Raphael have decided to substitute a seated figure beside the window with head turned back towards two standing poets to the right. The means by which this and the corresponding group of figures on the left-hand side were finally articulated will be described in connection with the literary content of the fresco.

There are no early composition drawings for the *School of Athens*, and we know a great deal less about the way in which it grew. Whereas the space structure of the *Disputa* was arrived at through changes in the subject matter of the fresco, and the space structure of the *Parnassus* was achieved empirically, in the *School of Athens* the space structure seems to have been planned in isolation and the figures were sub-ordinated to it. The steps that run across the scene are disproportionately deep and high in relation to figures on the scale of those employed, and as a result the poses of the standing figures in the middle distance to the right of centre, whose weight is distributed between two steps, betray a certain awkwardness. Perhaps the nature of the difficulty Raphael experienced with them transpires more clearly from a drawing at Oxford (Fig. 87)[31] than from the completed work; in the drawing the upper step is even deeper than in the fresco while the lower step is much reduced. This tends to reinforce Vasari's view that the architecture, which is the lynch-pin of the concep-tion, owes more to Bramante than it does to Raphael.[32] Hence the appearance of Bramante's portrait on the right, in the character of Euclid, in close proximity to those of the two painters. A case could indeed be stated for supposing that Raphael in the *School of Athens* was faced with the same order of problems as those with which Masaccio seems to have been confronted, through the conjectural intervention of Brunelleschi, in his fresco of the *Trinity*. Whether it was designed by Raphael or by Bramante or, as is possible, by the two artists in association, the ideal architecture of the *School of Athens* was central to the subject of the fresco, and the painter's task was

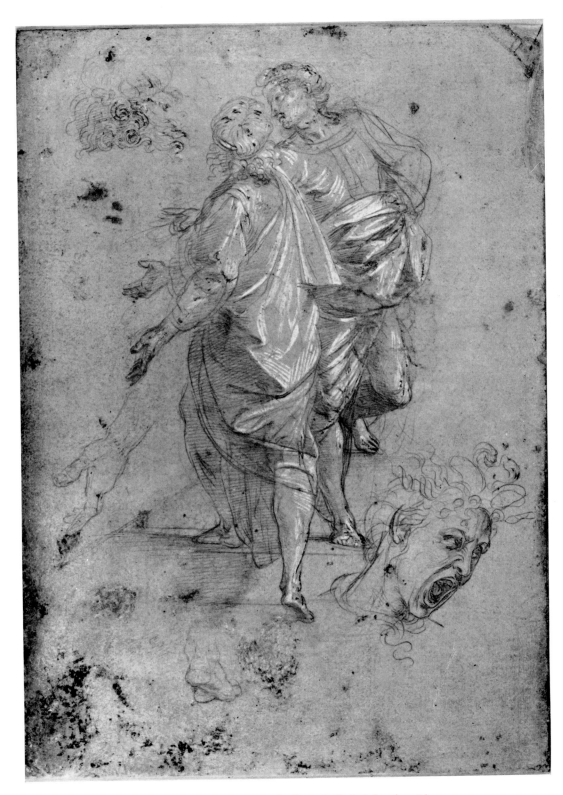

87. Raphael: *Study for the School of Athens*. Oxford, Ashmolean Museum

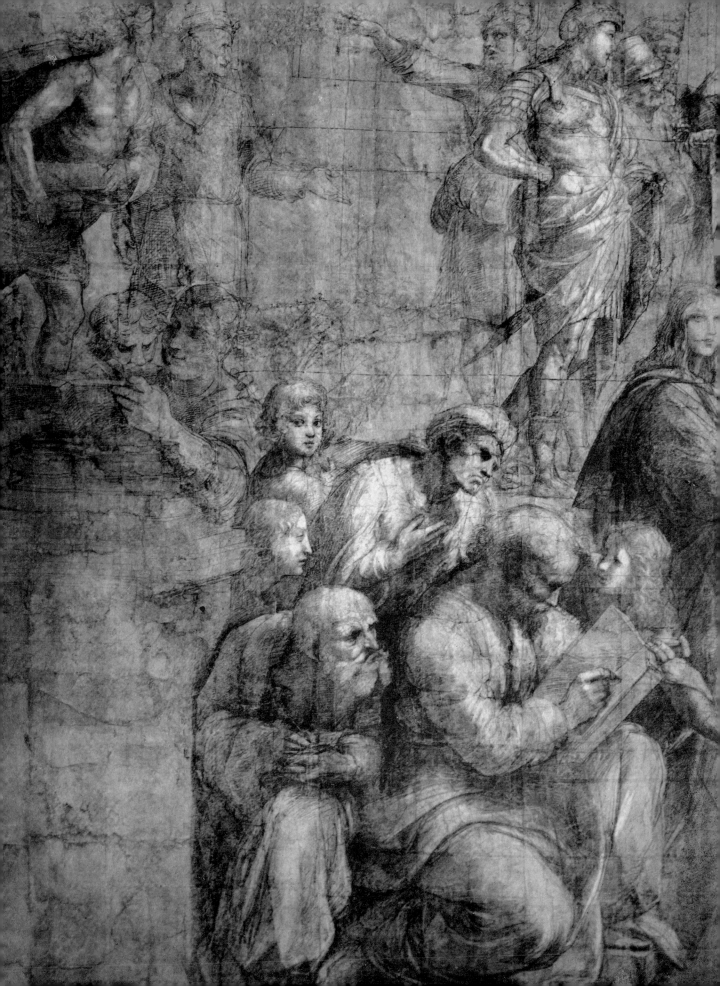

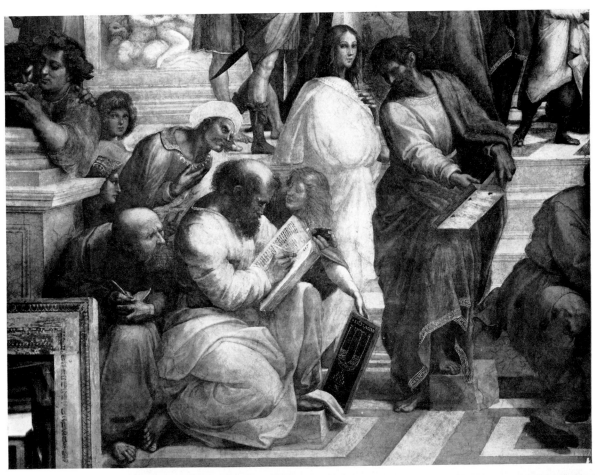

89 (above). Raphael: *Detail from the School of Athens*. Vatican
90 (below). Raphael: *Study for the School of Athens*. Vienna, Albertina

88. Raphael: *Cartoon for the School of Athens*. Milan, Ambrosiana

to articulate his figures inside pre-existing space. His attempt to do so is recorded in the vast black chalk cartoon in Milan (Fig. 88) for the figures in the fresco.[33] In it not only the broad lines of the architecture are incised, but every single vertical and horizontal through the entire scene. To take one area only, on the left side of the cartoon a horizontal incision running through the elbow of the man with right arm raised corresponds with the base of the relief behind him in the fresco, a lower incision corresponds with the base of the frame, a third incision defines the width of the moulding below it, and a fourth marks the upper edge of the relief beneath. Only in one respect does the cartoon differ significantly from the fresco, that it does not include the seated Heraclitus. We may infer that this figure was not envisaged when the cartoon was made, though without it the Plato and Aristotle appear to stand in a tunnel of space. Technical examination of the fresco confirms the evidence of the cartoon, and proves that the Heraclitus (Fig. 91) was painted on an area of fresh plaster inserted after the adjacent figures were complete.[34]

The foreground consists of two centralised groups, which reveal the influence of Leonardo both in their structure and in their constituents. The figure of a crouching man behind and to the left of Pythagoras (Fig. 89) is seemingly a recollection of the bald-headed King behind the Virgin and Child in Leonardo's unfinished *Adoration of the Magi*. Clearer and more spacious is the group of figures on the right, where the young spectators surrounding Euclid express by gesture their wonder and delight at the theorem he demonstrates. The youth stooping forward in profile on the left of this group originated as an acolyte in an early scheme for the *Disputa* and was transferred thence to the *School of Athens*.

Three or four of the extant figure drawings for the fresco relate to the Pythagorean and Euclidean groups, and one in particular, in Vienna (Fig. 90),[35] for Pythagoras and the figures round him, shows how their faultless symmetry was ensured. It must have been preceded by a quantity of earlier studies, since three of the six figures are in their final state. As we might expect, life models are employed, and close attention is paid to the musculature of their bodies, despite the fact that this would eventually be concealed by drapery. Between the preparation of this drawing and the painting of the fresco three changes were introduced into the group. The right knee of Pythagoras was lowered till it was almost on the ground, the man standing to the right was represented with head turned back expounding a text, and the head of the Leonardesque kneeling figure on the left was raised so that the light fell on his face as well as on his skull. Every single figure in the *School of Athens* must have been preceded by thoughtful, closely cogitated studies of this kind.

Late in 1510, while he was working on the *School of Athens*, Raphael's mind turned briefly to another project, the decoration of the Chigi Chapel in Santa Maria della Pace (Fig. 92). The proof of that is that on the back of one of the Oxford

91. Raphael: *Detail from the School of Athens*. Vatican

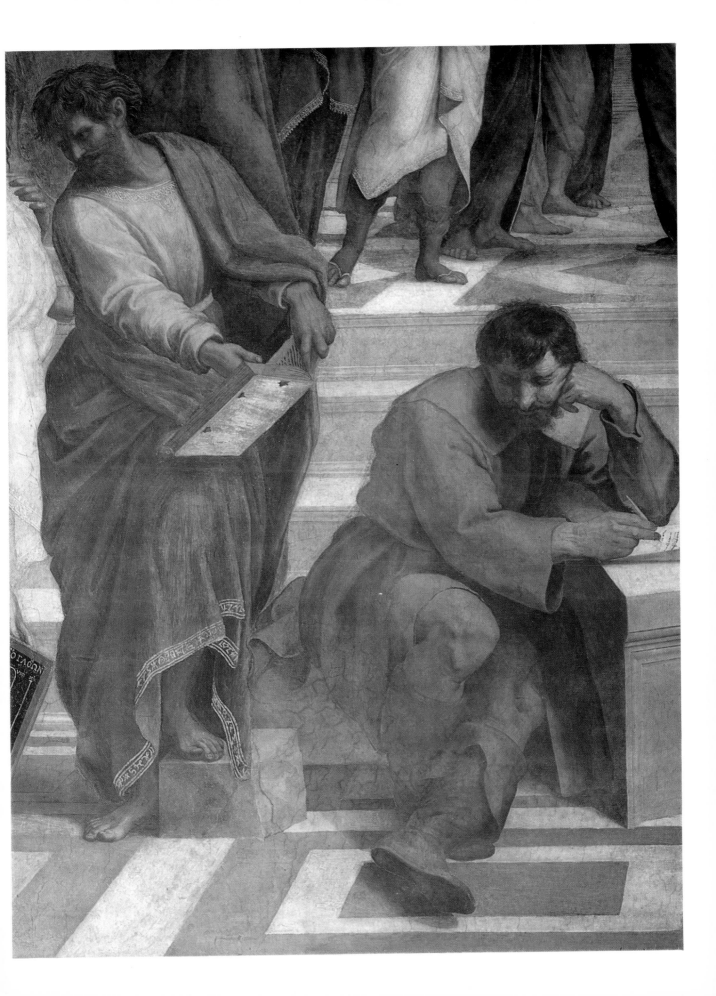

drawings for the *School of Athens* is a thumb-nail sketch showing half of the arch of the Chigi Chapel with a putto at the apex, two Sibyls to the right and two Prophets above.[36] This is the seed from which the fresco grew. It follows that the working up of what Focillon aptly calls the 'garland of figures' in Santa Maria della Pace must have proceeded hand in hand with the fourth and last of the wall frescoes in the Stanza della Segnatura. There is a manifest connection between the melodious link-ing of the figures in the Chigi Chapel and the principle of harmony embodied in the *Judicial Virtues* of the lunette in the Vatican (Fig. 93). Though the lunette is the most striking and successful feature of the fourth wall, what Raphael designed was a unified architectural structure, which would supply a background for two symbolic historical scenes at the bottom of the wall and would form a plinth for the *Judicial Virtues* at the top. One of the historical scenes, that on the left (Fig. 95), though designed by Raphael – the autograph drawing for it is at Frankfurt (Fig. 94)[37] – was painted by Guillaume de Marcillat, a maker of stained glass who also practised as a painter and was responsible for the windows in the choir added by Julius II to Santa Maria del Popolo and for the execution of the ceiling of the Stanza of Helio-dorus. It shows *Trebonianus consigning the Pandects to Justinian*, and the figure of Justinian assumes a classical form; it is seated in profile and is based on a Roman relief. In the fresco there is an uneasy dichotomy between the diagonal accent of the pavement and of the subsidiary figures and the Emperor's profile pose, but in the Frankfurt drawing the head of Justinian is turned inwards towards Trebonianus, so that the action becomes a mirror image of the action in the fresco opposite. The determining factor in the two diagonal compositions may have been the portrait of Julius II as *Pope Gregory IX approving the Decretals* in the fresco on the right (Fig. 96). The Pope is here shown with the beard which he wore after he returned to Rome from his cam-

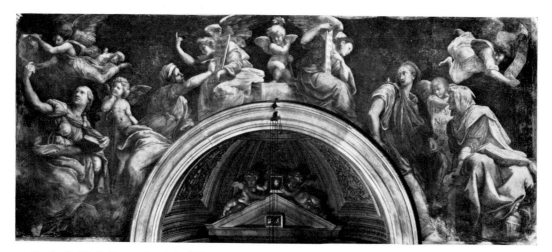

92. Raphael: *Sibyls*. Rome, S. Maria della Pace

paign in Central Italy on 27 June 1511 until it was shaved off in March of the following year. Shortly after the Pope's return Raphael began work on a portrait of him for Santa Maria del Popolo, of which the original or a good contemporary copy survives in the Uffizi, and the same cartoon seems to have been used both for the portrait and the fresco.[38] In the fresco the Pope is posed diagonally too, with results that were all but disastrous for the equilibrium of the wall. Late in 1511 work began in the Stanza of Heliodorus, and between this date and March 1512 Raphael must have made further studies of Julius II from the life which formed the basis of the much more vivid head in the fresco of the *Mass at Bolsena.*

Most visitors to the Vatican find their first encounter with the Stanze a bewildering experience, in that they go first into the Stanza dell'Incendio, which contains the latest of Raphael's frescoes, then into the Stanza della Segnatura, the earliest of the rooms he decorated, and finally into the Stanza of Heliodorus, which intervenes between the earlier and the later rooms. There are differences between the Heliodorus frescoes and the *Burning of the Borgo,* but it is between the Stanza della Segnatura and the Stanza of Heliodorus that the great rift occurs. They are not widely separated in time – the last of the Segnatura frescoes was finished in 1511 and the first of the frescoes in the new rooms was completed in the course of the next year – yet the stylistic discrepancy between them is very marked. The later frescoes are filled with movement and illustrate dramatic scenes, and they presented Raphael with problems of a different order from any he had met with in the preceding room.

In the absence of composition drawings for the first fresco,[39] the *Expulsion of the robber Heliodorus from the Temple* (Fig. 97), we must suppose that the design arose from the exigencies of the narrative. The focus of the drama is not the robber Heliodorus or the angels who expel him, but the priest Anias who summons them by

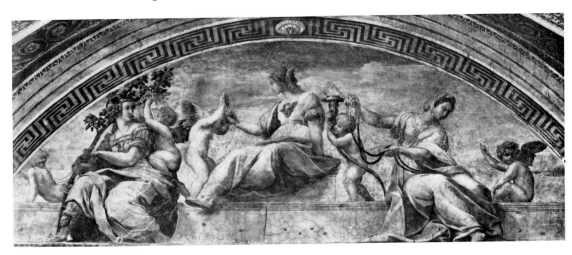

93. Raphael: *Judicial Virtues.* Vatican

prayer, and the altar at which Anias prays is set by Raphael in the exact centre of the scene. The fresco, as Raphael conceived it, was to make its primary effect through the contrast in scale between the distant priest and a colossal active group of Helio⁄dorus chastised by a riding angel on the right⁄hand side; and the narrow foreground area which had sufficed for the *School of Athens* was extended to accommodate the group. However carefully the diminution of the scale was calculated, it would seem arbitrary if the intervening pavement were unfilled, and this effect could be avoided only if a receding line of figures were inserted on the left⁄hand side. Though their main function is spatial, these figures fulfil a dramatic purpose too, in that their gestures, some of them directed towards the priest, some towards the heavenly messenger, serve to reconcile the two axes of the scene.

Evidence for the genesis of the window frescoes, the *Mass at Bolsena* and the *Freeing of St. Peter*, is more complete. The miracle depicted in the first of the two

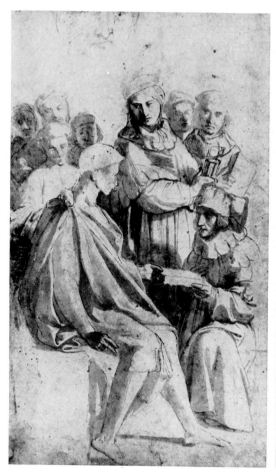 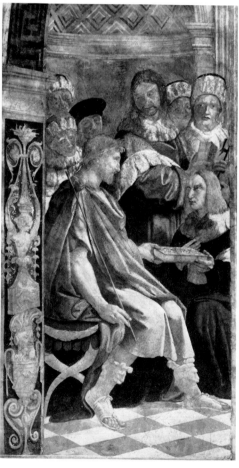

94. Raphael: *Study for Trebonianus consigning the Pandects to Justinian.* Frankfurt, Staedel Institute

95. Guillaume de Marcillat after Raphael: *Trebonianus consigning the Pandects to Justinian.* Vatican

96. Raphael: *Pope Gregory IX approving the Decretals.* Vatican

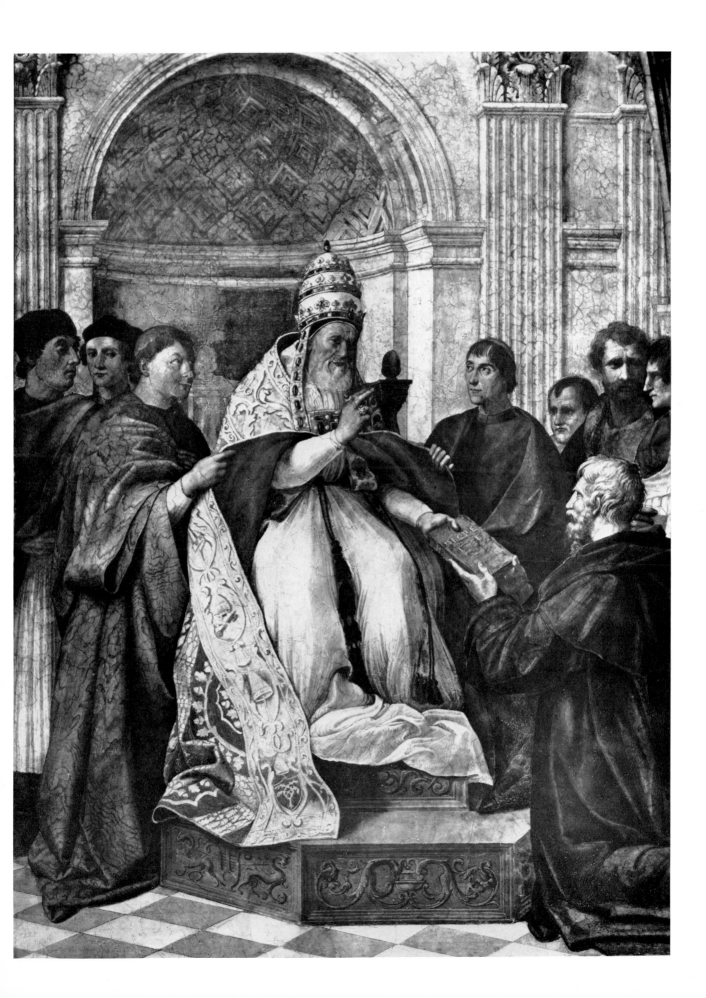

97. Raphael: *Expulsion of Heliodorus from the Temple.* Vatican

scenes (Fig. 99) occurred in 1263, when a German priest, who suffered doubts on the subject of transubstantiation while celebrating Mass in Santa Cristina at Bolsena found the corporal beneath the chalice stained with blood flowing from the Host. The corporal was taken to the near-by town of Orvieto, where the Pope, Urban IV, was resident, and in 1338 was encased in a reliquary in the Cathedral. The cult of the relic was twice endorsed by Pope Sixtus IV, the uncle of Pope Julius II, and the Chapel of the Corporal was visited by the reigning Pope in September 1506. This explains its inclusion in a fresco cycle of which the other scenes alluded, explicitly or by implication, to events in the Pope's reign.

Three copies of a lost autograph drawing for the fresco exist at Oxford (Fig. 98),[40] and in them the creative processes that had produced the *School of Athens* and the *Disputa* can once again be traced. The fresco field presented the practical difficulty that the window beneath it was to the left of centre, and Raphael, when he prepared the first design, was compelled to take this unavoidable imbalance into account. He did so by setting the altar at which the priest officiates in the centre of the window. Beside it he placed two candlesticks which read as extensions of the verticals of the window frame. This was compensated by the architecture at the back. The apse behind the altar is thronged with acolytes, to the right is a group of witnesses, and at the left in profile kneels the Pope. One of the objections to this early scheme is that neither of the foreground areas is adequately linked to the main space of the fresco. The altar is approached at each side by steps shown end on, but the steps leading to the altar are in turn conceived as standing on a platform raised by steps parallel to the projection plane. At the left the steps are six in number and descend at the edge of the painting, whereas on the right they are five and leave an area in front exposed. Even if we suppose, as may have been the case, that Raphael's purpose was to differentiate the reconstructed scene of the miraculous occurrence from the real scene of the Pope in prayer, this is an awkward device, and when the fresco came to be painted, the front steps were eliminated and the profile of the steps beside the altar was fortified.

The concave structure of the apse in the Oxford drawing is reminiscent of the *Disputa* rather than of the *School of Athens*, and its central bay is insufficiently emphatic to establish the centre of the fresco field. Instead, in the fresco Raphael has recourse to a central archway like that in the *School of Athens*, though by a stroke of incomparable ingenuity the concave construction from the first scheme is retained in the form of a wooden choir which separates the nave of the church from the area of the main scene. At the same time the platform created by the upper surface of the window frame is extended on the right so that the altar stands in the middle of the lunette and not in the centre of the window. The officiating priest and kneeling Pope are shown in close proximity, but the distinction between the scenes of the real and

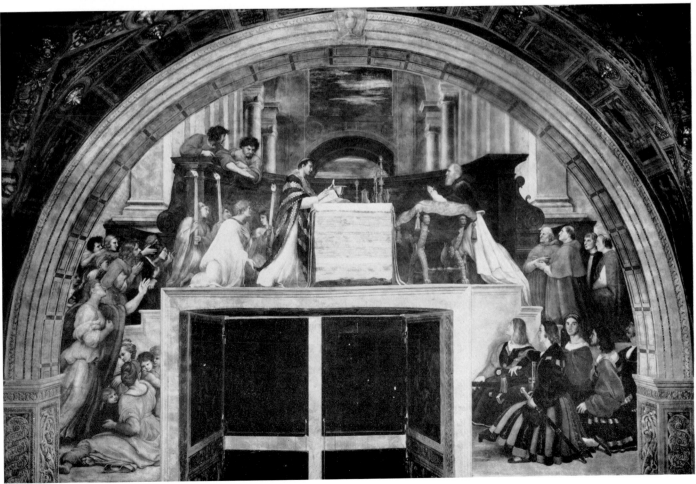

98 (above). After Raphael: *Study for the Mass at Bolsena*. Oxford, Ashmolean Museum

99 (below). Raphael: *The Mass at Bolsena*. Vatican

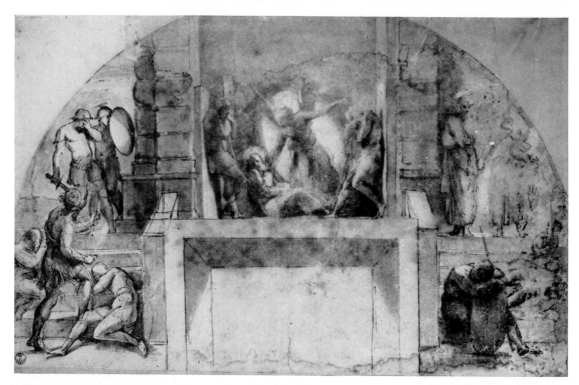

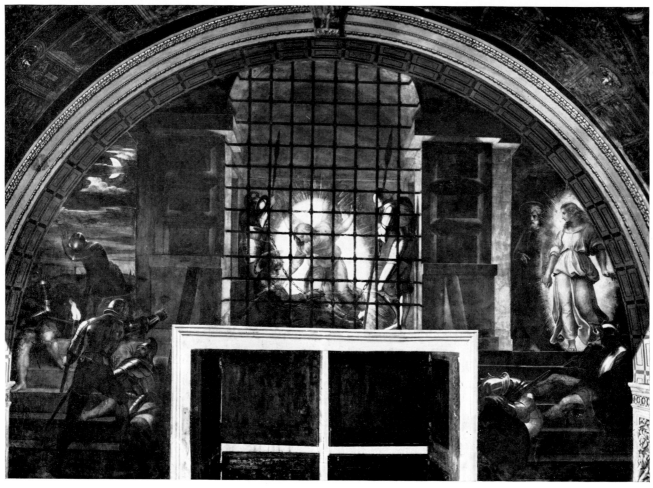

100 (above). Raphael: *Study for the Freeing of St. Peter*. Florence, Uffizi

101 (below). Raphael: *The Freeing of St. Peter*. Vatican

the imaginary action is preserved. The figures on the left, who are actually present at the Mass, participate fully in the miracle; they gesticulate with wonder and surprise. The figures on the right, on the other hand, are not participants; they are aware only of the presence of the Pope, who is shown kneeling, in profile to the left, absorbed not in the action but in meditation on the scene.

The lunette opposite, with the *Freeing of St. Peter*, was less intractable because the window was in the centre of the field. Raphael's preparatory drawing for this fresco is preserved (Fig. 100).[41] In it the prison extends almost to the full width of the window aperture, and the verticals of the window frame are continued in the form of two narrow rusticated piers running the full height of the lunette. To right and left are flights of steps so contrived as to leave a platform of space in the foreground at each side, and on their inner edges are handrails or banisters which terminate in flat supports beside the window. Between the making of this sketch and the painting of the fresco (Fig. 101) the surplus foreground was done away with, and the effective ness of the foreground figures was thereby greatly increased. The banisters were made to descend more precipitately and were severed by the window, and the walls of the prison were widened and crowned with a cornice. This last change had the result of decreasing the width and increasing the height of the main scene, and the figures inside the prison were consequently brought into a closer, more vivid relationship. At the sides Raphael resorted to the same expedient that had been forced on him in the *Mass at Bolsena*, to establish the contrast between an area of action on the left and an area of inaction opposite.

The terminal dates of the Stanza of Heliodorus are recorded in inscriptions under the *Mass at Bolsena* and the *Freeing of St. Peter*. They are the years 1512, the ninth year of the pontificate of Julius II, and 1514, the second year of the pontificate of Leo X. The fourth fresco, the *Repulse of Attila* (Fig. 102), was painted in 1513. A copy of a drawing for the fresco by Raphael at Oxford (Fig. 103)[42] shows Pope Leo the Great carried forward in a portative chair. In this he has the features of Julius II. Before the fresco was painted, however, in February 1513 Pope Julius II died, and in the final work Attila's antagonist is Pope Leo X, who chose to make his first formal appearance in Rome on the feast of St. Leo, 11 April 1513. The new Pope had been captured at the Battle of Ravenna, and though the fresco was planned before his predecessor's death, it came to be regarded as a reference to his release. Artistically the inclusion of a papal portrait was prejudicial to the narrative, and for one blessed moment Raphael supposed he could dispense with it, and so avoid a caesura be tween the papal retinue and the rearing horses on the right. That at least is suggested by a copy of a Raphael *modello* in Paris (Fig. 104), where the left side is filled with active figures and the papal procession is relegated to the back.[43] The testimony of this drawing has been questioned, but it is significant that in his next fresco in the

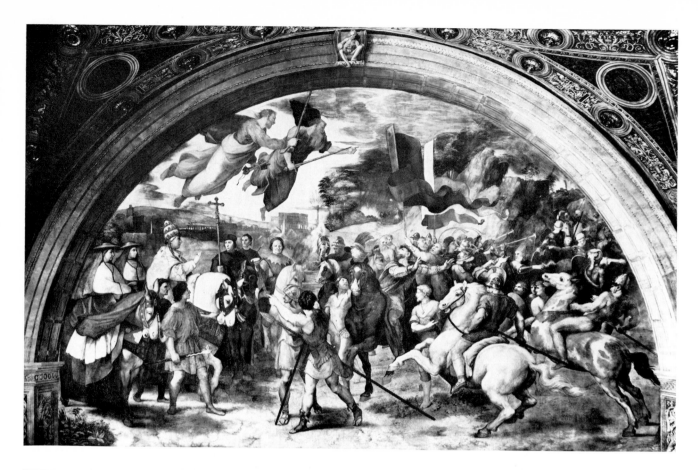

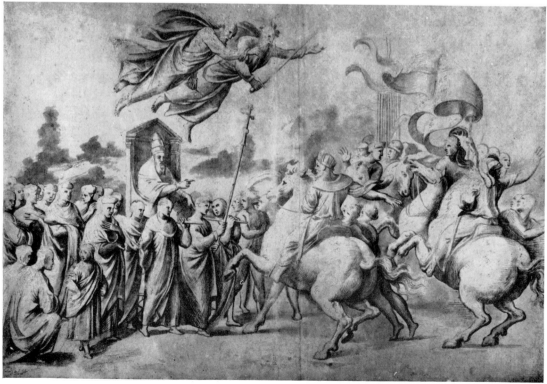

102 (above). Raphael: *The Repulse of Attila*. Vatican

103 (below). After Raphael: *Study for the Repulse of Attila*. Oxford, Ashmolean Museum

Stanze, the great and much maligned *Burning of the Borgo*, Raphael fell back on the same device.

The beginning of work in the Stanza dell'Incendio (Fig. 105) can be dated from a letter of July 1514,[44] in which Raphael refers to the frescoing of a new papal apartment. The scenes followed the journalistic precedent of the *Repulse of Attila*; they drew their sanction from the title of the reigning Pope and were chosen from the *Liber Pontificalis*, two from the reign of Leo III and two from that of Leo IV. The *Burning of the Borgo*, from which the room derives its name, illustrates a miracle which occurred in the ninth century, when Leo IV, with a gesture of benediction, quenched a fire which was threatening the Vatican. Comparatively little is written nowadays in favour of this fresco. Its structure is, however, more ambitious than that of the *Repulse of Attila* or of the *Heliodorus*. As in the *Heliodorus*, the action is pushed forwards to the front plane and the middle distance is almost void. At the extreme back outside St. Peter's is a knot of kneeling women who invoke the blessing of the Pope. Much closer thought was evidently given to the setting than was accorded to those of the immediately preceding frescoes. The ground is paved with brick, and two strongly marked perspective lines carry the eye back past classical porticos to a careful reconstruction of St. Peter's and to a loggia that frames the figure of the Pope.

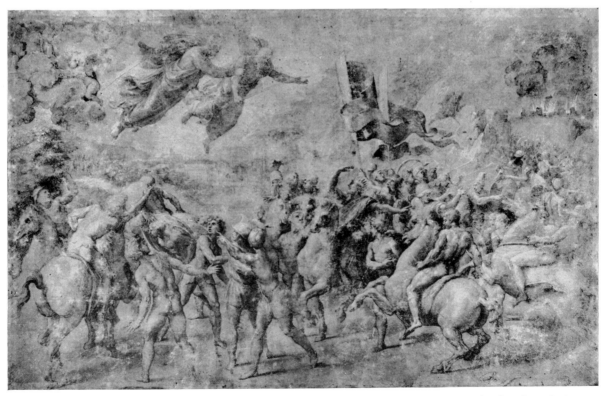

104. After Raphael: *Study for the Repulse of Attila*. Paris, Louvre

105. Raphael: *Stanza dell'Incendio*. Vatican

It has been argued that Raphael in employing these devices intended to establish that his setting was, in the antique sense, a tragic scene.[45] The setting can, however, be explained without any such hypothesis in the light of the study of Vitruvius on which we know from correspondence that he was engaged about this time,[46] of his mounting interest in archaeology, and of the bias towards academic classicising settings that is reflected concurrently in the *Presentation in the Temple* painted for Santa Maria della Pace by Peruzzi.[47]

Before the *Burning of the Borgo* was complete, and when the planning of the companion frescoes was still in a rudimentary stage, Raphael was deflected by a new commission, for tapestries destined for the Sistine Chapel. Though his cartoons and the tapestries that were woven from them have been studied frequently and in great detail there is much in this commission that is mysterious. The first record we have of it dates from June 1515, when Raphael received three hundred ducats for some of the cartoons. Another smaller payment was made in December of the following year.[48] There is no reason to suppose that the aggregate of these payments

represents the total sum received by Raphael for the ten cartoons that he prepared, and it cannot therefore be argued that two-thirds of the cartoons were finished by the time of the first payment and that the remaining third date from the following eighteen months. One of the cartoons, *Christ presenting the Keys to St. Peter* (Fig. 106), is stylistically less sophisticated than the other nine, and may have been prepared as early as 1512.[49] The bulk of them, however, seem to belong to the years 1514–16. The first instalment of tapestries reached Rome from Flanders in 1519, and on the Feast of St. Stephen of that year seven of them were hung in the Sistine Chapel. At this time an eighth was expected but had not yet arrived.[50] All ten tapestries are listed in an inventory made after the death of Pope Leo X in December 1521.[51] The evidence relates to ten tapestries, and to ten only, and ten tapestries survive, but since one of the tapestries hung outside the Cancellata of the Chapel and since the deaths of St. Peter and St. Paul and certain other scenes are not portrayed, the probability is that the tapestries delivered in 1519–20 were planned as the first part of a larger series designed to cover the altar wall and the full length of the side walls of the Chapel, which would have been continued had Raphael and his patron lived.[52] It follows that it is misleading to analyse the ten tapestries that were produced as though they form a unit that is self-consistent and aesthetically complete.

106. Raphael: *Cartoon of Christ presenting the Keys to St. Peter*

It has been established with a fair measure of certainty that the four tapestries with scenes from the life of St. Peter were designed to hang on the right side of the Chapel and that the tapestries with scenes from the life of St. Paul hung on the left.[53] The first tapestry of each series was placed on the altar wall, and along the lateral walls were, on the right, *Christ's Charge to Peter*, the *Healing of the Lame Man in the Temple* and the *Death of Ananias*, and on the left, the *Conversion of St. Paul*, the *Blinding of Elymas*, the *Sacrifice at Lystra*, the narrow scene of *St. Paul in Prison* and *St. Paul preaching at Athens*. Since the tapestries were intended to be put up and taken down, we should almost certainly be wrong in seeking in their designs the complex interconnections that occur in the frescoes in the Stanze which by virtue of their medium were irremovable. None the less the tapestries on the altar wall, the *Miraculous Draught of Fishes* on the right and the *Stoning of St. Stephen* on the left, were intended to be looked at simultaneously, and the use in both of figures bending forward invests them with a superficial unity. The design of the third tapestry on each lateral wall is centralised, and there is also some measure of correspondence between the *Death of Ananias* and the *Sacrifice at Lystra* (Fig. 107), which occupied the fourth place in the two cycles. Given the limitations of the medium, Raphael was forced back on a classical method of narration, by which the main figures were placed

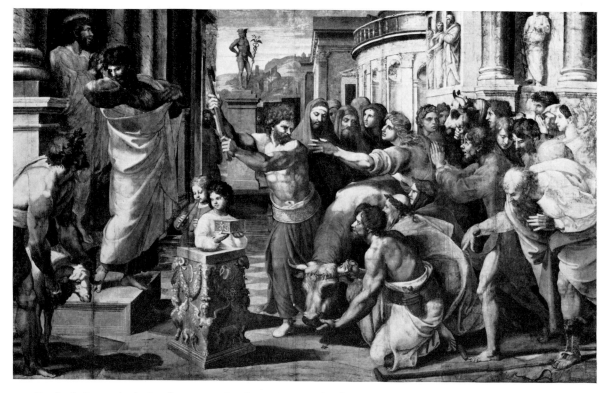

107. Raphael: *Cartoon for the Sacrifice at Lystra*. London, Victoria and Albert Museum (lent by H.M. the Queen)

squarely in the foreground of the scene. This practice is followed in the *Healing of the Lame Man* and the *Blinding of Elymas*. A drawing at Windsor for this last cartoon proves how carefully the space construction in it was worked out.[54] As in the cartoon in Milan for the *School of Athens*, all the guidelines of the architecture are punctiliously incised. From this point on the spatial content of the scenes was progressively increased. The first design in which this occurs is the *Death of Ananias*, where an extended foreground reminiscent of that in the *Heliodorus* fresco is used to brilliant effect, and it is followed by the *Sacrifice at Lystra*, where, in conformity with the *Burning of the Borgo*, the figures are posed in a block across the foreground in opposition to an architectural perspective at the back. From a spatial standpoint the most impressive of the cartoons is *St. Paul preaching at Athens* (Fig. 108), where the foreground is truncated, and the eye is led diagonally across the platform by the raised hands of Denis the Areopagite to the standing Saint and diagonally across the middle ground by the raised arms of St. Paul to the distant auditors (Fig. 110). The foreground figures are indissociable from the kneeling woman with back turned at the front of the *Burning of the Borgo* (Fig. 109), and the carefully reconstructed classical architecture recalls the *Burning of the Borgo* too.

The use of a truncated foreground carried with it the advantage that the area

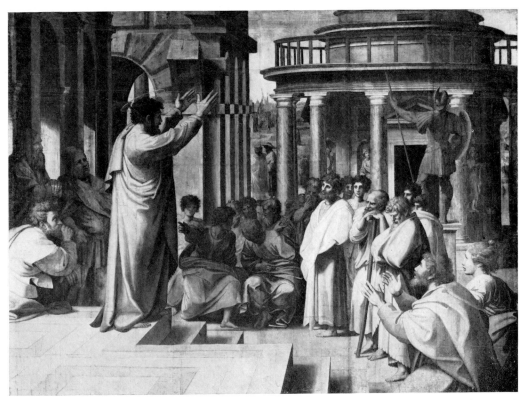

108 Raphael: *Cartoon for St. Paul Preaching at Athens*. London, Victoria and Albert Museum (lent by H.M. the Queen)

109. Raphael: *Detail from the Burning of the Borgo*. Vatican

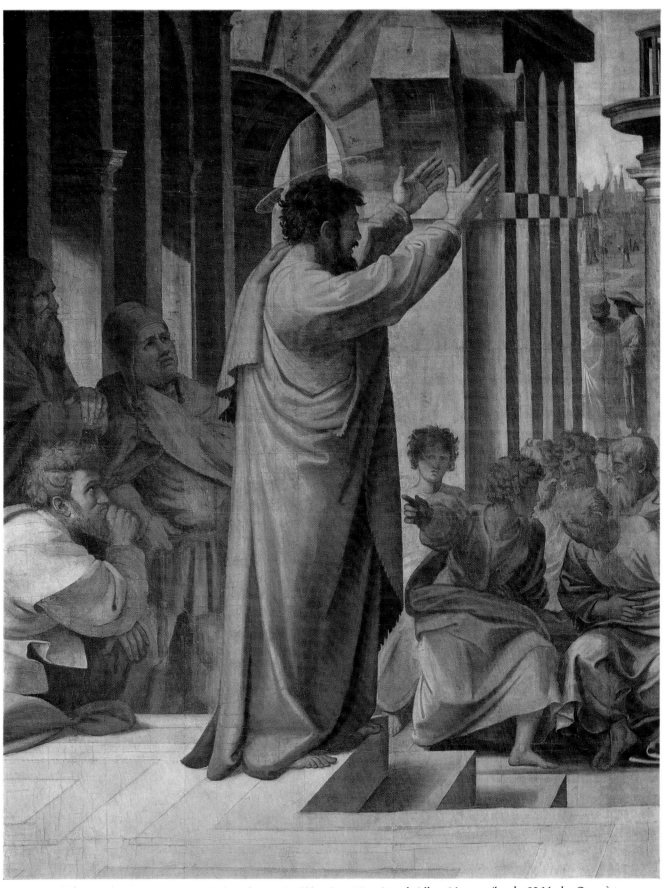

110. Raphael: *Detail from St. Paul Preaching at Athens*. London, Victoria and Albert Museum (lent by H.M. the Queen)

represented was no longer restricted by the width of the foreground of the scene. This device is employed again in a number of late works which Raphael designed but which he did not execute. The most notable is the *Coronation of Charlemagne* in the Stanza dell'Incendio.[55] In the little frescoes known as Raphael's Bible in the Loggia of the Vatican it recurs with obsessive frequency; examples of its application are the *Building of the Ark* and *David and Bathsheba*.[56] All these are pedestrian works, but in one painting of which Raphael's authorship cannot be denied, the triple portrait of *Leo X with Cardinal Giulio de' Medici and Luigi de' Rossi* in the Uffizi (Fig. 111),[57] it is put to inspired use. The three portraits are so well characterised and observed that even Wölfflin seems not to have enquired exactly how they are combined. In one earlier portrait by Raphael the sitter is depicted at a desk, but there the desk is aligned on the picture plane, and the width of the panel determines the size of the area that can be shown. If two or three figures were depicted in this way the room for manœuvre was inevitably limited, as can be seen in Sebastiano del Piombo's portrait of Carondelet, where the desk has the same relation to the picture plane that it does in Raphael's portrait of Tommaso Inghirami; two figures sit behind it, and a third portrait is inserted at the back. Had the portrait of Leo X been constructed in this way, it would have shown the Pope in full face across a table, Luigi de' Rossi on a slightly higher level behind his chair, likewise in full face, and Giulio de' Medici in profile opposite. Not only would the relationship between the portraits have been confused, but the requisite prominence would not have been accorded to the figure of the Pope. In the picture as it was executed, therefore, the viewing point is shifted to the right so that we look up at the Pope along the table edge. As in a close up photograph, everything that cannot be conveniently accommodated is excised, and the result is a portrait of incomparable immediacy. If we move, as we can do in the Uffizi, from this late masterpiece of Raphael to the early portrait of Francesco Maria della Rovere that hangs near by, we cannot but conclude that in structure, as well as in the record of physical appearances, it represents one of the great conquests in the history of art.

111. Raphael: *Pope Leo X with Cardinals Giulio de' Medici and Luigi de' Rossi*. Florence, Uffizi

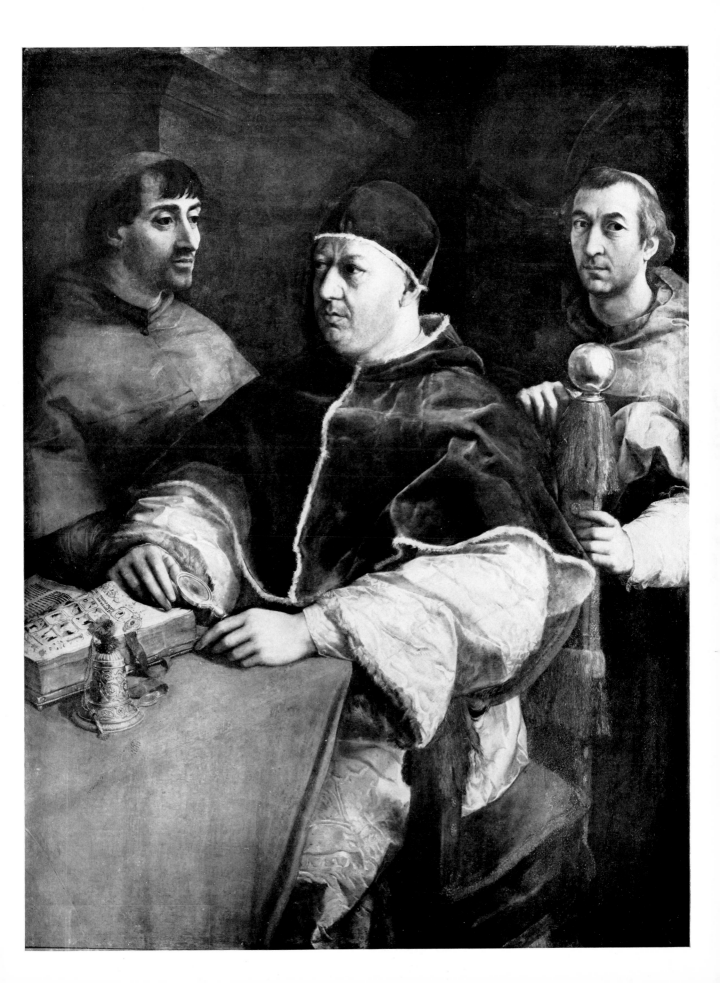

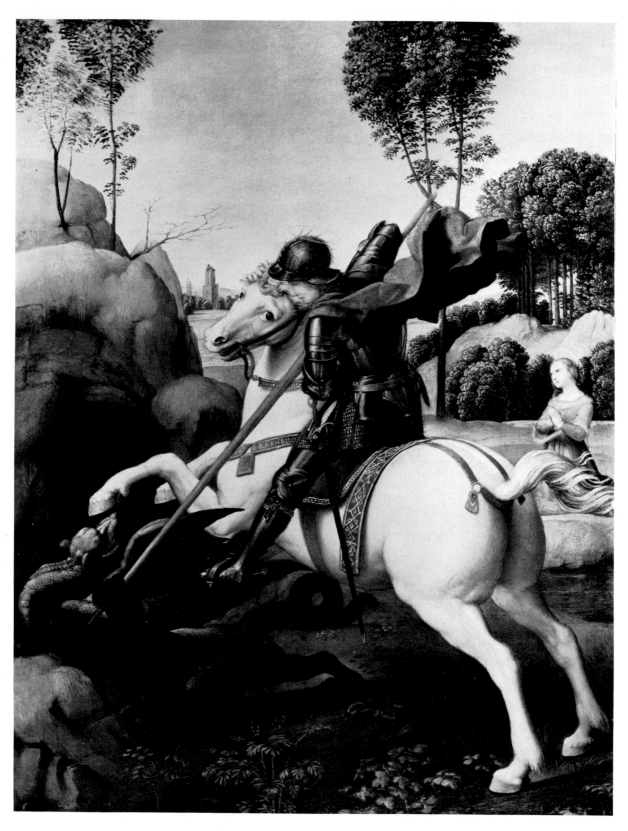

112. Raphael: *St. George and the Dragon*. Washington, National Gallery of Art (Mellon Collection)

IV · THE MUTE POET

IN HIGH RENAISSANCE THEORY it was widely accepted that the painter was a mute poet and the poet a painter with the gift of speech. The difficulties in the way of discussing this aspect of Raphael's work are very great. Whereas the visual imagination of a poet can sometimes be explained by reference to manuscripts and secondary sources, for understanding of the literary imagination of a painter (at all events of one who wrote few letters and kept no diaries) we are dependent upon inferences drawn from finished works and such preparatory studies for them as survive. For this reason it is convenient to begin by looking at two comparatively early paintings of a single subject, for both of which drawings are known, to enquire what they can tell us about Raphael's preconceptions as an illustrator.

They represent *St. George killing the Dragon*, and were produced in close proximity; the time interval that separates them is at most two years. The first of them, in Washington (Fig. 112),[1] is the less enterprising of the two. Its design is based on the intersecting diagonals of the horse's body and of the Saint's arm and lance, and in the foliage there is more than a suspicion of the gilded landscapes of Pinturicchio. In the second painting, in Paris (Fig. 115),[2] the dragon and the Saint are linked in a common spiral which reads like a coiled spring, and by one of those refinements which increase in frequency as Raphael's style matures, the conventional narrative, whereby the dragon is subdued by the Saint's lance, is heightened. Here the Saint's lance fails to subdue the dragon, and he depends for protection on his sword, while the Princess flees in terror from the scene. The structural principles implicit in this second painting derive from Leonardo.

The Washington panel dates from about 1505 – the handling of the light on the Saint's corselet closely recalls the *Ansidei Madonna* of that year in London – and the Paris painting is generally thought to have been produced a little earlier. But its narrative structure would alone suggest that it must be the later of the two, and this relationship can be confirmed from the preliminary drawings. The study for the Washington *St. George* (Fig. 113)[3] is, for Raphael, rather slack and lifeless; not only does the painting make an over-meticulous effect but the drawing does so too. The study for the *St. George* in Paris (Fig. 114),[4] on the other hand, is even more vital than the finished work; the rendering of action is easier, while a background of clouds and rock gives the little figures a greater sense of scale. The panoramic landscape, which is substituted in the painting, recalls the landscape of the *Madonna of the Meadow* in Vienna of 1506.

Raphael was never again called upon to paint this scene, but six or seven years later, when he drew up the cartoon for the angelic messenger expelling Heliodorus from the Temple, the old image rose to the surface of his mind, was developed along lines that by then were strictly classical, and was expanded to a heroic scale. The Paris *St. George* has as its companion panel a *St. Michael subduing Satan*,[5] where Hell is portrayed in terms that must derive from some painting by Bosch or Herri met de Bles which was available at Urbino or in Florence. Raphael's innermost sympathies lay with the figure of St. Michael, not with these febrile images, and twelve years later it was expanded into the Miltonic painting of the humane Saint vanquishing a humane Satan (Fig. 237) that he sent to France.[6]

The greatest single influence on Raphael's imaginative processes was the antique, and there is no way of telling exactly when or how his relationship with it began. The figure of Adam on a banner painted for Città di Castello in 1499 may depend from some classical relief. If it does so, it proves only that at this time Raphael's attitude to the antique was less sophisticated than that evinced by Perugino a decade earlier in the *Apollo and Maryas* in the Louvre. In Perugia, however, there was one fresco cycle which posed in an explicit fashion problems of style and subject matter akin to those that later confronted Raphael in the Stanza della Segnatura, and it is all but certain that Raphael was a member of Perugino's workshop at the time it was produced. Probably begun in 1497 and completed in or soon after 1500, the

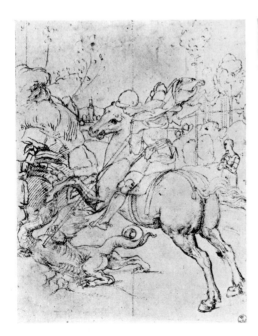

113. Raphael: *Study for St. George and the Dragon.* Florence, Uffizi

114. Raphael: *Study for St. George and the Dragon.* Florence, Uffizi

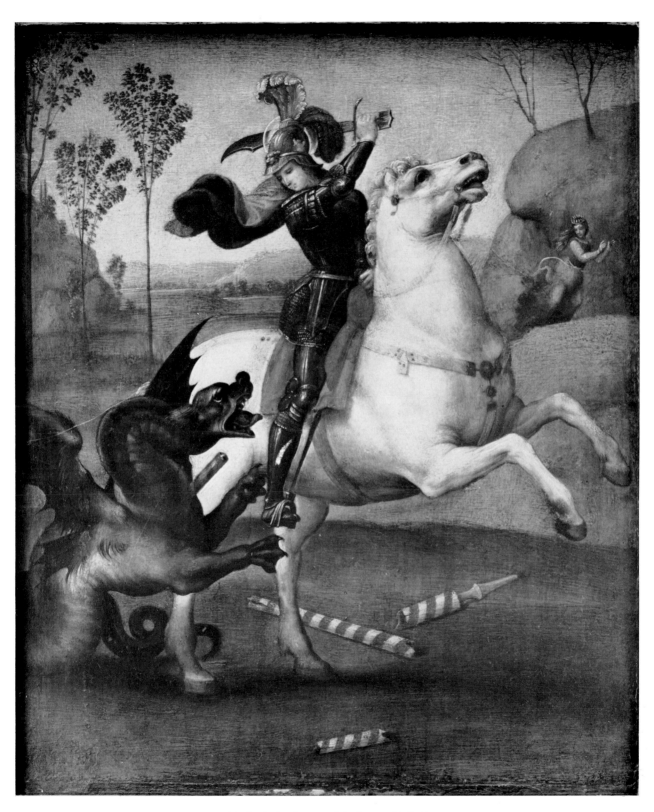

115. Raphael: *St. George and the Dragon*. Paris, Louvre

decoration of the Cambio (Fig. 116) was based on an uneasy compromise between the Umbrian convention and a classicising programme drawn up by a local humanist, Francesco Maturanzio.[7] The convention is represented by the Cardinal Virtues on the upper part of the wall surfaces and the classicising programme by heroes of antiquity beneath. It has been repeatedly suggested that Raphael himself worked on the frescoes, and even if he did not they establish a context for the first of his paintings that has a classical theme (Fig. 119). It shows the sleeping Scipio between two female figures who offer him a flower and a book and sword.[8] A good deal has been written on the meaning of the painting – the book and sword represent intelligence and strength and the flower symbolises sensibility – but what distinguishes it from the Cambio frescoes is not its subject matter, but the way in which the subject matter is portrayed. The standing figures were studied from the life – there is a drawing after Raphael at Weimar in which two boys in contemporary dress are shown in exactly the same pose – and the symbols are treated with a poetic conviction that assures us of their validity. The cartoon survives,[9] pricked for transfer so that it looks like a pattern for *petit point* (Fig. 117), and between it and the painting there occurred a process of revision like that in the Louvre *St. George*.

116. Perugino: *Fresco*. Perugia, Collegio del Cambio

117. Raphael: *Cartoon for the Dream of Scipio*. London, National Gallery

The river and bridge seen below the arm of the figure on the left became a road, and quite a number of the buildings changed as well, so that the panel was not just a transcription of the drawing but the last phase in a process of development in which the imaginative faculty was never for a moment still.

At the side, or on the back or front, of this miniature painting was a panel of the *Three Graces* (Fig. 118) in which Raphael makes use for the first time of a recognisable antique.[10] The classical group was in Siena, where Raphael worked with Pinturicchio on the frescoes in the library, and had been copied in the fifteenth century in three medals by Niccolò Spinelli.[11] The version on the medals is stiff and angular, whereas in Raphael's panel the linking of the figures has been understood,

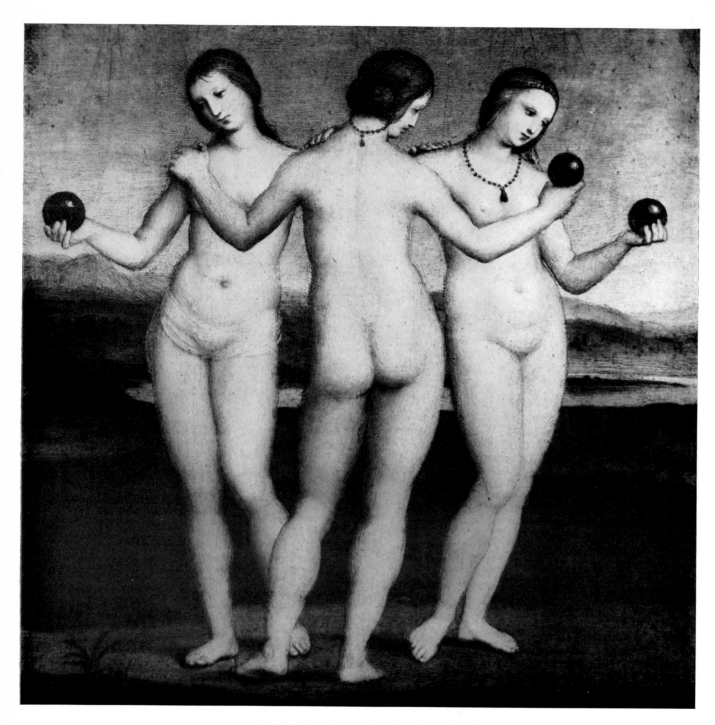

118. Raphael: *Three Graces*. Chantilly, Musée Condé

119. Raphael: *The Dream of Scipio*. London, National Gallery

and the bodies betray the voluptuous response to the beauty of the human form that ripens in the drawings for the Farnesina frescoes. Once more changes were intro‑ duced as work on it progressed. Thus the right hand of the central figure was originally placed on the shoulder of the figure on the right, and the ball that it holds now was introduced only as an afterthought. Whether some arcane refinement of philosophic meaning or simple visual intuition was accountable for this revision we do not know.

The narrative talent that Raphael evinces in these panels was not confined to paintings whose subjects were antique. It can indeed be seen to still greater effect in an almost contemporary religious work, the predella of the *Madonna of the Nuns of Sant'Antonio*, which consisted of three narrative panels, in the middle *Christ carrying the Cross*, in the National Gallery in London,[12] on the left the *Agony in the Garden*, in the Metropolitan Museum in New York,[13] and on the right the *Lamentation over the dead Christ*, in the Gardner Museum in Boston,[14] with two little upright panels of SS. Francis and Anthony of Padua at the ends. A copy made of the predella by Claudio Inglese Gallo (Fig. 121) shows very clearly how it looked when it was still intact.[15] Though there could be no unity of scene, a common horizon ran through all three panels, and much of their emotional intensity was due to the contrast be‑ tween the foreground figures and the expanse of landscape against which they were set.

Though Raphael was undoubtedly responsible for more than the design of *Christ carrying the Cross*, the only figure that speaks with full authority is the one that attracted the attention of Vasari, a youth in the centre pulling at a cord tied round the waist of Christ.[16] The other two narrative panels are more successful. The figures in the Boston *Lamentation* (Fig. 120) depend from a Florentine work by Perugino, an altarpiece in the Uffizi which was painted in the early fourteen‑nineties, but the composition is more inventive and the treatment more emotional. A new device is introduced whereby the three main figures are set on a hillock, with Joseph of Arimathaea and Nicodemus standing behind it at the back and the Magdalen crouching at the side. Probably this predella marks the first occasion on which Raphael directed his attention to this theme. In the third of the panels, the *Agony in the Garden* in New York (Fig. 122), differences of level are once more introduced. The foremost apostles are seated on a sharply sloping hill, and at the top of the eminence is Christ whose head is turned towards an angel in the upper corner of the scene. Once more a painting by Perugino was in the forefront of Raphael's mind, not as a model that he wished to emulate but as a formula that he was anxious to avoid. Painted in Florence for San Giusto della Calza, it showed Christ kneeling in three‑quarter face on a hillock in the centre, and the three apostles slumped on the ground in front. All that Raphael retains of Perugino's composition is the figure in

120 (above). Raphael: *Lamentation over the dead Christ*. Boston, Isabella Stewart Gardner Museum

121 (below). Claudio Inglese Gallo: *Copy of the Predella of the Madonna
of the Nuns of Sant'Antonio*. Perugia, Pinacoteca Nazionale

profile in the foreground, who is invested with the type of a St. John. One of the earliest proofs of Raphael's genius as an illustrator is the veiled head of Christ which lends the scene an inwardness and privacy no Umbrian painting of the theme had had before. The drawing for the *Agony in the Garden* (Fig. 123)[17] is on exactly the same scale as the painting, and is faithfully transcribed in the completed work, save for one discrepancy, that in the drawing the chalice before which Christ prays stands on the cliff. Radiographs show that this part of the drawing was also reproduced, but was then painted out and replaced by the much more evocative chalice-bearing angel we see now. This little picture, like the *Lamentation*, was a preparatory

122. Raphael: *Agony in the Garden.*
New York, Metropolitan Museum of Art

phase in the painting of a more elaborate version of the theme. The second panel[18] was likewise comparatively small – Vasari calls it a 'quadretto' – and was painted in 1507 for Guidobaldo, Duke of Urbino.

If Raphael in his last years in Florence painted classical scenes, none of them has survived, though extant drawings leave no doubt that at this time he was engaged in a close study of the antique. He copied single figures, fragments of statuary, and reliefs, and by the time he reached Rome in 1508 he had acquired a grasp of classical narrative technique which conditioned the nature of his thinking when he was confronted with the programme of the Stanza della Segnatura.

Before one can fruitfully discuss an artist's attitude to illustration, it is necessary to establish beyond all reasonable doubt what he is illustrating. With the first of Raphael's great fresco cycles, in the Stanza della Segnatura, that is easier said than done. The frescoes are commonly interpreted in the light of the supposed purpose of

the room, and on that the evidence is contradictory. The Segnatura was a judicial tribunal, and the name Camera della Segnatura is used by Paris de Grassis in 1513. Under Pope Leo X, however, the term Segnatura is applied to the whole suite of rooms of which this Stanza forms part, so it may well allude to the function they fulfilled before Julius II moved from the Borgia apartments to the rooms above.[19] It has also been claimed, on the strength of the many literary allusions in the frescoes, that the room housed the Pope's private library. Between the spring of 1507 and the summer of 1509, however, a new library seems to have been constructed for the Pope elsewhere[20]. It had a ceiling with planetary symbols, and frescoed and gilded walls, perhaps by the Umbrian decorators who were responsible for the Appartamento Borgia and who had been employed by the Pope in Santa Maria del Popolo. The Pope may have transferred his library from one room to the other, and the tribunal of the Segnatura may, for the matter of that, have sat in the Pope's library, but the structure of fact is much too weak to admit of inferences based on either postulate.

The most detailed of the early descriptions of the room is one prepared in 1550 by Vasari. Unfortunately it does not show Vasari at his most reliable. It opens with the fresco we now call the *School of Athens* (Fig. 86), a history, says Vasari, 'in which the theologians reconcile philosophy and astrology with theology. In it are depicted all the wise men of the world who dispute in various ways. On one side are some astrologers who have written on some tablets figures and geometrical and astrological characters, and they send these to the Evangelists by means of certain most beautiful angels, and the Evangelists confirm them.'[21] In the seventeenth century this description of the foreground of the scene was decisively rejected – Bellori explained it by supposing that Vasari confused this painting with the *Disputa* opposite, and gave the scene the title *The Gymnasium of Athens*[22] – but already in 1524 the seated figure on the left (which we now call Pythagoras) was engraved by Agostino Veneziano as an Evangelist.[23]

Vasari goes on to describe the ceiling, and then embarks on the *Parnassus*. His description is more confident than that of the *School of Athens* but once more it is based on imperfect knowledge of the fresco. The scene contains, he says, 'an infinity of naked cupids picking sprigs of laurel and making garlands from them, and scattering them on the hillside'.[24] The only possible explanation of this mistake is that he refreshed his waning recollection of the fresco with the engraving made by Marcantonio from one of Raphael's early sketches for the scene, where cupids are introduced.[25]

From Vasari's standpoint the two remaining walls were less unorthodox, and his description of them is more precise; the *Exaltation of the Eucharist* he connected with the Florentine iconographical tradition of the *Disputa*,[26] and the other wall was filled with the three *Judicial Virtues* and two readily intelligible narrative scenes.

Inevitably as we stand in the Stanza della Segnatura, looking up at the classical evocation of the *Parnassus* and at the magisterial figures of the *School of Athens*, we succumb to the notion that has dominated interpretations of the room from Bellori's time almost to our own, that Raphael was presented with a progressive, probably Neo-Platonic programme, and that this programme determined the idiom he employed. The facts do not support that view. The programme of the wall frescoes in the Stanza della Segnatura seems to have been devised by a Franciscan, and is based mainly upon St. Bonaventure.[27] Bonaventure's distinction between the natural and rational sciences accounts in the *School of Athens* for the separation of the mathematicians, physicists and metaphysicians from the grammarians, logicians, and rhetoricians, and though the reconciliation of Plato and Aristotle was a common Neo-Platonic exercise, it is Bonaventure who describes how they were accorded respectively the 'sermo sapientiae' and the 'sermo scientiae', one gazing at higher and the other at lower things. Bonaventure's *Reductio Artium ad Theologiam* would explain likewise the presence of Evangelists in the *School of Athens* (if they were really there) and the iconography of the *Disputa*. The most ostentatiously classical of the scenes, the *Parnassus*, has its roots in Landino's commentary on Dante, where the mount of the earthly Paradise becomes an allegory of the contemplative life and the seven candlesticks which stand on it like trees – there are seven trees both in the fresco and in the engraving by Marcantonio – symbolise the seven gifts of the Holy Ghost. From a visual standpoint the sources of the programme may be puzzling, but historically they were predictable. The Pope's uncle, Sixtus IV, was a Franciscan, and the only major public commission with which he was associated before his election to the papacy, the Sixtus IV monument for St. Peter's, was based on a mediaeval programme which was clothed, through the enterprise of a Florentine sculptor, Antonio Pollajuolo, in a Renaissance dress. The fourfold division of the room into walls presided over by Poetry, Philosophy, Theology, and Justice must have preceded Raphael's intervention in the scheme, because the antecedent sections of the ceiling, the paired classical scenes which were painted by Sodoma before Raphael's arrival, presuppose a division precisely of this kind.[28] Some features of this scholastic interpretation of the programme are unacceptable. The seated figures in the *School of Athens*, for example, cannot be Evangelists, since one of them, the figure variously described as St. Mark and Heraclitus, was interpolated at a late stage.[29] The truth is probably that we are confronted in the Stanza della Segnatura with an old-fashioned programme drawn up for Sodoma, which was endowed with a new character, partly by virtue of the classical idiom Raphael employed and partly through organic changes in the scheme itself.

One of the first commissions of Julius II as Pope was the choir of Santa Maria del Popolo with its two great tombs by Andrea Sansovino.[30] In both the figures of the

Virtues (Fig. 124) are modelled on classical sculptures. Under their staid surfaces we can detect a new concern with applied archaeology. In the Stanza della Segnatura that is projected into painting. Though the layout of the early design for the *Parnassus* unmistakably recalls the Umbrian frescoes in the Borgia apartments, the Apollo in it (Fig. 83) is based on the antique – it has been convincingly related to the Apollo in a relief from the Villa Borghese in the Louvre – and the Muses grouped round him are studied from the Giustiniani sarcophagus in Vienna and a marriage sarcophagus in Rome.[31] In this early scheme for the *Parnassus* the prose of Andrea Sansovino is transmuted into halting verse. Luckily chance has preserved one of the drawings that was made by Raphael from a known antique for employment in the fresco. The antique is the *Ariadne* in the Vatican (Fig. 127), which was owned in 1508 by Girolamo Maffei, and the drawing Raphael made from it is in Vienna (Fig. 128).[32] It is marvellously little pedagogical; the findings are not so much stated as implied, and the figure is invested with a new continuity of line. When the lower part was incorporated in the fresco in the figure of the Muse Euterpe (Fig. 126), it was changed once more. The model for the Muse seated on the right, Erato, has

128. Raphael: *Drawing after Ariadne*. Vienna, Albertina

126 (left above). Raphael: *Euterpe, from the Parnassus*. Vatican

127 (left below). *Ariadne*. Musei Vaticani

129. Raphael: *Study for the Parnassus.*
Windsor Castle, Royal Library

been identified in the Palazzo dei Conservatori, but in this case no intervening draw⁄
ing is preserved.³³

Between the early design and the drawing out of the cartoon further changes
occurred. The Apollo was replaced by a new figure (Fig. 125) based on a lost antique
and as Dr. Winternitz has shown,³⁴ the musical instruments were all revised. The
old instruments were no more than notionally antique, but the new instruments
were faithfully copied from a Muse sarcophagus in the Mattei collection, now in
the Museo delle Terme. More strictly, all of them were copied save one, the con⁄
temporary *lira da braccio* played by Apollo. It has been suggested that Raphael's
intention in depicting this instrument was to express 'the timelessness of a Parnassus
that has room for Dante and Petrarch as well as for Homer and Virgil'.³⁵ But it
may also have resulted from a simpler calculation, that the music⁄making Apollo
could not fill the room with sound unless spectators were familiar with the timbre
of the instrument he played.

The same attention that had been given to the Muses and to the Apollo was
devoted to the portrait⁄heads. A beautiful drawing at Windsor for the heads of
Homer and Dante and an unidentified poet in the left foreground (Fig. 129) was
made when the lineaments had been decided on and only the expression remained
to be defined.³⁶ In a letter which was reputedly owned by Cassiano del Pozzo,
Raphael is supposed to have consulted Ariosto about the characterisation of the

130. Raphael: *Detail from the Parnassus*. Vatican

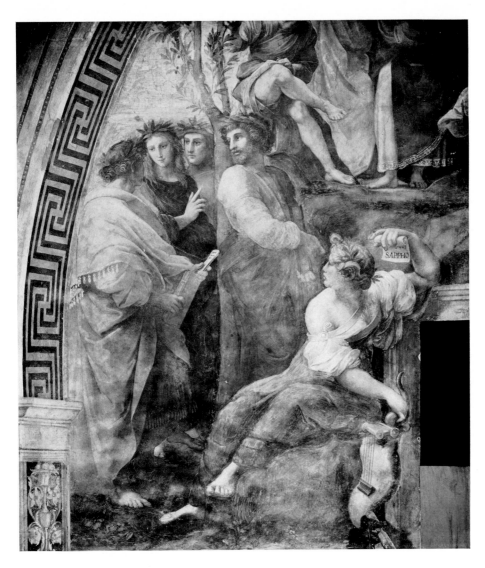

131. Raphael: *Detail from the Parnassus*. Vatican

heads in the *Disputa*, and he may also have done this in the case of the *Parnassus*.[37] The poets are presumably categorised, like the figures in the *School of Athens*, but a good many of them are unidentified, or have been identified so variously that there is no saying exactly who they are. The head seen to the right of Virgil is generally described as Statius or Ovid, but was believed by Bellori to be a self-portrait of Raphael.[38] Vasari supposed that it represented Ennius.[39] The four figures addressed by Sappho (Fig. 131) are generally conceded to be lyric poets, possibly Pindar and Propertius with Horace and Petrarch between them, but in the seventeenth century the two central figures were known as Petrarch and Laura, and the more feminine of them was also explained by Bellori as the Theban poetess Corinna.[40] A group of modern poets, Tebaldeo, Ariosto, Sannazaro, and Petrarch

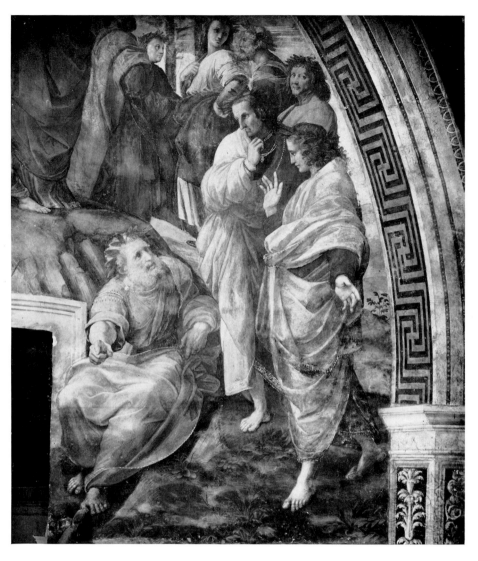

132. Raphael: *Detail from the Parnassus.* Vatican

among them, stand at the back. Apart from the portraits which can be identified with confidence we are free to interpret the groups as we prefer. We may believe with Bellori that the seated man to the right of the window (Fig. 132) is Pindar, pointing to the immortal heroes of the Olympiads,[41] or that the figure on the extreme left holds a petition begging Apollo that his poems become immortal. This wide margin of interpretation is permissible because the *Parnassus* deals in impalpables, conversations we cannot overhear, relations we cannot define, sounds we strain to catch. That was acknowledged by Vasari when he declared, in one of the most poetical passages in the *Lives*, that through the figures there blew a breath of inspiration which seemed supernatural,[42] and by Bellori when he described Apollo passing 'his bow over the sonorous strings and softening the air with his sweet sounds'.

From the *Parnassus* we may turn to the ceiling above (Fig. 133). In books on Raphael it is often assumed that the ceiling precedes the frescoes on the walls,[43] but that view is not easily reconciled with the relevant passage in Vasari, with the preliminary drawings for the ceiling frescoes that survive or with the style of the frescoes themselves. What Vasari says is this: that over Raphael's frescoes there was a ceiling frescoed by Sodoma, which the Pope enjoined should be torn down, but that Raphael decided to preserve its plan ('partimento' is the word used) and its grotesques.[44] The only parts of the surviving ceiling that are by Sodoma are the putti surrounding the arms of Pope Nicholas V in the central octagon, and the paired scenes between the allegorical figures.[45] If we adopt the conventional view that Raphael's ceiling precedes the frescoes on the walls, we are bound to suppose, against contingent probability, that Julius II (at a time when work on the Stanza was being pressed forward with all possible speed) enjoined the destruction of a recently completed ceiling and its replacement by a new ceiling by an unproved artist. Let it not be forgotten that in the *School of Athens*, Raphael introduces his self-portrait alongside that of Sodoma. Why should Sodoma have been included if he were responsible for no more than the inconspicuous frescoes that survive? The solution seems to lie in a literal reading of Vasari, which would lead us to conclude that at the time the *School of Athens* was painted the whole ceiling was by Sodoma, that it proved stylistically incompatible with the wall frescoes, and that the frescoes in the circular frames and the four frescoes adjacent to them were therefore carried out afresh. Technical examination has indeed shown that something of this sort occurred, since the sections of the ceiling for which Raphael was responsible were inserted on new intonaco.[46] It is likely therefore that the four Allegories represent not the concepts in the painter's or the patron's mind at the time the frescoes were commissioned, but a classical summation of the message of the room when three of the four frescoes were complete. It is as though the mind or minds which had guided Raphael through the scholastic maze of the programme of the walls reformulated the whole intellectual basis of the scheme.

The *Poetry* is the allegory on whose growth we are best informed. When we first meet it, in one of Raphael's most magical drawings, at Windsor (Fig. 134),[47] it is a seated figure naked to the waist, holding in the left hand a lyre like that held by Apollo in the early design for the *Parnassus*. The classical model from which it depends has not been identified, but it was used by Raphael twice more, once in a Roman panel painting, the *St. Catherine of Alexandria* in London, and again in a work of 1511, the *Galatea*. When we next come upon the *Poetry*, in an engraving by Marcantonio from a lost drawing by Raphael (Fig. 135),[48] the head is straighter and is surmounted by a wreath, and the great arching wings are flattened so that they no longer rise above the level of the head. In the final version (Fig. 136) this image is

133. Raphael and other artists: *Ceiling of the Stanza della Segnatura*. Vatican

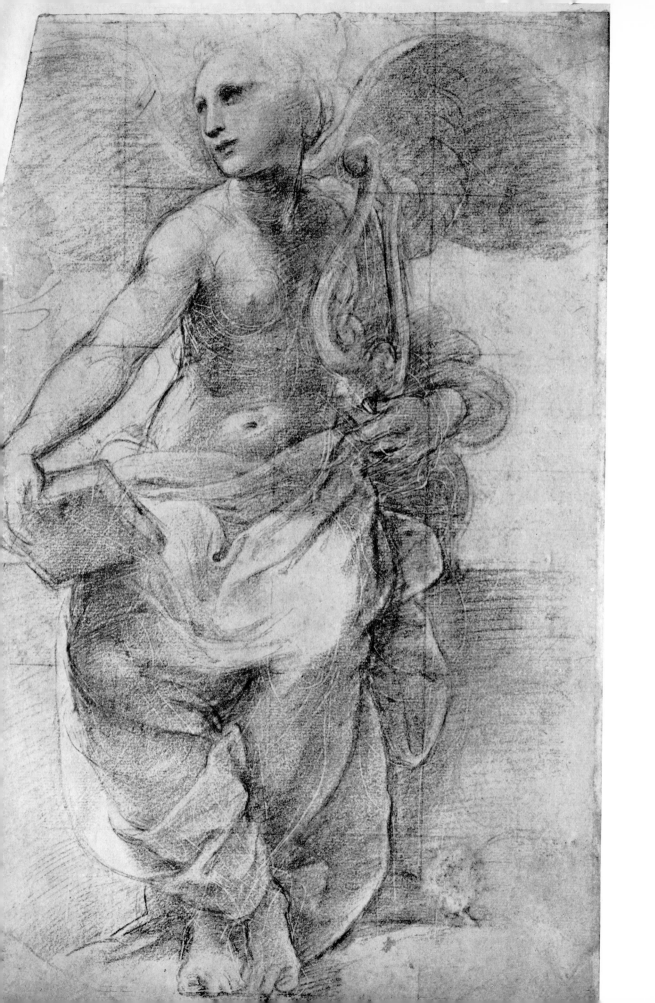

preserved almost intact, but the head is invested with greater delicacy and the effect of verticality inherent in the scheme is corrected by means of horizontal tablets running across the field.

The last fresco in the Stanza della Segnatura, the *Civil Law*, was carried out from Raphael's design by Guillaume de Marcillat, and in the next room, the Stanza of Heliodorus, the first fresco, the ceiling, was treated in the same way. The drawings and cartoons for it are one and all by Raphael, but its execution is inseparable from that of the frescoes which Guillaume de Marcillat painted at Arezzo in 1522.[49] Possibly it was intended that the ceiling should be finished *a secco* by Raphael. To this hiatus, before work started on the wall frescoes of the second Stanza, we owe the *Galatea* in the Villa Farnesina (Fig. 13).[50] Vasari mistakenly says that the fresco shows the Rape of Galatea, and many nineteenth-century writers on Raphael, Grimm and Crowe and Cavalcaselle among them, construed the upturned head as an appeal for help. But though the pose had served, in the drawing for the *Poetry*, as an ideogram of inspiration and, in the *St. Catherine of Alexandria* in London, as an ideogram of faith, in the *Galatea* it connotes neither of those states. The fresco has the same carefree character as the poem by Politian that it illustrates. Not only is the composition, with its paired groups wheeling round the central figure, self-sufficient in design, but at the time it was conceived it was dramatically self-sufficient as well.

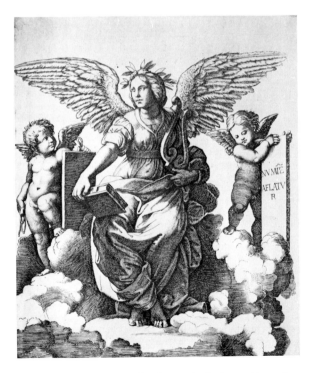

135. Marcantonio Raimondi after Raphael: *Poetry*. Engraving

136. Raphael: *Poetry*. Vatican

151

134. Raphael: *Drawing for the Allegory of Poetry*. Windsor Castle, Royal Library

137. Raphael: *Detail from the Repulse of Attila*. Vatican

The ruined fresco of *Polyphemus* to its left was painted by Sebastiano del Piombo, and it is often claimed that the commission for the *Galatea* was transferred to Raphael from Sebastiano.[51] Vasari asserts the contrary, that Sebastiano's fresco of *Polyphemus gazing at Galatea* was painted after Raphael's fresco was complete.[52] The probability is that from the first the *Galatea* was intended to be seen in isolation, the more so that it fulfils exactly the same function as the isolated frescoes on the walls of Roman villas that Raphael and Agostino Chigi knew so well.

In a sense the frescoes in the Stanza della Segnatura are dramatic fictions. The simulated human contacts depicted in them are an expedient by which the allegory is animated. The frescoes in the Stanza of Heliodorus, on the other hand, portray events. In one room the artist's task was to persuade, in the other it was to convince. The scenes in the Stanza of Heliodorus are, therefore, set in real, not in ideal space, the colour equations are consciously adjusted to what the eye perceives, and the unifying factor is that of light. The light is significant not only in a material sense; it adds a new spiritual dimension to the scenes. In the *Expulsion of Heliodorus* a beam of light descends on the isolated figure of the priest Anias at the back. In the *Arrest of Attila* the two Apostles appear against a strongly illuminated sky (Fig. 137), and in the *Miracle at Bolsena* the flickering candlelight catches on the surplices and hair of the servers at the Mass, and throws into full relief the wonderful expository arm of the witness of the miracle, the man leaning across the balustrade (Fig. 138). Finally in the *Freeing of St. Peter* a canon is established between three separate types of light,

152

138. Raphael: *Detail from the Mass at Bolsena*. Vatican

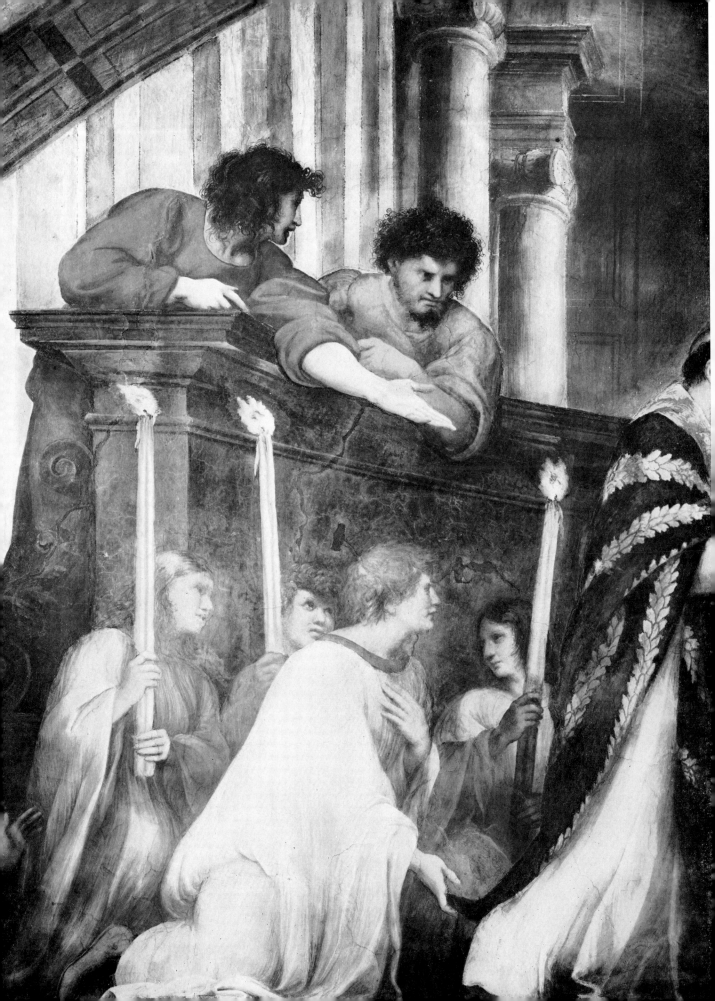

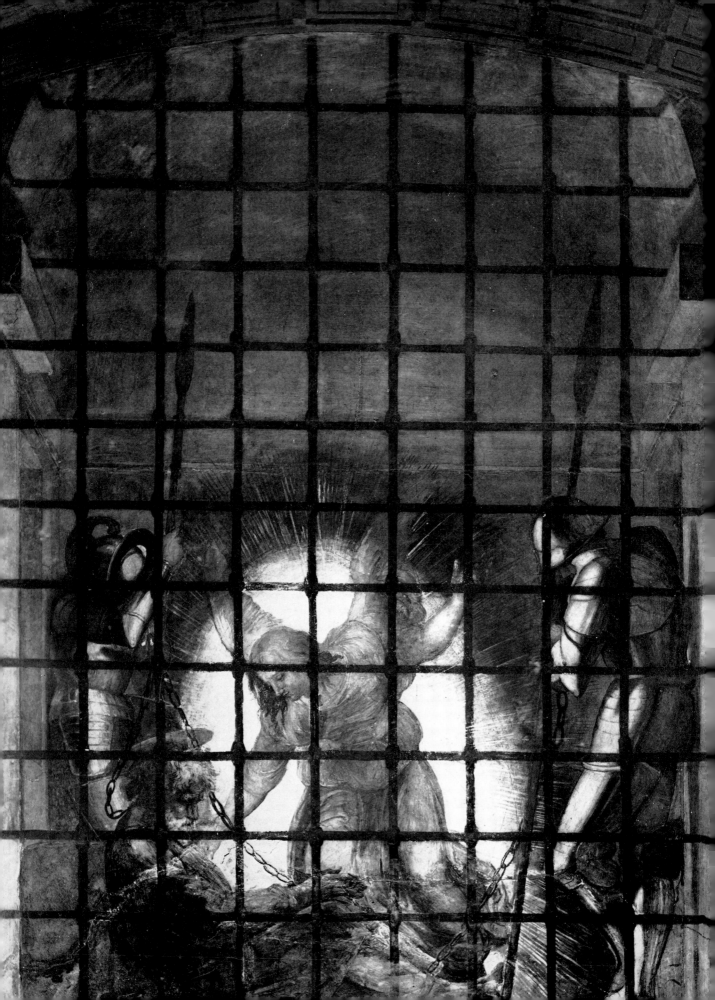

the cold moonlight which floods in on the left, the torch-light reflected on the armour of the startled soldiers, and the celestial radiance of the angel (Fig. 139) which lights up the whole height of the prison like a magnesium flare and reveals the trance-like features of the liberated Saint. When an invention becomes common currency, it is difficult to reconstruct just how it appeared when it was new. But we may doubt if, in 1514, visitors to the Vatican looked at this Stanza in quite the way that scholars do today, for all the academic problems with which we are preoccupied were secondary to the fact that the true miracle occurred not at Bolsena but in this room, in the form of an imaginative break-through, a sudden widening of representational and therefore of symbolic range, which is one of the turning points in the history of painting.

No sooner was the last of the frescoes in the Stanza of Heliodorus finished than Raphael moved on to the fresco of the *Burning of the Borgo* in the Stanza dell'Incendio. Probably there was no interval between them. The new room was started in July 1514 and the last payment for the old room was made a month afterwards.[53] In these circumstances it might be supposed that the style and narrative technique of the Stanza of Heliodorus would be transferred bodily to the new fresco. But that did not occur, and the difference between the *Freeing of St. Peter* and the *Burning of the Borgo* is in fact so great that a whole series of hypotheses has been introduced in order to explain it. It has been suggested that the new fresco was designed by Raphael but in large part painted by his pupil Giulio Romano[54] – Giulio Romano, it is worth remembering, was just fifteen at this time – and still more strangely that the architectural setting was drawn out by Peruzzi and was then filled with figures designed by Raphael.[55] If the differences between the Stanze are read at their face value, we may suspect that the controlling mind, which had already changed between the Stanza della Segnatura and the Stanza of Heliodorus, changed again. Possibly the deviser of the new scene was Castiglione. At all events in an undated letter of 1514 Raphael reports that he has made drawings in several different fashions on an invention Castiglione had supplied.[56] Whereas the use of artificial light in the Heliodorus frescoes was an intuitive response to the dramatic demands of the four scenes, in the *Burning of the Borgo* Loge takes charge. The fire which flickered in the background of the *Arrest of Attila* rages through the foreground of the scene. Without the dramatic unity of the frescoes that precede it – for the first time there is no protagonist – it is so devised that what hitherto was incidental, the response of onlookers to the main event, is thrown forward into the front plane. Of the other factors that are at work the most important is the urge to coin or reconstruct a strictly classical narrative technique. The fresco could well be construed as the classicist's reply to Michelangelo's anti-classical fresco of the *Flood*. What results is a relief-like composition in which the figures or groups of figures were first worked out in isolation and then juxtaposed.

139. Raphael: *Detail from the Freeing of St. Peter*. Vatican

This was a new departure in Raphael's style only so far as fresco was concerned. In 1511, as work in the Stanza della Segnatura was ending and when work in the adjacent room was about to be begun, he applied himself to the design of a *Massacre of the Innocents* for Marcantonio,[57] and here the same process occurred. One of the earliest drawings for the composition is a sheet in the British Museum (Fig. 140),[58] where the figures of the women protecting their children are conceived with frightening intensity. The most remarkable is the figure of a woman fleeing on the right, which was added in chalk after the remainder of the drawing was complete. Such a figure was, however, incompatible with the classical intention of the composition, and when, in a sheet at Windsor (Fig. 141),[59] the London drawing was pricked out and worked up, it was excised, and the emotions of the figures which remained were curbed in the interests of harmony. Though the engraving that resulted was a good deal more expressive than the Windsor drawing, it was still less expressive than it had been in the form it first assumed. Most of the drawings for the *Burning of the Borgo* belong to quite a late stage in its development,[60] but it seems that in this case too the original dramatic impulse must have been diluted as work on the design progressed. When a kneeling woman on the left of the *Heliodorus* fresco gazes imploringly at the High Priest, we believe in the reality of her appeal, but in the *Burning of the Borgo* when the beseeching gesture of the woman in the foreground (Fig. 109) is answered by the distant Pope, the device fails to register as visual fact. It must, however, be admitted that whatever the reserve we feel about the scene today, for centuries the admiration it excited was unqualified. To Burckhardt it appeared

140. Raphael: *Study for the Massacre of the Innocents*. London, British Museum

'the most exalted genre picture that exists: an image of flight, rescue, and helpless lamentation',[61] and for Goethe it was conclusive proof of the fallacious maxim that 'when men fight against the elements, or endeavour to save themselves from the dangers that surround them, there is a favourable subject for the visual arts'.[62]

In his first five years in Rome Raphael worked for a great patron, Pope Julius II, and at the end of his life he worked for another gifted patron, Giulio de' Medici, the future Clement VII. The calibre of Leo X was of a lower kind. He was vacillating and capricious – Michelangelo suffered from this weakness when, on the Pope's insistence, work on the tomb of Julius II was suspended, and the abortive scheme for the façade of San Lorenzo in Florence was begun – and the consequence of his vacillation can be read all through the Stanza dell'Incendio. In Florence the Pope's interest swung away from the San Lorenzo façade towards the Medici tombs, and in Rome it likewise veered from the Stanza dell'Incendio to the Sistine Chapel. Work in the Stanza dell'Incendio started in the summer of 1514, by the summer of the following year the fresco of the *Burning of the Borgo* must have been complete, and thereafter Raphael's personal contribution to the frescoing of the room was minimal.[63] The first payment for the cartoons for the tapestries destined for the Sistine Chapel was made in June 1515.[64] So long as we believe that Raphael's main preoccupation throughout 1515 was with the Stanza dell'Incendio, and that the tapestries were a commission of less consequence, we may well, like so many critics early in this century, presume that the cartoons were in part conceived and almost wholly executed in the studio. But if we accept the contrary hypothesis, that after the

141. Raphael: *Study for the Massacre of the Innocents*. Windsor Castle, Royal Library

142. Raphael: *Detail from the Burning of the Borgo*. Vatican

143. Raphael: *Cartoon for the Miraculous Draught of Fishes.*
London, Victoria and Albert Museum (lent by H.M. the Queen)

completion of the *Burning of the Borgo* the Stanza dell'Incendio was relegated to a secondary place and priority was given to the tapestries (which were designed for a more prominent position and were enormously much more expensive than any fresco), then our attitude to the cartoons must be revised. It is highly unlikely that they were not in great part autograph.[65]

Execution is not a matter that can be fruitfully discussed in general terms, but if we look at one cartoon, the *Miraculous Draught of Fishes* (Fig. 143), we shall discover large areas for which Raphael, and Raphael alone, can have been responsible. One of them is the head of St. Peter, where the movements of the brush recall those in the head of Aristotle in the *School of Athens* – the forms are built up essentially in

159

144. After Raphael: *Tapestry of the Stoning of St. Stephen*

the same way – and another is the magnificent left hand of St. Andrew, which has the same qualities of articulacy and expressiveness as the drawing at Oxford for the hands in the *Transfiguration* altarpiece. Working across the cartoon to the right we come to the figure of the boatman, which again was drawn by Raphael.

The challenge the cartoons presented was one that Raphael had not met before. The Brussels weavers practised low-warp weaving; that is to say, the loom was horizontal, and the weaver worked with the back of the tapestry uppermost and the cartoon facing him beneath the warp. In the tapestry, therefore, the design of the cartoon was inverted or reversed. Raphael was naturally cognisant of all that that implied. On the simplest level that knowledge is reflected in the gestures – in the cartoon of the *Miraculous Draught of Fishes* Christ blesses St. Peter with the left hand, and in the *Healing of the Lame Man in the Temple* it is St. Peter's left hand that is raised – but it also affects the character of the designs. The normal movement of the eye is from left to right, and in Raphael's frescoes account is taken of that fact. In the *Expulsion of Heliodorus*, for example, the eye moves from a relatively tranquil

160

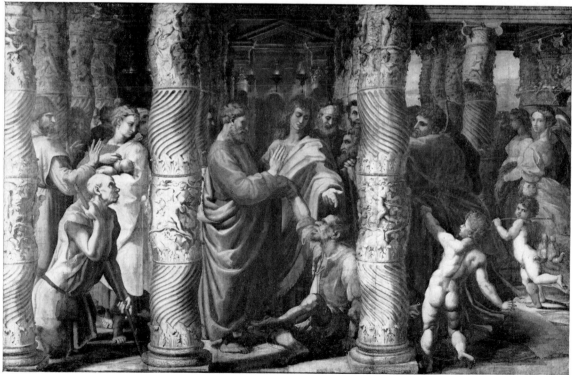

145 (above). Raphael: *Cartoon for the Healing of the Lame Man in the Temple*. London, Victoria and Albert Museum (lent by H.M. the Queen). 146 (below): *145 reversed*

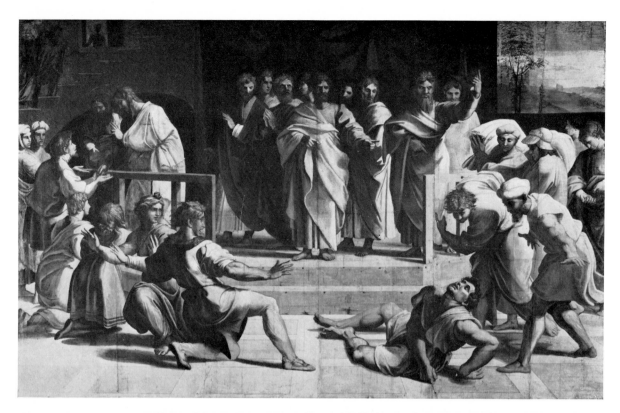

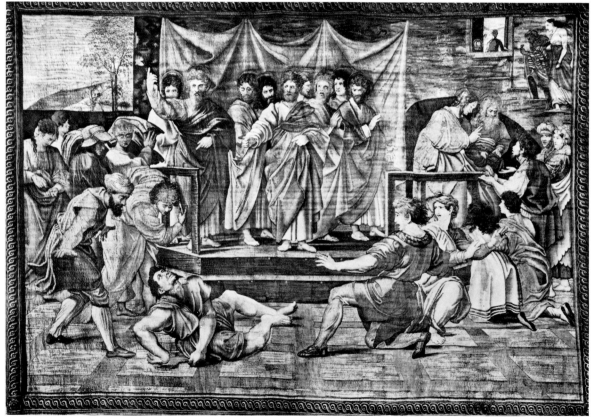

147 (above). Raphael: *Cartoon for the Death of Ananias*. London, Victoria and Albert Museum (lent by H.M. the Queen)

148 (below). After Raphael: *Tapestry of the Death of Ananias*. Pinacoteca Vaticana

area on the left to the focus of action on the right-hand side, and similarly in the *Freeing of St. Peter* the left side is occupied by the inessential scene of the startled soldiers, and the right by the key scene of the liberation. This practice is followed in the tapestries. In the *Stoning of St. Stephen* (Fig. 144), for example, the eye is carried forward from the man on the left picking up a stone to the Saint who is placed centrally, and finally comes to rest on the right on the vision to which the Saint's gaze is turned. In *St. Paul preaching at Athens*, the eye again moves from the figures on the left to the climactic point on the extreme right, the figure of St. Paul standing with arms raised. In reverse in the cartoon the effect is very different; the figure of St. Paul on the left appears less prominent, and the secondary figures on the right fail to supply a climax to the scene. Similarly in the cartoon of the *Healing of the Lame Man in the Temple* (Fig. 145) our eye lights first on the group of figures on the left (the purpose of which in this form is not absolutely clear), then on the lame man with SS. John and Peter standing beside him, and finally on the mutilated man kneeling on the right. The second cripple, not the protagonist, is the figure on whom attention focusses. As soon as the cartoon is reversed (Fig. 146), the emphasis is changed. On the left is the kneeling cripple, gazing at and directing our attention to the cripple in the centre of the scene, in the middle the placing and gestures of the two Saints conspire to lend the subject of the miracle the utmost prominence, and that emphasis is reinforced by the figures shelving away on the right-hand side. It goes without saying that from a figurative standpoint the cartoons were impoverished when they were translated into tapestry. When, for example, the tapestry of the *Death of Ananias* (Fig. 148) is juxtaposed with the superb cartoon (Fig. 147), there can be no question but that the cartoon, figure for figure, is by far the more dynamic of the two. But there can also be question that only in the tapestry can Raphael's compositional intentions be adequately read.[66]

As we might expect, the factor of reversal was in Raphael's mind from the very start. For the most damaged of the cartoons, *Christ's Charge to Peter*, where many of the heads are scarcely legible, there survives a fragmentary life study in the Louvre for the figure of Christ, in the same direction as the cartoon, with the left arm raised.[67] From this sheet Raphael took an offset (Fig. 149), which was corrected and worked up in much the same fashion as the early auxiliary cartoons.[68] The bulk of the preliminary drawings – if one can use that term of the very small number of sheets that have come to light – were made in the sense of the cartoons, not of the tapestries. After the design of *Christ's Charge to Peter* had been modified, with the free arm of Christ pointing towards Peter, the design was copied in Raphael's studio – the relevant drawing is in the Louvre – and to it Raphael added, in pen, the indications of a landscape at the back.[69] Though it is comparatively weak, this sheet gives us a more unambiguous indication of the expressions Raphael devised for the Apostles

than does the cartoon in its present state. The other drawings for the cartoons include a study of miraculous delicacy for the St. Paul rending his robes in the *Sacrifice at Lystra* (Fig. 150),[70] where the pose reads more incisively than it does in the cartoon, and a drawing at Windsor for the *Blinding of Elymas*,[71] also in the direction of the cartoon, which shows that the grouping of the figures at the sides was originally to have been more compact than it is now.

Unluckily the vicissitudes suffered by the tapestries, which are now in the Vatican Gallery, were even greater than those sustained by the cartoons,[72] and till recently it was difficult when looking at their sombre, discoloured surfaces, to realise how vivid they originally were. But two of them have now been lightly washed, and for the first time we can understand how Paris de Grassis, who was present when they were first shown, could write, without hyperbole, that 'the whole chapel was struck dumb by the sight of these hangings. By universal consent there is nothing more beautiful in the world.'[73] Though the ceiling of the Chapel was then brighter and more legible than it is now, it must in 1519 have been temporarily eclipsed by the vision of these scintillating scenes at eye level on the walls.

The commission for the Sistine tapestries was the great confrontation between

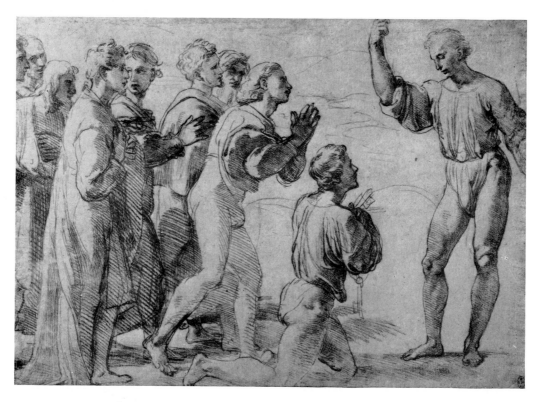

149. Raphael: *Contre-Épreuve of a Study for Christ's Charge to Peter.* Windsor Castle, Royal Library

150. Raphael:
Study for the Sacrifice at Lystra.
Chatsworth

Raphael and Michelangelo, and this affected the whole way in which Raphael approached his task. Scholars assure us that he 'turned for inspiration to the most famous and extensive pictorial rendering of the life of the Apostle (St. Peter) known to him', and that his cartoons 'were deliberately executed in what we might call the spirit of the Early Christian tradition'.[74] Those two sentences perfectly describe the way in which Raphael's imagination did not operate. Inevitably he was aware of the traditional cycles of scenes from the lives of SS. Peter and Paul which existed in old St. Peter's and in San Paolo fuori le mura – they were, indeed, the reason why representations of these scenes were introduced into the Sistine Chapel – but there is not one single particular in the cartoons which can be referred, without strain, to any mediaeval prototype, and their relationship to the Early Christian tradition is essentially a matter of analogy. In Early Christian art a residuum of classical motifs is grafted on to Christian themes, whereas in the cartoons the Christian subject matter is redevised in the light of the antique.

Such a large exegetical literature exists on the cartoons that one feels rather embarrassed in speaking of their subjects. The practice through all the cartoons save one,

151. Raphael:
Cartoon for the Blinding of Elymas.
London, Victoria and Albert Museum
(lent by H.M. the Queen)

Christ's Charge to Peter, is uniform, that the climactic point of action is invariably illustrated. In the *Miraculous Draught of Fishes* the source is the gospel of St. Luke, and the moment illustrated is the point at which St. Peter, cognisant of the miracle, falls on his knees in front of Christ. The scene, none the less, forms part of a continuum of action, and the occupants of the second boat (which is also mentioned in the Gospel narrative) pursue the task of hauling up the catch. The moment o depiction in the *Healing of the Lame Man at the Temple* is the point at which St. Peter fastens his eyes on the lame man before lifting him to his feet. In the *Death of Ananias* St. Peter has already spoken and Ananias falls dying to the ground, while at the side there crouch the young men who are said in the *Acts* to have arisen after Ananias's death. The *Blinding of Elymas* (Fig. 151) shows the sorcerer at the point at which 'there fell on him a mist and a darkness, and he went about seeking some to lead him by the hand'. Where the cartoons depart from the sequence of the *Acts*, the reason is that the artist has recourse to the concept of unity of time. The *Acts* tell us that Sapphira was apprised of the death of Ananias some hours after it had taken place. In the cartoon, however, she becomes a horrified spectator of the miracle. The *Acts* provide a long account of St. Paul's disputation with the Stoics and Epicureans at Athens, adding only in the last verse: 'Howbeit certain men clave unto him and believed: among the which was Dionysius the Areopagite, and a woman named Damaris, and others with them.' In the tapestry, by a device which even now can scarcely fail to move us, Dionysius and Damaris are introduced into the foreground of the scene. The substitution of simultaneity for sequence is most striking in the *Sacrifice at Lystra*, where the act of healing which caused the sacrifice is represented

at one side (in the tapestry, the left) and in the centre the ritual of sacrifice has already been begun. At the back stands a statue of the God Mercury, under whose name St. Paul is hailed, and on the other side is St. Paul about to descend in his rent garments among the populace. Raphael's attitude towards the text is that of a classical dramatist, who successfully compresses the discrete elements of narrative into the compass of a single stage.

The first of the cartoons is the sole exception to that rule. It represents a traditional allegorical subject, the *Presentation of the Keys*, not a scene from the lives of the Apostles; it is devised in a more primitive fashion – there is a conflict between the tightly composed figure group and the vast expanse of landscape in which it is placed – and it would seem to be earlier in date than the companion scenes.[75] Elsewhere Raphael was confronted with the problem of applying to an unfamiliar medium his by then figure-dominated style. The *Miraculous Draught of Fishes* is the first scene in which the attempt is made. The two figures hauling in the net are faithful to the same style principles as the figures on the left of the *Burning of the Borgo*, the device whereby the prow of the boat and the punt pole are severed by the frame recurs in the *Battle of Ostia*, and the figures reflected in the water represent a further application of the illusionism that had gone into the making of the *Freeing of St. Peter* in the Stanza of Heliodorus. The figure of Heliodorus in the *Expulsion of Heliodorus from the Temple* likewise forms a point of departure for the dying Ananias in the tapestry cartoon, and as we might expect the second version of the pose is the more cogitated and expressive of the two.

In the *Burning of the Borgo* use is made of antique models, and in the cartoons they are also introduced. The two cases must, however, be distinguished; the fresco shows a historical event reconstructed in defiance of historical considerations as though it were occurring in antiquity, whereas in the cartoons recourse to the antique is bound up with the idea of historicity. There was an archaeological as well as an aesthetic case for basing the proconsul in the *Blinding of Elymas* on an Aurelian carving on the Arch of Constantine and for adapting the central group of the *Healing of the Lame Man* from one of the companion reliefs.[76] One source, however, transcends all others in importance. In the year in which the first payment for the cartoons was made, the great reliefs of scenes from the life of Marcus Aurelius were moved from Santa Martina, where they had been preserved, to the Palazzo dei Conservatori. Seemingly these reliefs established both the idiom of the tapestry cartoons and the limits within which Raphael's imagination moved. The semi-divine figures of the Apostles take on the primacy of the imperial effigy, and their acts assume the character of a staid Roman ritual.

From this time on Raphael's archaeological interests tended to expand. In August 1515 he added to the office of Chief Architect of St. Peter's the post of Commissary

of Antiquities,[77] with the charge of acquiring for the Fabbrica of St. Peter's the marbles and stones thrown up by excavations and of checking the use of classical remains for road-building material. According to archaeologists who have been through the documents, Raphael did not discharge this part of his task in an effective way. But conservation did not constitute his only term of reference; the commission was bound up with the preparation of a plan or model of ancient Rome with which he was still busy at his death. Michiel, writing in 1520, tells us that Raphael's death 'caused special lamentation among humanists in Rome because he had been unable to prepare the description and picture of ancient Rome on which he was engaged', and Andrea Fulvio, in the introduction to the *Antiquitates Urbis* of 1527, alludes to a conversation he had had with Raphael on some forthcoming excavations only a few days before he died.[78] This range of interests is reflected in the creative commissions that he undertook. It gave rise in 1516 to the bathroom of Cardinal Bibbiena[79] and two or three years later to the loggetta of the Vatican (Fig. 152),[80] both of which reveal an absorbed study of Roman wall painting. The painted decorations of the Domus Aurea had been available for twenty years, but they were not systematically studied before Raphael scrutinised them in the last five years of his career. At every point in the two sets of frescoes we are conscious of an analytical intelligence applied to Roman methods of space projection, to the use of interval in Roman painting, and to technique and iconography. What Raphael conjured from

152. Raphael: *Loggetta*. Vatican

these archaeological remains none the less were works of art, and works of art of entrancing freshness and elegance and verve.

These works lead up to the commission for the Loggia of Psyche in the Villa Farnesina (Fig. 153).[81] The house was planned as a Renaissance recreation of a Roman villa, and its decoration was rigorously classical. In it were frescoes by Sodoma based on Lucian and by Peruzzi and Sebastiano del Piombo based on Ovid, as well as Raphael's *Galatea*. His later and greater work, the decoration of Peruzzi's loggia with scenes from the legend of Cupid and Psyche based on Apuleius, was finished by the end of 1518 and was probably begun in the preceding year. The frescoes were much damaged by the atmosphere, were restored by Maratta, and have since been further tampered with, and it is very hard today to imagine how they looked like before the Loggia was filled in with glass, and when the visitor's gaze could move uninterruptedly from a garden loaded with antique statues to the fictive textiles on the ceiling, the narrative scenes in the pendentives and the flying putti in between. In the pendentives Raphael confined himself to those scenes which took place in heaven or which could be transferred there, with the result that the frescoes as narrative are incomplete. It has been suggested that the missing scenes were either to be shown in tapestries on the walls or to be painted in the lunettes which are now filled by the fictive windows. There is no proof of either hypothesis.[82]

Raphael's pictorial sources have in large part disappeared, but pictorial sources

153. Peruzzi:
Loggia of Psyche. Rome, Villa Farnesina

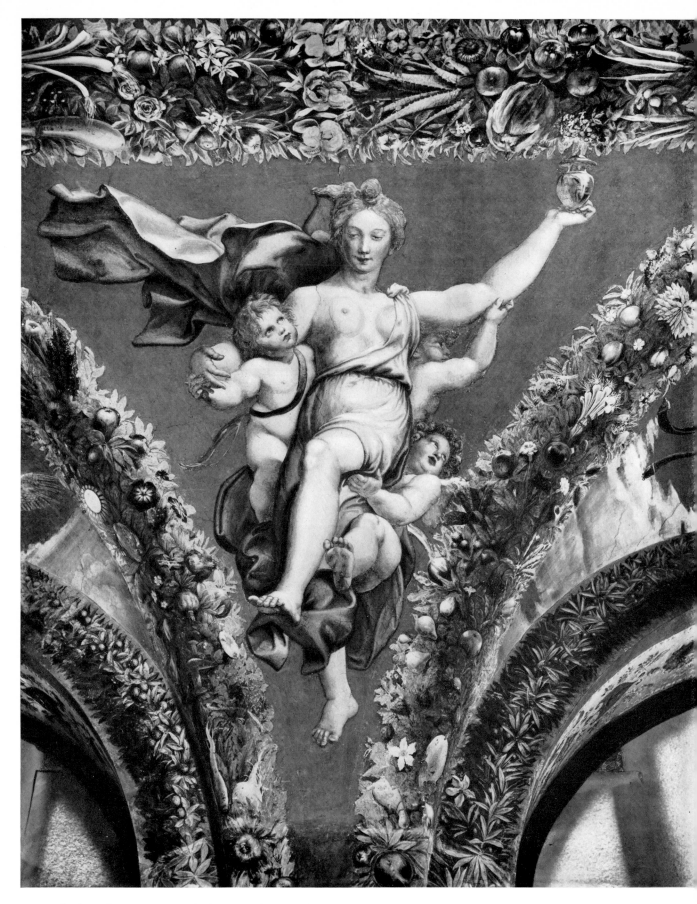

154. Raphael: *Psyche carried to Heaven by the Breezes*. Rome, Villa Farnesina

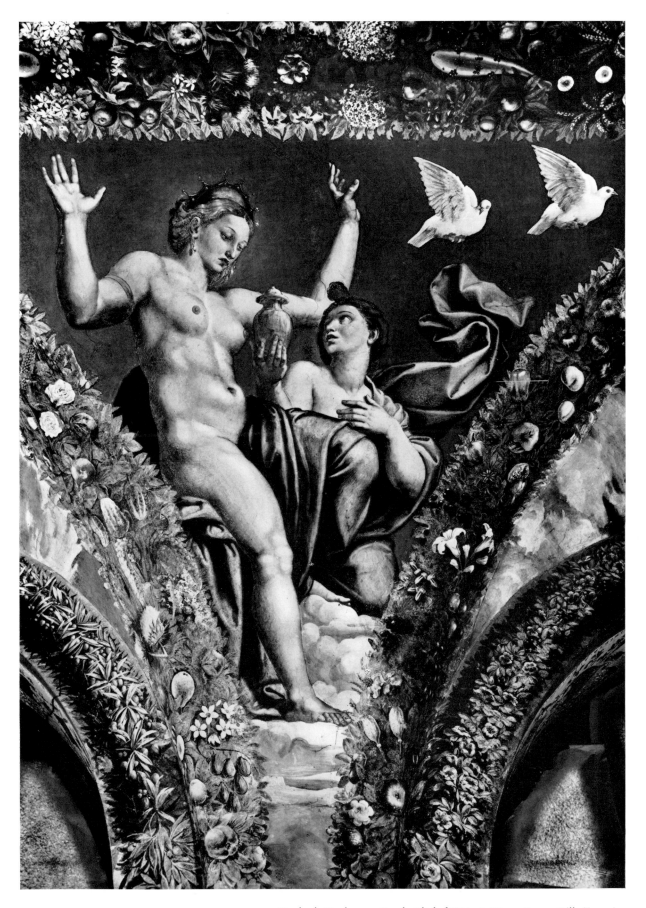

155. Raphael: *Psyche presenting the Phial of Water to Venus.* Rome, Villa Farnesina

there unquestionably must have been. A suggestive connection has been established between a fresco from the House of the Vettii at Pompei and the pendentive showing Mercury conducting Psyche to Heaven; Raphael cannot have known this fresco, but the resemblance is so exact that he and the Roman fresco painter must have depended on a common source.[83] Some of the other pendentives must have had Roman pictorial sources too. Of the sculptural models a small number have been identified. Paolo Giovio, in a letter, implies that the Mercury was based on a statue in the Loggia of Leo X,[84] and if the holding of antiques owned by Agostino Chigi could be satisfactorily reconstructed (part of it is now at Dresden) many of the figures in the ceiling frescoes might prove to be of sculptural origin.

From comparatively early times it was recognised that the frescoes were planned by Raphael, but were painted by members of his studio. Vasari acknowledged that that was so. The belief was current in the seventeenth century that though Raphael intervened here and there in the execution, the only certain pendentive by him was that of the *Three Graces*.[85] When the autograph preparatory drawings are compared with the frescoes, it will be found that the figures in the frescoes are almost always coarser, more mannered and less classical. So it is from the drawings that Raphael's intentions have to be deduced.[86]

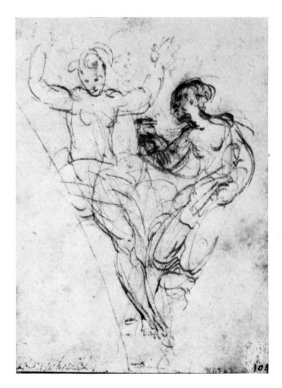

156. Raphael: *Study for Psyche presenting the Phial of Water to Venus*. Oxford, Ashmolean Museum

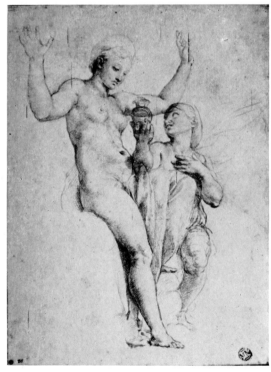

157. Raphael: *Study for Psyche presenting the Phial of Water to Venus*. Paris, Louvre

A wide variety of view has been expressed as to the meaning of the frescoes. It is not open to dispute that in the Renaissance the story of Psyche's vicissitudes and her ascent to heaven could be, and was, interpreted as an analogue of the psyche or soul. A cycle of scenes from the legend of Psyche was, for example, painted by Giorgione in Venice, and Ridolfi, when he describes them, refers to the story an allegory of the human soul filled with divine love.[87] There is, however, no evidence that that interpretation is applicable to the Farnesina ceiling, and we have no reason to suppose that Raphael was preoccupied with anything else than his ostensible task, to recreate a classical legend in terms that were authentically classical.

By what is surely more than a coincidence, the closest precedent for the narrative scenes occurs in an earlier commission for Agostino Chigi, the Sibyls in Santa Maria della Pace, where the pairs of figures are threaded, with great subtlety, round the edge of a semi-circular field. In the Villa Farnesina the decision to relegate the narrative episodes to the pendentives presented the same order of problems; each incident was compressed into an inverted triangle, and was presented without setting by means of the figure or figures alone. The preliminary drawings provide some fascinating sidelights on the working of Raphael's mind. His first thought for the beautiful figure of Psyche carried to heaven by the breezes is recorded at Chatsworth in a *contre-épreuve*.[88] Psyche is seated sideways, both legs in profile, with one arm extended and the other resting on a cloud. When the cartoon came to be drawn out, it was revised in favour of a frontal figure whose legs occupy the lower part of the pendentive and whose left arm and cloak are aligned with the upper edge (Fig. 154). The new scheme has the advantage of greater coherence and of greater clarity, for in her left hand Psyche now holds the phial of water which she has fetched from Proserpine. The next pendentive, where Psyche presents the phial to Venus (Fig. 155), was evolved in rather the same way. At first Psyche was shown in profile and Venus was gazing down (Fig. 156),[89] but in the final resolution the two figures were more closely linked, and their psychological connection was intensified (Fig. 157).[90] Because the scenes were one and all worked out in this inspired but punctilious fashion they rapidly became the most popular reconstructions of classical myth that have ever been produced. They were illustrated in book after book, and engraved again and again, and they form a central part of Raphael's legacy to later artists.

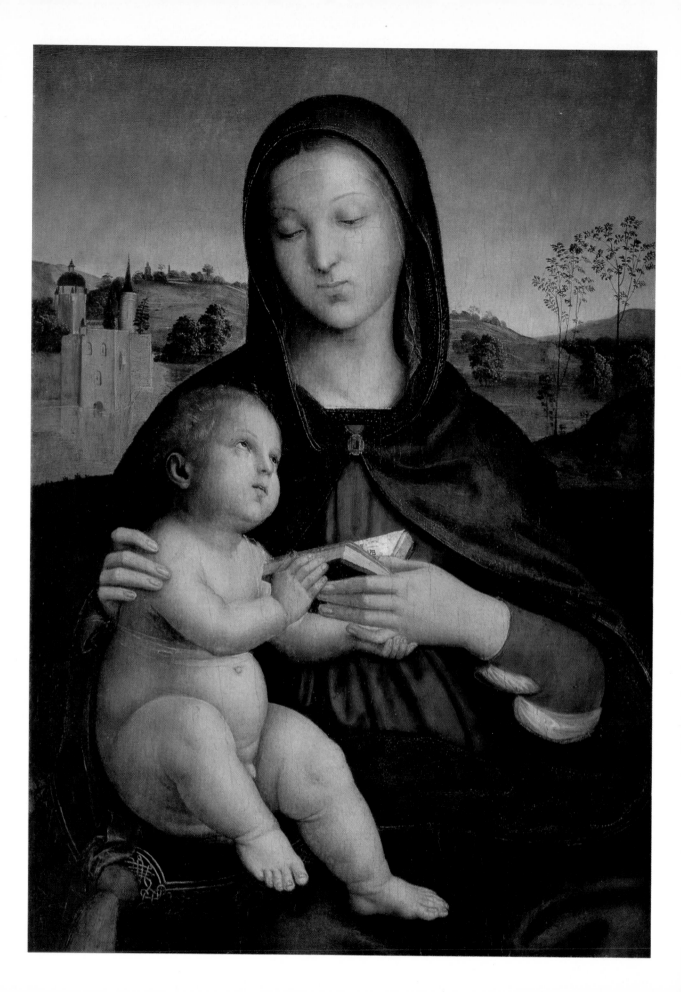

V · RAFAEL OF THE DEAR MADONNAS

THE TITLE of this chapter comes from the poem *One Word More*, in which Browning speaks of the artist's wish to apostrophise his loved one in some other medium than that which he normally employs. Dante, he says, painted a portrait of Beatrice, while Raphael

> made a century of sonnets,
> Made and wrote them in a certain volume
> Dinted with the silver-pointed pencil
> Else he only used to draw Madonnas.[1]

The trouble with what Browning calls 'the dear Madonnas' is that we know them much too well. They look out at us so pertinaciously from porcelain plaques and trinket boxes, from plaster reliefs and from embroideries, that an act of conscious disassociation is required before we can separate the debased copy from the pristine work of art. Most people today are instinctively resistant to pictures which appeal for sympathy. If the aesthetic meaning of these paintings is to be understood, writes Roger Fry, it is necessary to 'disregard the distracting impertinences of Raphael's psychology'.[2] But the objection to doing that is that for Raphael form and content were indivisible. The precondition of the formal experiments that can be traced through the Madonnas was a lifelong concern with the thematic aspect of the scene which was portrayed.

Raphael's Madonnas appear so meditated that we tend to look on each of them as the outcome of an act of cerebration which could lead only to this particular result. To judge from the preliminary drawings that was not the way in which they were produced. As the artist sat down at his drawing board, image after image sped through his mind, and in the space of perhaps half an hour he would note down the substance of four separate groups. If we look at a sheet of drawings by Leonardo for a Virgin and Child, we find that it consists of a number of alternative solutions of a single pictorial motif. By no stretch of the imagination can we suppose that a real mother and real child sat in front of Leonardo when the studies were made. With a comparable sheet by Raphael (Fig. 163) we feel less confident. If his sketches were

158. Raphael: *Madonna and Child*. New York, Private Collection

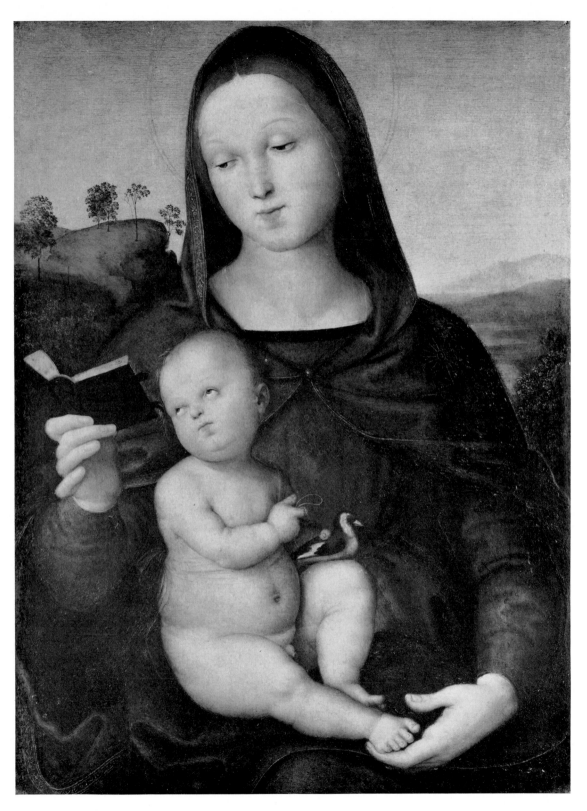

159. Raphael: *The Solly Madonna*. Berlin/Dahlem, Staatliche Museen

not made from life, they are memory images of astonishing vivacity, and their variety is bound up with their lifelikeness.

In Raphael the impulse towards lifelikeness operated almost from the start. One of the most popular cartoons used in the Perugino studio in the fourteen-nineties showed a seated Child with body facing to the right and head turned back.[3] In the form in which it first appeared, in 1493, the Child's attention was attracted by a standing figure at the side, but thereafter the standing figure was eliminated though the Child's peculiar posture was retained. It is employed by Raphael in one of his first paintings of the Virgin and Child, the *Solly Madonna* in Berlin (Fig. 159),[4] but is reinterpreted in human terms; the Child gazes at a book held in the Virgin's hand. From a pictorial standpoint, this Madonna is less guileless than it appears. The book is thrust forward, so that the space within the painting is defined, and by the simple expedient of placing the Child's foot in the left hand of the Virgin an element of pattern is imposed upon the lower part.

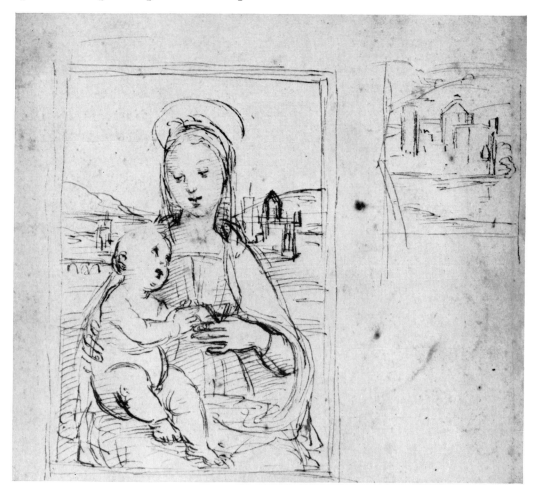

160. Raphael: *Study for a Virgin and Child*. Oxford, Ashmolean Museum

We can reconstruct the process by which Raphael arrived at this result, not in the case of this specific painting, but with another of rather later date. He started with a rapid pen drawing that determined the pose and the motif and estab-lished the relation of the figures to the frame (Fig. 160).[5] In the artist's mind special importance seems to have attached to this last point; there are later drawings of the same kind. In descriptions of them the frame is sometimes referred to as a window, but it is in fact a frame and nothing more. Then, also in pen, he went over those queries that seemed to him to demand further thought, what should be the exact angle of the Child's head, and should the left arm be disengaged or partly concealed behind the right. The next problem was the landscape; the figures divided it in two, but the two sides must cohere, and to make certain that they did so Raphael drew it as a whole, in a little sketch elsewhere on the sheet. By this time the castle, which was the main feature of the landscape, had been moved from right to left. In another sketch immediately beneath its form was clarified. When all this was done, he embarked upon life studies. Just as assistants in the workshop posed for the angels in the *Coronation of the Virgin*, so here an apprentice took up the Madonna's pose (Fig. 161).[6] One detail that needed to be reconsidered was the hand holding the book. There remained the head, and that too was slowly studied, till the fugitive contour of the neck, the form of the eyelids and foreshortened ear were satisfactorily registered, and could then be dressed up in a veil and wig (Fig. 162).[7] In the painting that sprang from this sequence of drawings (Fig. 158) the figure of the Virgin is

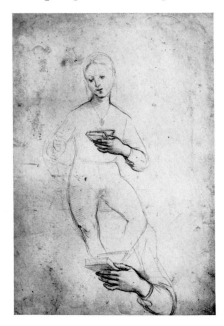

161. Raphael: *Study for a Virgin and Child.*
Lille, Musée Wicar

162. Raphael: *Study for a Virgin and Child.*
London, British Museum

163. Raphael: *Studies of the Virgin and Child*. London, British Museum

164. Raphael: *The Terranuova Madonna*. Berlin/Dahlem, Staatliche Museen

slightly lengthened, and is widened so that it impinges on the frame. The Child is set on a brocaded cushion, not on the Virgin's knee, and the position of both the Virgin's hands is changed; her right hand rests on the Child's shoulder, not his waist, the book held in her left hand is raised, and her left forearm recedes less abruptly into space. The landscape follows the drawing closely, but the profile of the castle is modified and the height of the two towers has been increased, while features which are barely adumbrated in the sketch, like the reflection of the castle in the transparent water and the light-irradiated trees beside the lake, are worked out with Eyckian sensibility. Nothing but sheer pictorial genius can account for the delicacy

of the resultant painting, but without the preternatural visual concentration to which the drawings testify it could never have assumed a form so faultless and definitive.

Designs like this and like the *Solly Madonna* in Berlin could be expanded by adding figures at the sides. Raphael's first experiment in this direction occurs in another painting in Berlin,[8] which is less than perfectly successful because one of the Saints, St. Francis, is based on an artificial formula of Pinturicchio's. Not long afterwards, seemingly in 1504, he returned to the problem in a drawing at Lille,[9] where the figures are lengthened and the Saints contribute to the action of the scene; St. Michael encourages the Baptist as he plays with a scroll held out by the Child. Very little is known about the subsequent vicissitudes of this design – nothing, that is, save for a copy of a Raphael drawing[10] – but in a slightly different form it was incorporated in the *Terranuova Madonna* in Berlin (Fig. 164).[11] The painting is circular and is bisected by a wall, and the types in it are indissociable from those in the *Madonna of the Nuns of Sant'Antonio* in New York. The dates given to these early Madonnas are approximate, and it has been argued with some plausibility that the *Terranuova Madonna* was painted after Raphael went to Florence.

For all we know, the Saints in the Lille drawing were included in the cartoon, for Raphael's practice was to revise his paintings after the cartoon stage. The clearest proof of that occurs in a work which was probably painted in the same year as the *Terranuova Madonna*, the *Conestabile Madonna* in the Hermitage (Fig. 165).[12] It is

165. Raphael: *The Conestabile Madonna*. Leningrad, Hermitage

166. *Record of the Underdrawing of the Conestabile Madonna*

167. Raphael: *Study for a Virgin and Child*. London, British Museum

the size of a small saucer, and at the end of the last century it was transferred from panel to canvas. During the transfer the underdrawing was revealed. A record made of it at the time (Fig. 166) proves that the Virgin was originally conceived as holding an apple or pomegranate. The underdrawing corresponds with an Umbrian drawing in Berlin and is also related to a chalk drawing by Raphael at Vienna for a rectangular Madonna, probably on a larger scale, where the foreshortening of the Child is less abrupt and the book is set endwise on the Virgin's knee, adumbrating the book held on the knee of the *Ansidei Madonna* of 1505 in London.[13] Only when

the picture came to be painted was there substituted a rather different scheme; the Virgin's silhouette was tactfully adapted to the containing frame, and the Child was represented in foreshortening with the right foot thrust forward into a front plane. Despite its tiny scale, the *Conestabile Madonna* is much more tactile and expressive than any of the paintings that precede it, and it is the gateway to that marvellous period of four years in which many of Raphael's best-known Madonnas were produced.

From this point on Raphael's attitude to the half-length Virgin and Child undergoes a change. The pictures increase in size, and the ratio of the figures to the picture space increases too. Perhaps the clearest indication of the new direction of Raphael's thought occurs about 1509 in a drawing in the British Museum (Fig. 167) made either for an unknown painting or with no painting at all in mind.[14] In it the group is reduced to its prime constituents of two solid forms, the heads of the Virgin and

168. After Donatello: *The Verona Madonna.*
London, Victoria and Albert Museum

169. Raphael: *The Tempi Madonna.*
Munich, Alte Pinakothek

183

the Child. Probably Raphael was encouraged to rationalise his problem in this way by the tradition of Florentine sculpture. At Urbino in his boyhood, as Longhi has observed, he must have looked day after day at the lunette modelled by Luca della Robbia for the church of San Domenico, and in Florence his knowledge of Luca della Robbia's work must have been much enlarged. In some reliefs by Luca the two heads were erect and juxtaposed; in others one head was erect and the second was set on a diagonal; others again were conceived in terms of genre and predicated a domestic interpretation of the theme. What Raphael learned from them is summed up in a series of Madonnas where the paint surface is treated as relief.

Since this connection is conjectural, it may be well to take one demonstrable instance of Raphael's indebtedness to quattrocento sculpture. Few fifteenth-century Madonna compositions were more popular than the *Verona Madonna* of Donatello (Fig. 168). Though the original is lost, stucco copies of it are frequently encountered, and by one of them Raphael was inspired to design the beautiful *Tempi Madonna* in Munich (Fig. 169).[15] In the *Tempi Madonna* the Child is carried on the Virgin's left hand and supported with her right, the opposite relationship to that in the relief, but the connection is not to be denied. Moreover, it seems that Raphael was attracted by the ambivalent sentiment of Donatello's relief as well as by its form.

Between 1504 and 1508, the Madonna and Child became the vessel into which most of Raphael's creative thought was poured. When he looked at works by Leonardo and Michelangelo and Fra Bartolommeo, what he deduced from them was applied in the first instance to this theme. There may even at this time have been a change in the way in which the paintings were produced. It seems that after 1500 Perugino sometimes made use of plastic models; at all events Vasari tells us that he commissioned a wax model of the *Deposition* from Jacopo Sansovino, and that is corroborated by the fact that a Sansovino model of this subject utilised in Perugino's paintings actually survives.[16] Probably Raphael made use of plastic models too. His earliest dated Florentine work is the *Ansidei Madonna* of 1505 in London – it was painted for Perugia, but is replete with Florentine experience – and the drawing which is typologically closest to it is a sheet in the Uffizi (Fig. 170) showing the Virgin in three-quarter length against a landscape, within a circular frame that recalls the *Conestabile Madonna*.[17] In this sketch as in the painting in the Hermitage the Virgin's left shoulder is pulled back, and since the Child is held on the retracted arm we look along his foreshortened thigh straight into his face. But was the composition truly circular? The drawing suggests that Raphael doubted this, since it shows traces of a second frame, this time rectangular. When the picture came to be painted the format adopted was a rectangle. In the painted version (Fig. 171) the group was turned clockwise, so that the Virgin's shoulders and the Child's thigh were parallel with the picture plane. The verticals of the standing Virgin and of the

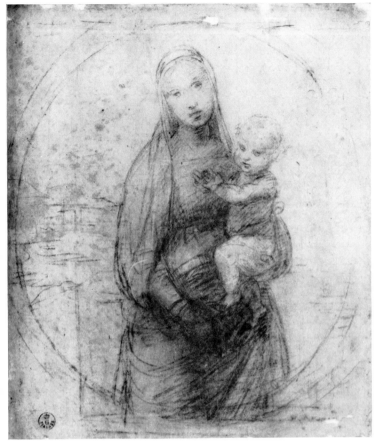

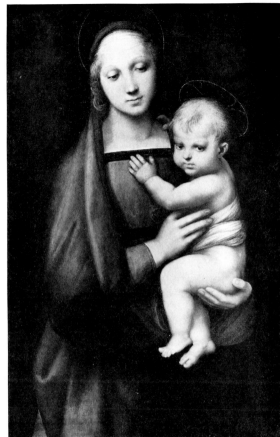

170. Raphael: *Study for the Madonna del Granduca.*
Florence, Uffizi

171. Raphael: *Madonna del Granduca.*
Florence, Palazzo Pitti

back and foreleg of the Child are offset by the horizontal accents of the Virgin's collar and of the Child's thigh and upper arm. The creative process revealed in the drawing and painting is susceptible only of two explanations. Either the Virgin and Child existed as a model which was actually rotated, or, less probably, they were conceived by Raphael as notional cubic units which could be revolved.

Today the *Madonna del Granduca*[18] looks a great deal solider and more mature than it can possibly have done at the date at which it was produced. It is difficult to speak of its condition with any confidence, but the dark ground that surrounds the figures seems not to be original, and there is some overpainting on the right-side of the Child's head and in the Virgin's dress and cloak. A poor sixteenth-century copy shows the Virgin standing against a parapet like that in *Terranuova Madonna* with a landscape at the back.[19] The proportions in this version are rather different; it is a little higher and considerably wider than the *Madonna del Granduca.* The status of the copy is too uncertain to enable us to use it as a means of reconstructing the original *Madonna* before time and taste reduced it to the state in which we see it now, but in

185

one respect it is convincingly Raphaelesque, that the landscape at the sides conforms closely to authentic landscapes that appear in Raphael's paintings at this time.

Raphael worked mainly in Florence for four years, and by good fortune we have a dated painting of the Virgin and Child for every year that we presume he lived there. There is one of 1505, the *Ansidei Madonna* in London, one of 1506, the *Madonna of the Meadow* in Vienna, one of 1507, the *Belle Jardinière* in the Louvre, and one of 1508, the *Large Cowper Madonna* in Washington. For this reason it is tempting to arrange the undated *Madonnas* in a cut-and-dried sequence and to ascribe them to specific years. To do that, however, implies a deep misunderstanding of the way in which the paintings were produced. Raphael was an involute artist, and his drawings lend absolutely no support to the theory that he concentrated his attention on one composition, elaborated it and then passed on to the next. On the contrary quite a number of paintings which we might, were there no other evidence, assign to different terms of years, prove to have been planned concurrently. The sheet of Madonna studies in London[20] contains sketches for four different paintings. In one of them, the top drawing on the left, the Child is shown at the Virgin's side, with one foot on her lap, and the Virgin's head is represented in two alternative positions, inclined towards and turned away from the Child. In no surviving painting is this scheme employed, but in the *Small Cowper Madonna* in Washington (Fig. 172) it is reversed, with the Child on the right not on the left.[21] No one can tell for certain whether the *Madonna* grew out of this drawing, or the drawing out of the *Madonna*. The tactility of the Child's body is stronger in the drawing than in the painting, but the awkward articulation of the painting – the Child's head hangs forward like a flower which is too heavy for its stem – seems to be due to its condition not to its earlier date.

With the drawing on the right of the sheet, which shows the Child turned on his back, we are on firmer ground. It was developed in red chalk and pen in a drawing in the Albertina in Vienna; in the pen sketch the Virgin holds a book in her left hand.[22] From these sheets there emerged the *Colonna Madonna* in Berlin (Fig. 173).[23] Better preserved than the *Small Cowper Madonna*, it is a less tranquil work. Where the figures in the latter coalesce in a single unit of form, in the former they are opposed. The two bodies are physically detached, and the book in the Virgin's hand is held out of the Child's obstreperous reach. Despite the freshness of the execution, the forms in this painting, especially the left hand of the Virgin and the right foot of the Child, are weaker than those in fully autograph paintings of the time. Vasari tells us that at the end of his years in Florence Raphael was associated with Ridolfo Ghirlandaio, who completed a painting commissioned for a Sienese collection and was then invited by Raphael to join him in the Vatican. So far as can be ascertained the *Colonna Madonna* was never in Siena and cannot therefore be the picture men-

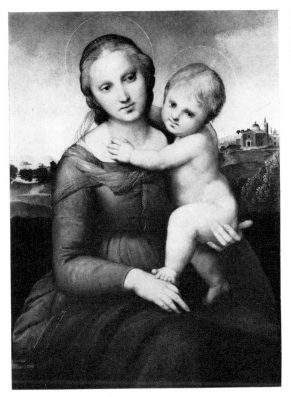

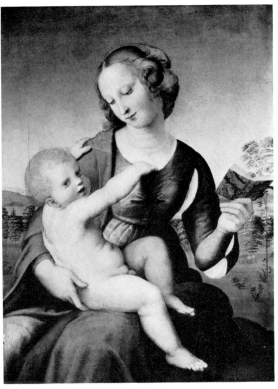

172. Raphael: *The Small Cowper Madonna.*
Washington, National Gallery of Art

173. Attributed to Raphael: *The Colonna Madonna.*
Berlin/Dahlem, Staatliche Museen

tioned by Vasari, but it seems also to have been collaborative. In the page of sketches in London there is a manifest relationship between the study for the *Colonna Madonna* and the larger drawing at the bottom of the sheet. In both the direction of the Virgin's posture is the same, head turned to her right and knees extended to her left. This little sketch is a document of cardinal importance for Raphael's Florentine years.

In Florence Raphael moved in the same small circle of patrons and collectors as was frequented by Michelangelo. He painted the portraits of Angelo and Maddalena Doni, who owned the Doni tondo by Michelangelo now in the Uffizi, and he was patronised by Taddeo Taddei. His debt to Taddei was acknowledged in generous terms in a letter written after he had gone to Rome.[24] Taddei was a humanist and a friend of Bembo, and in his palace there hung the marble relief by Michelangelo which is now in the Royal Academy in London. Probably it was carved in 1504, so Raphael may have been acquainted with it from the time he first reached Florence. The pen drawing he made from it, which is in the Louvre,[25] is a casual, rather careless sketch on the back of an elaborate figure composition, but it is sufficient to establish that the focus of his interest was not the compressed pose of the Virgin but the diagonal posture of the Child, which had been adapted by Michelangelo from a sarcophagus relief. Armed with this motif, Raphael started to experiment with an

187

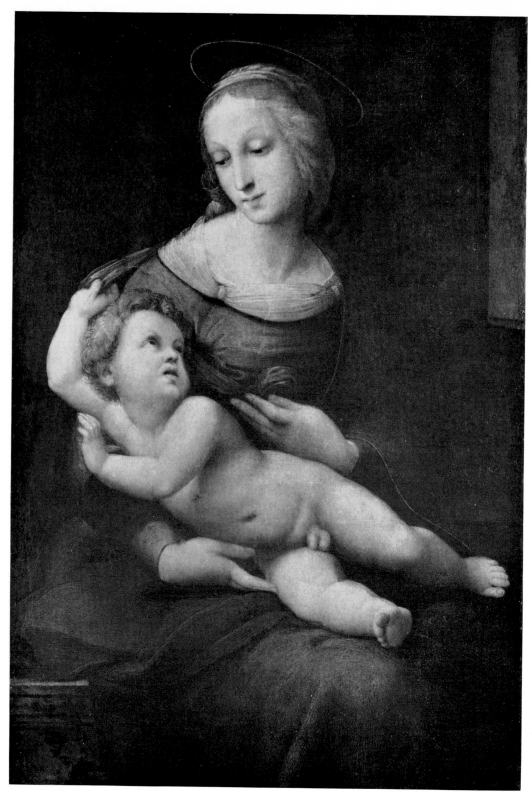

174. Raphael: *The Bridgewater Madonna*. Edinburgh, National Gallery of Scotland
(lent by the Duke of Sutherland)

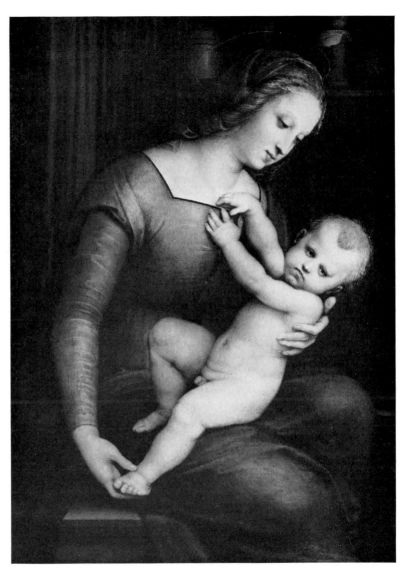

175. Raphael:
The Orléans Madonna.
Chantilly, Musée Condé

inverted composition in which the Child's legs were spreadeagled over the Virgin's knee, but the two figures combined in a common spiral movement, with the Child's head turned up towards the Virgin and the Virgin looking downwards at the Child. From the London sketch he made another less rapid drawing,[26] from which a painting, the *Bridgewater Madonna* (Fig. 174), was in due course produced.[27] In the painting the diagonal posture of the Child appears a little forced – one reason for that is that the young Baptist, by whom the Child's pose was explained in Michelangelo's relief, has been omitted, and another is that the motif of the legs straddling the Virgin's knee is discarded in favour of a pose in which the Child seems to swim across her lap. The intention behind this change transpires from an X-ray photograph, which proves that the influence of Leonardo on Raphael at this time was stronger than that of Michelangelo. The painting that resulted must have been a

masterpiece before it was transferred to canvas and reduced to the state in which we see it now, with a window added on the right, an original arcade in the background painted out, a gash through the Virgin's face, and ubiquitous retouching in the dress.

On a third occasion Raphael applied himself once more to a Madonna composition with an active Child set diagonally across it. The painting – no drawings for it survive – is the *Orléans Madonna* at Chantilly (Fig. 175),[28] where the Child is depicted on its back, like the Child in the *Colonna Madonna*, but has the same athletic vigour as the Child in the Edinburgh painting. Supported on one hand with the left leg stretched out to its full length, the Child seems to be strung across a bow formed by the Virgin's neck and shoulder and right arm. In books on Raphael it is disconcerting to find this tiny painting with its domestic detail inserted between the majestic *Granduca* and *Bridgewater Madonnas*. Passavant, writing in the eighteen-thirties, declared that the background of the *Orléans Madonna* had been repainted in the style of Teniers, but in actual fact it is the neutral backgrounds of the *Bridgewater Madonna* that is repainted, and this which is intact. The expressive repertory of all these paintings is extremely subtle, and the effect of the restorer's handiwork is to put them emotionally as well as compositionally out of key.

Not only are there no drawings for the *Orléans Madonna*, but there are none for what is on every count the finest of these half-length paintings, the *Large Cowper Madonna* in Washington (Fig. 176).[29] Admittedly in two small sketches some of the elements of the composition can be seen in the state in which they first occurred to Raphael's mind. In a sketch at the top of the London sheet the posture of the Virgin's head is predicated, though the Child is altogether different, and in a little drawing in the Uffizi the posture of the Child shows some correspondence with the *Large Cowper Madonna*, though the posture of the Virgin does not.[30] The *Madonna* is one of the best preserved of Raphael's paintings, but its excellence is not due simply to the fact that its condition is unimpaired. It is the first half-length Madonna in which, as a creative artist, he breaks free. The design is closely cogitated, yet abso-lutely unselfconscious, and the two heads have a depth and poignancy that is not present in any earlier painting. For the first time we feel, as we do with Raphael's later paintings, that the figures are too massive and voluminous to be comfortably enclosed within the picture space. The bold treatment of the Virgin's sleeve comes close to the free handling of the robes of the Apostles in the upper register of the *Disputa* in the Stanza della Segnatura, and if there were a properly authenticated drawing for the Child, we should expect it to look like the drawings for the fresco, not like the drawings for the earlier *Madonnas*. Perhaps the *Large Cowper Madonna* was painted at the end of 1508 in Rome, and was sent thence to Florence. Certainly it was produced in close association with the *Tempi Madonna* in Munich, and on a copy of the *Tempi Madonna* there is the suggestive date of 1510.[31]

176. Raphael: *The Large Cowper Madonna*. Washington, National Gallery of Art (Mellon Collection)

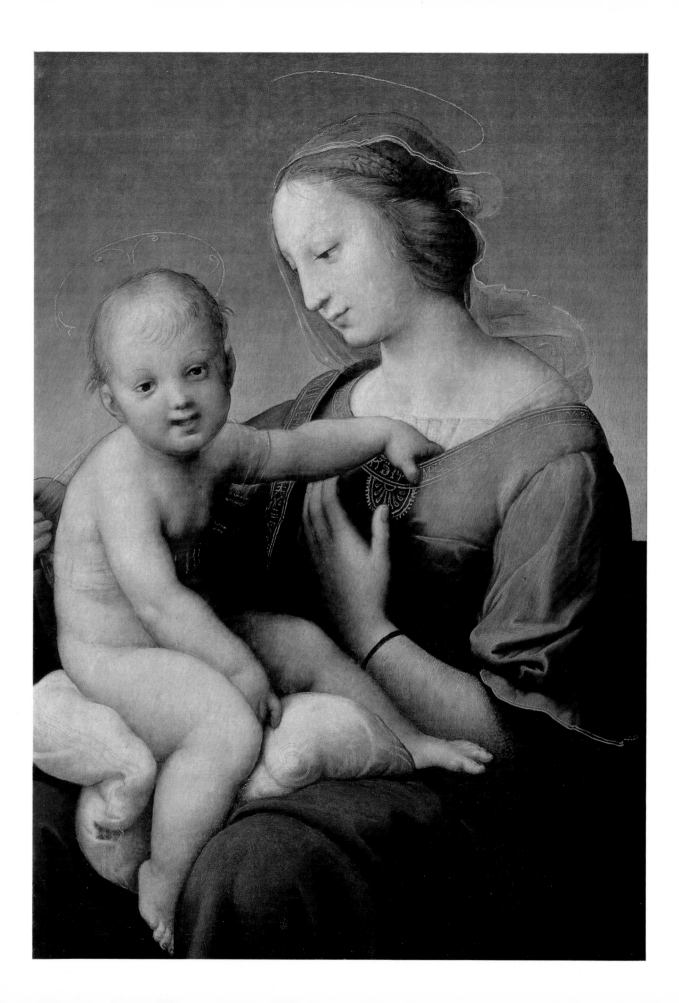

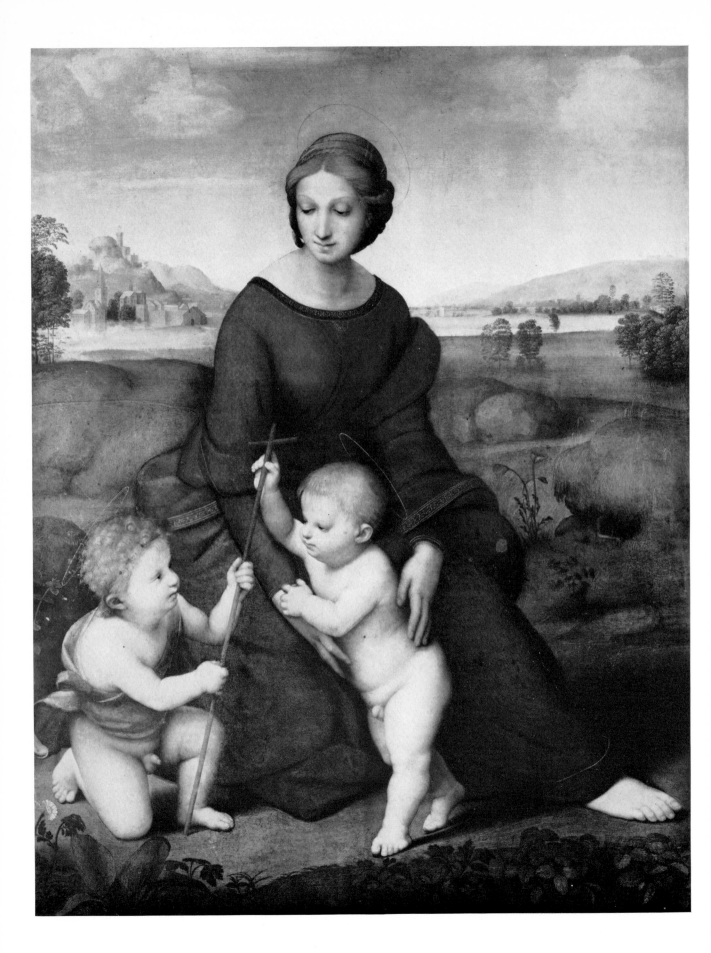

The graph that can be plotted from these half-length Madonnas reveals an artist of great sensibility, who freed himself slowly from the trammels of tradition, and realised his true potentialities only in 1507 or 1508 when he was twenty-four or twenty-five years old. This inference is confirmed by the Madonnas in full-length, on which he was engaged in the same term of years. The first of them, the *Madonna of the Meadow* in Vienna (Fig. 177), is dated 1506, and was painted for Taddeo Taddei.[32] The type of painting to which it belongs – the seated Virgin is shown in a landscape with the Child Christ and the Young St. John – was peculiar to Florence. Its inventor was Leonardo, and by 1504, when Raphael arrived in Florence, simplicist deriva-tions from Leonardo's archetype, the *Madonna of the Rocks*, were being turned out in some quantities. In the *Madonna of the Meadow* the Virgin's head is set a little to the left of the centre of the panel, and forms the apex of a triangle of which the lower angles are established by the young St. John – a conscious reminiscence of the Baptist in the *Madonna of the Rocks* – and by the Virgin's bared right foot. By a device which is acceptable only as geometry the foot is extended almost to the frame. This rather unattractive feature had some contemporary appeal, and was imitated by Franciabigio.[33]

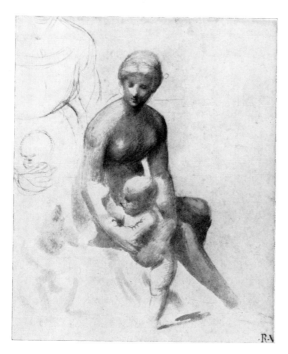

178. Raphael: *Study for the Madonna of the Meadow.*
Oxford, Ashmolean Museum

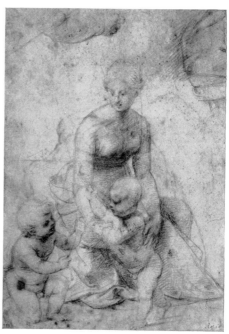

179. Raphael: *Study for the Madonna of the Meadow.*
New York, Metropolitan Museum of Art

177. Raphael: *The Madonna of the Meadow.* Vienna, Kunsthistorisches Museum

A wash drawing at Oxford (Fig. 178),[34] where the Virgin is represented nude and the arms are reduced to long, simplified brush strokes, is a frank avowal of the geometrical basis on which the composition is built up. But before long, in a superb red chalk drawing in the Metropolitan Museum in New York (Fig. 179),[35] flesh was put on to this skeleton, and the figures were clothed, though in such a way that the clarity of the design was not impaired. In this respect the drawing is a good deal superior to the finished work, where the effect is just a little tentative and the design has become blurred. Raphael himself, after the cartoon had been drawn out, seems to have had second thoughts about the placing of the Virgin's hand. Some studies in the Albertina of the Child reaching up to right arm of the Virgin,[36] are probably to be interpreted as a subsequent critique by Raphael of the scheme he had evolved.

The main ground on which the painting lay open to criticism was the stiff pyramid of the Virgin's pose, and to judge from a drawing at Oxford (Fig. 180)[37] that was recognised by Raphael. At all events the Virgin is now shown bending forward, and her psychological connection with the Child is established through an open book which forms a kind of fence between the young Baptist and the Child. The Baptist is cast in the pose of the Baptist in Michelangelo's Taddei tondo. As in the *Madonna del Granduca*, a plastic model may have been employed, for when the group was incorporated in a painting, the *Madonna of the Goldfinch* in the Uffizi (Fig. 181),[38] it

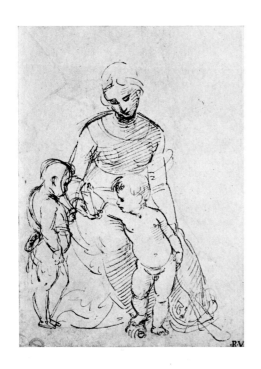

180. Raphael: *Study for the Madonna del Cardellino*
Oxford, Ashmolean Museum

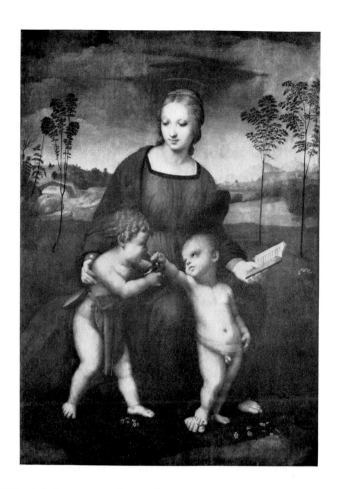

181. Raphael:
Madonna del Cardellino.
Florence, Uffizi

was slightly turned, so that the Virgin's knee was thrust forward and the Child was seen not in profile but in three-quarter face. At the same time the book was transferred from the Virgin's right hand to her left, the Baptist was equipped with the goldfinch that he holds in the Taddei tondo, though paradoxically his pose was at the same time made less Michelangelesque, and the eyes of the Virgin were focussed on the captive bird.

Though it is one of the most popular of Raphael's works, the *Madonna of the Goldfinch* is also one of the most mutilated. It was damaged in an earthquake in 1547, was pieced together, seemingly by Michele di Ridolfo, from seventeen splintered fragments, and has been repainted on two occasions since. The landscape lacks the transparency of the *Madonna of the Meadow*, and the three trees seem to date from the first campaign of restoration. With the year 1507, however, we reach two works that time has spared. One is the delicate and underrated *Holy Family with the Palm Tree* at Edinburgh,[39] where the figures are arranged in frieze-like fashion across the surface in such a way as to suggest that the painting was evolved at the same time as the *Entombment* in the Borghese Gallery, and the other is the *Belle Jardinière* (Fig. 182),[40] where the aspirations embodied in the *Madonna of the Meadow* and the *Madonna of the*

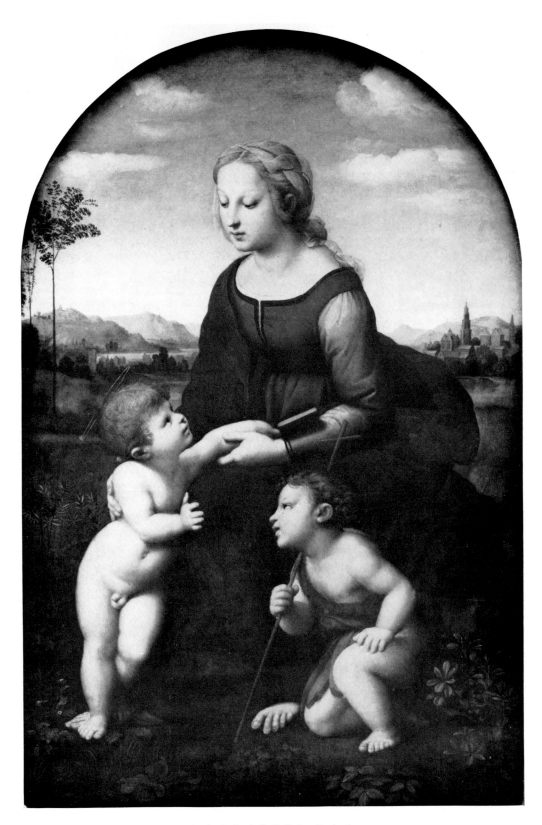

182. Raphael: *La Belle Jardinière*. Paris, Louvre

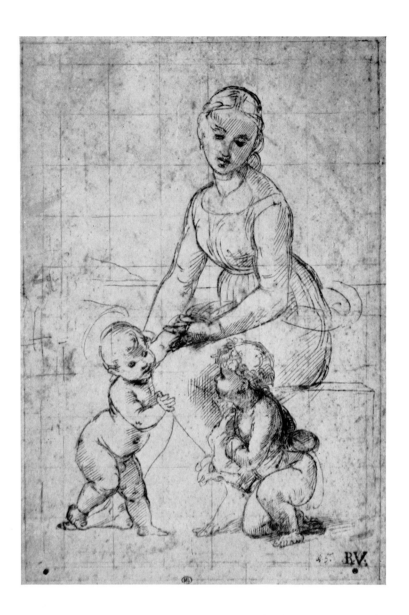

Goldfinch are fully realised for the first time. The painting is a little higher than the *Madonna of the Goldfinch* and almost exactly the same width, but the effect it makes is more emphatic, partly because the scheme is more coherent and partly because the figures abut more closely on the frame.

Elaborate as is their structure, there is nothing in these works that is iconographically arcane. In Perugia, Raphael aimed to bridge the gap between the sterile formulae of Perugino's workshop and the world that lay before his eyes, and in Florence his task was to reinfuse conventional symbols with natural sentiment. What distinguishes the *Madonna of the Meadow* and the *Madonna of the Goldfinch* from contemporary Florentine works are the human values by which they are inspired. Never must we fall into the trap of regarding them as formal schemata. A sheet like that

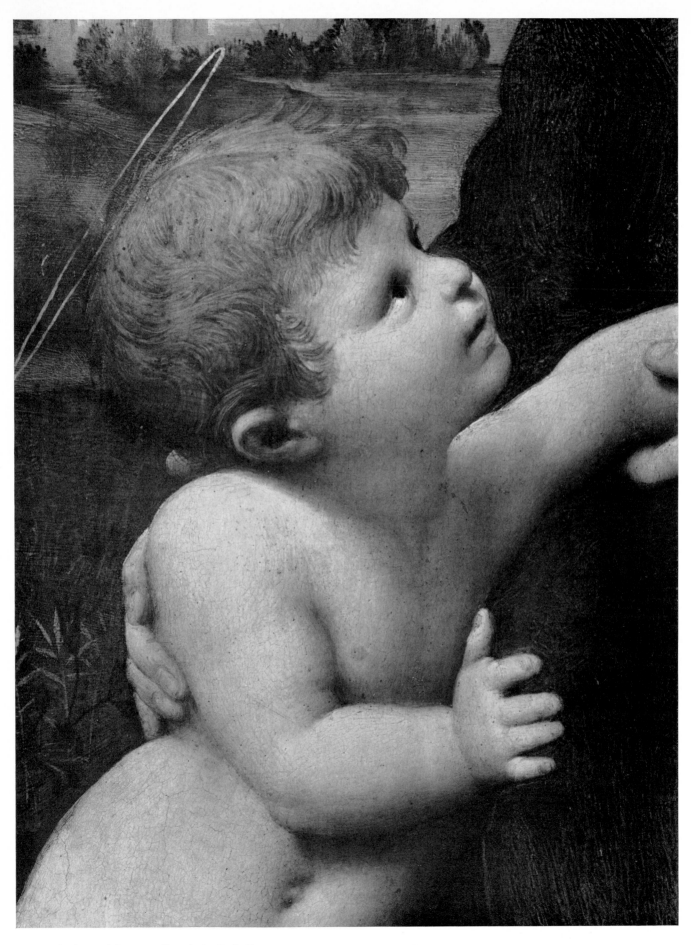

184. Raphael: *Detail from La Belle Jardinière*. Paris, Louvre

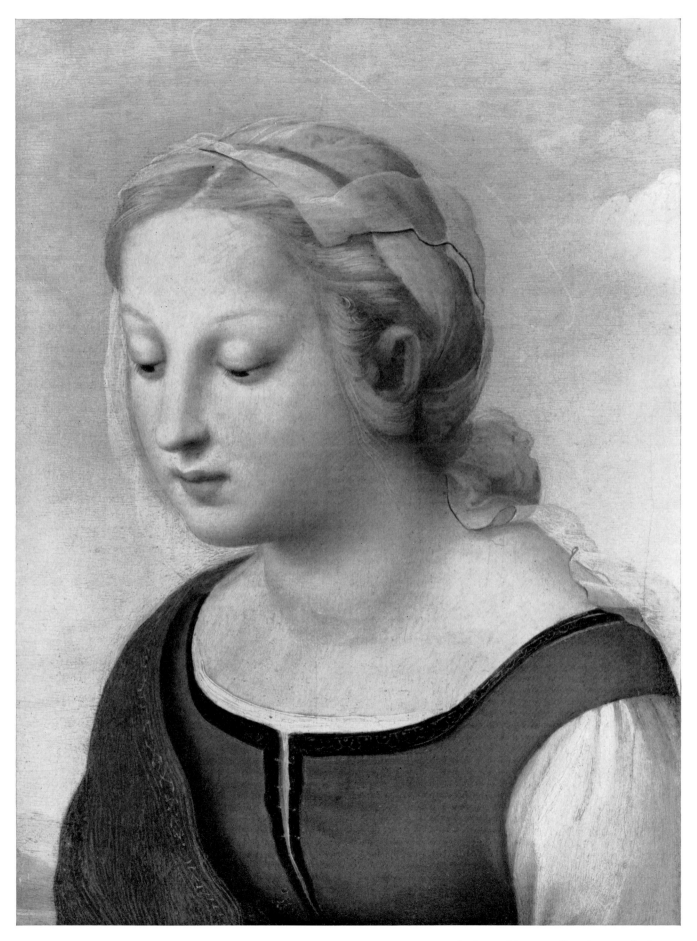

185. Raphael: *Detail from La Belle Jardinière*. Paris, Louvre

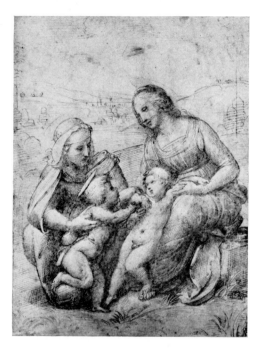

186. After Raphael: *Study for the Canigiani Holy Family*. Chantilly, Musée Condé

187. Raphael (reworked): *Study for the Canigiani Holy Family*. Windsor Castle, Royal Library

with studies of Christ and the young Baptist at Vienna is indeed intelligible only if we accept the proposition that the subject of the dialogue is not the setting of two children in space, but the relationship between a divine and human child.[41] In the *Madonna of the Meadow* the young Baptist genuflects, and in the *Madonna of the Gold-finch* the Child Christ draws back behind his mother's knee. The earliest drawings for the *Belle Jardinière* (Fig. 183) start from this point.[42] The Child is supported by his mother's hand, and the young Baptist is shown kneeling on the right. But even when the poses were consolidated, when the Child Christ was drawn more firmly and the Baptist leaned forward in adoration, the distinction between them was not clearly made. At this juncture Raphael had recourse to Michelangelo, not to a painting or relief, but to the *Bruges Madonna*, which was despatched to Flanders in August 1506. Probably the lower part of a drawing at Oxford[43] was made directly from the marble group in the first half of that year. In the *Bruges Madonna* the Virgin holds the Child by the right arm (the considerations here were formal; Michelangelo was concerned with the torsion of the Child), and this is ignored by Raphael. Instead the Child in the *Belle Jardinière* is held, as he was held in the early drawings, by the left arm, and the passage where the two hands meet is treated with consummate sensibility. Design and substance move forward side by side; the young St. John gazes in adoration at the Child, and between the Child (Fig. 184) and Virgin (Fig. 185) there extends a form of reciprocal communication of the utmost

subtlety. This psychological invention is taken a stage further in a still later work, the *Canigiani Holy Family* in Munich (Fig. 9).[44]

Angelo Doni, whose portrait Raphael painted, was the owner of the tondo by Michelangelo which is now in the Uffizi. When it was designed, Michelangelo's mind was focussed on the battle fresco for the Palazzo della Signoria, and the experience of the fresco is distilled in the colossal central group. The Virgin is seated on the ground with St. Joseph kneeling behind her, and the Child, in defiance of iconographical tradition, is set above her shoulder on St. Joseph's thigh. The strain of rhetoric in this painting was at variance with the level of interpretation on which Raphael's mind at this time moved, but its structure offered a challenge that he rose to meet. The painting in which he did so resulted from a graft between the Doni tondo and his antecedent works. Its structure is pyramidal and not simply triangular; two adult figures kneel in the foreground and St. Joseph leans over from behind. One of the hazards Michelangelo overcame in the Doni tondo was that figures disposed in depth might coalesce. In the *Canigiani Holy Family* the same problem arose, and it was solved in precisely the same way. The group, that is to say, is illuminated uniformly from the left, so that the right side of St. Joseph is in shadow and the left is strongly lit; the lighted area of his cloak is used as a foil for the shaded face of St. Elizabeth, while the darkened area serves as background for the Virgin's brightly illuminated head.

The Munich painting is rightly described as a Holy Family, but in the form in which it was first thought of there was no St. Joseph; it consisted of two adult figures and two children, St. Elizabeth, the Virgin, the young Baptist, and Christ. Its subject was the confrontation of the children, and Raphael's first notion was to introduce an element of movement like that in the Taddei tondo of Michelangelo. In one drawing he used exactly the same means as Michelangelo; the Child is frightened by a goldfinch held out by the young St. John.[45] In another the goldfinch was left out and the Baptist was shown pinching the Child's left arm (Fig. 187).[46] In both drawings the genre motif of the two children contrasts uneasily with the majestic figures at the back. At this point, in a drawing which is known only through a copy at Chantilly (Fig. 186),[47] Raphael revised the scheme, eliminating the genre motif and representing the two children playing with a scroll.[48] With this change the painting became an overtly symbolic scene, and for the first time the standing figure of St. Joseph was introduced. The moment when St. Joseph was inserted is recorded in a copy of a Raphael drawing at Oxford.[49] At a still later stage there was added another of the key motifs, the head of St. Elizabeth turned up towards St. Joseph (which gives literary meaning to what might otherwise have been an academic device).

In the *Canigiani Holy Family* as we see it now there is an unhappy conflict between

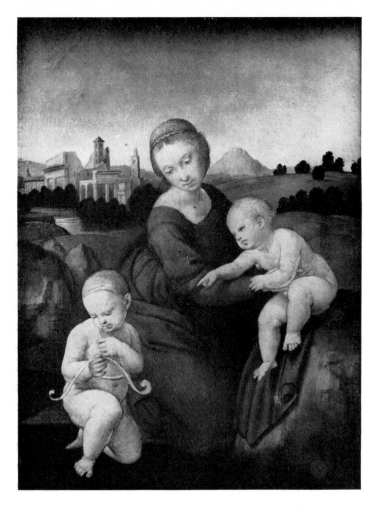

188. Raphael:
The Esterházy Madonna.
Budapest, Szepmuveszeti Museum

the tightly compressed pyramid of the figures and the open space in which they are set. According to tradition, the upper corners of the panel were filled with putti, and X-ray photographs (Fig. 8) reveal the traces of groups of putto heads blocking the corners of the panel and framing the central group. The landscape has also been modified, and some of the features which are most unaccountable because most Northern were introduced when the putti were painted out. As can be seen in an engraving by Bonasone, it was central to the conception that the sky should open and that celestial light should pour down on the group.

In two other small paintings of the time this symbolic thinking is pursued. One is the *Holy Family with a Lamb* in Madrid,[50] where the theme is that of the revised *Virgin and Child with St. Anne* of Leonardo; the lamb, that is, is a symbol of the Child's predestined fate, and the Virgin, in her role as mother, dissuades him from embracing it. The device by which Raphael ensures that the eye is carried upwards to St. Joseph standing at the side is the same that is employed in the *Canigiani Holy Family*. In the second picture, the little *Esterházy Madonna* at Budapest (Fig. 188),[51]

189. Raphael: *St. Catherine of Alexandria*. London, National Gallery

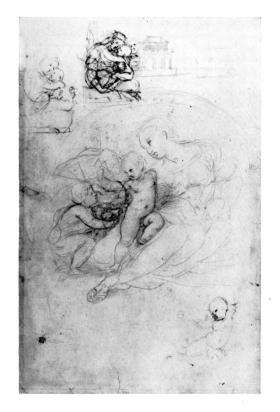

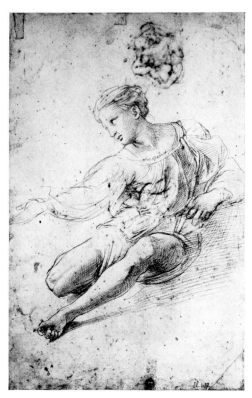

190. Raphael: *Study for the Alba Madonna.*
Lille, Musée Wicar

191. Raphael: *Study for the Alba Madonna.*
Lille, Musée Wicar

the lamb is omitted, and St. John holds a cartellino with the words *Ecce Agnus Dei* in its place. This jewel-like painting is unfinished, but an exact point of reference for its style is supplied by the *Madonna del Baldacchino*, the last of Raphael's Florentine altarpieces, which was commissioned for Santo Spirito in about 1507. In the altarpiece the head of the Child is turned over his right shoulder, his left arm is placed diagonally across the Virgin's throat, and the front plane is realised as a triangle formed by the right arm, the back and the right thigh. The compact poses of the children in the Budapest *Madonna* continue this experiment. Presumably the *Madonna* was left unfinished for the same reason as the Dei altarpiece, that Raphael abandoned it when at short notice he moved to Rome. Its transitional character is established by a preliminary drawing in which the background is a Florentine land-scape.[52] In the painting, perhaps in allusion to the prospects that opened out before him, a Roman ruin is shown.

These paintings, and the Borghese *Entombment*, were the outcome of four years of work. For the next seven years Raphael's creative zest was canalised in the frescoes in the Vatican, and during the years when he was working in the Stanza della Segnatura only three or four independent paintings were produced. One of the most beautiful of them, the *St. Catherine of Alexandria* in London (Fig. 189),[53] forms a

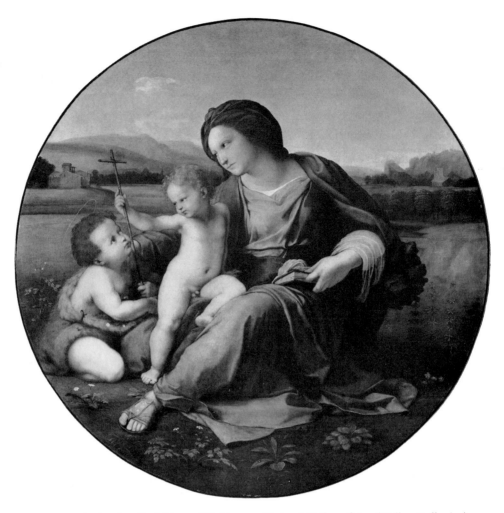

192. Raphael: *The Alba Madonna*. Washington, National Gallery of Art (Mellon Collection)

Roman epilogue to his Florentine activity. The figure is based on the antique, and though generally assigned to 1507, was probably produced in 1509, when Raphael's style was saturated by the classical scene. The Saint looks forward to the allegories on the ceiling of the Stanza della Segnatura. It might be expected that the independent paintings of these years would reflect other aspects of Raphael's Roman style, above all the circular movement of the groups in the foreground of the *School of Athens*. About 1510, in the *Alba Madonna* in Washington (Fig. 192), these expectations are fulfilled.

The seed from which this painting grew is contained on the back of a drawing at Oxford where a naked female figure with right arm extended is shown seated on the ground.[54] This study is generally referred to the *Disputa* or to the *School of Athens*, but in neither fresco is there any figure that corresponds with it. In a drawing at Lille (Fig. 191) the pose was elaborated from a living model,[55] and before long it evolved, in Raphael's usual fashion, into a seated Virgin with the Child at her side and the

young Baptist kneeling in profile on the left (Fig. 190). From the first the painting was to be circular; in the Lille drawing[56] a roughly indicated frame presses in upon the group on the right and immediately above the Virgin's head. This close framing applies the principles of the *Large Cowper Madonna* to a circular painting, and anticipates later Madonnas like the *Madonna della Sedia* and *Madonna della Tenda* which are cut by the frame in rather the same way. Yet when the picture (Fig. 192) came to be painted,[57] the panel was considerably larger than that envisaged in the drawing, and the rhomboid of the figures was set in a wide landscape and was freed from the oppressive frame. We cannot tell why Raphael fell back on the more timid and more open scheme that we know now, but the painting that resulted is none the less a masterpiece, less humanly appealing than the Florentine Madonnas, but more deep searching in its interpretation and more ambitious in its design.

Probably it precedes by a matter of months the little *Aldobrandini Madonna* in the National Gallery in London (Fig. 193).[58] Like the *Alba Madonna*, the *Aldobrandini Madonna* is approximately datable. The drawing for it at Lille[59] forms part of what is known as Raphael's Pink Sketchbook, a group of sheets originating from a single volume that includes a study for the *School of Athens*, so the picture must also have been painted when Raphael was working on the fresco. The main point the Madonnas have in common is the Child, the lower part of whose body is shown in a closely similar fashion in both. In the *Aldobrandini Madonna* the three figures are set in confined space, the Virgin seated sideways on a kind of altar, turning back with a protective gesture to fondle or restrain the young St. John. They are familiar, yet their meaning is transformed. The Virgin is more remote, and the Baptist seems to re-enact some age-old ritual as he reaches up to the bird held by the Child. The retreat from spontaneity apparent in this painting becomes still more explicit in the work that follows it, the *Madonna of Loreto*.

The original of the *Madonna of Loreto* has disappeared,[60] and our knowledge of it depends from copies (Fig. 194) which record no more than the rudiments of its scheme. The picture was painted for the Della Rovere church of Santa Maria del Popolo, probably as a commission from the Pope. The Virgin, watched by St. Joseph, was shown standing behind a bed on which Christ was exposed and in her hands was a transparent veil which she was removing from the Child. The composition, with the Child isolated in the foreground, could leave no doubt in the beholder's mind that what was represented was not a simple Holy Family, but an allegory of the divinity of Christ. None the less the factor of life study is implicit in the Child Christ's wonderfully inventive pose, and it is not impossible that a sheet of drawings in the British Museum of a child lying on its back was made with this picture in mind.[61] The head of the Virgin recalls the head of Justice in the Stanza della Segnatura.

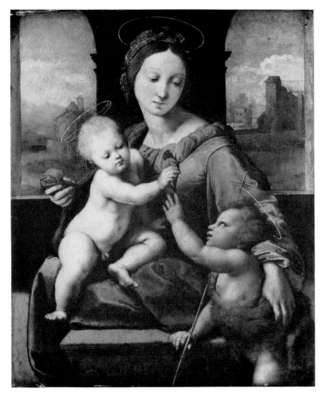

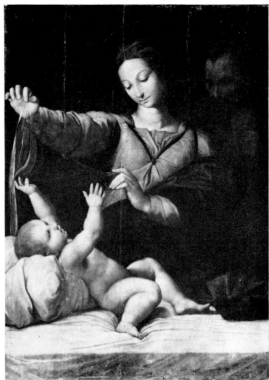

193. Raphael: *The Aldobrandini Madonna.*
London, National Gallery

194. After Raphael: *The Madonna of Loreto.*
Paris, Louvre

Since the experience of the Segnatura frescoes is so clearly reflected in these Madonna paintings, it might be expected that the abrupt transition to the Heliodorus frescoes would be reflected in the paintings that succeed them. The first work of which that is true is the altarpiece of the *Madonna di Foligno* (Fig. 195),[62] which was commissioned for the Aracoeli. The Aracoeli stood on the legendary site of the Sibyl's prediction to Augustus of the Birth of Christ, and by convention the scene of Augustus and the Sibyl included an apparition of the Virgin and Child in the sky. Sometimes the apparition of the Virgin and Child is shown above a crescent moon. Though as a result of recent cleaning the moon in the *Madonna di Foligno* is now so bright as to have led one scholar to describe it as the sun, that is the iconography which Raphael adopted for the altarpiece. A drawing made for the upper figures illustrates at least one of the stages through which the design passed.[63] In it the Virgin is turned sharply to the right; her right forearm is held flat, and the Child has both legs on her lap. In a later study recorded in an engraving by Marcantonio[64] the Child's head and right arm are still preserved, but the right knee is drawn up, and the left leg is extended at the Virgin's side. In making these changes Raphael was once more inspired by memories of the Doni tondo of Michelangelo. At the same time the Virgin's right hand was brought forward and her left foot was

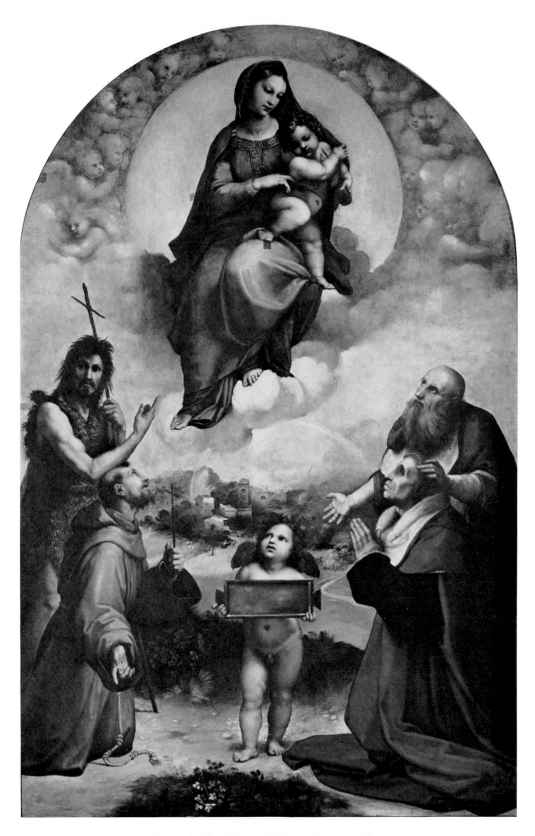

195. Raphael: *The Madonna di Foligno*. Pinacoteca Vaticana

pulled back. The purpose of these alterations was to heighten the tactile character of the group, and in this form it was incorporated in the painting (Fig. 196).

The donor on the of right the *Madonna di Foligno* is the historian Sigismondo de' Conti, who died in 1512 and was buried in the Aracoeli. Conti had been attached to Giuliano della Rovere before his election to the papacy and throughout the reign acted as the Pope's chamberlain or secretary. The altarpiece was probably commissioned before his death, but the system of illumination that is employed in it – the landscape in the background is irradiated by a meteor which falls on Conti's house and the foreground figures are lit centrally from the celestial glory behind the Virgin and Child – suggest that it was carried out in the same term of years as the *Miracle at Bolsena* and the *Repulse of Attila*. Now that the *Repulse of Attila* has been cleaned and the landscape is fully legible, the suggestion that the romantic landscape of the *Madonna di Foligno* is by any other hand than Raphael's cannot be seriously credited. The picture is executed with consummate confidence; a French engraver, who watched its transfer to canvas in 1802, reported that the underpainting, visible from the back of the paint film, bore every trace of rapid execution, and that the only significant change was in the right hand of St. Jerome.

Raphael's reputation in these years was not confined to Rome. In a letter written about 1510 the administrator of the Benedictine abbey of San Benedetto Po near Mantua[65] discusses the possibility of inducing him to paint a fresco on the end wall of the refectory. Though nothing came of this proposal, Raphael's next altarpiece was painted for a community which belonged to the same Cassinensian Congregation, San Sisto at Piacenza.[66] The convent was an old foundation, and in 1494 it was decided that its church should be rebuilt. Work was begun in 1499, and by 1511 the church was practically complete, or was at least sufficiently advanced to admit of a commission for frescoing the pendentives beneath the cupola. In 1500, during the early stages of this operation, Cardinal Giuliano della Rovere, the future Pope Julius II, visited Piacenza and made a contribution to the building fund. Between the summer of 1510 and the summer of the following year the Pope was engaged in operations against the former papal states, and in June 1512, his victories were celebrated in Rome. The climax of his success was an announcement that Piacenza had adhered voluntarily to the papacy. The *Sistine Madonna* (Fig. 198)[67] was an expression of papal approbation of this decision, and must have been commissioned between June 1512 and the Pope's death on 21 February 1513. The reason for saying that is that the kneeling figure of St. Sixtus in the altarpiece wears a cope decorated with the Della Rovere acorns and has the features of the Pope. There is no evidence of the date at which the altarpiece was set up at Piacenza, but it is likely to have been in position when the church was re-dedicated in 1514.

The painting is planned as a kind of window, with a ledge across the bottom on

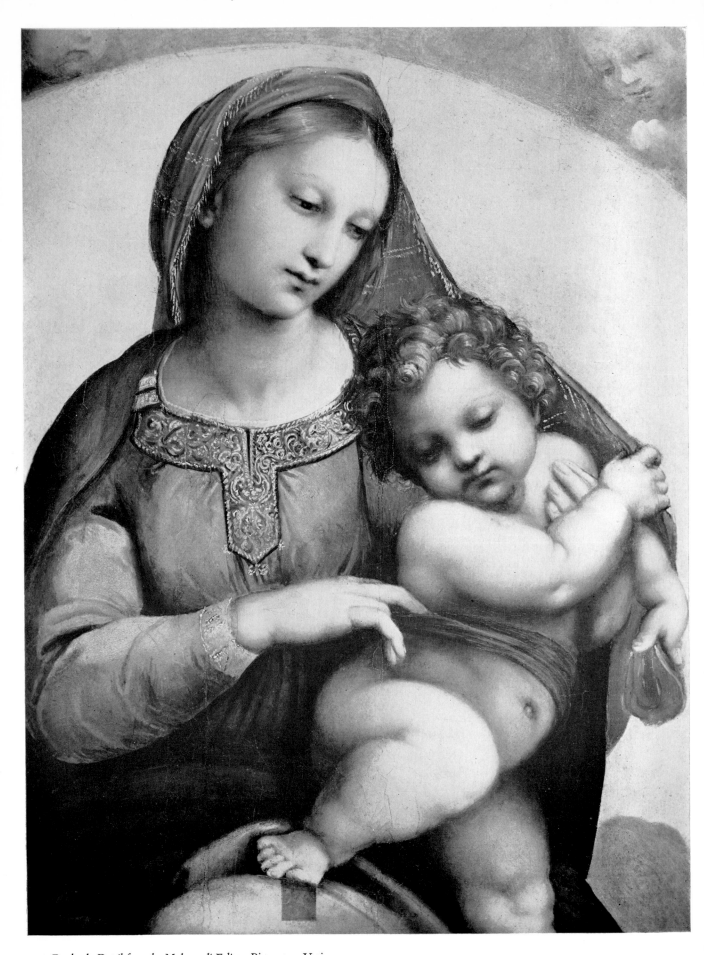

196. Raphael: *Detail from the Madonna di Foligno*. Pinacoteca Vaticana

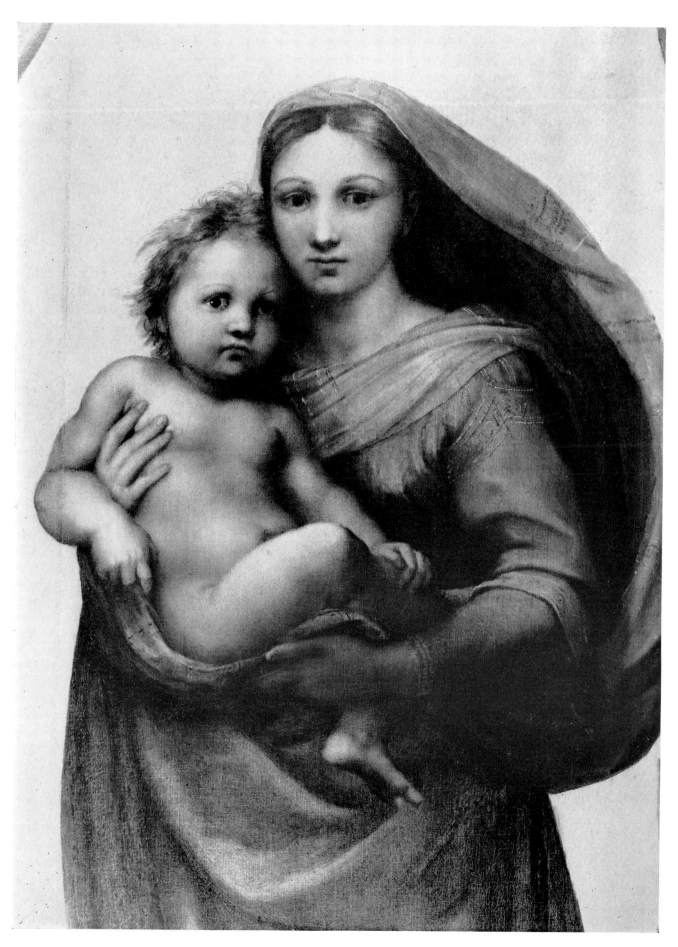

197. Raphael: *Detail from the Sistine Madonna*. Dresden, Gemäldegalerie

which stands the mitre of St. Sixtus, and on which two putti in the centre support themselves like children in a swimming bath. A stable frame is also postulated at the top, where a curtain rod covers the aperture. Exactly how the painting was originally sited is not known, but in the eighteenth century, when it was moved to Dresden, a copy was set up in the church. It stands higher than Raphael's altarpiece, but still testifies to the effect which this great artificial window must have made when it was first installed.[68]

The curtain hanging from a rod is an old though an exceptional device. One of the most notable examples of its use is in the Donatello tabernacle, now in the Sagrestia dei Beneficiati of St. Peter's; it shows at the top two angels drawing back a curtain to reveal the scene of the Entombment which is taking place behind. What is disclosed in Raphael's altarpiece is a celestial vision for which his earlier paintings offer no precedent, and to explain it the altarpiece must be replaced in the Roman setting where it was produced.

In October 1512 the ceiling of the Sistine Chapel was at last complete. Given the personal hostility between himself and Michelangelo, Raphael can hardly have been cognisant of the later histories on the ceiling before they were revealed to other eyes as well. Their message, once it was received, was unambiguous. Whereas the earlier histories were conceived, like the *Drunkenness of Noah* and the *Sacrifice of Noah*, in the style of classical reliefs, with the main figures ranged in a front plane, or, like the *Flood*, made use of projected space, in the later histories the spatial element was first reduced and then eliminated. In the three last histories, the *Separation of the Sky and Water*, the *Creation of the Sun and Moon*, and *God the Father dividing Light from Darkness*, the scene is treated not as a picture imposed on the surface of the ceiling, but as a void through which the celestial regions beyond the ceiling can be seen. In the earlier histories the framing of the scene is faithfully maintained, but in the later frescoes it is denied, and in the last fresco of all, the *Dividing of the Light from Darkness*, three of the four youths contiguous to the scene impinge upon the fresco field. This goes hand in hand with another equally important change. In the early histories the figures are comparatively small in scale, whereas in the intermediate scenes of the *Expulsion of Adam and Eve* and the *Creation of Eve* in the centre of the ceiling they are enlarged, and in the last four frescoes they reach proportions so heroic that in neither of the smaller scenes can the complete figure of God the Father be shown. This has a threefold relevance to the *Sistine Madonna*. It explains why the altarpiece is planned as a celestial vision, it explains why Raphael had recourse to the illusionism of the curtains to modify the prosaic rectangle of the altarpiece, and it explains why the scale of the three figures is proportionately larger than that of the *Madonna di Foligno*.

Unlike the *Madonna di Foligno* the painting was executed on canvas. It is sometimes described as a processional banner, but there is no proof that it was ever carried in

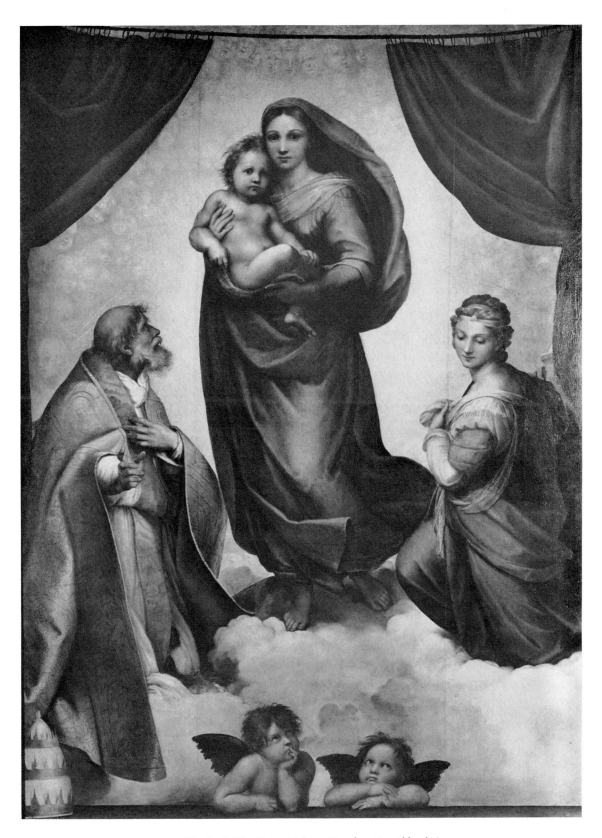

198. Raphael: *The Sistine Madonna*. Dresden, Gemäldegalerie

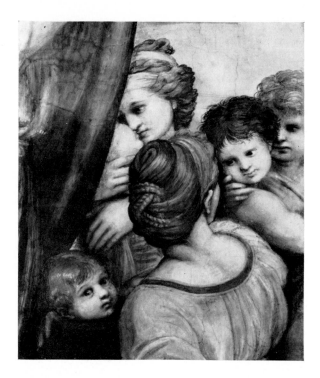

199. Raphael:
Detail from the Mass at Bolsena.
Vatican

procession,[69] and the most likely explanation of the use of canvas is an artistic one, that Raphael wished to instil into the altarpiece the freshness and immediacy of the frescoes on which he was working at the time. The reputation of the *Sistine Madonna* from his day down to our own is in great part due to his success in doing so.

In the *Madonna di Foligno* the single intimation of movement is provided by the Child. In the *Sistine Madonna*, on the other hand, the Child is represented in repose and the Virgin is shown walking forwards on a cloud. The Child of the *Madonna di Foligno*, soft faced and curly haired, is replaced by a prophetic Child which recalls the children on the left side of the Heliodorus fresco. From a formal standpoint one of the most beautiful features of the painting is the way in which the Virgin's left arm and the Child's right thigh continue and complete the circle that is established by the billowing veil (Fig. 197). The presence of kneeling figures beneath the Virgin imposes on the altarpiece a pyramidal structure like that of the *Madonna di Foligno*, but in practice the scheme is varied by the disequilibrium of the curtain and by the fact that the two lower figures are set on different planes. One Saint, St. Sixtus, looks upwards at the Virgin and gesticulates towards the congregation with a foreshortened hand which extends to the level of the picture frame, while the other, St. Barbara, shrinks back with lowered eyes. Would that we had the drawings in which this miraculous equation was worked out.

The groups of women and children in the *Mass at Bolsena* (Fig. 199) and in the *Heliodorus* fresco supply a key to three half-length Madonnas that Raphael painted at this time. The first of them, the *Mackintosh Madonna* in the National Gallery in

214

200. Raphael:
Madonna della Tenda.
Munich, Alte Pinakothek

London (Fig. 243), is one of those wretched paintings that was transferred from panel to canvas in France, and is now all but a total loss.[70] The cartoon, however, survives.[71] In it the Child presses his head against the Virgin's cheek and the Virgin holds him round the waist, so that the figures are not opposed as they are in the *Madonna di Foligno*, but comprise a single unit of form. This was one of Raphael's compositions that appealed most strongly to later artists; it was copied by Sassoferrato and Ingres.

The painting that succeeds it is the *Madonna della Tenda* in Munich (Fig. 200),[72] where the Virgin is seen against a curtain, seated informally with legs drawn up and with the Child Christ in her lap. The young St. John peers through the curtain at the back. The children's heads are very close to those of the children in the *Mass at Bolsena*, and the panel must date from not long afterwards, probably from about 1514. Though it is damaged, enough of the paint surface has been preserved to prove

201. Raphael:
Study for the Madonna of the Fish.
Florence, Uffizi

that the volume-enhancing use of light, which is so notable an innovation in the Stanza of Heliodorus, was likewise transferred to panel paintings. The *Madonna della Tenda* is also the first religious painting in which use is made of the enriched technical vocabulary with which Raphael describes the forms in portraits painted at this time.

What was involved was not simply the use of a more realistic style, but a more realistic interpretation of the theme of the Virgin and Child. The significance of this transpires from a remarkable drawing at Oxford, made probably in 1513 in preparation for an engraving, which shows the Virgin, seated on a household chair, clasping the Child in a passionate embrace.[73] This sheet establishes the idiom of the greatest of Raphael's half-length Madonnas, the *Madonna della Sedia* of about 1515 in Florence (Frontispiece).[74] The setting is less informal than in the *Madonna della Tenda* in that the Virgin is seated on a kind of throne. In place of the conventional blue robe she wears a patterned veil and shawl which are recorded with the same care as the dresses in the foreground of the *Miracle at Bolsena*, and with a voluptuous impasto that was not attainable in fresco. The composition is more concentrated than in the Munich painting for not only are the forms carefully adjusted to the circular field, but the protruding elbows of the Virgin and the Child create an illusion of con-

202. Raphael:
The Madonna of the Fish.
Madrid, Prado

vexity. The new emphasis on realism affects both the descriptive aspect of the painting and its interpretative character. The divine Child who gazes confidently out from the *Large Cowper Madonna* gives way to a shrinking Child comforted by the protection of his mother's arm.

From the first it was the presupposition of Raphael's Madonna paintings – the smaller Madonnas not the altarpieces – that their execution should be autograph, for intimations so personal could hardly be transcribed by other hands. After 1515, when Raphael over a large part of his work became an ideator instead of an executant, the Madonna paintings were the main casualties. What occurred can be seen very clearly in the only one of the late Madonnas for which a number of composition drawings survive. The work is the *Madonna with the Fish* in Madrid,[75] and a drawing in the Uffizi (Fig. 201) testifies to the tremulous invention with which it was begun.[76] To

217

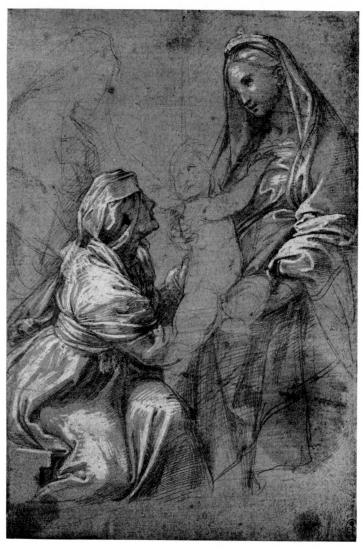

judge from its technique the beautiful red chalk study for the painting was made at about the same date as the earliest drawings for the tapestry cartoons. It was followed by a wash drawing, also by Raphael, in which the scheme was slightly revised.[77] Presumably Raphael also prepared, or supervised the preparation, of the cartoon, for one major change was introduced, that the throne was no longer aligned at an angle to the picture plane, as it is in the two drawings, but was flattened and centralised. This change brought the design into conformity with the tapestry cartoons on which Raphael was working at the time. In the completed work (Fig. 202), however, those features that make the drawings personal – the pleading expression of the Archangel and the nervousness with which the young Tobias approaches the Virgin's throne – are stratified, and the forms become solid and commonplace.

If the only change in the late Madonnas was that Raphael's share in carrying them out was reduced as it is here, that would not be difficult to understand. But after 1515

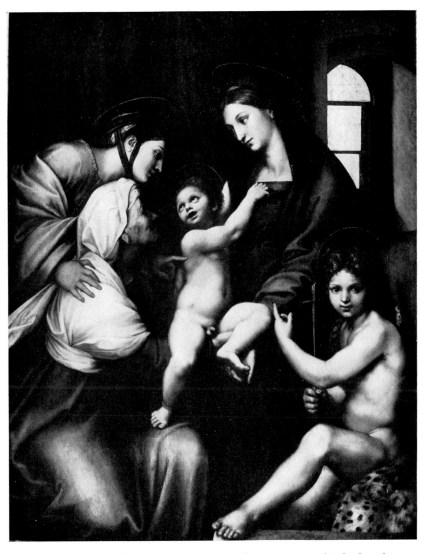

204. Workshop of Raphael:
Madonna dell'Impannata.
Florence, Palazzo Pitti

the type of Madonna he designed changes once more. The point at which the change
occurs is in the drawing at Windsor for the work we now know as the *Madonna
dell'Impannata* (Fig. 203).[78] It is as though Raphael about 1516 took up the threads
he had dropped at the time of the *Canigiani Holy Family*. When we turn to the
painting (Fig. 204)[79] – it is really a small altarpiece – that impression is reinforced;
it is an intensely unnatural work with a pronounced expository character. Even if we
imagine it as it might have looked had Raphael himself painted it, if we tighten up
the Child's loose pose and correct the ill-drawn hand on the shoulder of St. Eliza-
beth, it is difficult to see it as anything but a failed painting. The puzzle is the greater
in that it was commissioned by Bindo Altoviti, of whom Raphael painted the great
portrait which is now in Washington.[80] The portrait is observed with extraordinary
acumen – the corkscrew pose with head turned back over the shoulder originates
in the Stanza della Segnatura – and the features are handled with a solicitude and

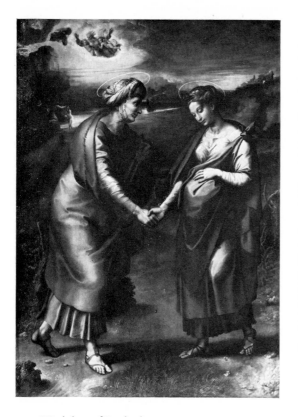

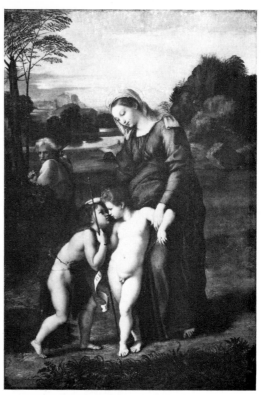

205. Workshop of Raphael:
Visitation.
Madrid, Prado

206. Workshop of Raphael: *Madonna del
Passeggio*. Edinburgh, National Gallery of
Scotland (lent by the Duke of Sutherland)

strength of which there is no trace in the larger painting. Perhaps at this time
Raphael's interest as an executant lay in portraiture not in ideal painting. Certainly
in these years a surprisingly high number of carefully cogitated, slowly executed
portraits were produced, not the *Leo X* alone, but the *Castiglione* in the Louvre
(Fig. 21), the *Donna Velata* in the Palazzo Pitti, the beautiful portrait of a youth
formerly at Cracow, the double portrait of Navagero and Beazzano in the Palazzo
Doria (Fig. 22), the still more vivid double portrait in the Louvre, and the entran-
cing female portrait at Strasbourg. All these paintings date from after 1515 and all of
them are in large part autograph.[81] It is symptomatic of Raphael's make-up at the
time that when in 1518 he designed a painting to despatch to France, the point at
which he intervened in the completed work (Fig. 234) was not the Virgin or
the Child, which are comparatively weakly executed, but the magnificent figure of
St. Joseph brooding on the scene.[82]

One of Raphael's characteristics as an artist was an obsessive concentration on
the work in hand. Between 1504 and 1508 the focus of his thought was the Ma-
donnas. Between 1508 and 1514 it was the frescoes in the Vatican, to which the

Madonna paintings of the time have a tangential relationship; the greatest of them, the *Madonna della Sedia* and the *Madonna della Tenda*, may, indeed, have been inspired by the preliminary studies that were made in connection with the frescoes. Through 1515 it was the tapestry cartoons, and thereafter it was the portraits and the *Transfiguration*.

Though the quality of the late Madonna paintings suffers a decline, they were popular and influential works, and the fact that some of them were executed wholly in the studio is no reason for ignoring them today. We should be wrong to underrate the factor of invention in the feebly painted *Madonna under the Oak Tree* in Madrid[83] and in the *Madonna della Perla*,[84] in which Raphael's figure composition is lent an adventitious dramatic interest through the employment of directed light. We should also be wrong to do so in the case of the *Madonna del Passeggio* (Fig. 206), an even tamer and less enterprising work.[85] No Raphael drawing for it survives, but it is connected with a larger painting, the *Visitation* in the Prado (Fig. 205), which was installed under Raphael's name during his lifetime in San Silvestro at Aquila, and which he must likewise have planned.[86] Both the *Visitation* and the *Madonna del Passeggio* were painted by Raphael's pupil Gian Francesco Penni and were couched in the style of the little frescoes carried out under Raphael's supervision in the Loggia of the Vatican. The interpretative content of both pictures is Raphael's, and the method of narration is the same that was adopted in the Loggia frescoes. We may wish that the figures of the Virgin and St. Elizabeth were less inert and that the illusion of movement in the children of the *Madonna del Passeggio* was more effectively conveyed, but better far that Raphael's poetic concept should be realised in this fashion than that it should remain in the realm of the unknown. Nowadays we are suspicious of art as illustration, and we believe that the ideation of a painting and its execution are, or should be, one. But at one time people at least as discriminating as ourselves believed the opposite, that the pictorial idea accounted for a great part of the value of a work of art, and that the supreme illustrator was the supreme artist.

207. Raphael: *Detail from the Predella of the Entombment.* Pinacoteca Vaticana

VI · POST-RAPHAELITISM

IT IS NOT ALWAYS a useful exercise to discuss the influence of great artists. With Raphael, however, there is no alternative to doing so, since the painters whom he influenced have much to tell us about the nature and meaning of his work. His style has been said to consist of 'approximately imitable generalisations';[1] that is a better description of Raphael criticism than it is of Raphael's paintings. In practice it was inimitable, because it presupposed a balance between intelligence and feeling, between mind and heart, that was personal to him, and was not attainable by painters whose temperaments were less serene and whose brains were less incisive than his own. In particular it was denied to Giulio Romano, who tended, while still employed in Raphael's studio, to disrupt the even tenor of Raphael's thought. After Raphael died, the divergence became still more marked, so that by 1523 Giulio Romano could produce, in the altarpiece in Santa Maria dell'Anima, a painting that violated all those principles for which Raphael stood.[2] He had been a leading member of the workshop during the painting of the Loggia of Psyche in the Villa Farnesina, but when at Mantua he took up the Story of Psyche, he accomplished a revolution against Raphael's work.

To two artists the aspect of Raphael's style that Vasari describes as 'grazia' was of prime significance. The older of them came to Rome from Emilia, probably in 1517, when Raphael was at the height of his career, and the younger arrived there after Raphael's death in 1524. The first, Correggio, was in Rome only for a short time, and what he saw there must be deduced from the works that he turned out in Parma after his return. He seems to have looked with admiration at the *Madonna di Foligno*, as well as at Raphael's earlier frescoes, the *Galatea*, the *Disputa*, and the *School of Athens*. At all events Correggio's decorations in the Camera di San Paolo in Parma contain references to the last of these three frescoes,[3] while in the cupola of San Giovanni Evangelista not only are the colossal figures seated on the clouds indebted to the *Disputa* but the rich facture is based on Raphael's fresco technique.[4]

The reactions of the second artist, Parmigianino, were rather different. He had Raphael's pretensions to gentility – Vasari says that the spirit of Raphael passed into his body, and that 'he tried to imitate him in all things, but above all in painting'[5] – and what he sought in Raphael was the elusive quality of charm. The place in which he found it was in the Angels and Sibyls and Prophets above the altar arch of Santa Maria della Pace, from which he deduced the principles of rhythmic

structure of his otherwise unRaphaelesque late works. When a decade or so later he made a copy of a Raphael modello for the *School of Athens* (Fig. 208)[6] – the lost original seems to have been made before the Heraclitus was included in the scene and before the figures in the background on the left were opened out – what concerned him was the harmonious linking of the figure groups.

More penetrating was the artist who ranks after Michelangelo as the greatest High Renaissance sculptor. Raphael's interest in sculpture can be sensed at quite an early time. In 1507 the predella of the *Entombment* altarpiece was planned as a monochrome relief (Fig. 207), while the *School of Athens* contains fictive sculptures of Apollo (Fig. 209) and Minerva and fictive grisaille reliefs. Looking at these figures without foreknowledge, we might suspect that before long Raphael would experiment with painted figures in combination with real sculptures, and once the Stanza della Segnatura was concluded, in 1511, that was what he did. The site of the experiment was Sant'Agostino for which he was commissioned by Johann Goritz, a member of the papal court, to design an *ex voto* to St. Anne; it took the form of a fresco of the *Prophet Isaiah*, with, beneath it, a marble group of the *Virgin and Child with St. Anne* (Fig. 210).[7] The painting is by Raphael, and the sculpture is signed by Andrea Sansovino. It is a common assumption that the two works, though contemporary, were planned in isolation, but the more closely one examines the statue the more doubtful does that theory seem. The *Virgin and Child with St. Anne* does not proceed

208. Parmigianino after Raphael: *Study for the School of Athens*. Windsor Castle, Royal Library

209. Raphael: *Detail from the School of Athens*. Vatican

210. Andrea Sansovino: *Virgin and Child with St. Anne*. Rome, S. Agostino

logically from Andrea Sansovino's previous Roman works (the monuments in Santa Maria del Popolo where he was probably directed by Bramante), but has an unmistakable connection with Leonardo, which runs parallel to that maintained by Raphael in the foreground figures in the *School of Athens* and in earlier panel paintings. Particularly curious is the Child, where the sculptor experiments with a motif from Leonardo that is closely analogous to the motif used by Raphael in the underpainting of the *Bridgewater Madonna*. In 1511 Raphael was a more prominent and more powerful artist than Andrea Sansovino, and the possibility cannot be discounted that the *Virgin and Child with St. Anne* was generated in his mind and depended from his designs. Two later commissions lend colour to that view.

The first is the Chigi Chapel in Santa Maria della Pace, where Raphael made provision for two bronze reliefs. The reliefs, of the *Incredulity of St. Thomas* (Fig. 211) and *Christ in Limbo*, are now at Chiaravalle, and Raphael's preliminary drawings exist at Cambridge (Fig. 212) and in the Uffizi.[8] The study for the *Christ in Limbo* in particular is a miracle of understatement, rhythmical, elegant, evocative, but when it was translated into bronze relief by a secondary sculptor, Lorenzetto, its emotional overtones evaporated, and it became rigid and inert. If we did not know that this

225

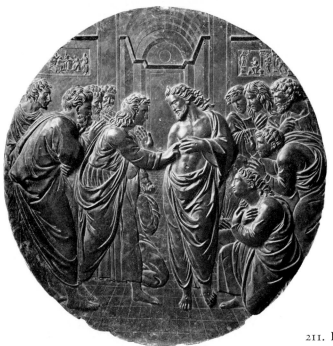

211. Lorenzetto: *Christ and St. Thomas*. Chiaravalle

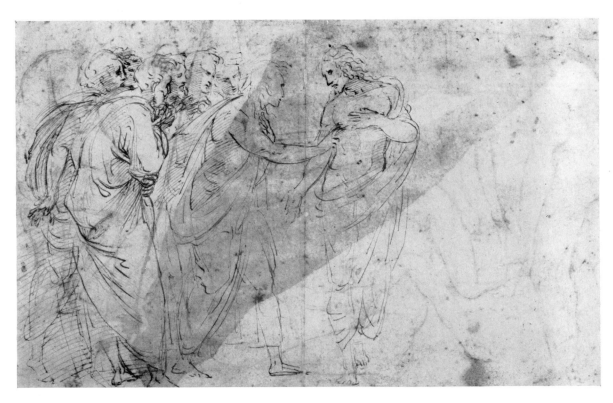

212. Raphael: *Study for Christ and St. Thomas*. Cambridge, Fitzwilliam Museum

213. Raphael:
The Chigi Chapel.
Rome, S. Maria del Popolo

roundel was based on a Raphael drawing, it would be of little interest as a work of art. In the second and later commission, for Agostino Chigi's funerary chapel in Santa Maria del Popolo (Fig. 213), Raphael functioned as architect, painter, mosaicist, and designer, and sculpture was again involved.[9] The tomb of Agostino Chigi was intended to include a bronze relief, now set in the altar of the Chapel, which is also by Lorenzetto and is again a flaccid, banal work, though by analogy with the drawings for the two bronze roundels we can at least guess at the beauty of the Raphael drawing on which it was unquestionably based. Moreover, the architecture of the Chapel made provision for four niches for marble sculptures, and one of these, the *Jonah*, was believed by Vasari, almost certainly correctly, to have been designed by Raphael, though it was carved by Lorenzetto. The discrepancy between the sculpture Raphael conceived and the sculpture that was actually produced is less great than with the bronze reliefs, and what confronts us in the Chapel is an aspirant Hellenistic statue. If it illustrates, as it must do, the kind of sculpture Raphael wished to propagate, it is natural that the greatest classical sculptor of his time, Jacopo Sansovino, should have felt magnetically attracted to his work. Three years younger than Raphael, Jacopo Sansovino was in Rome through the whole period of the decoration of the Stanza della Segnatura. When he returned to Florence in 1511, he carved the *Bacchus*, now in the Bargello, which affirms the same classical principles as the figures in the Segnatura paintings, and though it would be speculative

to ascribe that to the influence of Raphael, it is followed by a relief in which Sansovino's debt to Raphael is unconcealed. Its subject is the *Story of Susanna* (Fig. 214), and the style concept embodied in it is drawn from the engraving of the *Massacre of the Innocents* by Marcantonio after Raphael.[10] So firm and so confident is the modelling that one cannot but wish Sansovino and not Lorenzetto had transcribed Raphael's designs for Santa Maria della Pace and Santa Maria del Popolo. What masterpieces they might have been.

The relationship between the two artists continued after Raphael's death. In the early fifteen-twenties Sansovino includes, in the lunette of the Sant'Angelo monument in San Marcello, a relief in which the conventional Madonna reliefs on the tombs of Andrea Sansovino are revised in the light of the *Madonna di Foligno*.[11] Of all marble reliefs, this is the most authentically Raphaelesque. Not long afterwards, the Sack of Rome drove the sculptor from Rome to Venice – Pietro Aretino wittily compares Venice to a Noah's Ark which sheltered artist-refugees from Central Italy – and there he became an intimate of Titian and an upholder of the conservative classicising view of art which was codified by Dolce, and of which the first article of faith was that Raphael was a greater artist than Michelangelo. No doubt he found a sympathiser in Lorenzo Lotto, who had been working in the Stanze of the Vatican at the same time as Raphael, in 1509, and who had himself been influenced, in a less fundamental fashion, by Raphael's work. The outcome can be read all over Venice, but most succinctly in the bronze door commissioned for St. Mark's in 1546, where the narrative scenes of the *Resurrection* and *Entombment* are once more Raphaelesque.

214. Jacopo Sansovino: *The Story of Susanna*. London, Victoria and Albert Museum

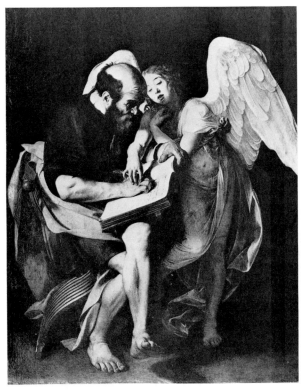

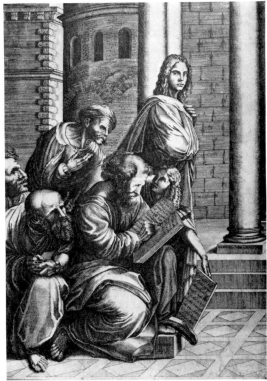

215. Caravaggio: *St. Matthew*.
Formerly Berlin, Kaiser Friedrich Museum

216. Agostino Veneziano after Raphael:
St. Luke

No painter in the middle of the Cinquecento had the same intuitive sympathy for Raphael as Sansovino. Towards the end of the century, however, with the reaction against Mannerism, painters took a fresh look at Raphael's work. The most per⁄ cipient of them was Caravaggio. The factor in Raphael's work that attracted him was very different from the aspect that attracted Correggio and Parmigianino. He responded not to the grace of the Stanza della Segnatura, but to the vitality and lifelikeness of the late works. In the first version of the *Martyrdom of St. Matthew* in the Contarelli Chapel in San Luigi dei Francesi the influence of the Stanza dell'Incendio is very marked,[12] and in the earlier of the two altarpieces of St. Matthew painted for the Chapel (Fig. 215), he took as his starting point the engrav⁄ ing in which Agostino Veneziano portrayed Pythagoras in the *School of Athens* as St. Luke (Fig. 216).[13] Still more powerful were the lessons to be gleaned from the foreground of the *Transfiguration*. We may indeed question if the figure on the right of the *Supper at Emmaus* would have gesticulated so freely and with such violence had not Raphael's Apostles given vent to their emotions with this same repertory of gesture and with this same force. In 17th⁄century art writing Caravaggio is always described as the disrupter and Annibale Carracci as the conserver of tradition. If their relationship to Raphael be accepted as a test, that is the opposite of the truth.

The part played by Raphael in the formation of the style of the Carracci was not in practice very great. There were only two large works by Raphael in Emilia, the *St. Cecilia* at Bologna (Fig. 217)[14] and the *Sistine Madonna*, and though the *St. Cecilia* exercised some influence over the Carracci and the members of their academy, the lessons to be learned from the altarpieces were submerged by a flood of Correggio-inspired paintings. When Francesco Albani migrated from Bologna to join the studio of Annibale Carracci in Rome, he complained, in the light of his experience there, that the *St. Cecilia* was unrepresentative. Raphael's hands, he said, had been tied by the patron who commissioned the painting.[15] Why could he not have been invited to paint a more exacting, more copious, more erudite scene, such as the Saint's marriage or her martyrdom or the episode where she gave her possessions to the poor? Probably these complaints would have been echoed by Domenichino, the leader of the neo-classical faction in Annibale Carracci's studio, for when, in 1614, he was invited to decorate the chapel of St. Cecilia in San Luigi dei Francesi, those scenes were illustrated, and the style in which they were portrayed was Raphael-esque. The Raphael to whom Domenichino was addicted was not the painter of the Stanza della Segnatura but the artist of the Stanza of Heliodorus and the *Burning of the Borgo*, and the frescoes he based on these works are at once the strictest and more sensitive of the attempts to adapt Raphael's mature style to the decorative needs of the Seicento.

One example will illustrate what was involved. Because of the window frame in the Stanza of Heliodorus, the *Mass at Bolsena* was planned on two levels, which are linked by the raised hands of the spectators standing on the left. On the left of the *Burning of the Borgo* this device was adapted to a field with a continuous base. Domenichino's *St. Cecilia distributing her Alms to the Poor* (Fig. 218) is planned in the same way; the Saint, that is, appears on a balcony above, and the poor reach up towards her. It seems moreover that Domenichino, when he showed the Saint leaning across the balcony, recalled the woman handing down the child from the flaming house on the left of the *Burning of the Borgo*. One of the most highly rated groups in Raphael's fresco was the naked men escaping from the burning building on the left (Fig. 105), and Domenichino introduces a similar feature in the form of two boys climbing a wall. These figures, and the children trying on clothes on the left, were based on careful studies from the life, and the preliminary drawings for them establish that Domenichino, though a less incisive draughtsman than Raphael, put the act of drawing to similar use.[16]

Such freedom of articulation was not arrived at easily. Soon after he came to Rome, Domenichino fell under the spell of the classical art theorist, Agucchi, and his success was sealed in 1604 by a painting of *St. Peter in Prison* in San Pietro in Vincoli, which was based on Raphael's *Freeing of St. Peter*.[17] Four or five years later,

217. Raphael: *St. Cecilia*. Bologna, Pinacoteca Nazionale

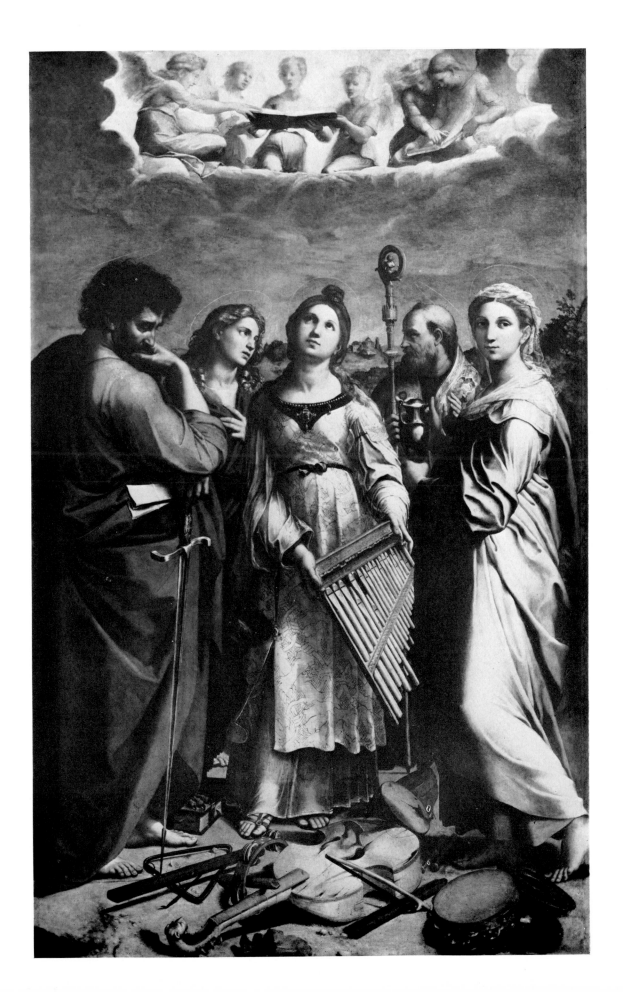

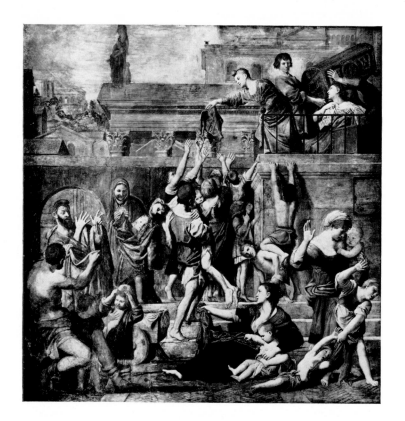

218. Domenichino:
St. Cecilia distributing Alms.
Rome, S. Luigi dei Francesi

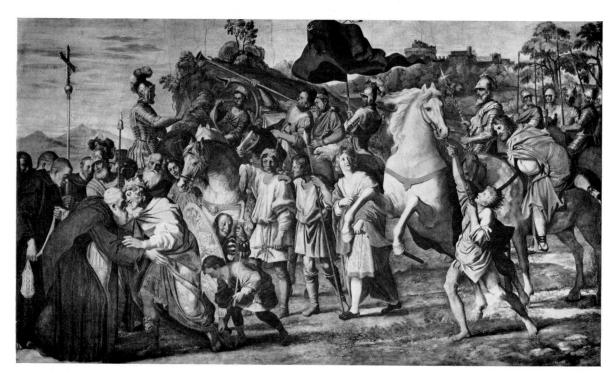

219. Domenichino: *The Meeting of St. Nilus and the Emperor Otto.* Grottaferrata

when he received the commission for his first great fresco cycle, in the Abbey at Grottaferrata, Raphael still occupied the forefront of his mind. The clearest proof of that is the *Meeting of St. Nilus and the Emperor Otto* (Fig. 219), which harks back to Raphael's *Repulse of Attila* (Fig. 102).[18] As Domenichino's style evolved, the spirit of Raphael started to bulk larger than the form. One of his exemplars was a late altarpiece, the *Spasimo di Sicilia*, then in Palermo, now in Madrid (Fig. 16). In a series of drawings of about 1612 Raphael's vertical design is adapted by Domenichino to an oblong field.[19] A horseman on the left and a kneeling woman on the right still flank the scheme, but the centre is opened out, and a new and poignant connection is established between the Virgin and the suffering Christ. In the painting that was based on it (Fig. 220) all those features that derived from Raphael were left out;[20] the banner and the horseman and the figure of the Virgin were excised, and instead emphasis was thrown on the largely independent central group, which was developed in the spirit of Raphael without recourse to Raphael's motifs.

Domenichino's was an organic development of Raphael's style, and nowhere is that more apparent than in his greatest works, the frescoes in Sant'Andrea della Valle, where one of his subjects, the *Calling of Saints Peter and Andrew*, had a precedent in Raphael's tapestries.[21] It was the tapestries Domenichino knew, not the cartoons, but the connection with the cartoon is closer than with the tapestry, since he inverted Raphael's group. The two Saints are fused at a lower spiritual intensity, but they

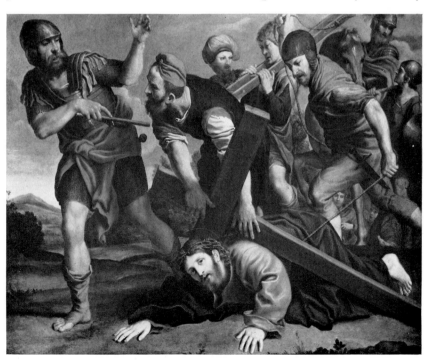

220. Domenichino:
Christ carrying the Cross.
Private Collection

remain deeply impressive works. With each visit to Sant'Andrea della Valle, the frescoes testify afresh that this indubitably was a great artist.

One of the most exacting painters who has ever lived believed that too. In 1624, two years before Domenichino's narrative scenes in Sant'Andrea della Valle were begun, Nicolas Poussin arrived in Rome. His taste moved in the same direction as Domenichino's. Bellori declares that Raphael was the spiritual father through whom he awoke to the life of art, and long before he went to Italy he was introduced to Raphael's work by engravings owned by the mathematician Courtois. Domenichino was the prey of impulse, a neurotic controlled by the emotions, but Poussin's thought processes were restrained and purposive, and when Domenichino, in the early sixteen-thirties, was submerged in the tidal wave of the baroque, Poussin pursued his predetermined course. Throughout his life his relationship to Raphael forms a mirror image of Raphael's relationship to the sources from which he in turn derived.

He knew, through an engraving, the seated *Virgin and Child* which had been designed by Raphael at the same date as the *Madonna della Sedia*, about 1515 (Fig. 221), and from it in 1641 he evolved the *Roccatagliata Madonna* at Detroit (Fig. 222),[22]

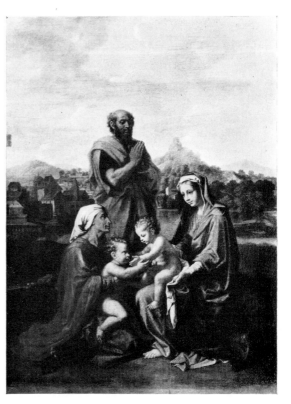

222. Poussin: *The Holy Family*. Detroit, Institute of Arts

223. Poussin: *Holy Family in a Landscape*. Paris, Louvre

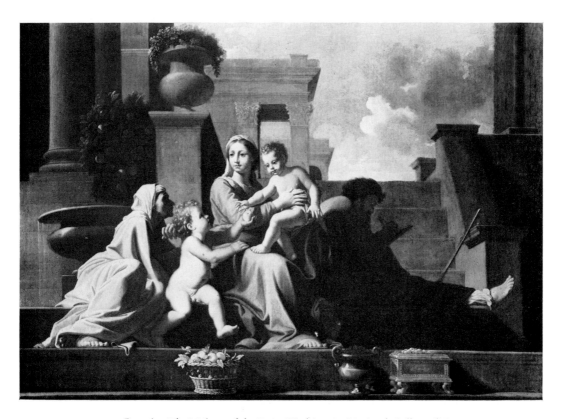

224. Poussin: *The Madonna of the Steps*. Washington, National Gallery of Art

where the Virgin again leans forward from her household chair, but the vertical
Child of Raphael is replaced by a horizontal Child gazing up into her face. He knew
the *Madonna of the Fish* (Fig. 202), which stood till 1638 in San Domenico Maggiore
in Naples, and from it he evolved the beautiful group of the Virgin and Child in
the *Madonna of the Steps* (Fig. 224),[23] setting it in ideal space which changed the whole
character of the design. On the left the Tobias of Raphael's altarpiece became the
young St. John, and behind him there appears a St. Elizabeth adapted from the
Canigiani Holy Family (Fig. 9), a painting then in Medici possession which had
been engraved. Much later, about 1656, he returned to the same theme in a picture
in the Louvre (Fig. 223),[24] where the Canigiani group has been thought out afresh
with the Child raised above the Baptist on the Virgin's knee and the figure of St.
Joseph shown in prayer in three-quarter face. In all these paintings the debt to
Raphael is manifest, but the pictures that result are as personal in spirit as is the
Canigiani Holy Family, where Raphael in his turn had made use of ideas culled
from Michelangelo.

The aspects of Raphael that appealed to Poussin were not those that had attracted
Domenichino. In the first place there was an inexhaustible appeal in Raphael's
mythological inventions, not in the Loggia of Psyche, whose complicated system of
illusionism was irrelevant to Poussin's work, but in the *Galatea*, which in 1653
inspired the great *Triumph of Neptune and Amphitrite* at Philadelphia,[25] where the
composition is extended at the left by the addition of another figure based on
Raphael and on the right by a naked woman with back turned from the *Wedding
Feast of Cupid and Psyche* on the Farnesina ceiling. One aspect of the picture seemed
to Poussin unclassical and therefore uncongenial, the circular movement of the
central group, and Poussin's figures are flattened out so that they constitute a frieze
spread across the painting.

More fundamental still was the influence of the *Parnassus*.[26] In Paris Poussin must
have got to know the Marcantonio engraving of Raphael's first design (Fig. 83),
and in Rome he examined the original (Fig. 82). The effect of both experiences
can be read in the drawing of the subject that he made (Fig. 225). The five flying
putti from the engraving are preserved, but Apollo has been moved off centre, and
plays a *lira da braccio* as he does in the fresco, and beneath is another feature from the
fresco, the Castalian Spring. The heads are imperfectly defined, but the figures have
been explained as Homer and Virgil crowned by Calliope in the centre, and on the
left Tasso introduced by Melpomene to Mount Parnassus. What can be seen is at
least sufficient to establish that a new narrative character is imposed upon the
scheme. Poussin restudied both the engraving and the fresco before the painting in
the Prado (Fig. 226) was produced. Two figures in the fresco were inapplicable to
the painting, the so-called Pindar and the Sappho, whose function was to link the

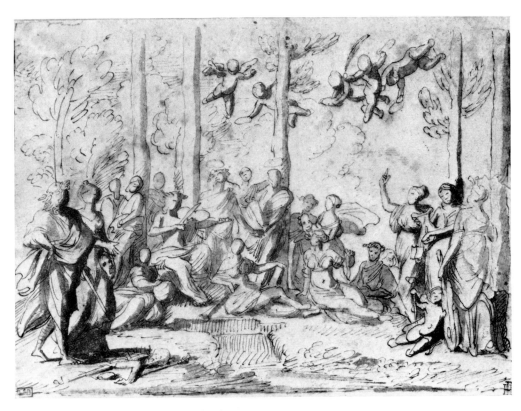

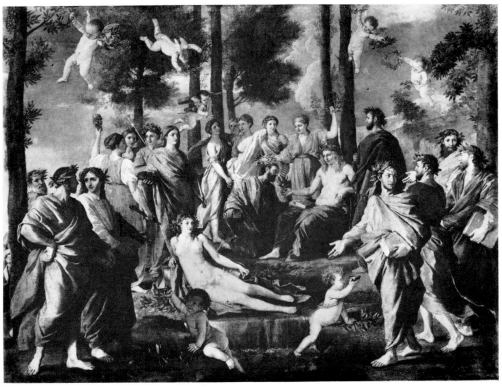

225 (above). Poussin: *Study for the Parnassus*. Paris, Wildenstein Collection

226 (below). Poussin: *Parnassus*. Madrid, Prado

space within the fresco to the real space of the room; in Poussin's canvas they could have no place, and the effect of their omission was to accent the vertical emphasis of the two lateral groups. That on the left is closer to the fresco than to the engraving, but on the right the action of the engraving is preserved. The central void was filled by a reclining female figure and two putti, and the flying Cupids, which Raphael had omitted from the fresco, were once more reinstated in the sky. Not only the group of Muses in the centre, but the thematic content of the scene was consciously transformed, in that Apollo is no longer portrayed as a musician, but offers the cup of inspiration to a poet kneeling at his feet. In this respect the scene conforms to the interpretation of Raphael's *Parnassus* given by Bellori. The imagery of the fresco was significant for Poussin in other ways as well. One of the most memorable of its inventions was at the back on the left, where the words of the blind Homer are taken down by a seated youth who is sometimes described as Ennius. In Poussin the image struck a responsive chord, and its outcome was the *Inspiration of the Poet* in the Louvre.

Almost equally important were the principles Raphael laid down for active figure compositions. Not till the Seicento did the engraving of the *Massacre of the Innocents* strike root. Re-study of it is likely to have been responsible for developing Poussin's painting of the *Rape of the Sabines* of about 1635 into the more lucid, powerful composition of two years later in New York. Its fascination was felt even by Lanfranco, the painter whom Domenichino attacked as an arch-renegade from classicism, for we find Lanfranco introducing, into the foreground of a baroque painting (Fig. 228), figures which presuppose a careful analysis of the engraving and of the *Battle of Ostia* in the Stanza dell'Incendio (Fig. 227).

The same goes for the tapestry cartoons, which blazed the trail for Poussin in the *Seven Sacraments*.[27] In the *Sacrament of Marriage* (Fig. 229) we find him making use of the same classical narrative technique that Raphael had employed for the *Healing of the Lame Man* (though the surrounding space is once again un-Raphaelesque), and when he was first cogitating the subject of the *Presentation of the Keys*, his mind returned to Raphael's scheme.[28] That stage is recorded in a drawing in the same direction as the tapestry. In the picture as it was painted,[29] he abandoned Raphael's scheme for a centralised design, but the new invention in a looser sense was also Raphaelesque. Striking as they are such examples afford scarcely the least impression of how intimate the contact between Raphael and Poussin was. Among the links that bound them were a common preoccupation with decorum, a common interest in archaeology, and a common belief in the poetic potentialities of painting.

Gian Lorenzo Bernini, when he was in Paris in 1665, expressed his admiration for Signor Poussin's pictures.[30] They were, he said, based on the antique and Raphael, and comprised everything which one could wish for in painting. The

227 (above). Raphael: *The Battle of Ostia*. Vatican

228 (below). Lanfranco: *Funeral of an Emperor*. Madrid, Prado

respect Bernini felt for Raphael is attested by his own works. His first great sculpture, the *Aeneas and Anchises* of 1618, is a sculptural paraphrase of the heroic group that Raphael introduced into the *Burning of the Borgo*, and when two decades later he treated the *Pasce Oves Meas*, a subject Raphael had portrayed, the influence of Raphael's imagery can again be clearly felt.

None the less as a painter Raphael spoke most unambiguously to painters, and to none more firmly than to Rubens. In Rubens' drawings there is abundant proof of the attention that he gave to Raphael's work. He studied the *Disputa* and the Psyche frescoes, and in Edinburgh there is a careful drawing made from the Prudence in the *Justice* lunette in the Stanza della Segnatura.[31] Rubens was an inveterate copyist – he copied the Prophets on the Sistine Ceiling and in his studio when he died there were copies of Raphael's tapestry cartoons[32] – but the drawings he made after Raphael were inspired by something more than curiosity. At Mantua, working under the lengthening shadow of Giulio Romano, his attention naturally centred upon Raphael's work, and there, about 1604, he turned his thoughts to the late masterpiece of the *Transfiguration* (Fig. 58). The painting (Fig. 230)[33] he evolved from it, at Nancy, is horizontal and not vertical, and is extended at the left by a wooded area which balances the landscape on the right, but the upper figures, and quite a number of the foreground figures too, have Raphael as their starting point. In Rubens' hands

229. Poussin: *The Sacrament of Marriage*. Edinburgh, National Gallery of Scotland (lent by the Duke of Sutherland)

they take on a baroque complexion, and the mystical character of the whole scene is changed. Whereas in Raphael's *Transfiguration* the afflicted boy and all the fore-ground figures are conscious of the vision at the back, with Rubens the contact is removed from the plane of human vision and symbolic rays of light flood down from the transfigured Christ on to the foreground of the scene. The pointing gestures are done away with, the boy gazes out at the spectator, and the protagonist is the kneeling woman in the centre whose face is touched with divine light and whose faith seems to have brought about the miracle.

In Rubens' tapestries the reference to Raphael is equally direct, not with the Sacrament tapestries, but in the Constantine cycle, some of the cartoons for which arrived in Paris in 1622.[34] The standards by which they were praised were based on Raphael – 'Everyone', Rubens was told, 'admired your profound knowledge of antique costumes' – and where they were found wanting, in a tendency towards realism which impaired their ideality, the criterion of criticism was Raphael too. Just as Raphael in his tapestry cartoons made overt reference to the antique, so Rubens in the Constantine tapestries made overt reference to Raphael. In the *Marriage of Constantine* there are details, the children beside the altar in the centre and the youth holding down the sacrificial ox, which relate to Raphael's *Sacrifice at*

230. Rubens: *Transfiguration*. Nancy

Lystra. In the *Battle of the Milvian Bridge* Rubens, like Domenichino at almost precisely the same time, introduces the motif of figures stretched against a wall, first of all in a sketch in the Wallace Collection, as a subsidiary feature of the composition, and then in the tapestry (Fig. 231) as a main feature in a form that brought them closer to the *Burning of the Borgo*. Finally, in the *Baptism of Constantine* Rubens in turn makes use of the celebrated scheme of Raphael's *Healing of the Cripple at the Golden Gate*; there are the same spiral pillars framing the central scene, there is a doorway at the back to lend the figures emphasis, and in the centre are the two protagonists. But as with Poussin the nature of the space is changed. The receding pillars are reduced to two, so that the recession of Raphael's composition is condensed, and the careful equipoise in the foreground of Raphael's tapestry is deliberately disjointed by a figure standing forward of the pillar on the right-hand side.

Among the works by Raphael in which Rubens felt special interest were the late Madonnas, where there was latent so much that anticipates baroque design. At Mantua he made a careful study of one of the Madonna compositions of which the best known version is in the Louvre.[35] He ignored the landscape – a romantic landscape which could have had almost no appeal in the Seicento – and changed the heads into bucolic Northern types, but he retained the composition, that is the linking of the figures. This and other formulations were stored away in the capacious wardrobe of his mind. The eventual outcome was an altarpiece of 1630 painted on the commission of the Infanta Isabella, the *Holy Family under the Apple Tree* in Vienna (Fig. 233),[36] where the figures derive from the *Holy Family of Francis I* in the Louvre

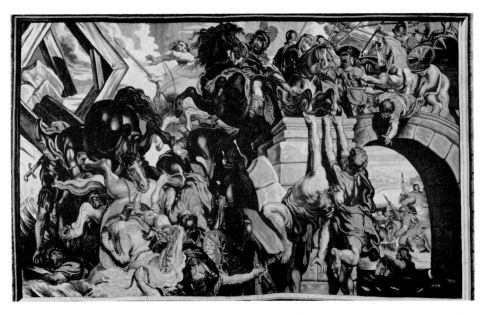

231. Rubens: *The Battle of the Milvian Bridge*. Tapestry. Philadelphia, Museum of Art (Kress Collection)

232. Workshop of Raphael (Giulio Romano?):
*Virgin and Child with SS. Elizabeth
and John the Baptist.* Paris, Louvre

233. Rubens:
Holy Family under the Apple Tree.
Vienna, Kunsthistorisches Museum

(Fig. 234), but with a change of role for in the hands of Rubens Raphael's Christ becomes a figure of the young St. John. These late Madonna compositions of Raphael had very little impact in the sixteenth century, and effectively Rubens is the first artist by whom their message was understood.

The little painting in the Louvre (Fig. 232) whose composition Rubens copied though designed by Raphael, was painted by Giulio Romano.[37] Rubens probably was cognisant of that, and so was Philippe de Champaigne when he discussed it in an Academy lecture in 1669.[38] 'It might have been expected', says Champaigne, 'that Raphael would have painted this rare work with his own hand, instead of entrusting the execution, as he did, to Giulio Romano.' Had he done so, the lecture goes on, he would have taken more pains with the placing of the Child Christ; the stance of the Child on the cradle would have been more convincing, and the Virgin's foot would have been less small. As it was, the figures and landscape were lit from different sources, and the merits of the picture lay in the figurative group, which was not perforated and therefore had strong relief; the disposition was designed to confer the utmost grace and sweetness on the figures. The forms beneath the draperies were so convincing that Champaigne supposed Raphael to have followed his usual practice of making nude drawings of the figures from life. The Child,

243

234. Raphael:
Holy Family of Francis I.
Paris, Louvre

while expressing child-like joy, had at the same time a certain spiritual pre-eminence over the Baptist, who submitted himself humbly to His caresses. Here as always Raphael showed himself supreme in the spiritual sphere of art; the eye could understand the words that were spoken by the figures he portrayed. The lecture, in short, concentrates on two aspects of the painting, its literary content and its form. The tone throughout is a good deal more sensitive and more percipient than was usually the case in addresses about Raphael at the French Academy, and especially than that in the addresses devoted to Raphael by Lebrun.

One of the inventions of Raphael that was most relevant to the seventeenth century was the last work that he designed, the *Victory of Constantine over Maxentius* in the Sala di Costantino of the Vatican (Fig. 235).[39] After Raphael's death Giulio Romano claimed to be in possession of the drawings for the fresco, and already in the fifteen-twenties in a life by Paolo Giovio the scheme of the fresco is attributed to Raphael.[40] No one who is alert to the personal qualities of Raphael's style can find it an ingratiating work, but it had an accidental value for posterity; in the absence of the battle frescoes of Leonardo and Michelangelo in Florence, it was the only extended Central Italian High Renaissance battle piece. For that reason Rubens studied it, and in the sixteen-thirties Pietro da Cortona returned to it once more when he was preparing his own *Battle of Arbela*.[41] In Pietro da Cortona's painting the format of the fresco is preserved, but the rear figures are elevated so that they close in the scene. When Lebrun was in Rome in the early sixteen-forties, he examined both Raphael's fresco and Pietro da Cortona's composition, and they were still present in his consciousness twenty years later at the time his own *Triumphs of Alexander* were designed. In one of his compositions, the *Crossing of the River Granicus* (Fig. 236),

he imitated the diagonal recession of the foreground in Raphael's fresco, and in another, the *Battle of Arbela*, he reinstated the panoramic background that Pietro da Cortona had excised. The *Alexander* paintings have been justly described as 'a didactic demonstration of the method of academic classicism',[42] and nowhere is their reclassicising, anti-baroque bias more apparent than it is here.

If that had been the limit of Lebrun's relationship to Raphael, all might have been well, but it was the symptom of a much more serious phenomenon, that in France Raphael was academicised. At the French Academy in Rome and at its dependency, the Florentine Academy, copying was the mainstay of the curriculum and sculptors were subjected to the most sterile of all forms of academic training, the copying of paintings in relief. In the French Academy reliefs were made from paintings by Poussin and Pietro da Cortona, and in the Florentine Academy talented young sculptors like Soldani were encouraged to treat the frescoes in Raphael's Loggia in the same way. Nicolas Coypel, one of the early directors of the French Academy in Rome, declared that the painters under him were 'disgusted with copying', and well they might have been. This practice of compulsory copying brought with it a theoretical literature in which the whole mistaken procedure was vindicated.

One Saturday in May 1667 a party of Academicians and their pupils visited the French Royal Collection, and before Raphael's *St. Michael* (Fig. 237) were addressed by Lebrun.[43] It will not be necessary to listen to the whole harangue, since a phrase or two suffices to give the general argument. The first cause for wonder is the body of the Saint, which seems to be supported in the air and yet has a heavy downward thrust. Its various parts show an agreeable contrast one with the other, and the devil beneath is disposed (there is a tell-tale phrase here) 'with the same industry'. The contours are traced as finely as by painters in antiquity, and the beauty of the drawing

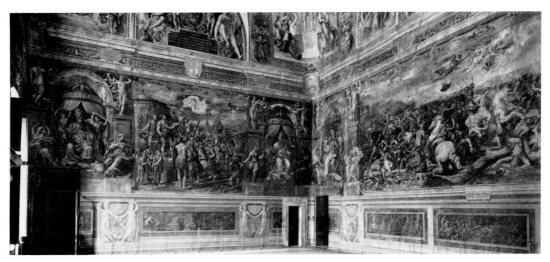

235. Workshop of Raphael: *The Victory of Constantine over Maxentius*. Vatican

245

236. Lebrun: *The Crossing of the River Granicus*. Paris, Louvre

can be followed even in shaded parts. The Saint's action expresses the power of God, and his virile beauty is appropriate to the role that he performs. His face is stamped with 'a certain disdain that is apparent in the eyes and mouth', and only scorn for the enemy that he has vanquished prevents him from delivering the coup de grâce. To Lebrun's way of thinking (and in this he was influenced by contemporary psychology), the peculiar merits of Raphael resided not just in his poses and compositions, but in the range of expression represented in his work. That line of thought eventuated in Lebrun's notorious handbook on the expression of emotion in the visual arts,[44] where standardised images are given for the various states of mind, choler, compassion, devotion, and the rest. Though its illustrations do not depend from Raphael, most of them are generically Raphaelesque. This concern with expression in Raphael's work was resumed in the next century by Mengs, who prepared a series of engravings from heads in the *School of Athens*.[45]

This is something of a cul-de-sac in the story of Post-Raphaelitism, but we must continue along it for a few steps more, because it influenced the way in which the nineteenth century saw Raphael's work. The *School of Athens* was not the only victim of this atomising tendency, for the *Transfiguration* was exploited in precisely the same way by Vincenzo Cammuccini[46]; it was broken up into a series of simplified engravings, which could be copied in crayon in drawing-rooms, and would supposedly transmit even to the most phlegmatic amateur some notion of the emotive world of the great altarpiece. In England, later in the nineteenth century, the Raphael cartoons were treated in the same way in a volume entitled *Poynter's South Kensington Drawing Book*.[47] There, from the title-page, the familiar face looked out at one, and inside were 'twelve fine figures bearing the unmistakable stamp of Raphael's genius' which could be traced. The principle behind the book was a perversion of the doctrine of Sir Joshua Reynolds, that 'the habit of contemplating and brooding over

237. Raphael: *St. Michael*. Paris, Louvre

238. Mengs after Raphael:
The School of Athens (detail).
London, Victoria and Albert Museum

the ideas of great geniuses till you find yourself warmed by the contact is the true method of an artist-like mind'.[48] This state of mind provoked a famous explosion by Ruskin: 'It being required to produce a poet on canvas, what is our way of setting to work? We begin by telling the youth of fifteen or sixteen that Nature is full of faults, and that he is to improve her; but that Raphael is perfection, and that the more he copies Raphael the better; that after much copying of Raphael, he is to try what he can do himself in a Raphaelesque but yet original manner. And we wonder we have no painters.'[49]

Not only did Mengs make isolated studies from the *School of Athens*, but in 1755 he prepared a full-scale copy of it.[50] Some preliminary drawings are at Karlsruhe, and the painting is in store in London in conditions which allow it to be illustrated only from details of the figures. If we juxtapose a section of the copy (Fig. 238) with a section of the work that Mengs was copying (Fig. 239), the limitations in his comprehension of Raphael's style require no stress. Three years later the devitalising process continued in the fresco of the *Parnassus*[51] in the Villa Albani. No more than

248

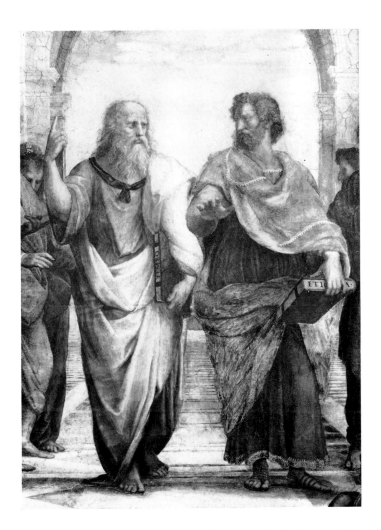

239. Raphael:
The School of Athens (detail).
Vatican

Lebrun, or Poussin, or Domenichino before him, was Mengs a plagiarist, and his intention was to evoke the spirit of Raphael's fresco, not its forms. The style of the fresco indeed, in so far as it is Raphaelesque, relates less to the *Parnassus* than to the Loggia of Psyche in the Villa Farnesina, where the figures are likewise based on antique sculptures and are disposed thinly across a horizontal field. Half a century later, one of the workmen who had prepared the plaster for Mengs took part in the preparation of the frescoes by his successors, the Nazarenes, in the Palazzo Zuccari.[52]

When Byron was in Rome in 1817, he wrote in a letter to John Murray: 'I perceive you are publishing a life of Raphael of Urbino; it may perhaps interest you to hear that a set of German artists here allow their hair to grow and trim it in his fashion. If they would cut their hair, convert it into brushes, and paint like him, it would be more "German to the matter".'[53] The Nazarenes had arrived in 1810, inspired by religious ideals which found a direct outlet in their style. They were obsessed by Raphael's early works, and no matter the date of the prototype they followed, whether it be the Stanze-inspired frescoes in the Casino Massimo, or

249

Führich's paraphrase of the *Miraculous Draught of Fishes*, or Schnorr von Carolsfeld's pastiche of the *Burning of the Borgo*, it was transposed into an idiom in which the influence of the young Raphael was predominant. The consequences can best be seen in Overbeck's *Triumph of Religion in the Arts* (Fig. 240),[54] where the composition is indeed based on the *Disputa* but is rephrased in the short, crisp sentences of the *Coronation of the Virgin* in the Vatican. Behind that development lay the personality of Wackenroder and the movement that was known in France and England as Christian Art. In practice a reassessment of value judgements on Raphael's paintings was involved. Delacroix in his journal describes Ravaisson expounding 'des idées néo-chrétiennes dans toute leur pureté' and apostrophising the young Raphael,[55] and in 1867 in the Vatican we come upon the Goncourts spluttering with anger in front of the *Transfiguration*[56]: 'The most disagreeable impression of badly painted paper that the eye of a colour loving painter can possibly receive. In all this there is not an atom of feeling, such as one finds in Simone Memmi, Filippo Lippi, Botticelli, Piero di Cosimo – that feeling which even the least gifted of primitive painters were able to introduce into their scenes. In Raphael the Transfiguration is purely academic, shot with a paganism which is particularly apparent in the foreground, where a woman, a bit of antique statuary, kneels like a heathen for whom the Gospels have never been spoken. I know no picture which disfigures Christianity in a more grossly material way, and I know no canvas depicting this scene in commoner prose.' In the same spirit Ruskin declares of the tapestry cartoons that 'the clear and tasteless poison of the art of Raphael infects with the sleep of infidelity the hearts of millions of Christians'.[57] Raphael, concludes Ruskin with errant logic, 'painted best when he knew least'.

But there was one artist in the nineteenth century who approached Raphael's work in a different spirit and with more perspicacious eyes than any painter who preceded him. The story goes back to 1775 when Jacques Louis David arrived in Rome. Endowed with strongly realistic propensities, he was attracted not by Raphael, but by the realists, Caravaggio, Ribera, and Valentin, and was insistent from the start on the value of study from the life. When he was eventually converted to a style based on the antique, this insistence on life study precluded his reverting to the inanities advocated by Winckelmann and perpetrated by Mengs. In 1796 he was joined by the young Ingres, whose interest in Raphael had been awakened at Montauban by a copy of the *Madonna della Sedia*, and whose later life was a long act of obeisance at the shrine of the man-god. 'The objects of my adoration', he said in 1821,[58] 'are always Raphael, his century, the ancients, and above all the divine Greeks.' 'Nothing essential remains to discover in art', he wrote on another occasion,[59] 'after Phidias and Raphael, but there remains the task of tending the cult of truth and perpetuating the tradition of beauty.' Raphael, he said again,[60] after visiting the

240. Overbeck: *The Triumph of Religion in the Visual Arts.*
Frankfurt, Staedel Institute

Stanze in 1814, 'worked from genius and carried all nature in his head or rather in his heart. There one becomes a second creator.' At the end of his life he used to advise visitors to the Louvre to put on blinkers and look at nothing before they reached the room in which the Raphaels were shown. Ingres understood, as no previous artist had done, the primacy of drawing in Raphael's work and the Neo-Aristotelian imitative theory on which his style was based. 'Raphael,' he declared, 'imitating ceaselessly, always remained himself.'[61]

So did Ingres, whose copies after Raphael are documents of extraordinary interest. The young Raphael might speak to the Nazarenes, but he did not speak to Ingres. Indeed one of the few pre-Roman Raphaels that Ingres studied intensively was the *Madonna del Granduca*, of which there is a copy at Montauban (Fig. 241).[62] What concerned him here was not expression, but the placing of the column of form within

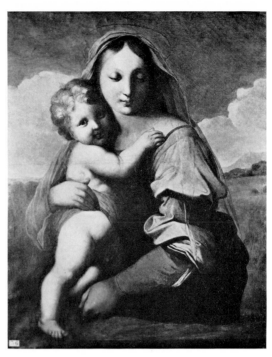

241. Ingres after Raphael: *Madonna del Granduca*. Montauban, Musée Ingres

242. Ingres after Raphael: *The Mackintosh Madonna*

the frame. When that had been established, work was broken off. Instead the weight of emphasis was placed where it ought properly to fall, on those aspects of Raphael's mature work which were forward-looking and were therefore open to development. One of the first copies he made when he arrived in Rome was of the *Miracle at Bolsena*, and the passage that he copied was not the figure of the priest or the papal retinue on the right, but the really miraculous heads of the women and children on the left-hand side, whose full contours could be transferred to his own paintings.[63] Back in Paris in 1815, when so many of Raphael's greatest works were shown together in the Louvre, he set to work once more. He copied the head of the *Madonna di Foligno*[64] and the whole of the *Madonna dell'Impannata*,[65] where his interest centred on the composition and not on the defective, little-tactile forms. At the same time he made a copy, at first or second hand, of the painting in London that is known as the *Mackintosh Madonna* (Fig. 243).[66] The copy (Fig. 242) is said to have been prepared from a version by Sébastien Bourdon, not from the original, and it is very easy to believe that that was so, for in the nineteenth century the original was already in the ruined state in which it is today, and it would have needed an act of preternatural empathy to reinvest its blunted silhouette with the Poussinesque precision of the version that Ingres made. Ingres indeed looked at the scheme with almost the same eyes with which Philippe de Champaigne had looked at the *Madonna* in the Louvre more than a century and a half before. When in 1820 he was planning the *Vow of*

Louis the Thirteenth (Fig. 246), he revised the figure of the Child along lines that Raphael would himself have approved, painting it as it might have looked had the *Mackintosh Madonna* been designed a few years later than it was and preserved as well as the *Madonna di Foligno*.[67]

Commissioned for the Cathedral at Montauban, the *Vow of Louis XIII* forms the climactic point in Ingres' life – it was the painting through which he secured the public recognition that was never later to elude him – and it was the climactic point in his relationship to Raphael too. Ingres at first jibbed at the theme. The picture was to represent an *Assumption of the Virgin* with the figure of Louis XIII in the foreground, and the objections that Ingres raised to it are curiously like those which were raised by Shaftesbury to Raphael's *Transfiguration*. It implied, he said, a lack of unity, and all his experience of the way in which anachronistic subjects were treated in Italian painting led him to one conclusion, that a simple *Assumption of the Virgin* was to be preferred. This was the opposite of Raphael's own reaction to the *Transfiguration* altarpiece, where the simple subject of the Transfiguration was, at the painter's instigation, changed into a dual scene. In fact there was no modifying the

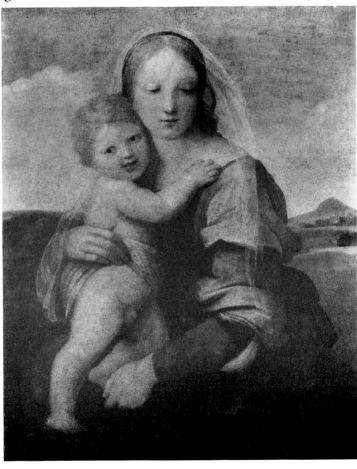

243. Raphael:
The Mackintosh Madonna.
London, National Gallery

253

thematic content of the altarpiece for Montauban, and inevitably it was to Raphael that Ingres turned for help. 'I am sparing no pains', he says in a letter of 1821, 'to make the work Raphaelesque and at the same time my own, delving into nature, that veritable mother of artists, where one finds and will always find treasures as great as the variety of objects that lie hidden beneath the sea.' One minor change was indeed introduced, that the Assumption of the Virgin at the back was replaced by a Virgin and Child. We know from a sketch that the Virgin of the Assumption was based on the *Sistine Madonna*, and when the crucial change was made, and the Virgin was shown seated holding the Child, it was the *Mackintosh Madonna* which supplied Ingres with his starting point. In addition, the curtains were now held back by angels, one of which was based on Raphael's angels in Santa Maria della Pace.

One of the difficulties that the work presented was the linking of the unaccompanied figure of the kneeling King to the Virgin at the back. How to provide it with a counterpoise, and how to establish an unambiguous connection between the figures? The problem of balance was solved comparatively easily. The painter's mind reverted to the *Madonna del Baldacchino* and the *Sistine Madonna*, with their paired putti, and to the *Madonna di Foligno*, with its single putto holding a tablet, and two putti with a tablet were therefore inserted in the foreground of Ingres' painting. For the figure of the King there was also a precedent in Raphael; it occurred in the *Burning of the Borgo* in the kneeling woman appealing to the distant Pope, and

244. Workshop of Raphael: *Joanna of Aragon.*
Paris, Louvre

245. Ingres: *Madame Moitessier.*
London, National Gallery

254

though the form in which Ingres uses it is more schematic – the King's arms are parallel, and not splayed wide apart like the arms of Raphael's figure – the origin of the device is not in doubt. It has been said that the *Vow of Louis XIII* is a 'despairing synthesis' of Raphaelesque motifs. It can, however, be looked at from a different point of view as the most comprehensive and intelligent analysis of Raphael's style supplied by any later artist.

It would be wrong to conclude that for Ingres Raphael's work provided signposts in an unfamiliar countryside. It did a great deal more than that. If, for example, we try looking at Raphael's portraits through Ingres' eyes – at the hands of the *Donna Gravida*, for instance, or at the portrait of Tommaso Inghirami in Boston – it becomes clear that the debt Ingres owed to them was of a much more general kind. When he painted the portrait of Bertin in the Louvre, though he visualised it in a way that is utterly un-Raphaelesque, he enlivened it with one device from Raphael, that the source of light, a window, is reflected on the chair arm on the right-hand side. He did so because he knew that in the great triple portrait of Leo X in the Uffizi the source of light was reflected on the knob of the chair in the same way. Unless he had known the Raphael-planned *Joanna of Aragon* in the Louvre (Fig. 244),[68] it is almost inconceivable that he would have reformulated the Pompeian source of the portrait of Madame Moitessier in London (Fig. 245)[69] precisely as he did. In this case the later is much the greater portrait; it realises Raphael's intentions more closely than the wretched painting that was worked up from his design.

The subject of this chapter has been the attitude of artists – artists not scholars – to the works Raphael produced. It may be that after it the quotation from Crowe and Cavalcaselle from which this inquiry started will seem just a little less absurd than it appeared at first. Wonder, delight, and awe did take possession of their souls, and it is no cause for pride if they do not inhabit ours. There is a clear-cut conflict between the artistic processes that have been described and the creative procedures which are sanctioned by our aesthetic today. The cult of self-expression, the habit of indiscipline, the thirst for novelty, are hurdles in the way of a proper understanding of Raphael's work. But if we can temporarily free ourselves from these inhibitions, and look once more at the artist Poussin and Ingres saw, through force of contrast the message becomes more categorical. Those embodied intellectual aspirations, those images of zeal and awe, that unflagging physical vitality, the elemental definition of emotion, those heads instinct with the acuity and ambivalence of the human mind, are still vigorously alive, and must continue to command affection and respect. If the message has been read by so many artists in so many different ways, can we be quite certain that its efficacy is exhausted and that it cannot once again be reinterpreted? Time will tell. Meanwhile we may repeat with Reynolds that 'of the just hyperbole the perpetual instance is the divine Raphael'.

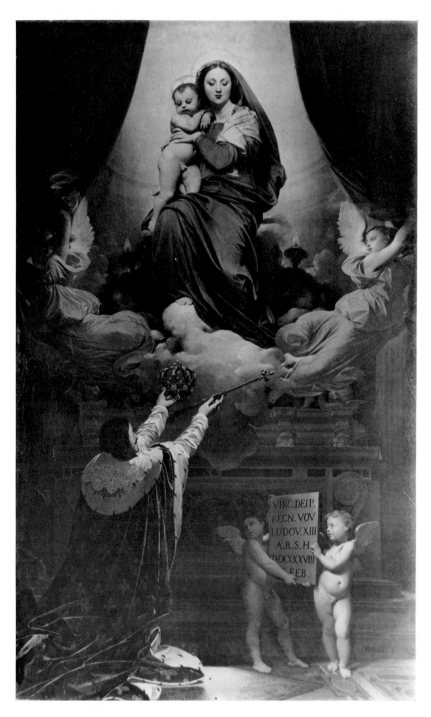

246. Ingres: *The Vow of Louis XIII*. Montauban, Musée Ingres

NOTES TO THE TEXT

BIBLIOGRAPHICAL ABBREVIATIONS

BELLORI, *Descrizione*
Giovanni Pietro Bellori, *Descrizione delle imagini dipinte da Raffaello d'Urbino nelle Camere del Palazzo Apostolico, Vaticano* Rome, 1695.

CAMESASCA
Tutta la pittura di Raffaello, a cura di Ettore Camesasca. 2 vols. 2nd ed., Milan, 1962.

CROWE AND CAVALCASELLE
J. A. Crowe and G. B. Cavalcaselle, *Raphael: his Life and Works*, 2 vols., London, 1882.

DUSSLER
L. Dussler, *Raffael: Kritisches Verzeichnis der Gemälde, Wandbilder und Bildteppiche*, Munich, 1966.

FISCHEL, 1948
O. Fischel, *Raphael*, translated from the German by B. Rackham. 2 vols., London, 1948.

FISCHEL, 1962
O. Fischel, *Raphael*, Berlin, 1962.

FISCHEL, *R.Z.*
Raphaels Zeichnungen, herausgegeben von Oskar Fischel, i–viii, Berlin, 1913–41.

FISCHEL, *Versuch*
O. Fischel, *Raphaels Zeichnungen: Versuch einer Kritik der bisher veröffentlichten Blätter*, Strassburg, 1898.

FISCHEL, *Z.d.U.*
O. Fischel, *Die Zeichnungen der Umbrer*, Berlin, 1917.

GOLZIO
V. Golzio, *Raffaello nei documenti, nelle testimonianze del contemporanei, e nella letteratura del suo secolo*, Rome, 1936.

OBERHUBER, *Incendio*
K. Oberhuber, 'Die Fresken der Stanza dell'Incendio im Werk Raffaels', in *Jahrbuch der Kunsthistorischen Sammlungen in Wien*, lvii (n.f. xxii), 1962, pp. 23–72.

OBERHUBER, *Transfiguration*
K. Oberhuber, 'Vorzeichnungen zu Raffaels "Transfiguration",' in *Jahrbuch der Berliner Museen*, n.f. iv, 1962, pp. 116–149.

P.J.
Jahrbuch der Preussischen Kunstsammlungen.

PARKER
K. T. Parker, *Catalogue of the Collection of Drawings in the Ashmolean Museum*, ii: *Italian Schools*, Oxford, 1956.

PASSAVANT
J. D. Passavant, *Raffael von Urbino und sein Vater Giovanni Santi*, 2 vols., Leipzig, 1838, iii, Leipzig, 1858.

POPHAM AND WILDE
A. E. Popham and J. Wilde, *The Italian Drawings of the XV and XVI Centuries in the Collection of His Majesty the King at Windsor Castle*, London, 1949.

POUNCEY AND GERE
Italian Drawings in the Department of Prints and Drawings in the British Museum: Raphael and his Circle. By P. Pouncey and J. A. Gere. 2 vols., London, 1962.

PUTSCHER
M. Putscher, *Raphaels Sixtinische Madonna: das Werk und seine Wirkung*, Tübingen, 1955.

REDIG DE CAMPOS
D. Redig de Campos, *Raffaello nelle Stanze*, Milan, 1965.

Rendiconti
Atti della Pontificia Accademia Romana di Archeologia: Rendiconti.

SHEARMAN, *Stanze*
J. Shearman, 'Raphael's unexecuted projects for the Stanze,' in *Walter Friedlaender zum 90. Geburtstag*, Berlin, 1965.

VENTURI, *Storia*
A. Venturi, *Storia dell'arte italiana*, Milan, 1901–40.

W.J.
Jahrbuch der Kunsthistorischen Sammlungen des Allerhöchsten Kaiserhauses in Wien (continued as *Jahrbuch der Kunsthistorischen Sammlungen in Wien*).

NOTES TO THE TEXT

NOTES TO CHAPTER I

1. J. A. Crowe and G. B. Cavalcaselle, *Raphael: his Life and Works*, 2 vols., London, 1882.

2. Florence, Uffizi. No. 288 Panel: 45 × 33 cm. The tradition, recorded by Camesasca, i, Milan, 1962, pp. 46–47, that the painting was presented to the Accademia di San Luca in Rome in 1588 by Federigo Zuccaro, and was later sold by the Accademia to Cardinal Leopoldo de' Medici, is incorrect. As established by E. Ridolfi, 'Di alcuni ritratti delle Gallerie Fiorentine', in *Archivio storico dell'arte*, iv, 1891, pp. 425–8, it reached Florence in 1631 from Urbino with the property of the Grand Duchess Vittoria della Rovere, and is identical with No. 32 in the inventory of the Urbino paintings printed by Gotti, *Le gallerie e musei di Firenze*, 2nd ed., Florence, 1875, p. 335 ('Uno detto in tavola Ritratto di Raffaello, di sua mano'). The correct provenance is given by Dussler, No. 39, p. 31.

3. For the self-portrait in the fresco see G. Vasari, *Vite*, ed. Milanesi, iv, Florence, 1879, p. 332, and D. Redig de Campos, 'Notizie intorno all'auto ritratto di Raffaello nella Scuola d'Atene', in *Rendiconti*, xxviii, 1955–6, pp. 251–7.

4. Crowe and Cavalcaselle, i, pp. 281–2, observe that the portrait 'hardly reveals the energy and deter-mination which are manifested in the works that have just been described', adding the rider that 'few pictures of the master have suffered more'. In the Italian edition (G. B. Cavalcaselle and J. A. Crowe, *Raffaello: la sua vita e le sue opere*, Florence, 1884, i, p. 289) this passage is modified to read: 'il suo ritratto . . . non mostra oggi tutte le bellezze che vedonsi nelle altre sue opere a causa dei danni e dei restauri patiti'.

5. E.g. H. Grimm, 'Raphaels Gesichtsbildung,' in *Fünfzehn Essays*, Erste Folge, 3rd ed., 1884, pp. 480–9 ('Meine Vermuthung, der Kopf so wie er heute dasteht, sei in Farbe wie Umrissen eine Fälschung') and A. Springer, *Raffael und Michel-angelo*, i, Leipzig, 1883, p. 383 ('wenigstens die Umrisse intact geblieben sind'). The case is restated by M. Putscher, *Raphaels Sixtinische Madonna*, Tübingen, 1955, pp. 180–1, on the basis of a retouched photograph. For the attitude adopted in the mid-nineteenth century to this and other portraits of Raphael see also Grimm, 'Raphael's eigene Bildnisse' (1869), in *Fünfzehn Essays*, Berlin, 1875, pp. 293–330.

6. For this painting see particularly P. Cellini, 'Il S. Luca di Raffaello', in *Bollettino d'Arte*, xxx, 1936–7, pp. 282–8, and 'Il restauro del S. Luca di Raffaello', in *Bollettino d'Arte*, xliii, 1958, pp. 250–62. The painting appears in inventories of the Accademia di San Luca after 1579. In the early seventeenth century, when it was examined on behalf of the Duke of Mantua by Pietro Fachetti (d. 1613), it was believed to have been painted by Raphael for the church of SS. Martina e Luca. The attribution to Raphael is revived by Cellini and dismissed by Dussler, No. 111, p. 62.

7. The bust, for which see Cellini, loc. cit., was commissioned from the sculptor Naldini (1615–1691) in 1674.

8. Bellori, *Descrizione*, 1695, p. 104.

9. O. Kutschena-Woborsky, 'Ein kunsttheoreti-sches Thesenblatt Carlo Maratta's und seine aesthetischen Anschauungen', in *Mitteilungen der Gesellschaft für Vervielfältigende Kunst*, 1919, pp. 9–28.

10. K. Gerstenberg, 'Die künstlerischen Anfänge des Anton Raphael Mengs', in *Zeitschrift für Kunst-geschichte*, ii, 1933, pp. 277–88.

11. *An Account of the Picture of Frederick Overbeck representing Religion glorified by the Fine Arts, now in Staedel's Art Institute at Frankfurt-on-the-Maine*, Oxford, 1850.

12. The opening of the tomb is described in a letter from Nibby to Quatremère de Quincy, printed in Quatremère de Quincy, *Raphaël*, Paris, 1835, pp. 461–7. The monument, provision for which was made under the terms of Raphael's will, is the subject of an excellent study by T. Buddensieg, 'Raffaels Grab,' in *Festschrift Kauffmann: Munu-scula Discipulorum*, Berlin, 1968, pp. 45–70.

13. A. Comolli, *Vita inedita di Raffaello da Urbino*, Rome, 1790. A. Springer, 'Die Echtheit des Anonymus Camolli's' in *Repertorium für Kunstwissenschaft*, v, 1882, pp. 357-63, proves conclusively that details in this book are drawn from the Bottari edition of Vasari (1759).

14. N. Schlemoff, *Ingres: ses sources littéraires*, Paris, 1956, p. 137. The first of the paintings by Ingres based on the Comolli life is the *Fiançailles de Raphaël* of 1813 (Lapauze, *Ingres: sa vie et son œuvre*, Paris, 1911, pp. 148-50).

15. G. Wildenstein, *Ingres*, London, 1956, Nos. 85, 86, 88, 89, 231, 297. The first version of *Raphael and the Fornarina* dates from 1813 and the last from 1860.

16. *Zwölf Umrisse zum Leben Raphaels von Urbino entworfen von J. Riepenhausen*, Berlin und Göttingen, 1833. The engravings are the work of Johann Riepenhausen (1798-1860) and were published two years after the death of his brother Franz (1786-1831).

17. J. D. Passavant, *Raffael von Urbino und sein Vater Giovanni Santi*, i, ii, Leipzig, 1838, iii, Leipzig, 1858.

18. For the putative portraits of the child Raphael at the age of three in Berlin and at the age of nine in a fresco at Cagli see Passavant, i, pp. 366-70.

19. For this painting see P. della Pergola, *Galleria Borghese: i dipinti*, ii, Rome, 1959, pp. 49-50, No. 70. The picture is listed in an inventory of 1790 as 'ritratto di Raffaello da se medesimo', and according to Passavant, i, pp. 366-70, 'dürfte den jungen Rafael in einem Alter von 12 Jahren vorstellen'. It is given by Passavant to Timoteo Viti, and by other scholars to Ridolfo Ghirlandaio.

20. Passavant, i, p. 74: 'Herr von Rumohr ist der erste, welcher richtig die jugendliche Gestalt neben dem Pinturricchio im Bild der Heiligsprechung der Catharina von Siena, als Bildnis Rafael's bezeichnet hat.'

21. H. Ruland, *The Works of Raphael Santi da Urbino as represented in the Raphael Collection in the Royal Library at Windsor Castle formed by H.R.H. the Prince Consort 1853-1861 and completed by Her Majesty Queen Victoria*, London, 1876.

22. E. Müntz, *Raphaël. Sa vie, son œuvre et son temps*, Paris, 1881.

23. O. Fischel, *Raphaels Zeichnungen: Versuch einer Kritik der bisher veröffentlichten Blätter*, Strassburg, 1898.

24. *Raphaels Zeichnungen*, herausgegeben von Oskar Fischel, i-viii, Berlin, 1913-41.

25. O. Fischel, *Raphael*, translated from the German by Bernard Rackham, 2 vols., London, 1948. The book is best read in the later German edition (*Raphael*, Berlin, 1962).

26. The corner-stone for our knowledge of Raphael's features in the last years of his life is a frescoed portrait on a ceiling in the Villa Lante, Rome, which was built and decorated by Baldassare Turini, the datary of Leo X and a patron of Raphael (for this see T. Steinby, *Villa Lante*, Helsingfors, 1957, p. 66). The features in the frescoed portrait correspond with those of the rear figure in a painting of ca. 1518-19 in the Louvre traditionally known as *Raphael and his Fencing Master*, whose much disputed but well founded attribution to Raphael is supported by Fischel, 1948, i, pp. 119-20, and 1962, p. 89, and rejected by Dussler, No. 107, p. 61. The eccentric title of this picture is due to the fact that the forward figure, whose identity cannot be established, conforms in pose to the strongly activated foreground figures of the *Transfiguration*. An engraving of Raphael by Bonasone (B. xv 347) is either a free variant of the rear figure in the Louvre portrait or a transcription of another lost self-portrait. The evidential value of a supposed self-portrait identified by Fischel in the *Expulsion of Heliodorus* and of an engraving by Marcantonio Raimondi (B. xiv 496) (for which see H. Delaborde, *Marc-Antoine Raimondi*, Paris, 1888, pp. 254-6) is debatable.

27. From the extensive literature of this subject see particularly F. Villot, *Notices des tableaux exposés dans les galeries du Musée National du Louvre*, i, Paris, 1851, p. xliv: 'Dans la même année des tableaux recueillis à Venise, à Florence, à Turin, à Foligno, après avoir été exposés pour la plupart dans l'état où ils se trouvaient afin de satisfaire l'impatience des artistes et des amateurs, reparaissent, après une courte absence, admirablement restaurés. . . . Une main habile les fixe sur la toile, les rend à la vie, et les procédés employés en pareilles circonstances, procédés dont on avait fait jusque-là un

mystère, sont minutieusement décrits dans la notice de 18 ventôse an X (9 mars 1802).' A report on the action taken is also printed as an appendix to the French edition of Passavant's *Raphaël* (éd. revue et annotée par M. Paul Lacroix, ii, Paris, 1860, pp. 621–9: 'On ne sait point assez la reconnaissance que les amis des arts doivent à la France, qui peut avec orgueil s'attribuer l'honneur d'avoir véritablement sauvé plusieurs chefs-d'œuvre de la peinture. . . . Le gouvernement de la République française chargea l'institut national de chercher les meilleurs moyens pour obvier à la perte totale des tableaux de Raphael.')

28. For the vicissitudes of this painting see D. Redig de Campos, 'L'Incoronazione della Madonna di Raffaello e il suo restauro', in *Fede e Arte*, nos. 7–8, 1958, pp. 343–8.

29. A. Gotti, *Le gallerie e musei di Firenze*, 2nd ed., Florence, 1875, pp. 207–22, records eight Raphaels among the sixty-three paintings confiscated from the Palazzo Pitti in 1799. The *Madonna del Baldacchino* was among a number of paintings distributed to the French provinces in 1803–5, and was eventually reclaimed at Brussels. For this reason it escaped transfer to canvas.

30. The painting was moved from Foligno to Paris in 1797. Owing to damage suffered in transit, it was recommended that it should be transferred to canvas, and the operation was undertaken in 1800–1. The painting was restored again in 1957–8. A report on its condition after its arrival in Paris is printed in the French edition of Passavant's monograph on Raphael (revue et annotée par M. Paul Lacroix, Paris, 1860, pp. 621–9). For the later restoration see D. Redig de Campos, 'La Madonna di Foligno di Raffaello', in *Miscellanea Bibliotecae Hertzianae zu Ehren von Leo Bruhns*, Munich, 1961, pp. 184–97.

31. The *St. Cecilia* was one of thirty-two works seized in Bologna in 1796. According to C. Masini (*Storia della Pinacoteca di Bologna*, 1888, pp. 6–11) the condition of the fourteen works returned to Bologna in 1815 was satisfactory, 'se non che il Raffaello andato in Francia dipinto in tavola ritornò trasportato sulla tela, e bisognoso di un restauro nell'aria di fondo, che vi fù operato'.

32. A useful summary of the condition of the Prado

paintings is supplied by P. de Madrazo, *Catalogue des tableaux du Musée du Prado*, Madrid, 1913, p. 63. The *Madonna of the Fish*, the *Spasimo di Sicilia*, the *Madonna della Perla*, and the *Visitation* were taken to Paris in 1813. They appear to have suffered from damp in transit at Tours, and though ceded by Louis XVIII to Ferdinand VII of Spain could not leave Paris owing to their precarious state. It was recommended by Canova that they should be transferred to canvas before their despatch to Madrid. The *Madonna of the Fish* and the *Visitation* were transferred by Hacquin and Bonnemain in the first half of 1816, and the *Spasimo di Sicilia* was transferred in 1818.

33. For the condition of the *Transfiguration* see G. Male, 'La Transfiguration de Raphaël: quelques documents sur son séjour à Paris, (1798–1815)', in *Rendiconti*, xxxiii, 1960–1, pp. 225–36. When the painting left Rome, it was reported to have been restored some sixty years before. The flaking paint was replaced before it was put on exhibition in November 1798. A proposal that the panel should be cradled was disallowed. The *Transfiguration* was varnished on its return to Rome in 1817, and underwent further superficial restoration in 1932.

34. For the condition of the *St. Michael* and the *Holy Family of Francis I* see S. de Ricci, *Description raisonnée des peintures du Louvre: 1, Écoles Étrangères, Italie et Espagne*, Paris, 1913, pp. 130–1, 124–6. Both pictures were cleaned and varnished by Primaticcio at Fontainebleau in 1537–40, and the *St. Michael* was restored by Guélin in 1685. In 1749 it was reported to be in bad condition, in 1750 advice was given that it should be transferred to canvas, and a year later a detailed account of its state was prepared by a committee headed by Coypel. The picture was transferred from panel to canvas in 1751 by Picault. The paint film was laid down on new canvas by Hacquin in 1776, the canvas was again renewed in 1800 by Picault the Younger, and the painting was restored once more in 1860 when it was 'menaçant de tomber complètement par écailles'. Crowe and Cavalcaselle, ii, p. 396, observe that 'the foreground and figure of Satan are very much injured, and the foot of St. Michael on the shoulder of Satan is entirely new'. Unfavourable reports were made on the state of the *Holy Family of Francis I*, in 1749, 1763, and 1776, and it was transferred to canvas by Hacquin in 1777.

35. The altarpiece remained in S. Francesco at Città di Castello till 1798, when, despite the opposition of the French commissary at Ancona, it was offered as a public gift to General Giuseppe Lechi. Lechi sold it in 1801 to a Milanese collector, Giacomo Sannazaro, who three years later bequeathed it to the Ospedale Maggiore in Milan. At the insistence of the Accademia di Belle Arti it was compulsorily acquired by the French government in Milan for the Pinacoteca di Brera in 1806. Unsuccessful attempts to establish a title to the picture were made by the Franciscan community at Città di Castello (1819) and by the Gualterotti family, to whom rights over the altar in S. Francesco had passed from the commissioning family of Albizzini in 1633. In 1859 it was proposed that the painting should be presented to the then victorious French government. The altarpiece was later restored 'malgrado molte proteste' by Giuseppe Molteni (for this see F. Malaguzzi-Valeri, *Catalogo della R. Pinacoteca di Brera*, 1908, pp. 267-9), who, according to Crowe and Cavalcaselle, 'flattened the battens and stopped the wormholes with quicksilver. But the cleaning to which he or earlier restorers subjected the panel injured the patina of the picture and threw the colours out of focus. The most discoloured part is the flagged pavement behind the principal figures.'

36. For the condition of this picture see p. 287, note 44.

37. For the condition of this picture see p. 286, note 27.

38. For the condition of this picture see p. 285, notes 18, 19.

39. The best account of the condition of the painting before its transfer to canvas is that of Crowe and Cavalcaselle, ii, p. 126: 'Before the picture was transferred to canvas it had two very unfortunate cracks – one of them, running down the centre of the picture vertically, taking the cheek and leg of the Madonna and the right side of the Saviour. A second split runs down the landscape to the right of the Virgin. These fissures have led to a necessary patching in the parts which they injured. But besides this there are retouches in the left eye, nose, mouth, and cheek of the Virgin, the hair, temple, cheek, left thigh and knee of Christ, and breast and neck of the Baptist. The colours are injured

in the background and dresses. But in preserved places, such as the knee of the Baptist, and the right knee and leg of Christ, the exquisite finish of Raphael is maintained.'

40. For this picture see p. 287, note 51.

41. It is confirmed by the National Gallery of Art that both haloes in this painting have been renewed and do not register in X-ray photographs. The form of the present haloes is different from and weaker than that shown in photographs made before the sale of the painting from Panshanger. The paint surface is otherwise in excellent condition.

42. The best account of the condition of the frescoes in the Loggia of Psyche is that of R. Foerster, *Farnesina-Studien: ein Beitrag zur Frage nach dem Verhältnis der Renaissance zur Antike*, Rostock, 1880, pp. 34-38. For the text of the relevant part of the bull of 24 April 1580 see Foerster, op. cit., p. 127. The earliest of Cherubino Alberti's engravings is that of *Jupiter embracing Cupid*, which dates from 1580.

43. There is some doubt whether a restoration stated by Foerster, op. cit., p. 36, to have been undertaken ca. 1650, on the initiative of Ranuccio II Farnese, Duke of Parma (1646-1694), actually took place. For the restoration by Maratta see G. B. Bellori, *Descrizione*, 1695, pp. 83-84: 'La loggia di Raffaello, benche più antica, è stata rispettata dal tempo più di quello . . . non vi è stato bisogno di restringere, o di ristorare muri, ma solamente di riattaccare ed inchiodare la colla nella istessa maniera, che si è fatto della Gallerie d'Annibale, con mettere in opera 850 chodi. Il danno fatto dall'aria a detta loggia è stato molto più considerabile . . . Il danno fatto ai colori, che hanno perduto la loro vivacità, e sopratutto alle mezze tinte in gran parte sparite, ed universalmente a tutti i campi, che erano divenuti cosi neri, che appena si conosceva esser stati formati con quel buono azzurro, che in qualche parte o meno esposta, o meglio tinta pure si vedeva. Ma perchè questo è un male troppo difficile a ripararsi senza offendere la superstizione di alcuni, che consentono piuttosto alla caduta totale di una pittura egregia, che a mettervi un puntino di mano altrui, benchè perito, ed eccellente, è certo un inganno commesso a credere che non si possa fare altro che attendere a conservare al meglio che

si può gli avanzi del tempo, e le venerate reliquie di così mirabili lavori.'

44. Bellori, *Descrizione*, 1695, p. 85: 'Raffaelle, e gli eccellenti Discepoli della sua scuola non condussero a fine l'opera suddetta, perchè i festoni de' fiori, e frutti dipinti di Gio. da Udine non si stendevano fino alla cornice, come richiedeva l'intenzione dell'opera, rimanendovi da dipingere over due over tre palmi di distanza per far poggiare il festone sopra detta cornice.'

45. Bellori, *Descrizione*, 1695, p. 85, notes that in this pendentive there was a 'mancanza totale de' vestigi', and that Maratta accordingly 'si poneva a disegnare statue antiche, come fece in particolare dell'Antino, e del Torso dell'Ercole di Belvedere, donde Raffaëlle prese le suddette due figure'.

46. Bellori, *Descrizione*, 1695, p. 84.

47. Institut Néerlandais, Paris (Lugt Collection). The relation of the drawing to the fresco is discussed by M. Jaffé, 'Italian Drawings from Dutch Collections', in *Burlington Magazine*, civ, 1962, p. 233. The drawing is given by J. Shearman ('Die Loggia der Psyche in der Villa Farnesina', in *W.J.*, lx, 1964, p. 94), in my view mistakenly, to Giulio Romano.

48. Bellori, *Descrizione*, 1965, p. 86. The decoration of the pilasters was renewed in the seventeenth century by Giovanni Paolo Mariscotti, who may also have worked on the surface of the fresco.

49. J. Richardson, *An Account of the Statues, Bas-reliefs, Drawings and Pictures in Italy, France, &c. with Remarks*, 2nd ed., London, 1854, pp. 123-4: 'The *Galatea*: 'tis pretty well preserv'd, but does not answer the idea I had of it. The face of the *Galatea* is not handsome, nor perfectly well Drawn: And her Drapery, which was Red, and is flying in the Air, besides that it has no graceful Shape, is now so Black that it looks intolerably Heavy, and as Hard against the Ground as if it was Inlaid: But doubtless much of this is owing to the Changing of the Colour. Throughout the Colouring is disagreeable, upon the Dirty Reddish Tinct.'

50. The description of the state of the fresco in the Italian edition of Crowe and Cavalcaselle's

Raphael (ii, p. 242) differs from that in the earlier English edition (ii, p. 212). According to this, 'ridipinto quasi totalmente il mare e, con parziali ritocchi, il cielo'. There is no reference to damage to Galatea's eyes.

51. D. Redig de Campos, in *Rendiconti*, xxxi, 1959, p. 273, and *Stanze*, pp. 19-20.

52. G. Clelio, *Memorie*, Naples, 1638, p. 118, cited by J. Hess, 'On Raphael and Giulio Romano', in *Kunstgeschichtliche Studien zu Renaissance und Barock*, i, Rome, 1966, p. 184. Clelio's statement is denied by Redig de Campos, *Stanze*, p. 41.

53. A vivid and substantially accurate account of the condition of the frescoes in the seventeenth century is given by Giovanni Bottari in an imaginary dialogue between Maratta and Bellori printed at Lucca in 1754 and subsequently reissued in editions printed at Naples and Reggio (*Dialoghi sopra le tre arti del disegno di Monsignor Giovanni Bottari*, 2nd ed., Naples, 1772, pp. 314-17, 3rd ed., 1826, pp. 173-5). The relevant passage reads as follows: '*Mar.* E un fiorentino mi disse essere questa l'ammirabile Madonna del Sacco, che può stare a fronte delle più belle di Raffaello; e mi soggiunse che a conto del non averla spolverata, vi si era sopra appiastrata in guisa la polvere, che n'era quasi sfuggita la testa del S. Giuseppe, e il resto tutto addombrato.
Bel. Così erano le pitture di Raffaello delle stanze del Vaticano, quando venni a Roma.
Mar. Anzi erano in peggior stato assai, e le pitture, che erano sopra i cammini erano per di più inverniciate di nero di fumo, ch'era una maraviglia, e nell'ultima stanza erano state fino smorzate le torce in quei bellissimi chiari scuri, che rappresentano varie grottesche; e generalmente i maravigliosi imbasamenti di tutte le stanze erano stati sgraffiati con coltelli, o punte di ferro, per iscrivervi nomi, e cognomi, e mille altri sciocaggini. E questi danni andavano tutto di crescendo; e, pure essendo io stato fatto dalla S.M. d'Innocenzio XI soprintendente, e custode di quelle stanze a fine di ripulirle, a spolverarle, e ridurle nello stato, che sono al presente, non fù possibile mai, per quante premurosissime istanze, che io ne facessi, di venire alla conclusione, se non dopo molti anni, cioè nel 1702, per l'opposizioni ridicolose, che facevano i ministri, e i principali della corte per mostrarsi intelligenti; e perchè erano creduti tali, benchè dal loro ragionare

apparisse la loro imperizia, mentre che pensavano di fare vedere la loro intelligenza . . . E in quel deplorabile stato sarebbero tuttavia, anzi a poco a poco sarebbero perite affatto, se non s'incontrava per buona sorte ad esser collocato sul trono di S. Pietro un sommo pontefice intendentissimo veramente di queste cose, che non dando retta alla chiachiere, volle, che io mettessi mano all'opera, e me ne diede tutto il commodo, e poi mi difese, e mi sostenne contra i pubblici, e universali clamori, che si suscitarono per ogni angolo di Roma dall'ignaro vulgo; e quando dico vulgo, intendo di parlare nella lingua dell'Ariosto. . . . E crediatemi, che l'opera appena cominciata rimaneva sospesa, ed io rovinato, e scredito per sempre, se il papa non veniva in persona a vedere quello, che io aveva fatto, ne il vedere da se serviva a nulla, se egli non fosse stato intelligente, come egli è; e quei veri miracoli della nostra professione perivano miseramente, prima per colpa della somma trascuraggine de' passati, e poi della falsa perizia de' pretesi intelligenti, e de' signori di buon gusto.'

54. D. Redig de Campos, in *Rendiconti*, xxx, xxxi, 1957–9, pp. 273–83, and *Indice cronologico e bibliografico dei lavori eseguiti per il restauro delle opere d'arte dal 1939 al 1957*, in *Triplice Omaggio a Sua Santità Pio XII*, ii, 1958, pp. 319–36.

55. Goethe, *Italienische Reise*, Munich, 1961, p. 128.

56. Creuze de Lesser, *Voyage en Italie et en Sicile*, Paris, 1806, pp. 227–8: 'Une pensée qui afflige continuellement dans ces salles, c'est l'assurance qu'on y acquiert sans cesse que toutes leurs peintures, déjà très détériorées, marchent à un anéantissement rapide . . . bientôt on ne verra que les fantômes de ces peintures. Il serait temps encore de les faire copier en mosaïque.'

57. W. Hazlitt, 'The Vatican', in *Criticisms in Art*, 2nd series, London, 1844, pp. 173–89.

58. It was supposed by Vasari (v, pp. 211–13) that engravings of Raphael's works were made by Marcantonio Raimondi at Raphael's instigation, were printed by a pupil of Raphael called Il Baviera, and were sold for the profit of the artist. Kristeller, 'Marcantons Beziehung zu Raffael', in *P.J.*, xxviii, 1907, pp. 199–229, in a classic analysis of Marcantonio's relations with Raphael, concludes, almost certainly correctly, that the engravings were not made on Raphael's commission or under his eyes. Marcantonio arrived in Rome in 1509–10 while Raphael was at work in the Stanza della Segnatura, and five of his seventeen engravings after Raphael relate to the Segnatura frescoes.

59. B. xiv 350.

60. For the adaptations cited in the text and for a systematic account of the influence of Marcantonio engravings on Northern art see A. Oberheide, *Der Einfluss Marcantonio Raimondis auf die nordische Kunst des 16. Jahrhunderts*, Hamburg, 1933.

61. The engraving by Agostino Veneziano of *Christ carrying the Cross* (B. xiv 28) is dated 1517, and the painting appears to have been executed in the preceding year.

62. B. xiv 18. As noted by Oberheide, op. cit., an adaptation of the design by Araldi at Parma is dated 1514. For the variants at Mount Athos, which date between 1535 and 1568, see Millet, *Monuments de l'Athos*, i, 1927, pl. 122, 159, 168, 198, 224.

63. B. xiv 245. For the Northern derivatives see Oberheide, op. cit. A careful analysis of this engraving and of other related engravings after the antique is given by H. Thode, *Die Antiken in den Stichen Marcantons, Agostino Venezianos, Marco Dentes*, Leipzig, 1881.

64. The compositions of the cartoons were diffused initially through engravings by Marcantonio Raimondi (B. xiv 44: *St. Paul preaching at Athens*) and Agostino Veneziano (B. xiv 43: *The Blinding of Elymas*, d. 1516; B. xiv 42: *The Death of Ananias*) and chiaroscuri by Ugo da Carpi (B. xii 13: *The Miraculous Draught of Fishes*; B. xii 27: *The Death of Ananias*). The earliest engraving of *The Healing of the Lame Man* is that of Battista Franco (B. xvi 15).

65. K. Frey, *Sammlung ausgewählter Briefe an Michelagniolo Buonarroti*, Berlin, 1899, pp. 66–67.

66. A. Condivi, *Vita di Michelagnolo Buonarroti*, Rome, 1553, p. 47 (repr. Golzio, p. 294): 'Anzi ha sempre lodato uniuersalmente tutti, etiam Raffaello da Urbino, in fra il quale et lui già fù qualche contesa nella pittura, come ho scritto.'

67. Dolce, *L'Aretino*, reprinted by Golzio, p. 297.

68. Ed. O. Bacci, *Vita di Benvenuto Cellini*, Florence, 1901, p. 190: 'Per la sua mala lingua essendo lui in Roma, gli aveva detta tanto male de l'opere di Raffaello da Urbino, che i discepoli suoi lo volevano ammazare a ogni modo.'

69. Dolce, *L'Aretino*, reprinted by Golzio, p. 301.

70. Vasari, *Vite*, iv, pp. 373–9.

71. Bellori, *Descrizione*, p. 86: 'non ad altro fine, che di sottomettere Raffaelle, e donare il primato a Michel Angelo, con farlo suo discepolo'.

72. Lodovico Dolce, *Dialogo della pittura intitolato l'Aretino*, Venice, 1557. The principal passages on Raphael are reprinted by Golzio, pp. 294–302, but are best read in the well-annotated edition of P. Barocchi, *Trattati d'arte del cinquecento*, i, 1960, pp. 143–206.

73. F. Zuccari, *Il lamento della Pittura su l'onde venete*, Mantua, 1605, reprinted by Golzio, pp. 338–9.

74. Giovanni Battista Armenini, *De' veri precetti della Pittura*, Ravenna, 1587, p. 25: 'Per ciò si chiama la Pittura, Poetica che tace, & la Poetica, Pittura che parla, & questa l'anima dover essere, & quella il corpo, dissimile però in questo si tengono, perche l'vna imita con i colori, l'altra con le parole. Ma certamente che in quanto all'inventione predetta & in quanto alla verità sono d'una stessa proprietà, & d'uno effetto medesimo.'

75. On the genesis of the doctrine of 'Ut pictura poesis' see particularly R. W. Lee, '*Ut Pictura Poesis*: the Humanistic Theory of Painting', in *Art Bulletin*, xxii, i, 1940, pp. 197–269.

76. Dolce, *L'Aretino*, reprinted by Golzio, p. 298: 'il quale fù tanto ricco d'inventione, che faceva sempre a quattro e sei modi, differenti l'uno dall'altro, una historia, e tutti havevano gratia, e stavano bene'. The same tradition is recorded by Armenini, op. cit., in the passage: 'Dicesi poi che Raffaelle teneva un'altro stile assai facile, perciò che dispiegava molti disegni di sua mano, della quale egli già ran parte n'havea concetta nell'Idea, & nell'uno, hor nell'altro guardando, & tutta via velocemente dissegnando, cosi veniva a formar tutta la sua inventione, il che pareva che nescesse per esser la mente per tal maniera aiutata, & fatta ricca per la moltitudine di quelli.'

77. Golzio, pp. 30–31.

78. The most comprehensive and intelligible summary of the varying iconographical interpretations of the frescoes in the Stanza della Segnatura is that of A. Chastel, *Art et humanisme à Florence au temps de Laurent le Magnifique*, Paris, 1959, pp. 468–83.

79. A. Springer, 'Raffael's Schule von Athen', in *Die Graphischen Künste*, v, 1883, pp. 53–106.

80. Bellori, *Descrizione*, 1695, pp. 61–62.

81. O. Miller, *Zoffany and his Tribuna*, London, 1966. The painting, which was commissioned by Queen Charlotte in 1772 and is now in the Royal Collection, shows the Tribuna of the Uffizi, but introduces the *Madonna della Sedia,* which was then as now in the Palazzo Pitti. The *Niccolini Madonna* is held up by the painter for the inspection of its purchaser, Lord Cowper.

NOTES TO CHAPTER II

1. The painting, now in the Galleria Nazionale delle Marche at Urbino, was commissioned from Timoteo Viti on 15 April 1504, for the funerary chapel of Arrivabene, Bishop of Urbino (d. 1504) in the Duomo at Urbino. The chapel was dedicated to SS. Thomas of Canterbury and Martin, and the altarpiece shows these Saints with kneeling figures of Arrivabene and Guidobaldo, Duke of Urbino. For the documentation of the painting see Pungileoni, *Elogio storico di Timoteo Viti*, 1835, pp. 11–13.

2. London, British Museum. Pouncey and Gere, No. 259, p. 154.

3. Pouncey and Gere, No. 258, pp. 153–4.

4. National Gallery, London, No. 288. The *Tobias and the Angel* forms part of an altarpiece commissioned for the Certosa at Pavia by Lodovico il

Moro, Duke of Milan, of which one panel remains in the Certosa and three panels are in London. The altarpiece seems to have been commissioned in or about 1496 and was completed after 1499. It has been suggested, almost certainly incorrectly, that Raphael intervened in the execution of these panels.

5. Oxford, Ashmolean Museum. Fischel, *Z.d.U.*, No. 56, Fig. 127. Parker, No. 27.

6. The *Coronation of St. Nicholas of Tolentino* was commissioned by Andrea Baronzio for S. Agostino at Città di Castello on 10 December 1500, and was completed by 13 September 1501 (for the documents see Golzio, pp. 7–8). The church was damaged in an earthquake in 1789, and the ruined altarpiece was sold to Pope Pius VI to defray the cost of restoration. It was cut down in Rome, sections of it remaining in the Vatican till 1849. The only parts surviving are the head of an Angel in the Pinacoteca Tosio-Martinengo at Brescia and heads of the Virgin and God the Father in the Pinacoteca Nazionale di Capodimonte at Naples. Two panels in the Detroit Institute of Arts are wrongly identified by Valentiner ('Zwei Predellen zu Raffaels frühestem Altarwerk', in *Festschrift für M. J. Friedländer*, 1927, pp. 244–58) as parts of the predella. The altarpiece was commissioned jointly from Raphael and Evangelista di Pian da Meleto. The three fragments are accepted as early works of Raphael by Fischel, 1962, p. 17, but those at Naples have been widely ascribed (A. Venturi, Ortolani, Longhi) to Evangelista di Pian da Meleto. The basis of comparison is inadequate, and it is doubtful if Evangelista di Pian da Meleto intervened in the surviving sections of the altarpiece.

7. The basis for reconstruction of the altarpiece is (i) the drawing at Lille (No. 474; Fischel, *R.Z.*, No. 5), (ii) a free copy by Costantini formerly in S. Agostino, now in the Pinacoteca Comunale at Città di Castello, and (iii) a description of the complete altarpiece by Lanzi (*Storia pittorica dell'Italia*, 2nd ed., Bassano, 1795–6, pp. 387–9). A reconstruction by Fischel ('Raffaels erstes Altarbild, die Krönung des Hl. Nikolaus von Tolentino', in *P.J.*, xxxiii, 1912, pp. 105–21) is amplified and corrected by W. Schöne ('Raphaels Krönung des heiligen Nikolaus von Tolentino', in *Festschrift für Carl Georg Heise*, 1950, pp. 113–36). The two reconstructions

result in radically different dimensions for the altarpiece (Fischel 2·80 × 1·75 m., Schöne 3·92 × 2·30 m.) and in two somewhat different spatial schemes. So far as can be judged from the Lille drawing, the space projection in the altarpiece followed the practice of Giovanni Santi's studio, as it is seen in, e.g., the fresco of the *Virgin and Child with Saints and the Resurrection of Christ* in S. Domenico at Cagli.

8. Oxford, Ashmolean Museum. Chalk: 37·9 × 24·5 cm. Fischel, *R.Z.*, No. 8. Parker, No. 504.

9. The study occurs on the upper part of the sheet described in note 5.

10. Vienna, Albertina, S.R. 267. Metalpoint: 28·7 × 38·7 cm. Fischel, *R.Z.*, No. 305.

11. Windsor Castle, Royal Library. Red chalk (offset): 25·7 × 37·5 cm. Popham and Wilde, No. 802, p. 313.

12. Oxford, Ashmolean Museum. Red chalk: 21·4 × 20·9 cm. Parker, No. 566.

13. Lille, Musée Wicar, No. 475. Chalk: 39·5 × 25 cm. Fischel, *R.Z.*, No. 6. The drawing is identified by Fischel and Schöne, loc. cit., as a study for the God the Father in the *Coronation of St. Nicholas of Tolentino*. If the composition drawing and the copy of the altarpiece by Costantini are to be trusted, it is more closely related to the head of the Saint.

14. Painted for S. Domenico at Città di Castello and now in the Pinacoteca Comunale, Signorelli's *Martyrdom of St. Sebastian* (for which see Salmi, *Luca Signorelli*, 1953, p. 53) at one time bore the date 1498, and is likely to have been commissioned in the preceding year.

15. Oxford, Ashmolean Museum. Pen: 25·4 × 21·6 cm. Fischel, *R.Z.*, No. 2, Parker, No. 501. The sheet also contains a study made in connection with the God the Father in the banner of the *Creation of Eve* in the Pinacoteca Nazionale at Città di Castello. If the banner, as is plausibly supposed by Magherini-Graziani (*L'arte a Città di Castello*, 1897, p. 371), is associable with the plague of 1499, the pen study after Signorelli would have been made within a year of the installation of the altarpiece. The *verso* of a sheet

at Lille, of which the *recto* contains a study for a *Madonna*, shows the same soldier with back turned in conjunction with a second figure which does not occur in Signorelli's painting. Fischel, *R.Z.*, No. 50, infers that the sheet depends from a preliminary drawing by Signorelli. The *verso* of the Lille drawing is given by Fischel, to a 'schwache umbrische Hand', and by Salmi, loc. cit., to Raphael.

16. For presumed preliminary studies for this painting at Vienna, Oxford and Ottawa, see p. 270, note 1.

17. Rome, Pinacoteca Vaticana, No. 334. Dimensions: 2·77 × 1·65 m. The altarpiece is ignored in the first edition of Vasari's life of Raphael. In the second edition (iv, pp. 317–18) it is stated to have been commissioned by Maddalena degli Oddi for the church of S. Francesco at Perugia. The Oddi were overthrown by Giovanni Paolo Baglione after the death of Alexander VI (August 1503), and it was concluded by Passavant, i, pp. 67–68, that the painting was produced before this time. This reasoning is questioned by Crowe and Cavalcaselle, i, pp. 141–3, who argue that the women of the Oddi family are unlikely to have forfeited the use of the chapel in S. Francesco. Bombe ('Raffaels Peruginer Jahre', in *Monatshefte für Kunstwissenschaft*, iv, 1911, pp. 304–5) records an unsuccessful attempt to trace the Maddalena degli Oddi mentioned by Vasari, and concludes that the painting was commissioned by Alessandra di Simone degli Oddi (d. 15 July 1516), who was buried in the chapel.

18. Oxford, Ashmolean Museum. Silverpoint: (a) 19·1 × 12·7 cm.; (b) 18·9 × 12·6 cm. Fischel, *R.Z.*, Nos. 18, 19. Parker, No. 511. Other life studies for the Angels are at Lille, Musée Wicar (Fischel, *R.Z.*, Nos. 20, 21) and in the British Museum (Fischel, *R.Z.*, No. 22; Pouncey and Gere, No. 4).

19. The identification of Raphael's auxiliary cartoons is due to Fischel ('Raphael's auxiliary Cartoons', in *Burlington Magazine*, lxxi, 1937, pp. 167–8), who establishes Raphael's use of the technique from the time of the *Coronation of the Virgin* altarpiece to that of the earlier frescoes in the Stanza della Segnatura. No auxiliary cartoons for the later Segnatura frescoes or for the Stanza d'Eliodoro survive, but evidence for the practice recurs in the studies for the *Transfiguration* altarpiece.

20. London, British Museum. Chalk: 27·4 × 21·6 cm. Fischel, *R.Z.*, No. 23. As noted by Pouncey and Gere, Nos. 5–6, the heads in the drawing and in the painting are of precisely the same size.

21. Windsor Castle, Royal Library. Chalk: 23·8 × 18·6 cm. Discussed by Popham in *Old Master Drawings*, xii, 1937–8, pp. 45–46. Popham and Wilde, No. 788.

22. Stockholm, National Museum. Pen: 27·2 × 42 cm. Fischel, *R.Z.*, No. 29.

23. Oxford, Ashmolean Museum. Pen: 20 × 20 cm. Fischel, *R.Z.*, No. 30. Parker, No. 513.

24. Rome, Galleria Borghese. Panel: 184 × 176 cm. Signed on the left below: RAPHAEL/VRBINAS/M.D.VII. A summary of the available literature is supplied by Dussler, No. 112, pp. 62–63, and by P. della Pergola, *Galleria Borghese: i dipinti*, ii, 1959, pp. 116–20. A reference to the painting occurs about 1507 on the back of a drawing at Lille (for the text of this see Fischel, *R.Z.*, No. 162, and Golzio, p. 15). There is no evidence for the date of the commissioning of the altarpiece, which was ordered by Atalanta Baglione for the Baglioni Chapel in S. Francesco at Perugia in commemoration of the murder of her son Grifonetto Baglioni (July 1500). The painting was transferred to Rome in 1608. The monochrome predella, with figures of Faith, Hope, and Charity, is in the Vatican, and the central part of the lunette, with a figure of God the Father, is in the Pinacoteca Nazionale at Perugia. The God the Father, designed by Raphael (drawing at Lille) and painted by Domenico Alfani, is mistakenly regarded by Crowe and Cavalcaselle (op. cit., i, p. 308) as a copy made by 'some feeble Umbrian of a later age'. After the removal of the remainder of the altarpiece the lunette was installed above a painting by Orazio Alfani in the same church (for this see Passavant, ii, pp. 72–79). Vasari (iv, p. 325) states that the painting was commissioned by Atalanta Baglione before Raphael left Perugia for Florence, that the cartoon for the painting was made in Florence, and that the altarpiece was executed in Perugia.

25. Neilson, *Filippino Lippi*, 1938, pp. 178–9, 182–3, assumes that the altarpiece was subjected to overall retouching by Perugino. The painting was commissioned from Filippino Lippi by Fra Zaccheria di Lorenzo in 1503. On 5 August 1505 the commission was transferred to Perugino, who received a final payment for it on 9 January 1506.

26. Neilson, op. cit., pp. 179–82. See also Bombe, *Geschichte der Peruginer Malerei bis zu Perugino und Pinturicchio*, 1912, p. 376.

27. For this altarpiece, which is not documented but is signed and dated 1495 and is now in the Palazzo Pitti, see Canuti, *Il Perugino*, 1931, pp. 105–7.

28. Oxford, Ashmolean Museum. Pen: 17·9 × 20·6 cm. Fischel, *R.Z.*, No. 164. Parker, No. 529. The drawing formed the basis of an engraving by Marcantonio Raimondi (B. xiv 37), which is dated by Kristeller, 'Marcantons Beziehungen zu Raffael', in *P.J.*, xxviii, 1907, pp. 226–8, ca. 1515.

29. London, British Museum. Pen: 25 × 16·9 cm. Fischel, *R.Z.*, No. 165. Pouncey and Gere, No. 10.

30. Louvre, Paris, No. 319. Pen: 33·3 × 39·6 cm. Fischel, *R.Z.*, No. 168, notes correctly that the drawing has been extensively reworked.

31. London, British Museum. Pen: 21·5 × 32 cm. The drawing is analysed by Fischel, *R.Z.*, No. 170, who knew it only through an engraving. It is discussed in *British Museum Quarterly*, xxviii, 1964, pp. 57–58, and illustrated in *Burlington Magazine*, cvii, 1965, p. 536, Fig. 49.

32. British Museum, London. Pen over chalk: 23 × 31·9 cm. Fischel, *R.Z.*, No. 171. Pouncey and Gere, No. 12.

33. British Museum, London. Pen over chalk: 30·7 × 20·2 cm. Fischel, *R.Z.*, No. 178. Pouncey and Gere, No. 11.

34. The evidence for this is contained in copies of a lost Raphael drawing in the British Museum, London (Fischel, *R.Z.*, No. 179; Pouncey and Gere, No. 39, p. 35), and at Windsor (Popham and Wilde, No. 855).

35. Florence, Uffizi, Gabinetto dei Disegni. Pen: 28·7 × 29·7 cm. Fischel, *R.Z.*, No. 175. The drawing is squared in red chalk. The squaring records a crucial change, whereby the foot of the figure on the extreme left was cut, and the focus of the composition was moved to the right.

36. Crowe and Cavalcaselle, i, p. 318, comment that 'we may suspect the damaging influence of Domenico Alfani in those parts which hardly exhibit to the full the delicate subtlety of the master's hand'. Ragghianti, *La Deposizione di Raffaello Sanzio*, 1949, p. 8, complains of 'una certa crudezza e povertà di fattura' visible 'in varie parti, e segnalatamente nella quasi intera figura del giovane portatore, nelle gambe di Nicodemo, nel pianterreno', and infers that the colouring of the cartoon was entrusted in part to Raphael's assistants. It is also argued by Ragghianti that the composition of the painting depends from two separate cartoons which were slightly misaligned when they were transferred to panel. Allowance must be made for the condition of the panel, which was taken to Paris by Camillo Borghese, and was restored in 1816 on its return to Rome and again in 1875. The advisability of transferring the paint film to canvas was discussed at this time. Minor repairs (for which see Della Pergola, loc. cit.) were undertaken in 1914, 1933, and 1936.

37. Paris, Institut Néerlandais. Pen: 26 × 18·6 cm. Fischel, *R.Z.*, No. 177.

38. Raphael was in Urbino in October 1507 (Golzio, p. 16), and addressed a letter from Florence to his uncle Simone Ciarla in April 1508 (Golzio, pp. 18–19). The first evidence of his presence in Rome occurs in September 1508 in a frequently contested letter written by him to the Bolognese painter Francia (Golzio, pp. 19–20). Shearman, *Stanze*, p. 160n., argues from the terms of the will of Rinieri di Bernardo Dei that no contract for the Dei altarpiece had been allotted before July 1508, and that the *Madonna del Baldacchino* must therefore have been produced in the summer or autumn of 1508. In this event Raphael would have arrived in Rome at the extreme end of 1508 or early in the following year. The will of Rinieri di Bernardo Dei (for which see O. Giglioli, 'Notiziario', in *Rivista d'Arte*, vi, 1909, p. 151) is, however, dated 20 July 1506, and has no relevance whatever to Raphael's move to Rome.

39. Grimm, 'Raphaels erster Eintritt in Rom', in *Über Künstler und Kunstwerke*, ii, 1867, pp. 113–117. The putative document is dated 5 March 1508, and is in the form of a power of attorney in favour of Angelo di Domenico Canigiani. For the withdrawal see Grimm, *Raphael*, 1872, pp. 183–5.

40. Gamba, *Raphael*, 1932, p. 37.

41. Perugino's presence in Florence is recorded in October 1507 and again in April 1508. He appears to have been summoned to Rome by Pope Julius II early in 1508 and started work forthwith on the ceiling of the Stanza dell'Incendio.

42. The far from impossible story that Raphael was summoned to Rome by the architect Bramante is recorded by Vasari (iv, pp. 328–9), and has been widely accepted (e.g. by Crowe and Cavalcaselle, i, p. 380).

43. The frescoes in the Stanza della Segnatura are so closely interrelated that they must, at least in broad outline, have been planned simultaneously. On the basis of technique, however, and especially on the ratio of *secco* to true fresco painting, a chronological sequence can be established for the working up and execution of the designs. For this see Redig de Campos, *Raffaello nelle Stanze*, Rome, 1965, pp. 13–15, where it is argued that the *Disputa* is the fresco 'con il quale Raffaello esordì nella Segnatura', and Hoogewerff, 'La Stanza della Segnatura; osservazioni e commenti', in *Rendiconti*, xxiii–xxiv, 1947–9, pp. 317–56. An account of the restoration of the fresco is given by Redig de Campos, *Rendiconti*, xxiii–xxiv, 1947–9, pp. 381–4. For the remaining bibliography see Dussler, pp. 81–82.

44. Vasari, iv, p. 335, states that the figures in the lower part of the fresco 'scrivono la messa e sopra l'ostia che è sulla altare disputano'. The notion that the figures in the lower part of the fresco are disputing therefore goes back to 1550, though the title *Disputa* was not employed until a considerably later time (1610). Since the host was not included in the first version of the composition, more emphasis should perhaps be placed on the first three words of Vasari's description. For the content of the fresco see particularly Hoogewerff, loc. cit., A. Groner, *Raffaels Disputa: eine kritische Studie über ihren Inhalt*, 1905, H. B.

Gutmann, 'Zur Ikonologie der Fresken Raffaels in der Stanza della Segnatura', in *Zeitschrift für Kunstgeschichte*, xxi, 1958, pp. 27–39, and, in opposition to Gutmann, A. Chastel, *Art et humanisme à Florence au temps de Laurent le Magnifique*, Paris, 1956, pp. 475–7.

45. Windsor Castle, Royal Library. Brush: 28 × 28·5 cm. Fischel, *R.Z.*, No. 258. Popham and Wilde, No. 794.

46. Chantilly, Musée Condé. Brush: 23·2 × 40·5 cm. Fischel, *R.Z.*, No. 260.

47. Oxford, Ashmolean Museum. Brush: 23·3 × 40 cm. Fischel, *R.Z.*, No. 259. Parker, No. 542.

48. Windsor Castle, Royal Library. Chalk: 20·4 × 41 cm. Fischel, *R.Z.*, No. 261. Popham and Wilde, No. 795.

49. Paris, Louvre, Nos. 3980, 3981. Fischel, *R.Z.*, Nos. 262, 263 (as after Raphael).

50. London, British Museum. Pen: 24·7 × 40·1 cm. Fischel, *R.Z.*, No. 267. Pouncey and Gere, No. 33, give a detailed account of the respects in which the drawings differs from the fresco.

51. Frankfurt-am-Main, Kunstinstitut Staedel, No. 379. Pen: 28 × 41·5 cm. Fischel, *R.Z.*, No. 269.

52. Albertina, Vienna, *S.R.* 245. Brush: 30 × 43·7 cm. Fischel, *R.Z.*, No. 283.

53. For corresponding pentimenti in the fresco in the figures of SS. Thomas Aquinas and Bonaventure see D. Redig de Campos, in *Rendiconti*, xxii–xxiv, 1947–9, pp. 381–4.

54. Musée Fabre, Montpellier. Pen: 36 × 23·5 cm. Fischel, *R.Z.*, No. 287. The second drawing for this figure is on the *verso* of the same sheet.

55. The draft poems occur on sheets in the Ashmolean Museum, Oxford, the British Museum and the Musée Fabre, Montpellier, numbered by Fischel, *R.Z.*, Nos. 277, 279, 281, 286, 287. For a discussion of the texts see Fischel, *R.Z.*, text vol., pp. 306–21. A convenient transcription is provided in Raffaello Sanzio, *Tutti gli scritti*, Bibl. Universale Rizzoli, No. 1063, ed. Camesasca, 1956, pp. 74–89.

56. London, British Museum, Chalk: 26·3 × 35·7 cm. Fischel, *R.Z.*, No. 297. Pouncey and Gere, No. 31.

57. Ambrosiana, Milan. Pen: 29·9 × 19 cm. Fischel, *R.Z.*, No. 292.

58. Lille, Musée Wicar, No. 471. Chalk: 41 × 27·3 cm. Fischel, *R.Z.*, No. 289.

59. Milan, Ambrosiana (*recto* of drawing cited in note 57 above). Fischel, *R.Z.*, No. 291.

60. Rome, Pinacoteca Vaticana, No. 333. Panel: 405 × 278 cm. It is known that on 19 January 1517 the painting was not begun (Golzio, pp. 52–53), and that work on it was probably started only after 2 July 1518 (Golzio, pp. 70–71). It cannot, however, be precluded that the early schemes for the altarpiece date from before this time. According to Vasari, the painting was executed personally by Raphael 'di sua mano continuamente lavorando', and was within sight of completion at Raphael's death. The sum paid to Raphael's heirs (224 ducats) was roughly a third of the total price (650 ducats). The painting stood on the high altar of S. Pietro in Montorio, in a frame designed by Giovanni Barile (lost), from 1523 till 1797 when it was removed to Paris. For its vicissitudes there see p. 261, note 33.

61. For the literature of Sebastiano del Piombo's *Raising of Lazarus* see C. Gould, *National Gallery Catalogues: The Sixteenth-Century Venetian School*, 1959, pp. 76–80.

62. Vienna, Albertina. Wash: 40·2 × 27·2 cm. The drawing is discussed and reproduced by Oberhuber, 1962, Fig. 2.

63. Paris, Louvre, No. 3954. Wash: 41·5 × 27·4 cm. Oberhuber, 1962, Fig. 4, as Penni.

64. A. Ashley-Cooper, Earl of Shaftesbury, *Second Characters*, Cambridge, 1914, p. 118n.

65. Goethe, *Italienische Reise*, Munich, 1961, p. 443.

66. Chatsworth, Duke of Devonshire. Chalk: 24·6 × 35 cm. Fischel, i, 1948, p. 367, as Penni. Oberhuber, 1962, Fig. 6, as Raphael.

67. Vienna, Albertina. Pen: 40·2 × 27·2 cm. Oberhuber, 1962, Fig. 9.

68. Chatsworth, Duke of Devonshire. Chalk: 32·9 × 23·2 cm.

69. London, British Museum. Black chalk: 39·9 × 35 cm. Pouncey and Gere, No. 37, pp. 33–34.

70. Chatsworth, Duke of Devonshire. Chalk: 36·3 × 34·6 cm. A later study for this head is in the British Museum (Pouncey and Gere, No. 38, pp. 33–34).

71. Paris, Louvre, No. 3864. Red chalk: 34·1 × 22·1 cm.

72. Oxford, Ashmolean Museum. Chalk: 49·9 × 36·4 cm. Fischel, *Versuch*, No. 341. Parker, No. 568, pp. 310–1.

73. Amsterdam, Regteren-Altena Collection. Chalk: 33 × 24·2 cm. A tentative attribution of Oberhuber, 1962, p. 138, to Raphael is more probable than Hartt's attribution (*Giulio Romano*, i, 1958, p. 288, No. 30) to Giulio Romano.

NOTES TO CHAPTER III

1. London, National Gallery, No. 3943. The altarpiece is mentioned in the first edition (1550) of Vasari's life of Raphael (ed. Ricci, iii, p. 84), and is signed at the base of the Cross: RAPHAEL/VRBIN/AS/P. The Gavari altar in S. Domenico at Città di Castello, for which it was commissioned, is inscribed: HOC.OPVS.FIERI.FECIT. DNICVS/THOME.DEGAVARIS.MDIII. As noted by Passavant (ii, p. 12) and subsequent writers, the figure of the Virgin is closely similar and the disposition of the lateral figures is somewhat related to that in the contemporary *Crucifixion* by Perugino in S. Francesco in Monte at Perugia (1502). Unconvincing attempts have been made to identify drawings by Raphael in Vienna (Fischel, *R.Z.*, No. 185), Oxford (Fischel, *R.Z.*, No. 41, Parker, No. 509), and Ottawa (Popham, in *Old Master Drawings*, xiv, 1939–40, pp. 37–38) as preliminary studies for the painting. For the later history of the altarpiece

see Gould, *National Gallery Catalogues: The Six-teenth-Century Italian Schools (excluding the Vene-tian)*, 1962, pp. 158–9.

2. According to Mancini *(Istruzione storico-pittorica per visitare le chiese e palazzi di Città di Castello,* 1832, pp. 235–6) the predella of the altarpiece was removed in 1668 and presented to Cardinal Cesare Rasponi, papal legate at Urbino. For the two surviving predella panels, which represent *Eusebius reviving the three Corpses with the Garment of St. Jerome* (Museo de Arte Antiga, Lisbon) and *St. Jerome and the heretic Sabinianus* (North Carolina Museum of Art, Raleigh, N.C.), see particularly Gronau ('Zwei Predellenbilder von Raphael', in *Monatshefte für Kunstwissenschaft*, i, 1908, p. 1071) and C. Gilbert ('A Miracle by Raphael', in *Bulletin of the North Carolina Museum of Art*, vi, 1965, pp. 3–34). The iconography of the two panels depends from the *Hieronymianum* of Giovanni d'Andrea (Florence, 1491).

3. The altarpiece by Perugino in S. Maria Nuova at Fano is dated 1497. A suggestion of E. Durand Gréville, in *Bulletin de l'art ancien et moderne,* ix, 1907, pp. 287–8, 294–5, that the young Raphael intervened in the execution of this painting is revived by Longhi, in *Paragone,* 1955, May, p. 14, and Camesasca, i, pl. 145, on the strength of resemblances between the predella panel of the *Birth of the Virgin* and a fresco of the *Virgin and Child* in the Casa di Raffaello at Urbino. The fresco, which is much damaged, is probably by Giovanni Santi.

4. Paris, Louvre. Pen: 28·5 × 42·2 cm. Fischel, *R.Z.,* No. 28.

5. For this case see particularly R. Wittkower, 'The Young Raphael', in *Allen Memorial Art Museum Bulletin,* xx, 1963, pp. 150–68. According to this theory, Raphael would have painted the altarpiece of the *Coronation of the Virgin* before 1500, joined the workshop of Perugino in 1499 (thus account-ing for the Peruginesque style of the *Coronation of St. Nicholas of Tolentino* which was commissioned in the following year), and spent the years 1500–4 in the main at Città di Castello. Perugino was frequently absent from Perugia between 1495 and 1499.

6. The most recent and convincing statement of this case is that of Gilbert, loc. cit. A third view,

that Raphael worked in close association with Perugino only between 1500 and 1504, when he was already an autonomous master engaged on a number of independent commissions, is presented by O. Bock von Wülfingen, 'Ein unbekanntes Bild aus der Jugendzeit Raffaels' in *Münchner Jahrbuch,* iii, 1951, pp. 105–17.

7. The principal works produced in the Perugino workshop at this time are the Cremona altarpiece (1494), the *Pala dei Decemviri* in the Vatican (after 1495), the altarpieces at Sinigallia (1495?) and Fano (1497), the Tezi altarpiece in the Pinacoteca Nazionale dell'Umbria at Perugia (1500), the Vatican *Resurrection* (probably 1500), and the Cambio frescoes (1496–9). Reflections of Raphael's style are manifest in a number of paint-ings by Perugino dating from the first half decade of the sixteenth century (e.g. the altarpiece of the *Crucified Christ with Saints* in S. Agostino at Siena of 1502–6, and the Louvre *Battle between Love and Chastity* of 1503–5, which are indebted respectively to the main panel and to the predella of the *Crucifixion* altarpiece of Raphael). Some not always acceptable conclusions on Raphael's Perugian activity are advanced by Bombe, 'Raphaels Peruginer Jahre', in *Monatshefte für Kunstwissenschaft,* iv, 1911, pp. 296–308.

8. An altarpiece of the *Marriage of the Virgin* was commissioned from Pinturicchio for the chapel of S. Agnello in the Duomo at Perugia in 1489, was reassigned to Perugino in 1499, and was still un-finished in 1503. Perugino's authorship of the painting, now at Caen, is contested by Berenson (article of 1896 reprinted in *The Study and Criticism of Italian Art,* ii, 1902, pp. 1–22), who regards it as a derivative by Lo Spagna from the *Sposalizio* of Raphael, and is reaffirmed by L. Manzoni (in *Bollettino Umbro,* iv, 1898, pp. 511–29) and W. Bombe (in 'Raphaels Peruginer Jahre', in *Monatshefte für Kunstwissenschaft,* iv, 1911, pp. 296–308, and *Geschichte der Peruginer Malerei bis zu Perugino und Pinturricchio,* 1912, pp. 184, 195). The painting is given by A. Venturi *(Storia dell'arte italiana,* vii, 1913, pp. 684–8) to Andrea d'Assisi. Though the background is better pre-served than the figures in the front plane, there is a marked discrepancy in quality between the two; the upper part of the painting may have been carried out by Perugino and the lower by a member of the Perugino shop. The date of com-pletion of the altarpiece cannot be established. A

good survey of the problems relating to the painting is supplied in the catalogue *De Giotto à Bellini*, Paris, 1956, No. 105, pp. 77–79. The design of both altarpieces is anticipated by Perugino's *Christ presenting the Keys to St. Peter* in the Sistine Chapel.

9. Milan, Brera, No. 472. Panel: 170 × 117 cm. Signed on the architrave of the temple: R A P H A E L V R B I N A S., and dated M D I I I I. Painted for the Albizzini chapel in S. Francesco at Città di Castello, where it remained till 1798. The picture became the property of the Ospedale Maggiore in Milan in 1804, and was deposited at the Brera in 1806.

10. This aspect of the painting is described in a passage in the first (1550) edition of Vasari's life of Raphael (*Vite*, ed. Ricci, iii, p. 85): 'Nella quale opera è tirato un tempio in prospettiva con tanto amore che è cosa mirabile a vedere le difficoltà che in tale esercizio egli annava cercando'.

11. The relevant passages in Vasari occur in the lives of Pinturicchio (iii, p. 494: 'Ma è ben vero che gli schizzi e i cartoni di tutte le storie che egli vi fece, furono di mano di Raffaello da Urbino, allora giovinetto . . . e di questi cartoni se ne vede ancor oggi uno in Siena; ed alcuni schizzi ne sono, di man di Raffaello, nel nostro libro') and of Raphael (iv, p. 319: 'Pinturicchio, il quale essendo amico di Rafaello, e conoscendolo ottimo disegnatore, lo condusse a Siena; dove Rafaello gli fece alcuni dei disegni e cartoni di quell'Opera'). Pinturicchio was in Perugia for much of the years 1500–3. His influence on Raphael towards the end of this period is attested by the *Coronation of the Virgin* in the Vatican.

12. The construction of the Piccolomini Library was begun in 1492, and the commission for the frescoes was awarded to Pinturicchio in the summer of 1502 by Cardinal Francesco Todeschini Piccolomini, who soon after was elected Pope as Pius III. Work on the frescoes was interrupted by his sudden death. The contract with Pinturicchio was renewed by Andrea di Nanni Piccolomini in 1504, and provision was made for a fresco of the *Coronation of Pope Pius III* over the entrance to the Library. It is likely (Carli, *Il Museo dell'Opera e la Libreria Piccolomini di Siena*, 1946, pp. 48–49) that the painting of the ceiling was in large part complete at the time of the Pope's death, but the narrative frescoes seem to have been executed in 1505–7. The relevant documents are printed by Misciatelli, *La Libreria Piccolomini nel Duomo di Siena*, 1922. It is generally assumed that Raphael's collaboration with Pinturicchio was restricted to the year 1504.

13. The four sheets by Raphael made in connection with the Piccolomini frescoes are Fischel, *R.Z.*, Nos. 60, 61 (Florence, Uffizi, No. 537. Pen: 27·2 × 40 cm. *Recto*, study for horsemen in *Aeneas Sylvius leaving for the Council of Basle*, *verso*, studies after Signorelli), No. 62 (Uffizi, Florence, No. 520. Pen: 70 × 41·5 cm. Composition study for *Aeneas Sylvius leaving for the Council of Basle*), Nos. 63, 64 (Ashmolean Museum, Oxford. Silverpoint: 21·3 × 22·3 cm. *Recto*, studies for *Aeneas Sylvius crowned by the Emperor Frederick III*; *verso*, studies after Signorelli), and No. 65 (Contini-Bonacossi Collection, Florence, formerly Casa Baldeschi, Perugia. Pen: 54·5 × 40·5 cm. Composition study for *The Betrothal of the Emperor Frederick III*). For the last sheet see also O. Scalvanti, *Il disegno raffaellesco dei Conti Baldeschi di Perugia per la Libreria Piccolomini del Duomo Senese*, 1908. Though Raphael's authorship of these sheets has been challenged (e.g. by A. von Beckerath, 'Über einige Zeichnungen alter Meister in Oxford', in *Repertorium für Kunstwissenschaft*, xxx, 1907, pp. 291–8), it is accepted by Fischel, *R.Z.*, text vol. pp. 74–86, and is not in my view susceptible of serious doubt. The Oxford sheet is analysed by Parker, No. 510, who likewise attributes it to Raphael.

14. The San Severo fresco, which shows the Trinity with SS. Maurus, Placidus, and Benedict, and SS. Romuald, Benedict the Martyr, and John the Martyr, is inscribed on the left hand side R A P H A E L D E V R B I N O D. O C T A V I I/A N O S T E P H A N I V O L T E R R A N O P R I O/R E S A N C/T A M T R I N I T A T E M A N G E/L O S A S T A N T E S S A N C T O S Q V E/P I N X I T/A.D.MDV. The six standing Saints in the lower register were added in 1521 by Perugino. Passavant, ii, p. 47, suggests that the inscription with Raphael's name and the date 1505 was introduced at the time of the completion of the fresco. The inscription has also been assigned (Venturi) to a considerably later date. In view of its connection with the *Last Judgement* of Fra Bartolommeo (begun 1499), it is generally assumed that the fresco belongs to the last years of Raphael's Florentine period; it is more mature in

style than either the Ansidei or New York *Madonnas*, while in technique it looks forward to the *Disputa*. Wittkower (loc. cit.) suggests that it was begun in 1505 and completed two years later. Possibly the year 1505 is that of the commission and the fresco was carried out in 1507 or at the beginning of the following year (Fischel and others). If the fresco were executed at this time, it is intelligible that Raphael should have abandoned it before designing the lower part. The work was drastically restored by Caratoli ca. 1835 and by Consoni in the third quarter of the nineteenth century.

15. New York, Metropolitan Museum of Art. Dimensions: (main panel) 173 × 172 cm., (lunette) 76 × 172 cm. The picture, which is described by Vasari, was painted for the convent of S. Antonio at Perugia and remained in the nuns' choir of the convent till 1677, when it was sold for one thousand eight hundred scudi to Giovanni Antonio Bigazzini. It was replaced by a copy in the following year. The altarpiece passed from Bigazzini to the Palazzo Colonna in Rome, and thence (1798) to the Royal Palace in Naples, from which it was removed by Ferdinand I to Madrid. It was later purchased (1901) by Pierpont Morgan and was bequeathed by him (1916) to the Metropolitan Museum. It is generally agreed that the altarpiece was painted in two stages (Crowe and Cavalcaselle, Gronau and others). The scheme is less evolved than that of the *Ansidei Madonna* (see below), but the figures of the lateral Saints presuppose an experience of the work of Fra Bartolommeo.

16. National Gallery, London, No. 1171. Panel: 239 × 156 cm. Dated in the hem of the Virgin's mantle MDV (also read as MDVI and MDVII). Careful summaries of the available information on the altarpiece are supplied by Gould, *National Gallery Catalogues: the Sixteenth-Century Italian Schools*, 1962, pp. 151–3, and Dussler, pp. 40–41, No. 62. The altarpiece which is described in Vasari's 1568 life of Raphael but not in that of 1550, was painted for the Servite church of S. Fiorenzo at Perugia. The church was reconstructed in 1768–70, and the painting appears to have been removed about this time. Bought by Gavin Hamilton, perhaps in 1763, it passed to Lord Robert Spencer, and thence to the fourth Duke of Marlborough, and was purchased for the National Gallery from Blenheim in 1885. The altar (for which see 'La Madonna degli Ansidei',

in *Bollettino della Regia Deputazione di Storia Patria per l'Umbria*, v, 1899, pp. 627–45) was dedicated to St. Nicholas and bore the date 1483. It was endowed under the will of Filippo di Simone Ansidei (1490). The commission seems to have been due to his son, Bernardino Ansidei. The predella comprised panels of (*left to right*) *St. Nicholas of Myra calming a Storm at Sea*, *The Marriage of the Virgin*; and *St. John preaching*. The first two panels have disappeared; the third exists in the collection of Viscountess Mersey. The main panel of the altarpiece was cleaned in 1956.

17. According to Vasari (iv, p. 329), the *Madonna del Baldacchino* was abandoned by Raphael when he left Florence for Rome. Commissioned under the will of Rinieri di Bernardo Dei of 20 July 1506 (for this see Giglioli, 'Notiziario', in *Rivista d'Arte*, vi, 1909, p. 151), the altarpiece was destined for the Dei Chapel in S. Spirito in Florence, and was probably begun late in 1507 or early in 1508. An altarpiece by Rosso, also in the Palazzo Pitti, was commissioned for the Dei Chapel in substitution for the unfinished painting, and Raphael's altarpiece was sold to Baldassare Turini, at whose instance it was completed and installed in the Turini Chapel in the Duomo at Pescia. A *terminus ante quem* for the completion of the painting is supplied by a copy by Leonardo da Pistoia at Volterra dated 1516. It is inferred by Riedl ('Raffaels "Madonna del Baldacchino"', in *Mitteilungen des Kunsthistorischen Instituts in Florenz*, viii, 1957–9, pp. 223–41) that the painting was originally to have had a landscape background, and that 'die Folie des Bildes, die Architektur' was inserted, in imitation of the altarpieces of Fra Bartolommeo, about 1515. The flying angel on the left depends from a figure in Raphael's fresco in Santa Maria della Pace, Rome. According to this analysis, to which Dussler (p. 28) also subscribes, only the central group, the two putti in the foreground, and the Saints on the left were brought to their present state of completion by Raphael. Richa (*Notizie delle chiese fiorentine*, 1754, ix, p. 27) states that the panel was repainted by Niccolò Cassana in 1700 after its acquisition (1697) by Ferdinando de' Medici. A strip 32 cm. in depth was added to the top of the painting at this time. The figures of the Virgin and Child are reproduced in a number of copies; for these see B. Daun ('Einige der Madonna del Baldacchino Raffaels verwandte Madonnen', in *Repertorium für Kunstwissenschaft*, xxxvii, 1915, pp. 69–80.)

18. Chatsworth, Duke of Devonshire. Wash: 27 × 23 cm. Fischel, *R.Z.*, No. 143. An earlier composition drawing (lost) existed in the Orleans Collection (for this see Fischel, *R.Z.*, No. 142). Other preparatory drawings are in the Louvre (Fischel, *R.Z.*, No. 144. Pen: 25 × 18·5 cm. Virgin and Child in a landscape with SS. Sebastian and Roch), the École des Beaux-Arts, Paris (Silverpoint: 22 × 37 cm. Fischel, *R.Z.*, Nos. 145, 146; *recto* two studies for the Virgin's robe, *verso* studies for the Child), the Musée Wicar at Lille (Silverpoint: 12·3 × 19 cm. Fischel, *R.Z.*, No. 147: studies for the head and figure of St. Bernard) and the Uffizi, Florence (Brush: 21·9 × 13·3 cm. Fischel, *R.Z.*, No. 148: full-length study for St. Bernard).

19. The sole evidence for Raphael's presence in Rome in the autumn of 1508 is a letter to the Bolognese painter Francia reputedly written on 5 September of that year. Originally published by Malvasia, *Felsina Pittrice*, 1678, i, p. 45, it was for long regarded as a forgery. The case for its authenticity is restated by Filippini, 'Raffaello a Bologna', in *Cronache d'Arte*, ii, 1925, pp. 201–8, and is accepted by Golzio, pp. 19–20.

20. For the document relating to Raphael's appointment on 4 October 1509 as Writer of the Apostolic Briefs see Golzio, p. 22.

21. A supposed reference to the ceiling of the Stanza dell'Incendio is contained in Albertini's *De Mirabilibus novae urbis Romae*, 1510 (written in the preceding year): 'Sunt praeterea aula et camerae adornatae variis picturis ab excellentissimis pictoribus concertantibus hoc anno instauratae'. The subjects of the frescoes are identified by Canuti, *Il Perugino*, 1931, pp. 194–7, as (i) *God the Father creating the World*, (ii) *The Temptation of Christ* and *The Proclamation of Christ by St. John the Baptist*, (iii) *Christ conferring Power on the Apostles*, and (iv) *Christ as the merciful Judge*.

22. Sodoma was engaged on frescoes at S. Anna in Camprena in 1503–4, and between 1505 and the summer of 1508 was employed on the fresco cycle at Monteoliveto Maggiore. Thereafter he moved to Rome, where, on 13 October 1508, his services were made available by Sigismondo Chigi for work to a total of fifty ducats 'in cameris Sanctissimi Domini Nostri papae superioribus'. The relevant passage in Fabio Chigi's seventeenth-century life of Agostino Chigi (for which see G. Cugnoni, *Agostino Chigi il Magnifico*, Rome, 1878, p. 29) reads as follows: 'Praeterea Johannem Antonium Sodomam Vercellensem cuius opera frater Sigismundus Senis usus fuerat, Romam advocavit, ac Julio II Pontifici commendans, curavit ut Vaticana Cubicula pingenda impetraret; quae postmodum vix incepta, cum eiusdem Pontificis decreto deleta, ac Raphaeli Urbinati data fuissent, aegre ferens ille damnari artificis peritiam, suamque commendationem; proprium eidem cubiculum pingendum dedit, quod est prope aulam superiorem; ac brevi, demortuo Julio II, ipsum successori Leoni conciliavit, effecitque ut pulcherrima Lucretiae Romanae tabula depicta, ac donata, uberrime ob illud opus a Pontifice laudatus fuerit, et equestri dignitate insignitur.'

23. Peruzzi's activity in the Stanze is not referred to by Vasari, and is highly conjectural. Pouncey and Gere, pp. 134–5, observe that 'the grisailles (early) on the ceiling of the Stanza d'Eliodoro in the Vatican, as well as the four main scenes have been plausibly attributed to him on stylistic grounds'. Shearman, *Stanze*, p. 173, advances the theory that the ceiling of the Stanza of Heliodorus was painted completely by Peruzzi under Pope Julius II in 1508–9, and was then replanned by Raphael. This can neither be demonstrated nor disproved.

24. Golzio, pp. 21–22, summarises the records of payments to Sodoma and Ruysch (13 October 1508), Michele del Bocca da Imola and Bramantino (4 December 1508), and Lorenzo Lotto (9 March 1509), which are accurately reproduced by Hoogewerff, in *Rendiconti*, xxi, 1946, pp. 253–68. For the payment to Lotto see also Zahn, *Notizie artistiche tratte dall'Archivio segreto Vaticano*, Florence, 1867, p. 17.

25. For an over-rigid but valuable analysis of the preliminary composition studies for the Stanze see Shearman, *Stanze*, passim.

26. Hoogewerff, in *Rendiconti*, xiii/xiv, 1947–9, pp. 317–36, argues that Raphael started work on the *Parnassus* wall. For a statement of the contrary case see D. Redig de Campos, *Stanze*, pp. 13–18.

27. Redig de Campos, *Stanze*, p. 18: 'Nel corso di un recente restauro dell'affresco si è potuto accertare che Raffaello, per guadagnare spazio, abbassò

il vano della finestra quattrocentesca, in origine assai più alto, come son quelle dell'Apparta-mento Borgia. Lo stesso ha fatto nelle altre due Stanze.'

28. B. xiv 247.

29. Oxford, Ashmolean Museum. Pen: 29·2 × 45·8 cm. Fischel, *R.Z.*, No. 237A. Parker, No. 639. A red chalk copy from a drawing by Raphael for the group at the bottom of the fresco on the right is in the Louvre (Fischel, *R.Z.*, No. 238).

30. London, British Museum. Pen: 34·3 × 24·2 cm. Fischel, *R.Z.*, No. 240. Pouncey and Gere, No. 29, *recto*.

31. Oxford, Ashmolean Museum. Silverpoint: 27·8 × 20 cm. Fischel, *R.Z.*, No. 307. Parker, No. 550.

32. For the architecture of the *School of Athens* see particularly Geymüller, *Raffaello Sanzio studiato come architetto*, 1884, pp. 84–86, and O. H. Foerster, *Bramante*, 1956, pp. 195–6. Shearman, *Stanze*, p. 169n., argues that 'the transition from crossing to dome in the enormous arcus quadri-fons of the *School of Athens* is not properly re-solved; this seems to be adequate proof that it was not conceived by Bramante'. This excessively literal analysis is of doubtful validity.

33. Milan, Ambrosiana. Chalk: 280 × 800 cm. Fischel, *R.Z.*, Nos. 313–44, text pp. 349–58.

34. Redig de Campos, in *Raffaello e Michelangelo*, 1946, v.

35. Vienna, Albertina, S.R. 267. Silverpoint: 28·7 × 38·7 cm. Fischel, *R.Z.*, No. 305.

36. Oxford, Ashmolean Museum. Chalk and pen: 37·9 × 28·1 cm. The *verso* of the sheet was un-known to Fischel, and was disclosed in 1953. Parker, No. 553, mistakenly dismisses it as 'quite unimportant'.

37. Frankfurt-am-Main, Staedel Institute, No. 381. Brush: 36 × 21·5 cm. Fischel, *R.Z.*, No. 255. For the drawing for the companion scene, also at Frankfurt (No. 382. Brush: 38·5 × 25 cm.), see Fischel, *R.Z.*, No. 256. There are material dif-ferences between the drawing of *Trebonianus con-*

signing the Pandects to Justinian and the fresco, e.g. in the figure of Justinian which is shown in profile in the fresco and with head turned slightly away in the preliminary sketch, and the statement of Shearman, *Stanze*, p. 166, that 'between this project and the executed fresco there was no development, nor any change beyond the omission of a head, cramped by the frame', is incorrect. For the attribution to Guillaume de Marcillat see Donati, 'Dell'attività di Guglielmo di Marcillat nel Palazzo Vaticano', in *Rendiconti*, xxv–xxvi, 1949–51, pp. 267–76; it may originally have been intended that the fresco should be retouched *a secco* by Raphael.

38. The Pope returned to Rome on 27 June 1511 wearing a beard which was shaved off in March 1512. A portrait of the Pope bearded, apparently that in the Stanza della Segnatura, is mentioned by the Mantuan Ambassador in Rome on 11 August 1511. The S. Maria del Popolo portrait of the Pope was exhibited in the church in 1513. A preliminary drawing of the Pope's head at Chatsworth (Fischel, *R.Z.*, No. 257) was used for the S. Maria del Popolo portrait, and may also have formed the basis of the portrait in the fresco. The discrepancies between the drawing and fresco noted by Gould, op. cit., p. 160, may result from damage inflicted on the portraits in the fresco in 1527 and subsequent repainting.

39. A wash drawing in Vienna (Albertina) is re-garded by Shearman, *Stanze*, pp. 168–9, as a reproduction of a rejected composition sketch by Raphael for the *Heliodorus* fresco, on the ground that a figure on the left of this sheet corresponds with the *recto* of a drawing by Raphael in the Kunsthaus at Zürich. The Zürich drawing is accepted by Fischel (in *Burlington Magazine*, xlvi, 1925, pp. 134–9) and is related by Parker, p. 301, to a well-known study at Oxford for two kneel-ing women in the *Heliodorus* fresco. Though it establishes that the Vienna drawing is in some way connected with a lost project by Raphael for the *Heliodorus* fresco, it does not, as claimed by Shearman, prove that this is 'a copy, and a precise one, of a lost drawing'. If it were, the 'extraordinary rapidity of the growth of (Raphael's) architectural capacity' between the drafting of this scheme and the planning of the fresco would in-deed be startling.

40. Oxford, Ashmolean Museum. The three draw-

ings are listed as copies by Fischel, *Versuch*, Nos. 172–4, and Parker, Nos. 641–3, who suggests that No. 641 may be 'a free variation of the (fresco) . . . rather than an elaborated copy of an alternative design by Raphael himself'. This is improbable.

41. Florence, Uffizi, Gabinetto dei Disegni, No. 563E. Wash. Initially given by Fischel, *Versuch*, No. 178, to Perino del Vaga, and subsequently, 1948, i, p. 106, accepted as autograph.

42. Ashmolean Museum, Oxford. Wash: 38·8 × 58 cm. Parker, No. 645, pp. 343–4, who regards it as 'a copy of an earlier design, by Raphael, afterwards superseded', points out that the *verso* of a sheet in the Kunsthaus at Zürich contains an autograph study by Raphael for a horseman on the right. Parker's contention is followed by Shearman, *Stanze*, p. 171. The Oxford drawing and the copy of it in the British Museum are described by Pouncey and Gere, No. 71, as 'some kind of pastiche derivation from the fresco' respectively by and after Penni.

43. Paris, Louvre. Repr. H. de Chennevières, *Dessins du Louvre, École italienne*, Raphael 15, and Shearman, *Stanze*, Fig. 14. The sheet is regarded by Pouncey and Gere, loc. cit., as 'a modello of high quality and in our opinion more likely to be by Giulio Romano, representing an early idea by Raphael for the fresco in the Stanza d'Eliodoro', and by Shearman, *Stanze*, p. 171, as a copy of a lost Raphael scheme which intervenes between that recorded in the Ashmolean drawing and the fresco.

44. The letter (for the text of which see Golzio, pp. 31–32) is addressed to Simone Ciarla and dated 1 July 1514. The relevant sentence reads: 'ho cominciato un'altra stantia per S. S. ta a dipingere che montera mille ducento ducati d'oro'.

45. K. Badt, 'Raphael's "Incendio del Borgo"', in *Journal of the Warburg and Courtauld Institutes*, xxii, 1959, pp. 35–39.

46. The letter (for the text of which see Golzio, p. 35) is addressed to Fabio Calvo, and is dated 15 August 1514.

47. Peruzzi's *Presentation* in S. Maria della Pace (for which see A. Venturi, *Storia*, IX-5, 1932, pp.

391–3) appears to have been executed immediately before the artist's frescoes in the Ponzetti Chapel in the same church (1516–17).

48. The payments (for which see Golzio, pp. 38, 51) totalled 300 and 134 ducats respectively, and were made on 15 June 1515 and 20 September 1516. The problems arising from the tapestries and the cartoons are the subject of very thorough analysis by J. White and J. Shearman, 'Raphael's Tapestries and their Cartoons', in *Art Bulletin*, xl, 1958, pp. 193–221, 299–323.

49. It was not, however, despatched to Flanders in advance of the other cartoons, since the tapestry made from it was seen in Brussels by Antonio de Beatis in July 1517 (see L. Pastor, *Die Reise des Kardinals Luigi d'Aragona*, Freiburg, 1905, p. 117).

50. The relevant passages from the diaries of Paris de Grassis and Marcantonio Michiel are reprinted by Golzio, pp. 103–4.

51. White and Shearman, op. cit., p. 196.

52. White and Shearman, op. cit., p. 197, conclude that 'neither the documents as a whole, nor any other pieces of external evidence give valid grounds for thinking that the ten existing Vatican tapestries are not the whole of the original set'.

53. The proposals of E. Steinmann, 'Die Anordnung der Teppiche Raffaels in der sixtinischen Kapelle', in *P.J.*, xxiii, 1902, pp. 186–96, are invalidated by those of White and Shearman, op. cit., pp. 197–203, on which the present summary is based.

54. It is debatable whether the Windsor drawing is strictly a preliminary study for the cartoon, or was adapted by Raphael from a preliminary study in preparation for the engraving of the scene by Agostino Veneziano (B. xiv 43).

55. Freedberg, p. 298, justly observes that 'the *Coronation* – superficially the least attractive fresco in this room – is the most daring manipulation of a design in space since the beginning of the classical style; it is impossible that so unorthodox a novelty should have been generated in the mind of Penni.' The best formal analysis of the change in style between the *Burning of the Borgo* and the *Coronation of Charlemagne* is that of K. Oberhuber,

'Die Fresken der Stanza dell'Incendio im Werk Raffaels', in *W.J.*, lviii, 1962, pp. 23–72.

56. For the bibliography of the Loggia frescoes see particularly Dussler, pp. 98–101.

57. Florence, Uffizi. Panel: 154 × 119 cm. The portrait appears to have been painted between the second half of 1517, when Luigi de' Rossi was created Cardinal, and August 1519, when he died.

NOTES TO CHAPTER IV

1. Washington, National Gallery of Art (Mellon Collection), No. 26. Panel: 29 × 21 cm. Signed on the harness of the horse: RAPHAELLO V. The picture was despatched as a gift from Guidobaldo da Montefeltro, Duke of Urbino, to King Henry VII of England, in consequence of the Duke's appointment as Knight of the Garter in 1504. It was consigned to England after 10 July 1506.

2. Paris, Louvre, No. 1503. Panel: 31 × 27 cm. The painting formed a diptych with the *St. Michael* (see below), and has been variously dated ca. 1500 (Fischel), ca. 1502 (Gronau), 1504 (Morelli, Longhi) and 1505 (Camesasca). Dussler (No. 103, p. 59) assigns both panels to ca. 1504–5. Stylistically the panel seems to date from 1506 rather than from any earlier time.

3. Florence, Uffizi, Gabinetto dei Disegni, No. 529E. Pen: 26·4 × 21·3 cm. Fischel, *R.Z.*, No. 78.

4. Florence, Uffizi, Gabinetto dei Disegni, No. 53. Pen: 26·5 × 26·8 cm. Fischel, *R.Z.*, No. 57. In the background the clouds and the rock on the left give the drawing a greater sense of scale than the painting. The posture of the Saint is rendered more effectively than in the painting, as is the dragon, the planes of whose neck are weakened in the painted version, and the chest and muzzle of the horse.

5. Paris, Louvre, No. 1502. Panel: 31 × 27 cm. As noted by Passavant (ii, p. 34), Fischel (1948, i, p. 3), and others, the iconography is drawn from the *Divina Commedia*.

6. Louvre, Paris, No. 1504. Panel transferred to canvas: 268 × 160 cm. Inscribed on the dress: RAPHAEL.VRBINAS.PINGEBAT.M.D.XVIII. Though the execution of this much damaged painting is substantially by Giulio Romano, it is argued by Freedberg, *Painting of the High Renaissance in Rome and Florence*, i, Cambridge, 1961, pp. 351, 354, that Raphael was responsible for the painting of the head. The cartoon was presented to Alfonso I d'Este, Duke of Ferrara, as a work by Raphael (Golzio, pp. 74–75). First treated by Primaticcio in 1537–40, the picture has been restored on eight occasions since (for these see Seymour de Ricci, *Description raisonnée des peintures au Louvre – i, Écoles étrangères, Italie et Espagne*, Paris, 1913, pp. 125–6).

7. A resolution to commission frescoes for the Cambio was passed in 1496. In the absence of the contract it must be assumed that work started either in 1497 (when Perugino was absent from Perugia for a great part of the year) or in 1498. The frescoes are likely to have been completed in or soon after 1500, though the concluding payment for them dates from 1507. Fischel (i, 1948, p. 21) credits Raphael with the figure of Horatius Cocles and less positively with those of Solomon and Fortitude.

8. London, National Gallery, No. 213. Panel: 17·1 × 17·1 cm. Gould, *National Gallery Catalogues: The Sixteenth Century Italian School (excluding the Venetian)*, 1958, pp. 147–50, provides a useful summary of the iconographical and other problems presented by the painting, but accepts the very early dating proposed for it by Fischel and presumes that it was executed before Raphael joined the studio of Perugino. As is recognised by Crowe and Cavalcaselle and reaffirmed by Longhi, this and the companion panel can hardly have been painted before 1504/5. The identification of the subject as Scipio Africanus is due to Panofsky, *Herkules am Scheidewege*, 1930, pp. 37–83. On the subject matter of the painting see also Klaus Graf von Baudissin, 'Auf der Suche nach dem Sinngehalt', in *P.J.*, lvii, 1936, pp. 88–97, and the distinguished account of E. Wind, *Pagan Mysteries in the Renaissance*, 1958, pp. 8, 81.

9. London, National Gallery, No. 213A. Pen: 16·8 × 20·2 cm. Fischel, *R.Z.*, No. 40. On the Weimar drawing see Ruland, *The Work of Raphael … at Windsor Castle*, 1876, p. 144, and

Gould, loc. cit. A photograph of the drawing (which I have not seen in the original) is in the Raphael Collection in the Royal Library.

10. Chantilly, Musée Condé, No. 39. Panel: 17 × 17 cm. For the iconography see Panofsky, *Herkules am Scheidewege*, 1930, pp. 142–50, and for the visual sources of the panel E. Tea, 'Le fonti delle Grazie di Raffaello', in *L'Arte*, xvii, 1914, pp. 41–48. The pentimento referred to in the text was first noted by Frimmel, 'Ein Pentiment bei Raffael', in *Blätter für Gemäldekunde*, 1904, No. 2, pp. 17–21.

11. The medals on the reverse of which the Three Graces occur are those of Pico della Mirandola (Hill, *Corpus of Italian Medals of the Renaissance before Cellini*, 1930, No. 998), Maria Poliziana (Hill, No. 1003), and Giovanna Tornabuoni (Hill, No. 1021). Hill presumes that the reverses depend from some other classical prototype than the Siena group.

12. London, National Gallery, No. 2919. Panel: 24 × 85 cm. For the history and condition of the panel see Gould, *National Gallery Catalogues: The Sixteenth-Century Italian School (excluding the Venetian)*, 1958, pp. 156–7. The execution of the panel is given by Richter and Gronau to Eusebio di San Giorgio.

13. New York, Metropolitan Museum of Art, No. 32.130.1. Panel: 24 × 28 cm. Raphael's responsibility for the execution of the panel is wrongly questioned by Richter and Gronau.

14. Boston, Isabella Stewart Gardner Museum. Panel: 24 × 28 cm. Dussler (No. 11, p. 21) rightly maintains the autograph status of the panel against the doubts of Richter and Gronau.

15. The copy of the predella by Claudio Inglese Gallo is now in the depot of the Pinacoteca Nazionale dell'Umbria at Perugia. I am indebted to Dr. Francesco Santi for arranging to have it photographed. The documents relating to the sale of the original predella in 1663 are printed in *Giornale d'Erudizione Artistica*, iii, 1874, pp. 304–15.

16. Vasari, iv, p. 324: 'quando porta la croce, dove sono bellissime movenze di soldati che lo strascinano'.

17. New York, Morgan Library. Bistre wash: 22·5 × 26·2 cm. Fischel, *R.Z.*, No. 66.

18. Vasari, iv, pp. 322–3: 'Fece al medesimo un quadretto d'un Cristo che ora nell'orto, e lontani alquanto i tre Apostoli che dormono: la quel pittura è tanto finita, che un minio non può essere nè migliore nè altrimenti'. For a summary of information on the painting see Camesasca, i, p. 72.

19. Paris de Grassis, *Diarium*, Vienna, iii, 1882, p. 371. The second reference occurs in a record of a payment to Raphael of 3 January 1516 'in dipingendo cubicula signature palatii domini nostri' (Biermann, pp. 129–30). Careful summaries of the evidence are given by Pastor, *Geschichte der Päpste*, Freiburg-im-Breisgau, 1956, III–2, pp. 990–1025, Dussler, pp. 79–80, and Chastel, *Art et humanisme à Florence au temps de Laurent le Magnifique*, Paris, 1956, pp. 469–84.

20. The classical statement of the theory that the Stanza della Segnatura housed the Pope's library is that of Wickhoff, 'Die Bibliothek Julius II', in *P.J.*, xiv, 1893, pp. 49–64. The contrary case, that the room did not constitute a library and that its designation as 'Camera della Segnatura' 'est accidentelle et ne vaut pas qu'on s'y arrête', is stated by Dorez in *Revue des Bibliothèques*, 1896, pp. 98–126. The view that the room was used as a library is restated by J. Shearman, *Stanze*, pp. 158–80, with supporting arguments (i) from the presence of an unprecedentedly large number of books in the frescoes themselves, and (ii) from payments in 1509 to Lorenzo Lotto for work 'in Cameris superioribus papae prope librariam superiorem' and to a 'Johanni pictori' (presumed to be Johannes Ruysch) for work 'in camera bibliothecae'. Neither of these arguments is definitive. There is, moreover, some evidence that between 1507 and 1509 a new private library was prepared for the Pope elsewhere in the Vatican palace. The terms in which it is described on 3 June 1509 by Francesco Albertini, *Opusculum de mirabilibus novae urbis Romae*, ed. Schmarsow, 1886, p. 34 ('Est praeterea biblioteca nova secreta perpulchra (ut ita dicam) Pensilis Julia, tua beatitudo construxit signisque planetarum et coelorum exornavit, additis aulis et cameris ornatissimis atque deambulatoriis auro et picturis ac statuis exornatis non longe a capella syxtea') seem to preclude the possibility that it is identical with the Stanza della

Segnatura. A brief but judicious summary of the evidence is supplied by D. Redig de Campos, *Stanze*, 1965, p. 11n., who concludes that the Stanza della Segnatura was designed to house the library of Julius II, but was still in course of decoration at the time of the Pope's death, and was adapted as a library only under Leo X. According to Giovio, the Stanza dell'Incendio was a *triclinium penitior* or private dining-room.

21. Vasari, iv, pp. 330-2: 'Una storia, quando teologi accordano la filosofia e l'astrologia con la teologia: dove sono ritratti tutti i savi del mondo che disputano in varj modi. Sonvi in disparte alcuni astrologi che hanno fatto figure sopra certe tavellette e caratteri in vari modi di geomanzia e d'astrologia, ed ai Vangelisti le mandano per certi Angeli bellissimi; i quali Evangelisti le dichiarono. . . . Ne si può esprimere la bellezza e la bontà che se vede nelle teste e figure de' Vangelisti, a' quali ha fatto nel viso una certa attenzione ed accuratezza molto naturale, e massimamente a quelli che scrivono. E così fece dietro ad un San Matteo; mentre che egli cava di quelle tavole dove sono le figure, i caratteri, tenuteli da uno Angelo, e che le distende in su'n un libro; un vecchio che, messosi una carta in sul ginocchio, copia tanto quanto San Matteo distende; e mentre che sta attento in quel disagio, pare che egli tocca la mascella e la testa, secondo che egli allarga ed allunga la penna.'

22. Bellori, *Descrizione*, 1695, p. 15: 'Improprio è l'argomento, che si legge impresso sotto l'intaglio di questa Immagine, cavato dagli atti di San Paolo, quando il Santo Apostolo disputava fra gli Epicurei, e gli Stoici nell'Areopago . . . Improprio ancora è il nome importole dal Vasari . . . Tali errori scaturirono poco dopo la morte di Raffaello per inavertenza di coloro che presero ad interpretare le sue opere . . . Il nome di Scuola di Atene attribuitole communemente, è più convenevole, e si accosta meglio alla proprietà delle figure, avendovi riguardo ad una Città maestra delle discipline. Raffaelle ebbe intenzione di raccorre insieme gli studi, e le scuole de' più illustri Filosofanti, non di una età sola, ma de' più celebri del Mondo per formare l'Immagine della Filosofia, servendosi molto a proposito dell'anacronismo, o sia riduzione de' tempi, ne' quali vissero, Se noi dunque la chiameremo il GINNASO di ATENE, non sarà disconvenevole.'

23. B. xiv 492.

24. Vasari, iv, p. 334: 'Nell'aria una infinità di amori ignudi con bellissime arie di viso, che colgono rami di lauro e ne fanno ghirlande, e quelle spargono e gettano per il monte'.

25. B. xiv 297. For the relationship of the engraving to the fresco see particularly Kristeller, 'Marcantons Beziehung zu Raffael', in *P.J.*, xxviii, 1907, pp. 199-299.

26. Vasari, iv, pp. 335-7: 'Fece in un'altra parete un cielo con Cristo e la Nostra Donna, San Giovanni Batista, gli Apostoli, e gli Evangelisti e Martiri su le nugole, con Dio Padre che sopra tutti manda lo Spirito Santo, e massimamente sopra un numero infinito di Santi che sotto scrivono la messa, e sopra l'ostia che e sullo altare disputano. . . . Ma molto più arte ed ingegno mostrò ne' Santi Dottori cristiani, i quali a sei, a tre, a due disputando per la storia, si vede nelle cere loro una certa curiosità ed un affanno nel voler trovare il certo di quel che stanno in dubbio, faccendone segno col disputar con le mani.'

27. For the statement of this case see H. B. Gutmann, 'Zur Ikonologie der Fresken Raffaels in der Stanza della Segnatura', in *Zeitschrift für Kunstgeschichte*, xxi, 1958, pp. 27-39.

28. E. Wind, 'The Four Elements in Raphael's Stanza della Segnatura', in *Journal of the Warburg Institute*, ii, 1938, pp. 75-79, shows that of the paired scenes that above in grisaille is historical and that below in colour is mythological. The four sets of scenes refer to the elements of Fire (*Mucius Scaevola* and *Vulcan*), Water (*Marcus Curtius* and *Amor vincit Aquam*), Earth (*The Justice of Brutus* and *Vanquished Giants*), and Air (*Pax Augusta* and *Return of Amphitrite*), and the elements in their turn relate to Theology, Jurisprudence, Philosophy, and Poetry.

29. D. Redig de Campos, 'Il "Pensieroso" della Segnatura', in *Raffaello e Michelangelo*, Rome, 1946, pp. 83-98, and *Stanze*, pp. 15-17. Redig de Campos suggests that the figure may have been inserted in August 1511.

30. The commissions for the Ascanio Sforza and Girolamo Basso monuments appear to date re-

spectively from 1505 and 1507. Bramante's tribune was roofed over in the summer of 1509.

31. For the use of the Giustiniani sarcophagus by Marcantonio see H. Thode, *Die Antike in den Stichen Marcantons, Agostino Venezianos und Marco Dentes*, Leipzig, 1881, p. 18.

32. Vienna, Albertina, S.R. 262. Pen: 24·5 × 21·8 cm. Fischel, *R.Z.*, No. 250. The identification of the model as the statue of Ariadne in the Vatican is due to Michaelis, in *Jahrbuch des Kaiserlichen Deutschen Archaeologischen Instituts*, v. 1890, p. 18.

33. E. Winternitz, 'Archeologia musicale del Rinascimento nel Parnaso di Raffaello', in *Rendiconti*, xxvii, 1952–4, pp. 359–88, reprinted in *Musical Instruments and their Symbolism in Western Art*, 1967, pp. 185–201. The connection is also noted by Panofsky, *Renaissance and Renascences*, Uppsala, 1960, p. 202, who in addition associates the figure of Erato, to my mind mistakenly, with the Adam on the Sistine Ceiling.

34. Winternitz, op. cit., pp. 359–88.

35. Panofsky, op. cit., p. 205.

36. Windsor Castle, Royal Library. Pen: 26·5 × 18·2 cm. Fischel, *R.Z.*, No. 246. Popham and Wilde, No. 796.

37. J. Richardson, *An Account of the Statues, Bas-Reliefs, Drawings and Pictures in Italy, France, &c. with Remarks*, 2nd ed., London, 1754, p. 199.

38. Bellori, *Descrizione*, 1695, p. 24: 'Dopo Virgilio si scuopre il volto d'un altro Poeta laureato, in cui è ritratto l'istesso Raffaelle rivolto in placido sguardo; e ben qui degnamente è collocato in Parnaso over da primi anni gustò l'acque del fonte Ippocrene, e fù dalle Grazie, e dalle Muse nutrito'.

39. Vasari, iv, p. 335: 'E per comminciarmi da un capo, quivi è Ovidio, Virgilio, Ennio, Tibullo, Catullo, Properzio, ed Omero'.

40. Bellori, *Descrizione*, 1695, p. 24: 'Nel mezzo di costoro vaga, e gioconda apparisce la Tebana Corinna, di cui altra non fù più dotta, e famosa nel canto. Soave è il volto, lunghi i crini sulle spalle disciolti, e favellando ad uno, che si

avvicina al suo fianco, gli adita sopra il gran Cantore di Smirna, il grande Omero.'

41. Bellori, *Descrizione*, 1695, p. 25: 'Volgendoci ora dal sinistro lato del monte e all'altre figure collocate nell'istesso piano, al pari della dotta Saffo siede Pindaro principe de' Lirici più di ogni altro ad Apolline grato, ben si ravvisa al noto ritratto, gravi le ciglia, maestoso il volto. Canta egli, e distendendo il braccio fuori del manto, pare che con la mano additi gli Eroi vincitori in Pisa, ed in Olympia nelle sue Ode ancor vivi immortali.'

42. Vasari, iv, pp. 33–35: 'Nella facciata, dunque, di verso Belvedere, dove è il monte Parnaso ed il fonte di Elicona, fece intorno a quel monte una selva ombrosissima di lauri, ne' quali si conosce per la loro verdezza quasi il tremolare delle foglie per l'aure dolcissime . . . nel quale pare che spiri veramente un fiato di divinità nella bellezza delle figure e dalla nobiltà di quella pittura.' The figures at the bottom on the left are identified by Hoogewerff, 'A piè del Parnaso', in *Bollettino d'Arte*, vi 1926, pp. 1–14, as Pindar, Horace, Petrarch, and Sappho, and those in the corresponding position on the right as Aeschylus, Sophocles, and Euripides. This results from a schematic interpretation of the fresco whereby the figures at the back on the left would be epic poets, the figures at the back on the right would be modern poets, the figures at the bottom on the left would be lyric poets, and the figures at the bottom on the right would be tragic poets.

43. This is, for example, the view of Fischel, 1962, pp. 54–55, and Shearman, op. cit., who assumes that work on the ceiling was begun in October 1508 by Sodoma and Johannes Ruysch and was continued by Raphael. For a convenient summary of the literature, see Dussler, pp. 80–81. The evidence from preliminary drawings is in no way inconsistent with a dating in 1510–11 rather than in 1508–9.

44. Vasari, iv, pp. 332–3: 'E se bene l'opera di Giovanni Antonio Soddoma da Vercelli, la quale era sopra la storia di Raffaello, si doveva per commissione del papa gettare per terra, volle nondimeno Raffaello servirsi del partimento di quello e delle grottesche; e dove erano alcuni tondi, che sono quattro, fece per ciascuno una figura del significato delle storie di sotto, volte da quella banda dove la storia.'

45. For other attributions to Sodoma and to Peruzzi see Dussler, p. 81. The most extreme statements of the case for attributing certain of the tondi and the adjacent scenes to one or other of these artists are those of W. Arslan, 'Intorno al Sodoma, a Raffaello e alla Stanza della Segnatura', in *Dedalo*, ix, 1928–9, pp. 525–44, and G. Gombosi, 'Sodomas und Peruzzis Anteil an den Deckenmalereien der Stanza della Segnatura', in *Jahrbuch für Kunstwissenschaft*, 1930, pp. 14–24.

46. D. Redig de Campos, *Stanze*, pp. 21–22. It is here argued that the ceiling frescoes reflect the stylistic development of the frescoes on the walls, and that 'la sequenza corrisponde più o meno a quella in cui furono dipinti gli affreschi maggiori'. The stylistic development within the allegorical figures and the narrative scenes is, however, insufficiently pronounced to permit the assumption that they were produced sequentially in connection with the wall frescoes to which they relate.

47. Windsor Castle, Royal Library. Chalk: 36 × 22·7 cm. Fischel, *R.Z.*, No. 228. Popham and Wilde, No. 792.

48. B. xiv 382.

49. For the attribution to Guillaume de Marcillat of the ceiling of the Stanza of Heliodorus see M. Donati, 'Dell'attività di Guglielmo di Marcillat nel Palazzo Vaticano', in *Rendiconti*, 1949–51, pp. 267–76. Pouncey and Gere, No. 252, p. 150, 'agree with those who attribute the whole decoration of this ceiling to Peruzzi'. None of the preliminary drawings for the ceiling is by Peruzzi, and the connection of the fresco both in style and in technique with the frescoes by Guillaume de Marcillat on the roof of the Cathedral at Arezzo makes an ascription to this artist inescapable. Shearman, *Stanze*, p. 173, advances the hypothesis that the ceiling was painted by Peruzzi in 1508–9, and was then replanned by Raphael in 1513–14 when the Old Testament scenes were produced. According to this analysis, 'careful inspection of the framing shows that the ceiling was originally painted with eight ribs, four of which were removed to make way for new quadrant-shaped sections of intonaco on which the fictive tapestries were painted'.

50. Rome, Villa Farnesina. Variously dated between 1511 and 1515. Decisive arguments in favour of a dating ca. 1511 are provided by the style of the fresco, and by references in Gallo, *De Viridario Augustini Chigi . . . libellus*, Rome, 1511, and Blosio Palladio, *Suburbanum Augustini Chigi opus*, 1512, to a representation of Venus in the Villa Farnesina which can only be identical with the *Galatea*. Fischel, i, 1948, p. 177, is none the less of the opinion that 'this fresco came into existence hardly before 1514'.

51. E.g. E. Camesasca, ii, p. 43: 'Si vuole che il Chigi ne togliesse l'incarico a Sebastiano del Piombo per affidarlo al Sanzio'. Dussler, p. 110, dates the *Polyphemus* ca. 1511.

52. Vasari, v, p. 567: 'Dopo quest'opera avendo Raffaello fatto in quel medesimo luogo una storia di Galatea, vi fece Bastiano, come volle Agostino, un Polifemo in fresco allato a quella'. Saxl, 'The Villa Farnesina', in *Lectures*, i, 1957, p. 195, claims that 'the other paintings on the walls of this room were unfortunately not executed according to the original plan; they were to have represented scenes symbolizing the element of air'.

53. The payments date respectively from 1 July 1514 and 1 August 1514 (documents printed by Golzio, pp. 31–32, 33).

54. The principal exponent of this thesis is Hartt, *Giulio Romano*, i, 1958, pp. 22–24, who argues that Raphael was responsible only for 'the general design of the *Fire* and for its formulation in terms of an Albertian visual cone', and that Giulio Romano 'was left fairly free to work out his own ideas'. For a conclusive statement of the contrary case see Oberhuber, 1962, pp. 23–72.

55. K. Badt, 'Raphael's Incendio del Borgo', in *Journal of the Warburg and Courtauld Institutes*, xxii, 1959, pp. 35–59, argues that 'into a space design supplied by Peruzzi Raphael himself inserted the grouped figures in the foreground with the exception of those in the centre of the picture'.

56. Golzio, pp. 30–31.

57. B. xiv 18.

58. London, British Museum. Pen over red chalk: 23·3 × 37·6 cm. Fischel, *R.Z.*, No. 233. Pouncey and Gere, No. 21. Pouncey and Gere date the *Massacre of the Innocents* ca. 1509 on the ground

that the *versos* of two drawings for it in the Albertina contain studies for the *Astronomy* and the *Judgement of Solomon* on the Segnatura ceiling. If, as suggested above, the sections of the ceiling painted by Raphael date from ca. 1511, the *Massacre* would date from the same time.

59. Windsor Castle, Royal Library. Chalk over pencil: 24·8 × 41·1 cm. Fischel, *R.Z.*, No. 234. Popham and Wilde, No. 793, discuss the relationship of the sheet to the cognate drawing in Vienna (Fischel, *R.Z.*, No. 236). The series of drawings is analysed by Fischel, *R.Z.*, pp. 251–3. For some interesting observations on the iconography of the print of the *Massacre of the Innocents* see L. Donati, *Due note d'iconografia raffaellesca*, Florence, 1963, pp. 10–24.

60. The only indubitably autograph drawing for the *Burning of the Borgo* is a study for the Aeneas and Anchises in the Albertina, Vienna, sometimes mistakenly given to Giulio Romano. The remaining sheets associable with the fresco are the work of members of the studio copied or developed from lost drawings by Raphael. A summary survey of the sheets is given by Dussler, p. 93.

61. J. Burckhardt, *Der Cicerone*, ed. 1957, p. 872.

62. *Goethes Preisaufgaben für Bildende Künstler, 1799–1805*, ed. W. Scheidig, Weimar, 1958, p. 393: 'Wenn Menschen gegen Elemente kämpfen oder, von solcher Gewalt bedrängt, sich zu retten suchen, finden sich immer die günstigen Gegenstände für bildende Kunst. Raphael gewann auf diesem Felde den Stoff sowohl zur Sündflut als zum Brand des Borgo.'

63. It appears in effect to have been limited to the designing of the *Sea-Battle of Ostia* and the preparation of drawings for individual figures in this fresco, to the designing of the *Coronation of Charlemagne*, and to general supervision of the *Oath of Leo III*.

64. Golzio, p. 38. The terms of the payment suggest that the definitive commission for the tapestries must have been placed late in 1514 or early in the following year.

65. An excellent résumé of critical opinion on the authorship of the cartoons is given by Dussler, pp. 115–16. The best general discussion of their

style is that of S. J. Freedberg, *Painting of the High Renaissance in Rome and Florence*, i, 1961, pp. 266–7, 273–8.

66. On the factor of reversal see particularly H. Wölfflin, 'Das Problem der Umkehrung in Raffaels Teppichkartonen', in *Gedanken zur Kunstgeschichte*, 1941, pp. 90–96, and A. P. Oppé, 'Right and left in Raphael's Cartoons', in *Journal of the Warburg Institute*, vii, 1944, pp. 82–94.

67. Paris, Louvre, No. 3854. Red chalk: 25·6 × 13·3 cm. Fischel, *Versuch*, No. 244, and Hartt, i, p. 286, as Giulio Romano. Raphael's authorship of this sheet is correctly reaffirmed by Shearman, in *Burlington Magazine*, ci, 1959, p. 457.

68. Windsor Castle, Royal Library. Red chalk: 25·7 × 37·5 cm. Popham and Wilde, No. 802.

69. Paris, Louvre, No. 3863. Brush and pen: 22·4 × 35·5 cm. Raphael's responsibility for the entire sheet is maintained by Shearman and Oberhuber, loc. cit.

70. Chatsworth, Duke of Devonshire. Metalpoint: 22·8 × 10·3 cm.

71. Windsor Castle, Royal Library. Metalpoint: 27 × 35·5 cm. The sheet is dismissed by Fischel, *Versuch*, 1898, No. 253, as a school drawing related to the Agostino Veneziano engraving of 1516, and was regarded by Crowe and Cavalcaselle, ii, p. 320n., as a copy. Its reinstatement as an autograph study is due to Popham and Wilde, No. 803.

72. For the history of the tapestries see Dussler, pp. 111–18.

73. Golzio, p. 103.

74. C. G. Stridbeck, *Raphael Studies, ii: Raphael and Tradition*, Uppsala, 1963, p. 69. Despite this to my mind mistaken conclusion, the essay contains much useful information.

75. Stridbeck, op. cit., p. 28, suggests tentatively that Julius II should be regarded as the ideator of the tapestries. There is no documentary support for this view. The cartoon of *Christ presenting the Keys to St. Peter* is, however, markedly different in style

from the companion scenes, and its scheme could well have been arrived at during the last phase of work on the Stanza della Segnatura. The possibility must therefore be borne in mind that we have here to do with a trial cartoon of ca. 1512, which was modified in 1514/15 when a commission was placed for the cycle of tapestries.

76. These points are noted by Stridbeck, op. cit., pp. 66, 70.

77. The material relating to Raphael's appointment as Commissary of Antiquities is assembled by R. Lanciani, *Storia degli scavi di Roma*, i, Rome, 1902, pp. 166–95. The appointment was made on 27 August 1515 in consequence of the death of the previous occupant, Fra Giocondo. Lanciani concludes that 'l'opera del divino artista fù bensi efficace dal punto di visto teorico; nell'atto pratico riuscì a poco o nulla'.

78. For the plan of Rome see Lanciani, 'La pianta di Roma e i disegni archeologici di Raffaello Sanzio,' in *Rendiconti della Reale Accademia dei Lincei*, Cl. scienze mor., 5 ser. III, 1894, pp. 795ff. The dedication of Andrea Fulvio's *Antiquitates Urbis* (1527) contains the sentences: 'Ruinas urbis iterea tuis optimis auspiciis persecutus, ab interitu vendicare ac litterarum monumentis resarcire operam dedi, Quae jacerent in tenebris nisi litterarum lumen accenderet. priscaque loca tum per regiones explorans observavi, quas Raphael Vrbinas (quem honoris causa nomino) paucis an diebus que vita decederet (me indicante) penicillo finxerat.'

79. The frescoing of the bathroom of Cardinal Bibbiena in the Vatican is referred to in letters of 19 April, 6 May, and 20 June 1516 (Golzio, pp. 43, 45, 48), when it was complete. The best account of the frescoes remains that of Dollmayr, in *Archivio storico dell'arte*, iii, 1890, pp. 272–80, which is supplemented by an article by De Vito Battaglia, in *L'Arte*, xxix, 1926, pp. 203–12.

80. For the Loggetta see D. Redig de Campos, *Raffaello e Michelangelo*, 1946, pp. 31ff. The date of the Loggetta is established by a letter of 4 March 1519 from Michiel, according to which Raphael had painted the Stanze and 'una loggia longhissima . . . e va drieto dipingendo due altre loggie'. The style and sources of this work and of the Stufetta are discussed in an admirable article

by N. Dacos, 'Per la storia delle Grottesche', in *Bollettino d'Arte*, 1966, pp. 43–49.

81. The frescoes appear to have been completed by the end of 1518; they are referred to in a letter from Leonardo Sellaio to Michelangelo in January of the following year (Golzio, p. 65). For the bibliography of the villa and of the Loggia of Psyche see Dussler, p. 109, and for the frescoes and preliminary drawings J. Shearman, 'Die Loggia der Psyche in der Villa Farnesina und die Probleme der letzten Phase von Raffaels graphischem Stil', in *W.J.*, n.f. xxiv, 1964, pp. 59–100.

82. The principal theories are those of Michaelis, Hoogwerff, and Wind. Michaelis, 'Zu Raphaels Psychebildern in der Farnesina', in *Kunstchronik*, xxiv, 1889, pp. 1–2, suggests that 'der Plans des Bilderzyklus sich ursprünglich auch auf die sechs Leeren, vielleicht auch auf die drei teilweise von der Thüren eingenommenen Wandfelder erstreckte, und dass dort die irdischen Vorgänge des Romans . . . Platz finden sollten'. G. Hoogwerff, 'Raffaello nella Villa Farnesina, affreschi e arazzi', in *Capitolium*, xx, 1945, pp. 9ff., supposes that the walls were to be hung with tapestries, and that Raphael's preliminary drawings for them are reflected in a series of engravings by Michel Coxie of 1532–3. E. Wind, *Pagan Mysteries in the Renaissance*, London, 1958, p. 145, places the missing scenes in the lunettes beneath the ceiling. This last case is restated with strong supporting arguments by Shearman.

83. This conjunction is pointed out by I. Bergstrom, *Revival of Antique Illusionistic Wall-painting in Renaissance Art*, Göteborg, 1957, pp. 45–51. The decoration of the room is happily defined by Bergstrom in the following terms: 'What we see here is not an architectural illusionism inspired by antique art, but the poetic transfiguration of the traditional gods and goddesses, who have acquired a flesh and blood reality quite as convincing as that of the most illusionistic figures at Herculaneum and Pompei'.

84. Golzio, p. 194. The passage reads: 'un Mercurio d'età di tredici anni in circa a similitudine di quello di marmo, il quale ancora oggi dì vediamo ne la Loggia di Leone'.

85. Bellori, *Descrizione*, 1695, p. 77: 'Il dipinto di si grand'opera fu eseguito nella maggior parte dal

suo gran discepolo Giulio Romano. . . . Toccò in più luoghi Raffaelle, ma di sua mano non abbiano di certo altro, che il triangolo delle tre Grazie, particolarmente quella rivolta in schiena, mirabile nel suo colore a fresco più che al olio condotto.'

86. A good analysis of the drawings is provided by Shearman, who credits Giulio Romano with the important drawing in the Lugt Collection, Paris, for the ceiling fresco of the *Council of the Gods*. The Lugt drawing is given by Jaffé, in *Burlington Magazine*, civ, 1962, p. 233, and Oberhuber, 1962, p. 52, in my opinion rightly, to Raphael.

87. Ridolfi, *Meraviglie dell'Arte*, ed. Hadeln, i, 1914, pp. 102–3. Wind, op. cit., p. 145–6, interprets the theme of the Farnesina cycle as 'the torture of the mortal by the god who inspires him'.

88. Chatsworth, Duke of Devonshire. Red chalk (offset): 33 × 24·6 cm. Shearman, op. cit., Fig. 71.

89. Oxford, Ashmolean Museum. Pen over red chalk: 10·5 × 8 cm. Parker, No. 655 (wrongly regarded as 'a jotting made from memory at a date a good deal later than the fresco'). For a vindication of Raphael's authorship see Shearman, loc. cit.

90. Paris, Louvre, No. 3875. Red chalk: 26·4 × 19·7 cm. The drawing is given by Fischel, *Versuch*, No. 271, and Hartt, *Giulio Romano*, i, 1958, p. 288, to Giulio Romano, and by Shearman, Fig. 81, correctly, to Raphael.

NOTES TO CHAPTER V

1. It was long assumed that Raphael's 'century of sonnets' was a figment of Browning's imagination. Browning's source was, however, established in 1940 (letter to *Times Literary Supplement*, 25 May 1940, p. 255) by Mr. Frederick Page as the 1846 edition of Baldinucci's *Notizie* (iv, p. 26), where, after an account of the distribution of the effects of the painter Guido Reni, there occurs the sentence: 'Persesi però, con una collana d'oro, ed alcune argenterie, il famoso libro de' cento sonetti di mano di Raffaello, che Guido aveva comperati in

Roma, e ciò non senza qualche sussurro, quantunque poco fondato, che il tutto fosse stato rapito da un domestico.' This explanation is accepted by DeVane, *A Browning Handbook*, 2nd ed., New York, 1955, p. 277n. I am indebted for this information to Mr. Richmond D. Crinkley.

2. R. Fry, *Transformations*, London, 1926, p. 20.

3. The cartoon appears for the first time in the Fiesole altarpiece of 1493 in the Uffizi, and is employed again in the altarpiece in S. Agostino at Cremona of 1494. It recurs in three half-length *Madonnas* at Frankfurt (ca. 1497), Detroit (ca. 1500), and Washington (ca. 1500–1).

4. Berlin/Dahlem, Gemäldegalerie, No. 141. Panel: 52 × 38 cm. The painting is usually dated ca. 1500. Dussler (No. 5, p. 18) rightly observes that 'seine Entstehung wird kaum später als 1501 anzusetzen sein'.

5. Oxford, Ashmolean Museum. Pen: 11·6 × 13·1 cm. This and the related studies described below are listed by Fischel, *R.Z.*, Nos. 46, 47, 48, and 49, and by Parker, No. 508. The description of the composition as *Die Madonna im Fenster* is due to Fischel.

6. Lille, Musée Wicar, No. 442. Metalpoint: 25 × 17·5 cm. Fischel, *R.Z.*, No. 50.

7. London, British Museum, Metalpoint: 25·8 × 17·5 cm. Fischel, *R.Z.*, No. 51. The interrelationship of this and the cognate drawings at Lille and Oxford is accepted by Pouncey and Gere, No. 3. The completed picture is published as Homeless in Berenson, *Italian Pictures of the Renaissance: Central Italian and North Italian Schools*, iii, 1968, Fig. 1174, and is now in a New York Collection. Panel: $21\frac{3}{4} \times 15\frac{3}{4}$ in. Coll.: Thomas Townend (sale Christie, July 14, 1883, No. 75, as Francia, bt. in.); Col. J. F. S. Bullen.

8. Berlin/Dahlem, Gemäldegalerie, No. 145. Panel: 34 × 29 cm. Variously dated between 1499 and 1504. Both Gamba (p. 27) and Dussler (pp. 18–19, No. 6) relate the panel to the work of Pinturicchio; the former assumes that it was executed on a cartoon of Pinturicchio ca. 1499, and the latter postulates the influence ca. 1502 of Pinturicchio's S. Maria dei Fossi altarpiece

(Perugia, Pinacoteca). A reliable account of the condition of the picture is given by Crowe and Cavalcaselle (i, 1882, p. 110).

9. Lille, Musée Wicar, No. 431. Pen: 16·7 × 15·7 cm. Fischel, *R.Z.*, No. 54.

10. Berlin/Dahlem, Graphische Sammlung. Repr. Fischel, *R.Z.*, Fig. 62.

11. Berlin/Dahlem, Gemäldegalerie, No. 247A. Panel: 86 cm. diameter. The panel is regarded by Fischel ('Ein Kartonfragment von Raphael zur Madonna del Duca di Terranuova', in *Berliner Museen*, xliii, 1922, pp. 13–14) as dating from the period of Raphael's transfer from Perugia to Florence (1504) and by Dussler (p. 19, No. 8), on account of the Leonardesque treatment of the left hand, as a work of 1505.

12. Leningrad, Hermitage. Panel transferred to canvas: 18 cm. diameter. Variously dated 1502–3 (Dussler, p. 37, No. 54) and 1504–5 (Longhi, in *Paragone*, May 1955, p. 22), the painting should probably be dated to 1504. The surrounding ornament is due to Raphael and the frame (formerly engaged) is original.

13. The Berlin drawing (for which see F. Lippmann, 'Raffael's Entwurf zur Madonna del Duca di Terranuova und zur Madonna Staffa-Conestabile', in *P.J.*, ii, 1881, pp. 62–66, and Fischel, *Die Zeichnungen der Umbrer*, Berlin, 1917, p. 134, No. 68) is apparently a copy from a lost drawing by Raphael, and occurs on the obverse of the same sheet as the copy from a drawing for the *Terranuova Madonna* (note 10 above). The Vienna drawing (Albertina, No. 4879. Black chalk: 41 × 30 cm. Fischel, *R.Z.*, No. 53) represents a later recension of the design.

14. London, British Museum. Metalpoint: 14·3 × 11 cm. Fischel, *R.Z.*, No. 349, as a study for the *Mackintosh Madonna*. Pouncey and Gere, No. 24, as a late Florentine/Roman drawing by Raphael not directly connected with a surviving painting.

15. The *Tempi Madonna* (for which see note 31 below) is connected by Schmarsow (*Donatello*, Breslau, 1886, p. 46) and Dussler (p. 49, No. 84) with the small Madonna in the relief of *The Miracle of the New-born Child* in the Santo at Padua.

16. For this see Middeldorf, 'Sull'attività della bottega di Jacopo Sansovino', in *Rivista d'Arte*, xviii, 1936, pp. 249–60, and Pope-Hennessy, *Catalogue of Italian Sculpture in the Victoria and Albert Museum*, ii, 1964, No. 442, pp. 417–19.

17. Florence, Uffizi, No. 505. Chalk: 21·3 × 18·8 cm. Fischel, *R.Z.*, No. 105.

18. Florence, Palazzo Pitti, No. 178. Panel: 84 × 55 cm. The painting is variously dated 1504–5 (Dussler, p. 29, No. 36, and others) and 1506–7 (Camesasca, i, p. 42). A dating in 1505 is probable. The problem of the background is posed in an interrogative fashion by Fischel (1962, p. 34: 'fraglich, ob er dabei die Landschaft opferte oder ob sie noch heute unter dem eigentlich auffälligen schwarzen Grund liegt') and Dussler. Putscher (pp. 214–16) argues in favour of the authenticity of the present neutral background. The earliest responsible account of the condition of the painting is that of Rumohr, *Italienische Forschungen*, ed. Schlosser, Frankfurt-am-Main, 1920, pp. 529–530, who saw it at Würzburg in 1802.

19. A copy of the *Madonna del Granduca* with a landscape background, noted by Passavant (ii, pp. 35f.) in a French private collection and listed by Dussler (p. 29) as 'verschollen', is perhaps identical with a painting formerly in the hands of J. E. Böhler, Vienna, of which a photograph is in the Berenson Library of the Harvard Center for Renaissance Studies, Florence. The landscape in the copy does not correspond with the landscape in the drawing in the Uffizi.

20. London, British Museum. Pen over red chalk: 25·4 × 18·4 cm. Fischel, *R.Z.*, No. 109. The best analysis of the sheet is that of Pouncey and Gere (pp. 15–17, No. 19).

21. Washington, National Gallery of Art (Widener Collection), No. 653. Panel: 58 × 42 cm. The painting, which has an Urbino provenance, is variously assigned to 1504/5 (Longhi, in *Paragone*, May 1955, p. 22), 1505 (Fischel and others), and 1506 (Gamba, p. 49).

22. Vienna, Albertina, S.R. 250. Red chalk and pen: 26 × 19·2 cm. Fischel, *R.Z.*, No. 110.

23. Berlin/Dahlem, Gemäldegalerie, No. 248. Panel: 77 × 56 cm. The claim of Putscher (p. 246) that

the head of the Virgin is extensively repainted and the assertion of earlier students that the painting is unfinished are conclusively refuted by Dussler (p. 19, No. 9). The status of the panel as an autograph work of Raphael has repeatedly been questioned, e.g. by Rumohr (pp. 536-7), who identified it with a work stated by Vasari to have been completed by Ridolfo Ghirlandaio, Gamba (pp. 53-54), Longhi (in *Paragone*, September 1952, p. 46), and Camesasca (pp. 51-52). The *Lady with a Unicorn* in the Galleria Borghese, Rome, No. 371 (for which see Dussler, p. 63, No. 113), also based on a cartoon by Raphael, is by the same hand.

24. For the letter see Golzio, pp. 18-19. The relevant sentence reads: 'ancora uiprego carissimo Zeo che uoi uoliate dire al prete e alasanta che uenendo la Tadeo Tadei fiorentino elquale nauemo ragionate più volte insieme lifacine honore senza asparagnio nisuno e uoi ancora li farite careze per mio amore che certo liso ubligatissimo quanto che uomo che uiua'.

25. Paris, Louvre. Pen: 26·8 × 40·6 cm. Fischel, *R.Z.*, No. 108. The drawing occurs on the *verso* of the celebrated sheet of the *Assault on Perugia* (Fischel, *R.Z.*, No. 96).

26. Vienna, Albertina, S.R. 250 (*verso*). Black chalk and pen: 26 × 19·2 cm. Fischel, *R.Z.*, No. 111.

27. Edinburgh, National Gallery of Scotland (on loan from the Duke of Sutherland). Panel transferred to canvas: 81 × 56 cm. The *Bridgewater Madonna* is generally regarded as a late Florentine work of 1507/8. Fischel (in *Burlington Magazine*, lxxiv, 1939, p. 187) and Pouncey and Gere (p. 20) recognise, however, that the painting 'could belong to the early Roman period'. An account of the condition of the picture by Camesasca (i, p. 51) is incorrect. I am indebted to Mr. David Baxandall for allowing me to study an X-ray photograph.

28. Chantilly, Musée Condé. Panel: 29 × 21 cm. Variously dated between 1505 and 1507/8. A dating in 1507 is probable. The view that the background 'was repainted in the manner of David Teniers' was advanced by Passavant (i, p. 45) and denied by Crowe and Cavalcaselle (i, 1882, p. 284), and is without foundation.

29. Washington, National Gallery of Art (Mellon Collection), No. 25. Panel: 68 × 47 cm. Inscribed on the hem of the dress: M D VIII. R.V. PIN.

30. Florence, Uffizi. Pen: 15·7 × 9·1 cm. Fischel, *R.Z.*, No. 140.

31. Munich, Alte Pinakothek, No. H.G. 796. Panel: 75 × 52 cm. Though dated by Fischel (1948, i, p. 348) ca. 1504/5, the picture can hardly have been produced before 1507/8 and is either a late Florentine or an early Roman work. For the copy of 1510 see Crowe and Cavalcaselle, i, 1882, p. 270: 'A copy . . . was lately in the possession of Monsignor Badia at Rome, of the same size as the original, with the initials R.S. and the date MDX. The style was that of the Florentine Sogliani.'

32. Vienna, Kunsthistorisches Museum, No. 628. Panel: 113 × 88 cm. Inscribed on the Virgin's robe: M.D.V.I. The date has also been read as M.D.V. The provenance of the painting from Casa Taddei is attested by Baldinucci, *Notizie*, Milan, 1811, vi, p. 230.

33. Vienna, Kunsthistorisches Museum, No. 206.

34. Oxford, Ashmolean Museum. Bistre and chalk: 21·7 × 17·5 cm. Fischel, *R.Z.*, No. 118. Parker, No. 518.

35. Metropolitan Museum of Art, New York. Red chalk: $8\frac{13}{16} \times 6\frac{1}{4}$ in. For this drawing see J. Bean, 'A rediscovered Drawing by Raphael', in *Bulletin of the Metropolitan Museum of Art*, n.s. xxiii, 1964, pp. 1-10.

36. Vienna, Albertina, S.R. 248. Pen: 24·8 × 36·5 cm. Fischel, *R.Z.*, No. 116.

37. Oxford, Ashmolean Museum. Pen: 22·8 × 16·2 cm. Fischel, *R.Z.*, No. 114. Parker, No. 516.

38. Florence, Uffizi, No. 1447. Panel: 107 × 77 cm. For the early history of the painting see Vasari, iv, p. 338. I am indebted to Dr. Luisa Becherucci for facilities for examining the picture, which appears to date from 1506.

39. Edinburgh, National Gallery of Scotland (on loan from the Duke of Sutherland). Panel trans-

ferred to canvas: 140 cm. diameter. The connec-
tion of the painting with the Borghese *Entombment*
acts decisively in favour of the dating ca. 1507
proposed by Fischel, 1948, i, p. 359, and Dussler,
p. 42, No. 67.

40. Paris, Louvre, No. 1496. Panel: 122 × 80 cm.
Inscribed on the Virgin's robe: RAPHAELLO
VRB. MD VII. The picture, which seems to have
been painted for Filippo Sergardi at Siena, is
almost certainly identical wtih a painting stated
by Vasari (*Vite*, iv, p. 328) to have been left un-
finished by Raphael on his departure for Rome
and to have been finished by Ridolfo Ghirlandaio.
It is generally agreed that Ridolfo Ghirlandaio's
intervention (if it took place) was limited to the
Virgin's dress.

41. See note 36 above.

42. Paris, Louvre, No. 2012. Pen: 30·5 × 21 cm.
Fischel, *R.Z.*, No. 120.

43. Oxford, Ashmolean Museum. Pen: 28·7 × 16·5
cm. Fischel, *R.Z.*, No. 121. Parker, No. 521.

44. Munich, Alte Pinakothek, No. 476. Panel: 131
× 107 cm. Inscribed on the Virgin's dress:
RAPHAEL. VRBINAS. The painting, which is
described by Vasari, seems to date from 1507.
The repainting of the upper corners and of the
background dates from the eighteenth century,
and was in any event carried out before the paint-
ing was transferred from Düsseldorf to Munich in
1801. I am indebted for the X-ray photograph to
the Berenson Library of the Harvard Center for
Renaissance Studies, Florence. The effect of the
picture in its original condition can be judged
from a copy in S. Frediano in Cestello, Florence,
and from an engraving by Bonasone (B. xv 65).

45. Paris, Louvre, No. 3949. Pen: 22 × 18·2 cm.
Fischel, *R.Z.*, No. 131.

46. Windsor Castle, Royal Library. Pen: 23·4 × 18
cm. Fischel, *R.Z.*, No. 130. Popham and Wilde,
No. 790.

47. Chantilly, Musée Condé. Pen: 37 × 24·5 cm.
Fischel, *R.Z.*, No. 132.

48. See also Vienna, Albertina, S.R. 247. Pen: 27 ×
23·5 cm. Fischel, *R.Z.*, No. 133, text vol. p. 152.

49. Oxford, Ashmolean Museum. Fischel, *R.Z.*,
text vol. fig. 137.

50. Madrid, Prado, No. 296. Panel: 29 × 21 cm.
Inscribed on the Virgin's dress: RAPHAEL.
VRBINAS. MD VII. As noted by Dussler, pp.
43–44, No. 73, the Virgin and the Lamb depend
from the cartoon of the *Virgin and Child with St.
Anne* of Leonardo and the St. Joseph from Fra
Bartolommeo. A version of the composition dated
1504 published by Viscount Lee of Fareham in
Burlington Magazine, lxvi, 1934, pp. 3–19, is not
by Raphael and has no evidential value for the
date of origin of the composition. For a cartoon
in the Ashmolean Museum, Oxford, which was
unknown to Fischel, see Parker, No. 520.

51. Budapest, Szepmuveszeti Muzeum, No. 71.
Panel: 29 × 21 cm. At one time generally regarded
as a late Florentine or early Roman work, datable
between 1508 (Gronau and others) and 1510
(Rosenberg), the painting is assigned by Longhi
(in *Paragone*, May 1955, p. 22) and Camesasca
(p. 45) to a date ca. 1505. The early dating is
untenable.

52. Florence, Uffizi. Pen: 28·7 × 19·2 cm. Fischel,
R.Z., No. 126.

53. London, National Gallery, No. 168. Panel:
71·5 × 55·7 cm. Fischel (1948, i, p. 65) identifies
the source as presumably a Muse sarcophagus. A
careful account of the panel is given by Gould,
*National Gallery Catalogues: The Sixteenth-Century
Italian Schools (excluding the Venetian)*, pp. 146–7,
who analyses the differences between the painting
and the cartoon in the Louvre (Fischel, *R.Z.*,
No. 207. Chalk: 58·4 × 43·5 cm.). From some
preliminary studies at Oxford and a copy of a
Raphael drawing at Chatsworth it can be
established that the figure was originally drawn
by Raphael in full-length.

54. Oxford, Ashmolean Museum. Chalk and pen:
38 × 23 cm. Parker, No. 545. The figure sum-
marily indicated on this sheet is considerably
closer to the *Alba Madonna* than a silverpoint
drawing at Lille, Musée Wicar, No. 479, which
is identified by Fischel, *R.Z.*, No. 353, as an early
study for the painting.

55. Lille, Musée Wicar, No. 457. Chalk and pen:
41 × 26·4 cm. Fischel, *R.Z.*, No. 364. The sheet

contains secondary studies which are associated by Fischel wtith the *Madonna della Sedia* and the *Madonna della Tenda*. In both cases the connection is generic.

56. *Verso* of the preceding sheet. Fischel, *R.Z.*, No. 365.

57. Washington, National Gallery of Art (Mellon Collection), No. 24. Panel transferred to canvas: 95 cm. diameter. The painting was bequeathed by Paolo Giovio to the Olivetan church at Nocera dei Pagani, where it was exhibited over the high altar. It is variously dated 1508/1511. For the copies and variants of the composition see Dussler, pp. 73–74, No. 131.

58. London, National Gallery, No. 744. Panel: 37·8 × 32·7 cm. For the condition and history of the painting see Gould, *National Gallery Catalogues: The Sixteenth-Century Italian Schools (excluding the Venetian)*, pp. 150–1.

59. Lille, Musée Wicar. Silverpoint: 11·5 × 14·5 cm. Though Fischel (*R.Z.*, No. 352) is probably correct in identifying this sheet as a study for the *Aldobrandini Madonna*, it should be noted that only the Young Baptist corresponds exactly with the painting, and that the axis of the Virgin's pose and the posture of the Child are different.

60. The painting is described in S. Maria del Popolo in 1544–6 and was preserved there till 1591, when it was removed by Cardinal Sfondrato. The term *Madonna di Loreto* is an eighteenth-century designation, which has no historical sanction. None of the many surviving versions (most of which measure approximately 120 × 90 cm.) has a good title to be regarded as the lost original; the finest of them is a much damaged contemporary copy in the collection of Mr. Paul Getty. One version (for which see J. Graber, in *Mitteilungen der zentralen staatlichen Restaurierungs-Werkstatten*, ii, 1928) bears the date 1509. The preliminary drawings noted below (note 61) would seem on independent grounds to have been produced about this time. It has been argued, initially by Pfau and in great detail by Putscher, that the painting formed part of a diptych with the portrait of Julius II in the Uffizi or with the lost original of this composition. If the *Madonna di Loreto* were painted in 1509, this theory would be untenable, since the portrait dates from 1511–12. For the documentation of the paint-

ing see A. Scharf, 'Raphael and the Getty Madonna', in *Apollo*, lxxix, 1964, pp. 114–21.

61. London, British Museum. Metalpoint: 16·8 × 11·9 cm. Fischel, *R.Z.*, No. 350. The sheet is closely related to a sheet at Lille, Musée Wicar (No. 438. Fischel, *R.Z.*, No. 351. Metalpoint: 16·7 × 11·9 cm.), which portrays the Child in the same posture as the *Madonna di Loreto*. Pouncey and Gere, No. 23, concede that both sets of drawings are contemporary and were probably made with the *Madonna di Loreto* in mind.

62. Pinacoteca Vaticana, No. 329. Dimensions: 301 × 198 cm. Painted for the high altar of S. Maria in Aracoeli (Vasari), the altarpiece was moved in 1565 to S. Anna at Foligno, and remained there till 1797, when it was taken to France. It was transferred from panel to canvas in Paris in 1800–1, and was returned in 1815 to the Vatican. It was again restored in 1957–8 (for this see D. Redig de Campos, 'La Madonna di Foligno di Raffaello', in *Miscellanea Bibliotecae Hertzianae zu Ehren von Leo Bruhns, Franz Graf Wolff Metternich, Ludwig Schudt*, Munich, 1961, pp. 184–97). It is argued by Putscher (pp. 48ff., pp. 79ff., pp. 246ff.) that the painting was begun in 1509 and was changed and completed in 1512. Dussler (p. 65, No. 117) assumes that it was finished early in 1512. The landscape has been variously ascribed to Battista (Cavalcaselle, Mendelssohn) and Dosso (Longhi) Dossi.

63. London, British Museum. Chalk: 40·2 × 26·8 cm. Pouncey and Gere, No. 25.

64. B. xiv 47.

65. E. Menegazzo, 'Marginalia su Raffaello, il Correggio e la Congregazione Benedettina Cassinese', in *Italia Medioevale e Umanistica*, iii, 1960, pp. 329–40. The letter is datable between 1509 and 1512/13.

66. This account is based on the exhaustive and now standard book by M. Putscher, *Raphaels Sixtinische Madonna. Das Werk und seine Wirkung*, Tübingen, 1955.

67. Dresden, Gemäldegalerie, No. 93. Canvas: 265 × 196 cm. The painting was purchased by King Augustus III of Saxony in 1754. A survey of the main problems to which it gives rise is supplied

by Dussler, pp. 24–25, No. 24. I am indebted to Mr. Williams Suhr for securing information on the treatment of the painting since it reached Dresden. The principal facts are summarised by G. Rudloff-Hille, 'Aus der Restaurierungs-geschichte der Madonna Raffaels', in *Dresdener Galerieblätter*, 1957, No. 3, pp. 36–41.

68. For the substitute altarpiece see Putscher, pl. I and III, and for a plausible reconstruction of the original siting of the painting Putscher, pl. V.

69. The case for regarding the painting as a banner is stated by Rumohr, pp. 571ff., and Ortolani, *Raffaello*, 1945, pp. 61f., and is decisively rejected by Putscher. A convenient analysis of this and other problems arising from the altarpiece is supplied by Dussler, No. 24, pp. 24–25.

70. London, National Gallery, No. 2069. Panel transferred to canvas: 78·8 × 64·2 cm. For the history and condition of the picture see Gould, *National Gallery Catalogues: The Sixteenth-Century Italian Schools (excluding the Venetian)*, pp. 154–6.

71. London, British Museum. Chalk: 71 × 53·5 cm. Fischel, *R.Z.*, No. 362. For the relation of the cartoon to the painting see Pouncey and Gere, No. 26, pp. 22–23.

72. Munich, Alte Pinakothek, No. H.G. 797. Panel: 68 × 55 cm. An attempted attribution to Giulio Romano (Morelli, Dollmayr) is rightly rejected by Fischel (1962, p. 99) and most recent scholars. For the condition of the painting see Oertel, *Italienische Malerei bis zum Ausgang der Renaissance: Meisterwerke der Alten Pinakothek*, Munich, 1960, pp. 33f.

73. Oxford, Ashmolean Museum. Silverpoint: 16 × 12·8 cm. Fischel, *R.Z.*, No. 376. Parker, No. 501, pp. 304–5. The related Marcantonio engrav-ing is B. xiv 11. A related drawing at Chatsworth (Silverpoint: 19 × 14·1 cm. Fischel, *R.Z.*, No. 375) showing the Child standing beside the Virgin's chair, was engraved by Marco da Ravenna (B. xiv 48).

74. Florence, Palazzo Pitti, No. 151. Panel: 71 cm. diameter. The dates assigned to the painting vary between 1512 and 1516. The earlier dating rests on the presumed connection with a drawing at

Lille (Fischel, *R.Z.*, No. 364) in which a sketch loosely related to the *Madonna della Sedia* appears in association with a study for the *Alba Madonna*.

75. Madrid, Prado, No. 297. Panel transferred to canvas: 215 × 158 cm. It is generally recognised that a woodcut of 1517 by Gregorius de Gregoriis makes a dating before 1517 mandatory.

76. Florence, Uffizi, No. 524. Red chalk: 26·1 × 26·2 cm. Fischel, *R.Z.*, No. 371.

77. London, Colville Collection. Bistre over chalk: 25·8 × 21·3 cm. Fischel, *R.Z.*, No. 372.

78. Windsor Castle, Royal Library. Metalpoint: 21 × 14·5 cm. Fischel, *R.Z.*, No. 373. Popham and Wilde, No. 800, pp. 312–13.

79. Florence, Palazzo Pitti, No. 94. Panel: 158 × 125 cm. For the condition of the painting see Sanpaolesi, in *Bollettino d'Arte*, xxxi, 1937–9, pp. 495ff.

80. Washington, National Gallery of Art (Kress Collection), No. 534. 61 × 45 cm. The painting is certainly identical with a portrait of Altoviti listed by Vasari (iv, p. 351) as a work of Raphael. The identity of the sitter has been questioned; when the painting was sold ca. 1811 to the King of Bavaria, it was believed in the Altoviti family that it represented Raphael, not Bindo Altoviti (for this see C. Belloni, *Un banchiere del Rinasci-mento, Bindo Altoviti*, Rome, 1935). There can, however, be little doubt that Altoviti is in fact the subject of the Washington painting. The con-jecture of Fischel (1962, p. 91) that the painting is a self-portrait by a painter in Raphael's Roman following may be disregarded. The pose adopted in the portrait is not, as claimed by Dussler (No. 134, p. 75), based on Sebastiano del Piombo's *Youth with a Violin* of 1515 in the Rothschild Collection at Ferrières, but like the Sebastiano portrait is evolved from the standing figures with heads turned on the left of the *Disputa* and of the *School of Athens*. The attribution of the portrait to Giulio Romano is sustained among others by Dollmayr, Hartt and Dussler. Hartt (*Giulio Romano*, i, 1958, pp. 51–53) redates the picture between 1520 and 1524, and suggests that Altoviti is represented as a younger man than he would have appeared at the time the painting was produced. This is inherently improbable. Freed-

berg (*Painting of the High Renaissance in Rome and Florence*, i, Cambridge, 1961, pp. 338–9) considers that the painting was prepared from a cartoon by Raphael and was executed by Giulio Romano. The connection of the painting with Giulio Romano is in practice less close than the almost unanimous ascription to this artist might indicate. In style and quality it is markedly different from the *Joanna of Aragon* in the Louvre, which is known to have been executed in Raphael's shop from a cartoon by an unnamed pupil in 1518–19. Since Bindo Altoviti was born on 26 November 1491, the portrait can hardly be later than the terminal date ascribed to it by Altoviti's biographer, 1513. The Palazzo Altoviti was restored and extended in that year. X-ray, infra-red and ultra-violet photographs reveal that the face is in exceptionally good condition and that the whole picture is well preserved save for some repainting along the lower right side of the neck. The painting was transferred from the original wood to a new panel before its acquisition by the National Gallery of Art.

81. Wide differences of view have been expressed on four of these seven paintings. The Cracow portrait (which I do not know in the original) is denied to Raphael by Fischel, 1962, p. 93, and Freedberg, op. cit., i, p. 179, who gives it to Penni: the strong arguments in favour of an ascription to Raphael about 1516 are restated by Dussler, pp. 36–37, No. 52. The double portrait of Navagero and Beazzano in the Palazzo Doria, Rome, has sometimes been regarded as a copy, but appears to be an original of 1516. The painting of *Raphael and his Fencing Master* in the Louvre has been unconvincingly ascribed to Sebastiano del Piombo, but is an original work of rather later date (1518/19). The Strasbourg portrait has been tentatively, and in my view correctly, exhibited as Raphael (Paris, Petit Palais. *Le seizième siècle européen*, 1965, No. 198, p. 245), but is dismissed by Shearman (in *Burlington Magazine*, cvii, 1966, pp. 63–64) on grounds of its incompatability with the portrait of the Fornarina inscribed RAPHAEL VRBINAS in the Galleria Nazionale, Rome. The view that we have here to deal with 'une œuvre entièrement "inventée" et exécutée par J. Romain' is justly rejected by Laclotte.

82. Paris, Louvre, No. 1498. Panel transferred to canvas: 207 × 140 cm. Inscribed on the robe of the Virgin: RAPHAEL VRBINAS. PINGEBAT

M.D. X. VIII. The execution of the painting is substantially by Giulio Romano. Two preliminary drawings in the Uffizi, Florence (Fischel, *R.Z.*, Nos. 377–8), are, however, by Raphael, not by Giulio Romano, to whom they are ascribed by Hartt (*Giulio Romano*, i, 1958, p. 28) and certain other scholars. The identification of Raphael's hand in the head of St. Joseph is due to Hartt. A cartoon in the Louvre for this head (Fischel, *R.Z.*, text vol., Fig. 197) is, however, by Giulio Romano.

83. Madrid, Prado, No. 303. Panel: 144 × 110 cm. Inscribed on the cradle: RAPHAEL PINX.

84. Madrid, Prado, No. 301. Panel transferred to canvas: 144 × 115 cm. For the case against attributing the invention of the painting as well as its execution to Giulio Romano see Pouncey and Gere, No. 134, pp. 78–79, who state that: 'We are inclined to agree with Crowe and Cavalcaselle, who attribute the execution of the *Perla* to Giulio but think that Raphael had a preponderating share in the design of the composition'.

85. Edinburgh, National Gallery of Scotland (on loan from the Duke of Sutherland). Panel: 88 × 62 cm. The ascription of this painting to Penni is due to Crowe and Cavalcaselle (ii, 1882, p. 552), who give a careful and distinguished account of its subject matter, and is accepted by most students up to and including Dussler (No. 69, p. 43).

86. Madrid, Prado, No. 300. Panel transferred to canvas: 200 × 145 cm. Inscribed below: RAPHAEL . VRBINAS . F. The painting was completed and installed at L'Aquila by 2 April 1520.

NOTES TO CHAPTER VI

1. S. J. Freedberg, *Painting of the High Renaissance in Rome and Florence*, i, Cambridge, 1961, p. 272.

2. F. Hartt, *Giulio Romano*, i, New Haven, 1958, pp. 56–57: 'The dating is uncertain, but . . . it is temptation to place it late, probably in 1523 before the resumption of work in the Sala di

Costantino'. J. Hess, 'On Raphael and Giulio Romano', in *Kunstgeschichtliche Studien zu Renaissance und Barock*, i, Rome, 1967, p. 195, as before 1524.

3. E. Panofsky, *The Iconography of Correggio's Camera di San Paolo*, London, 1961, pp. 19–20.

4. R. Longhi, *Il Correggio e la Camera di San Paolo a Parma*, Genoa, 1958, pp. 26–35, who presumes Correggio's visit to have taken place after March 1518 and before January of the following year.

5. Vasari, v, pp. 223–4: 'lo spirito del qual Raffaello si diceva poi esser passato nel corpo di Francesco, per vedersi quel giovane nell'arte raro e ne'costumi gentile e grazioso, come fù Raffaello; e, che è più, sentendosi quanto egli s'insegnava d'imitarlo in tutte le cose, ma sopra tutto nella pittura'. For a penetrating definition of Parmigianino's relationship to Raphael see particularly S. J. Freedberg, *Parmigianino: his Works in Painting*, Cambridge, 1950, p. 63.

6. Windsor Castle, Royal Library. Popham and Wilde, No. 598.

7. For long a much underrated work, the fresco appears to have been executed in 1511–12, and was restored by Daniele da Volterra and subsequently treated in 1814. A recent cleaning in 1959, for which see P. Cellini, in *Bollettino d'Arte*, xlv, 1960, pp. 93–95, has revealed that it is a work of the same quality as the later frescoes in the Stanza della Segnatura, and has proved that there is no substance in Vasari's statement (iv, pp. 339–340) that after its completion the fresco was reworked by Raphael in a style conforming to that of the Sistine Ceiling of Michelangelo. For the fresco see Dussler, No. 4, p. 79, and for the statue of Andrea Sansovino, which is dated 1512 and remained in its original position till 1760, Pope-Hennessy, *Italian High Renaissance and Baroque Sculpture*, London, 1963, i, pp. 41, 42, ii, p. 50.

8. A careful account of the literature of the Chigi Chapel in S. Maria della Pace is given by Dussler, No. 9, pp. 103–5, based in part on an excellent article by M. Hirst ('The Chigi Chapel in S. Maria della Pace', in *Journal of the Warburg and Courtauld Institutes*, xxiv, 1961, pp. 161–85). Though it was recognised by Fischel, 1948, i, p. 182, and 1962, p. 137, that the two circular compositions recorded in the Uffizi and Fitzwilliam drawings were designed to flank the altar, and though the reliefs were known to Frizzoni (*I disegni della R. Galleria degli Uffizi, serie terza, fasc. ii, Disegni di Raffaello*, Florence, 1914, p. 2), who mistakenly believed them to be by Caradosso, neither the exact context of the reliefs nor their authorship had been established prior to Hirst's article. Hirst infers, probably correctly, that the two reliefs, which are now at Chiaravalle Milanese (Diameter: 87 cm.), were executed prior to the bronze relief in S. Maria del Popolo.

9. For the Chigi Chapel in S. Maria del Popolo see Dussler, No. 10, pp. 105–6, and a careful but in part unacceptable article by J. Shearman, 'The Chigi Chapel in S. Maria del Popolo', in *Journal of the Warburg and Courtauld Institutes*, xxiv, pp. 129–60. The Chapel seems to have been conceived in 1513; the date 1516 appears on the cupola. For the relief now on the altar see D. Gnoli, 'La sepoltura d'Agostino Chigi', in *Archivio storico dell'Arte*, ii, 1889, pp. 317–26, and Pope-Hennessy, *Italian High Renaissance and Baroque Sculpture*, London, 1963, ii, pp. 43–45. The tradition that the *Jonah* is the work of Raphael goes back to Vasari (iv, p. 369: 'ed a Lorenzetto scultor fiorentino fece lavorar due figure, che sono ancora in casa sua al macello de' Corbi in Roma').

10. London, Victoria and Albert Museum. Stucco and linen on wood: 55·9 × 128 cm. For this relief see Pope-Hennessy, 'A Relief by Sansovino', in *B.M.*, ci, 1959, pp. 4–10, and *Catalogue of Italian Sculpture in the Victoria and Albert Museum*, London, ii, 1964, pp. 419–21, No. 443.

11. Pope-Hennessy, *Italian High Renaissance and Baroque Sculpture*, London, 1963, i, p. 56.

12. W. Friedlaender, *Caravaggio Studies*, Princeton, 1955, pp. 111–14.

13. For the bibliography of this painting see Friedlaender, op. cit., p. 178.

14. Bologna, Pinacoteca Nazionale. Panel transferred to canvas: 238 × 150 cm. For the documentation of the painting, which seems to belong to the year 1514, see F. Malaguzzi Valeri, 'La Santa Cecilia di Raffaello', in *Archivio storico dell'arte*, vii, 1894, pp. 367–8, and for an interpretation of its theme W. Gurlitt, 'Die Musik in Raffaels Heiliger

Caecilien', in *Jahrbuch der Musikbibliothek Peters* (1938), Leipzig, 1939, pp. 84ff. A summary of the relevant literature is supplied by Dussler, pp. 20–21, No. 10.

15. C. Malvasia, *Felsina Pittrice, vite de' pittori bolognesi*, ii, Bologna, 1841, p. 164.

16. For Domenichino's frescoes in San Luigi dei Francesci, which seem to date from 1615–17, and for the preliminary drawings see Pope-Hennessy, *The Drawings of Domenichino in the Collection of His Majesty the King at Windsor Castle*, London, 1948, pp. 81–85.

17. The inventory of Domenichino's studio published by A. Bertolotti, *Artisti bolognesi, ferraresi ed alcuni altri del gia Stato Pontificio in Roma nei secoli XV, XVI, e XVIII*, Bologna, 1885, p. 174, includes a drawing by Domenichino after Raphael's fresco. E. Borea, *Domenichino*, Milan, 1965, p. 159, observes that the painting in S. Pietro in Vincoli 'tradisce uno studio del luminismo caravaggesco', and Mahon, *Studies in Seicento Art and Theory*, London, 1947, p. 79, also explains some of its features by the influence of Caravaggio.

18. Borea, op. cit., p. 146.

19. For the drawing see Pope-Hennessey, op. cit., pp. 43–44.

20. Città di Bologna, V Mostra Biennale d'Arte Antica: *L'Ideale Classico del Seicento in Italia e la Pittura di Paesaggio*, Bologna, 1962, No. 20, pp. 100–1.

21. The narrative frescoes in S. Andrea della Valle date from 1623–6/7.

22. A. F. Blunt, *The Paintings of Nicholas Poussin: a critical Catalogue*, London, 1966, p. 36, No. 46.

23. Blunt, op. cit., pp. 39–40, No. 53. The painting dates from 1648.

24. Blunt, op. cit., p. 42, No. 57. Datable on the strength of a statement by Félibien, 1656.

25. Blunt, op. cit., pp. 120–1, No. 167. Datable on stylistic grounds ca. 1635–6.

26. For a full analysis of the problems presented by the *Bacchus-Apollo* at Stockholm, the *Parnassus* in the Prado, and the preliminary drawing for the latter painting in the Wildenstein Collection see E. Panofsky, *A Mythological Painting by Poussin in the Nationalmuseum, Stockholm*, Stockholm, 1960. Blunt, op. cit., p. 90, No. 129, dates the *Parnassus* before 1630.

27. The two sets of *Sacraments* were painted respectively in the late sixteen-thirties (completed 1642) for Cassiano dal Pozzo and between 1644 and 1648 for Chantelou. A centralised design is used for the *Sacrament of Marriage* in both series.

28. *The Presentation of the Keys* in the first series of the *Seven Sacraments* in the collection of the Duke of Rutland relates to the design of Raphael's tapestry cartoon.

29. Edinburgh, National Gallery of Scotland (lent by the Duke of Sutherland).

30. M. de Chantelou, *Journal du voyage du Cav. Bernini en France*, ed. G. Charensol, Paris, 1930, p. 172.

31. K. Andrews, in *Fifty Master Drawings in the National Gallery of Scotland*, Edinburgh, 1961, No. 29. I am indebted in this section to the advice of Mr. Michael Jaffé.

32. For this see J. Denuce, *De Konstkamers van Antwerpen in de 16e. en 17e. Eeuwen*, Antwerp, 1932, pp. 59, 71–75, and M. Jaffé, 'Rubens and Raphael', in *Studies in Renaissance and Baroque Art presented to Anthony Blunt*, London, 1967, p. 102.

33. Jaffé, op. cit., pp. 103–4. The altarpiece of the *Transfiguration* was painted in 1604 for the Jesuit church at Mantua.

34. For the Constantine tapestries see particularly D. DuBon, *Tapestries from the Samuel H. Kress Collection at the Philadelphia Museum of Art*, London, 1964.

35. In opposition to Lugt, *Musée du Louvre: Inventaire général des dessins des écoles du Nord, École flamande ii*, Paris, 1949, 1057, pl. xli, and Müller-Hofstede, in *Master Drawings*, ii, 1, 1964, p. 14, who regard the source of Rubens' drawing as the *Small Gonzaga Madonna* in the Louvre, Jaffé, op. cit.,

p. 103, establishes its dependence from an engraving by Jacopo Caraglio (B. xv 69, 5).

36. Vienna, Kunsthistorisches Museum, No. 871. Painted in 1630–2.

37. For this panel see Camesasca, i, p. 67, pl. 131, and Dussler, pp. 57–58, No. 99, who gives a clear account of the problems of identification and authorship presented by the work.

38. A. Fontaine, *Conférences inédites de l'Académie Royale de Peinture et de Sculpture*, Paris, 1903, pp. 90–96.

39. A convenient summary of the material relating to the Sala di Costantino is provided by Dussler, pp. 96–98. Hartt, *Giulio Romano*, i, New Haven, 1958, pp. 42–51, dismisses the strong contemporary evidence for Raphael's share in the planning of the room and for the view that the *Battle of Constantine* was designed by Raphael. For a conclusive statement of the contrary case see J. Hess, 'On Raphael and Giulio Romano', in *Kunstgeschichtliche Studien zu Renaissance und Barock*, i, Rome, 1967, pp. 181–206.

40. For Giovio's life of Raphael, which appears to have been written before 1527, see Golzio, pp. 191–3. The relevant sentence reads: 'ejus extremum opus fuit devicti Maxentii pugna in ampliore caenaculo inchoata, quam discipuli aliquanto post absolverunt'.

41. D. Posner, 'Charles Lebrun's *Triumphs of Alexander*', in *Art Bulletin*, xli, 1959, p. 245.

42. Posner, op. cit., pp. 237–8.

43. H. Jouin, *Conférences de l'Académie Royale de Peinture et de Sculpture*, Paris, 1883, pp. 1–10.

44. Charles Lebrun, *Méthode pour apprendre à dessiner les Passions*, Paris, 1667.

45. A. R. Mengs, *Le LII Teste della celebre Scuola d'Atene dipinta da Raffaello Sanzio da Urbino nel Palazzo Vaticano disegnate in XL carte dal Cavalier Anton Raphael Mengs*, Rome, 1785.

46. V. Camuccini, *Studio del Disegno ricavato dall'estremità delle figure del celebre Quadro della Transfigurazione di Raffaelle*, Rome, n.d.

47. E. J. Poynter, *Poynter's South Kensington Drawing Book. Figures from the cartoons of Raphael*, London, 1888.

48. J. Reynolds, *Discourses on Art*, ed. R. R. Wark, San Marino (California), 1959, p. 219.

49. *Pre-Raphaelitism*, in *The Works of John Ruskin*, ed. Cook and Wedderburn, London, 1903–10, xii, p. 388.

50. D. Honisch, *Anton Raphael Mengs und die Bildform des Frühklassizismus*, Recklinghausen, 1965, p. 83. The oil copy by Mengs of the *School of Athens* was painted for the Duke of Northumberland in 1752, and is now in store at the Victoria and Albert Museum. The related cartoons are in the Kunsthalle at Kiel.

51. For the Mengs fresco of *Parnassus* in the Villa Albani (1761) see Honisch, op. cit., pp. 65–66.

52. K. Andrews, *The Nazarenes*, Oxford, 1964, p. 35.

53. *The Works of Lord Byron, Letters and Journals: IV*, ed. R. E. Prothero, London, 1900, p. 118. Letter of 9 May 1817 to John Murray.

54. For the iconography of Overbeck's painting see *An Account of the Picture of Frederick Overbeck representing Religion glorified by the Fine Arts, now in Städel's Art Institute at Frankfurt-on-the-Maine*, Oxford, 1850.

55. E. Delacroix, *Journal*, ii, 1853–6, ed. Joubin, Paris, 1932, p. 36.

56. Edmond et Jules de Goncourt, *Journal*, iii, 1866–1870, Paris, 1951, pp. 94–95.

57. *Modern Painters*, iii, in *The Works of John Ruskin*, ed. Cook and Wedderburn, London, 1903–10, v, p. 84.

58. *Ingres raconté par lui-même et par ses amis*, Paris, 1947, p. 20.

59. Op. cit., p. 88.

60. Op. cit., p. 97.

61. N. Schlemoff, *Ingres: ses sources littéraires*, Paris, 1856, p. 113.

62. G. Wildenstein, *Ingres*, London, 1956, No. 150.

63. Wildenstein, op. cit., No. 67.

64. Wildenstein, op. cit., No. 29.

65. Wildenstein, op. cit., No. 30.

66. Wildenstein, op. cit., No. 31.

67. For the painting and preliminary studies see Wildenstein, op. cit., Nos. 155–61, and for the history of the altarpiece B. Forestie, *Ingres et le Vœu de Louis XIII*, Montauban, 1945.

68. Paris, Louvre, No. 1507. Panel transferred to canvas: 120 × 95 cm. Raphael's responsibility for the painting appears to have been limited to the design and pose, and he was responsible neither for the life drawing nor for the cartoon, which were made in 1518 by a pupil, possibly Giulio Romano.

69. London, National Gallery. The portrait was executed between 1844 and 1856. M. Davies, 'A Portrait by the aged Ingres', in *Burlington Magazine*, lxviii, 1936, p. 261, comments: 'The construction I have indicated, extremely elaborate in its system of stresses, was of course for Ingres only the grammar of picture-making; it is one expression of the pictorial Latin culture he stole from Raphael'.

SUMMARY CHRONOLOGY

1483	6 April	Birth of Raphael at Urbino.
1494	1 August	Death of Raphael's father, Giovanni Santi.
1500	13 May	Raphael is recorded in a legal document as absent from Urbino.
	10 December	Commissioning of *Coronation of St. Nicholas of Tolentino* for S. Agostino, Città di Castello.
1501	13 December	Completion of *Coronation of St. Nicholas of Tolentino*.
1503		Commissioning of altarpiece for the church of Monteluce, Perugia. *Crucifixion* for S. Domenico, Città di Castello (National Gallery, London).

1504		*Marriage of the Virgin* for S. Francesco, Città di Castello (Brera, Milan).
	1 October	Letter of Giovanna, wife of Giovanni della Rovere, recommending Raphael to Piero Soderini, Gonfaloniere of the Republic of Florence.
1505		*Ansidei Madonna* for S. Fiorenzo, Perugia (National Gallery, London). Fresco in S. Severo, Perugia.
1506		*Madonna of the Meadow* (Kunsthistorisches Museum, Vienna).
1507		*Entombment* for S. Francesco, Perugia (Borghese Gallery, Rome). *Belle Jardinière* (Louvre, Paris).
	11 October	Raphael recorded in Urbino.
1508		*Large Cowper Madonna* (National Gallery of Art, Washington).
	21 April	Raphael writes from Florence to his uncle, Simone Ciarla, at Urbino.
1508	5 September	Raphael writes from Rome to Francesco Francia at Bologna (evidential value uncertain).
1509	13 January	Raphael receives payment for work in the Pope's apartments, probably in the Stanza della Segnatura.
	4 October	Raphael appointed Writer of the Papal Briefs.
1511		Date inscribed in two places in the Stanza della Segnatura. Commencement of work in Stanza of Heliodorus.
1512		Date beneath fresco of *Miracle at Bolsena*.
1513		Two payments to Raphael, apparently for work in the Stanza of Heliodorus.

1514		Date beneath fresco of *Freeing of St. Peter*. Completion of work in Stanza of Heliodorus. Commissioning of *St. Cecilia* for S. Giovanni in Monte, Bologna.
	1 August	Payment to Raphael, apparently for work in the Stanza dell'Incendio. Raphael named as Architect of St. Peter's.
1515	June	Payment for tapestry cartoons.
	27 August	Raphael is appointed Commissary of Antiquities.
1516		Date on mosaic decoration of cupola of Chigi Chapel in S. Maria del Popolo.
	20 June	Completion of *Stufetta* of Cardinal Bibbiena.
	20 December	Payment for tapestry cartoons.
1517	19 January	First reference to commissioning of *Transfiguration*. Date beneath fresco of *Oath of Pope Leo III*. Completion of Stanza dell'Incendio. *St. Michael* (Louvre, Paris).
1518	1 January	Loggia of Psyche in Villa Farnesina complete. *Holy Family of Francis I* (Louvre, Paris).
1518	20 July	Reference to execution of *Transfiguration*. Raphael reports to Pope Leo X on his archaeological survey of Rome.
1519		Loggia of the Vatican.
	26 December	Tapestries exhibited in Sistine Chapel.
1520	6 April	Death of Raphael.
	7 April	Raphael buried in Pantheon.

INDEX

(Numbers in italics refer to Illustrations)